The Guggenheim Collection

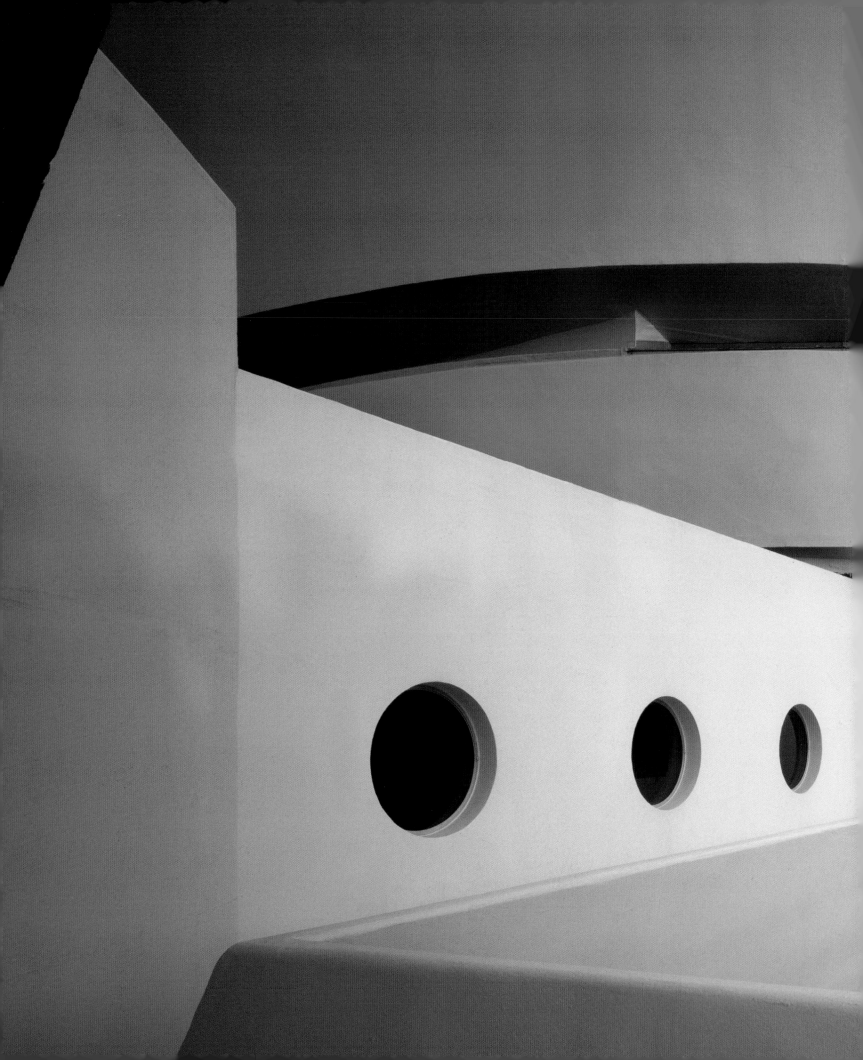

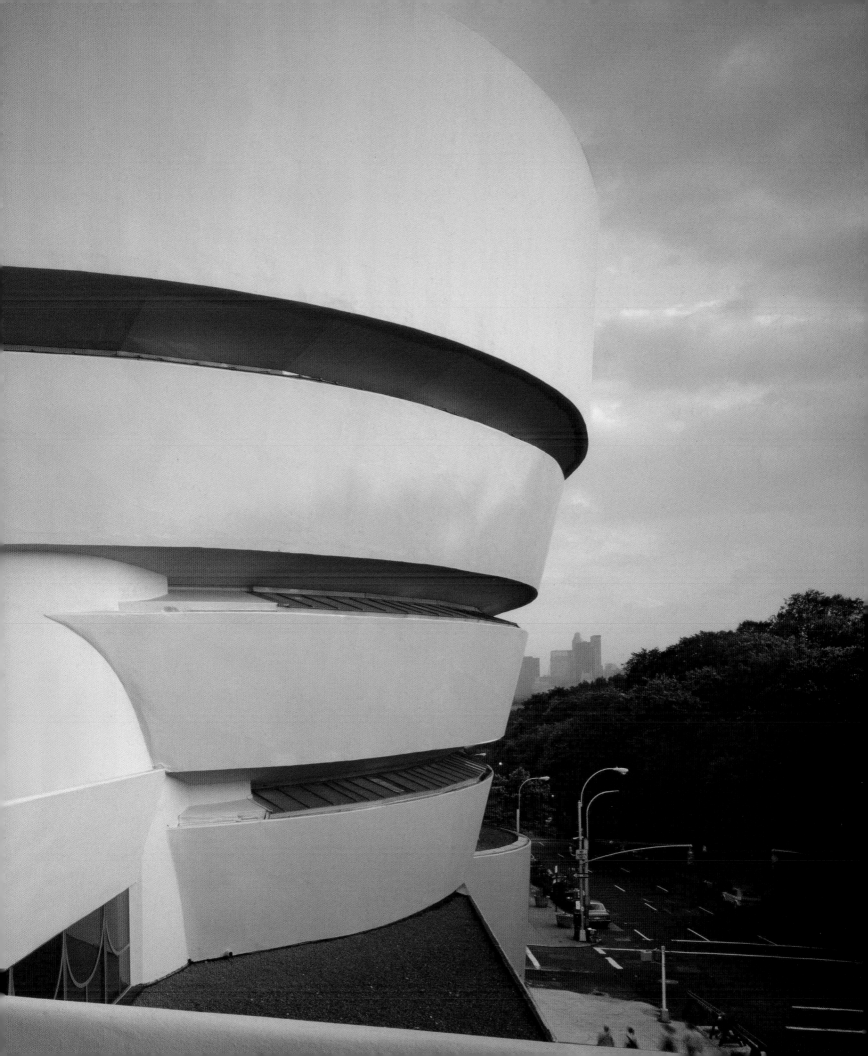

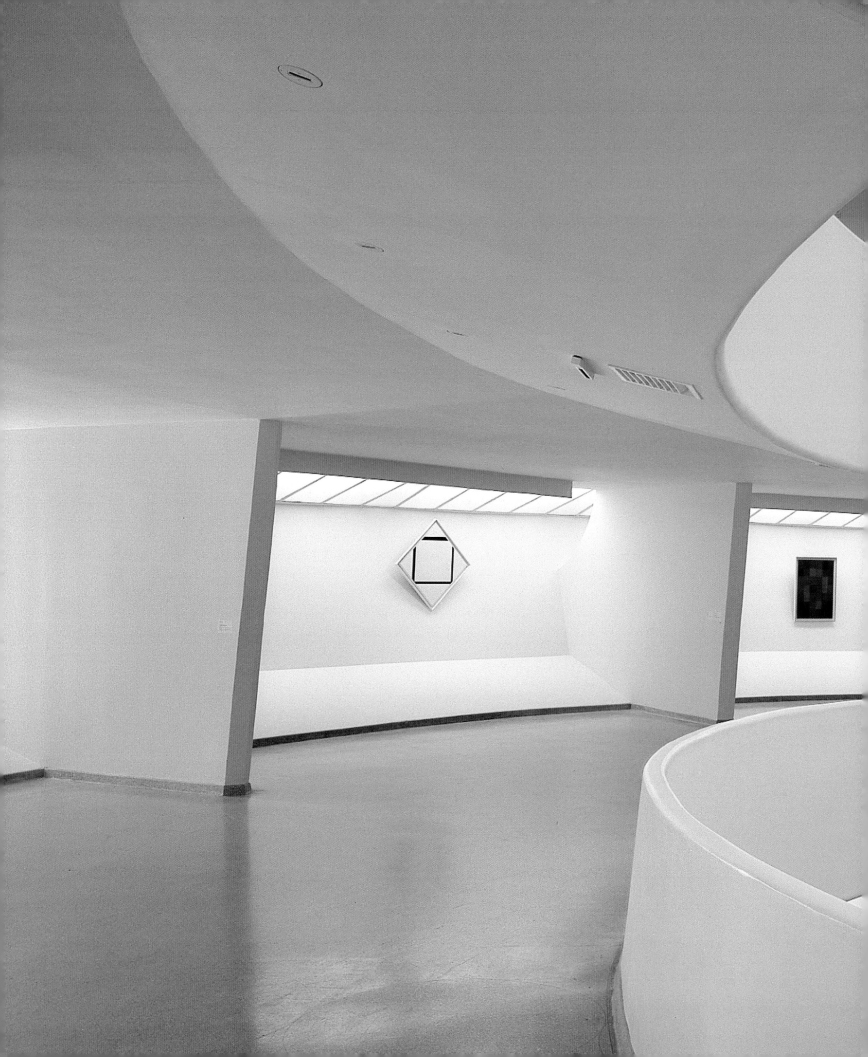

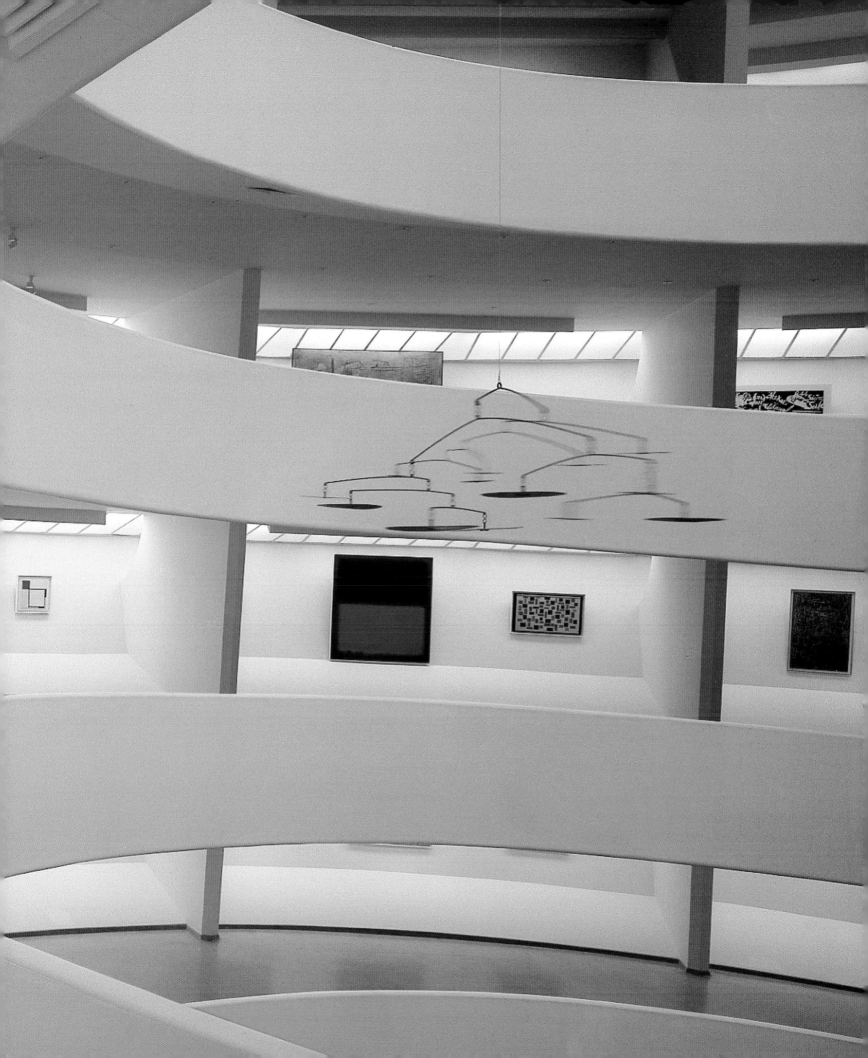

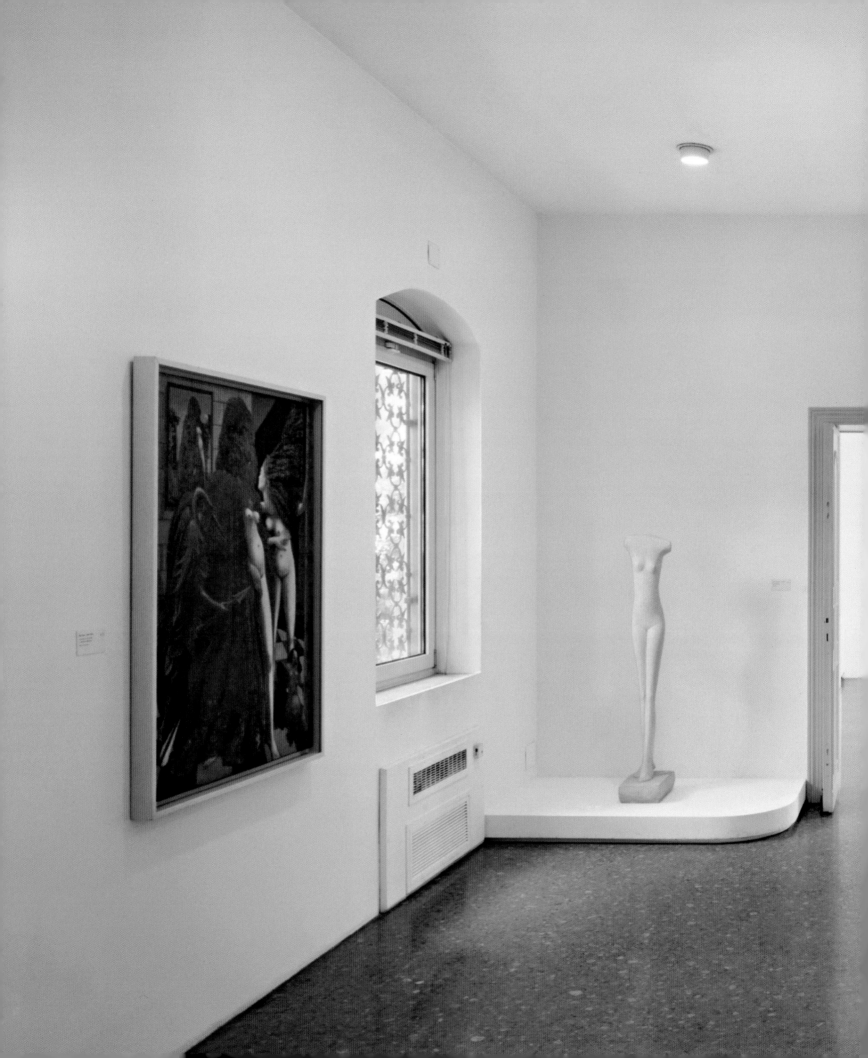

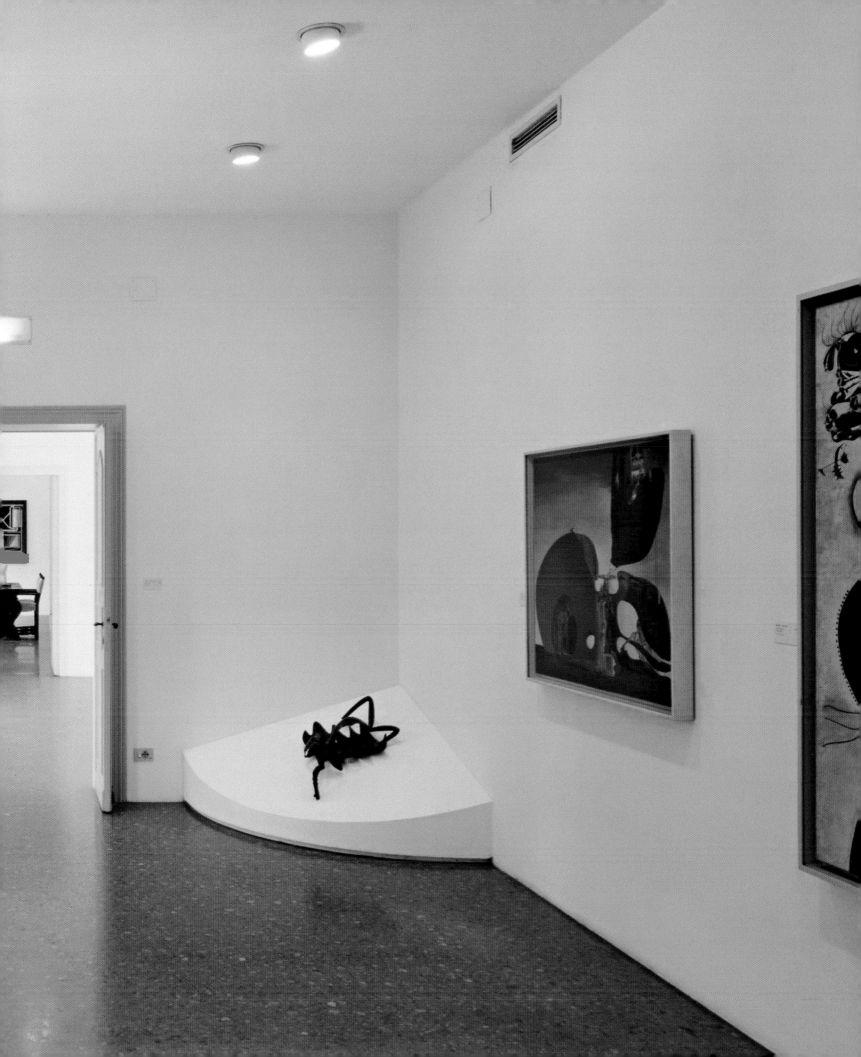

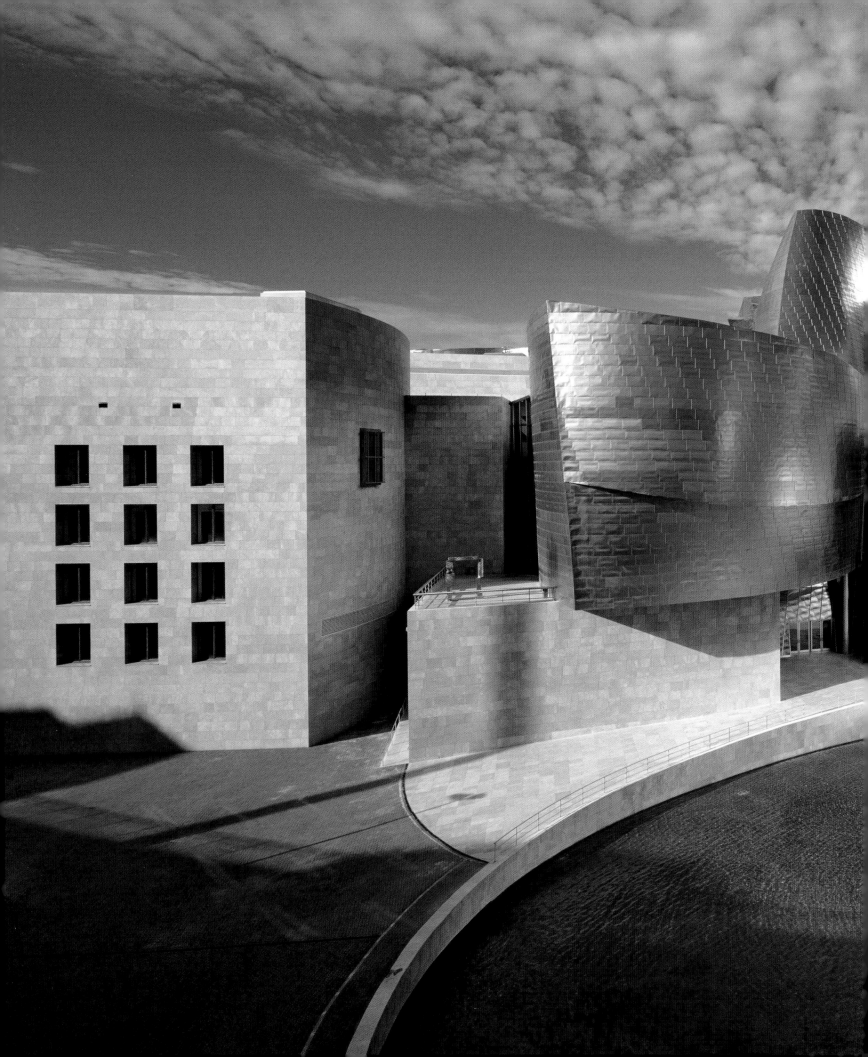

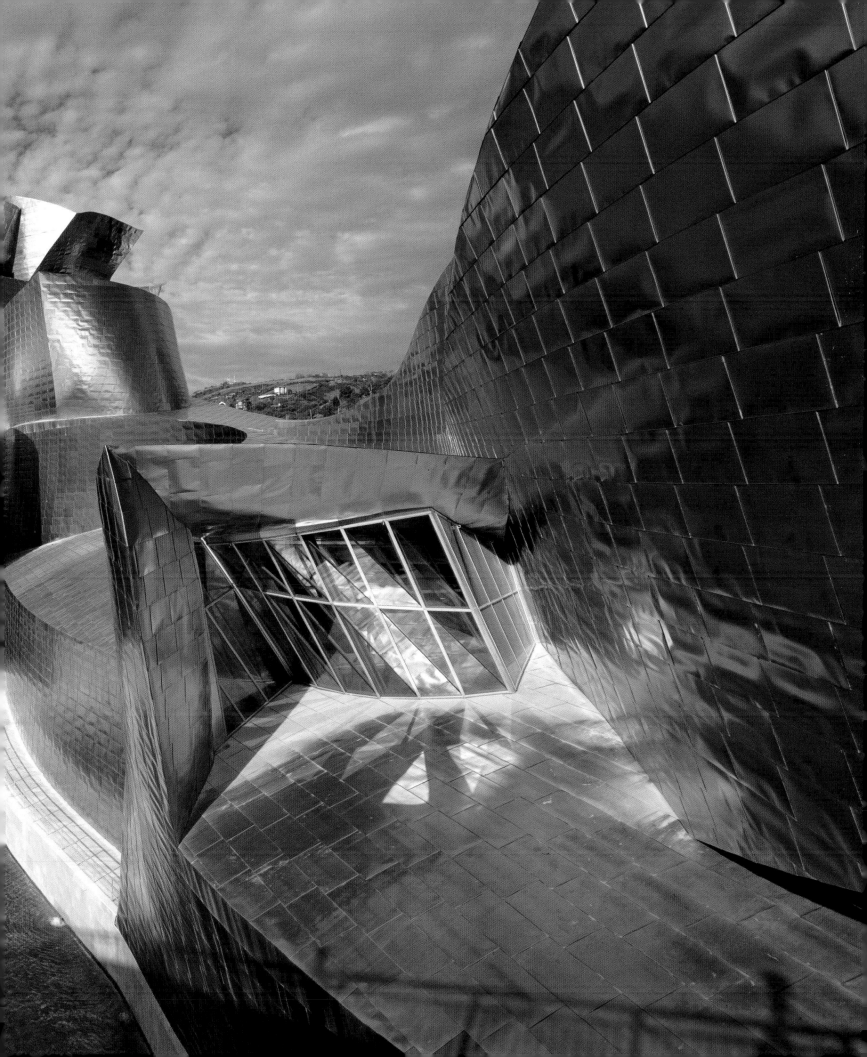

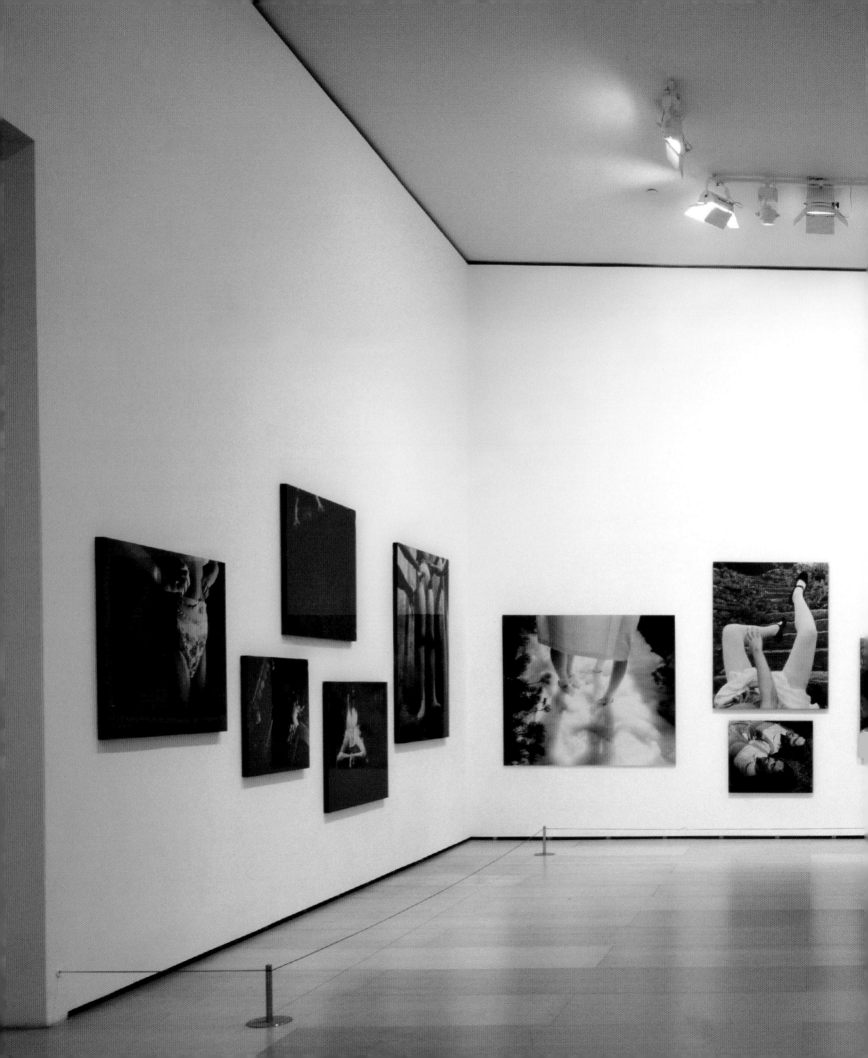

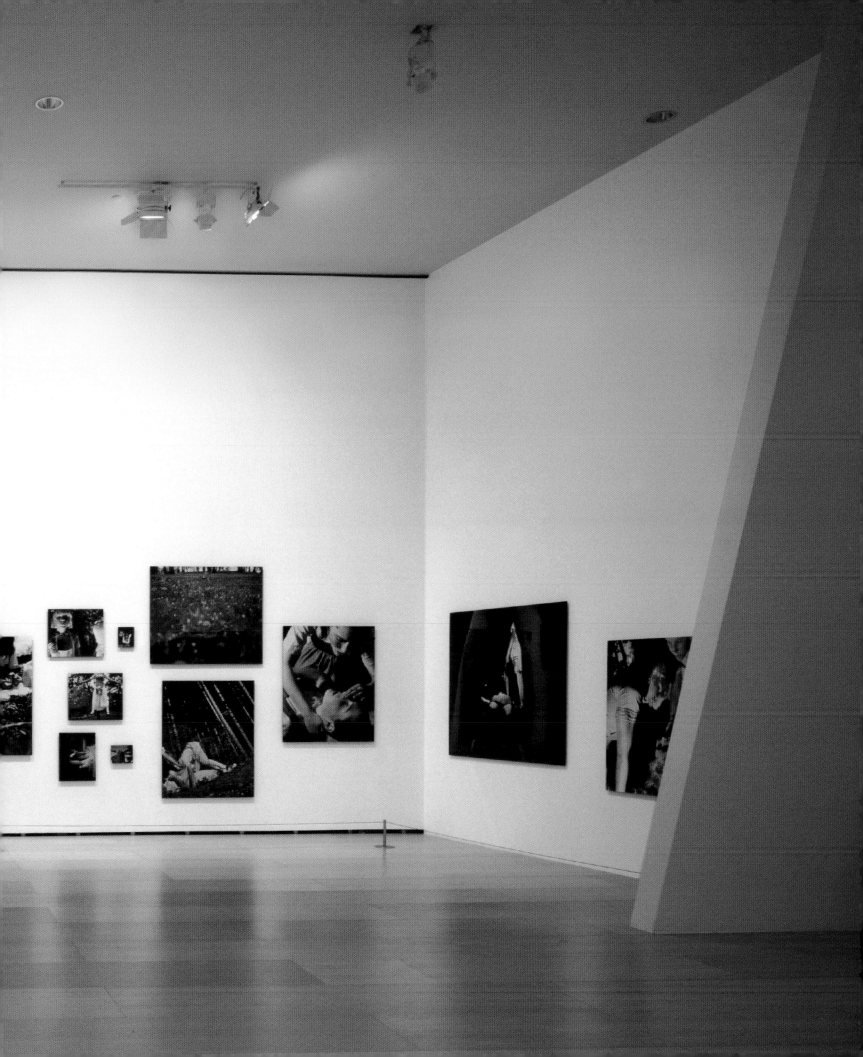

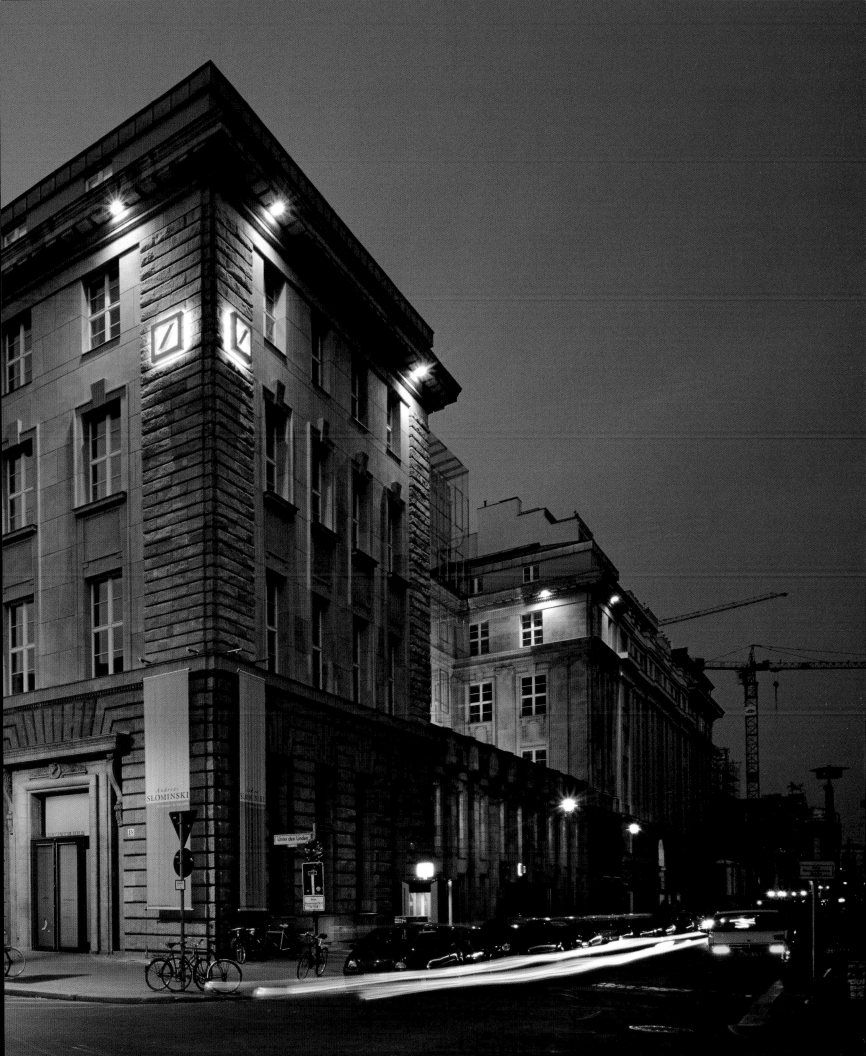

The
Gugge

enheim

Collection

Guggenheim MUSEUM

Published on the occasion of the exhibition
The Guggenheim Collection

This exhibition has been co-organized by the Solomon R. Guggenheim
Foundation, New York, and the Kunst- und Ausstellungshalle der
Bundesrepublik Deutschland, Bonn.

Kunst- und Ausstellungshalle der Bundesrepublik Deutschland, Bonn
Kunstmuseum Bonn
July 21, 2006–January 7, 2007

The Guggenheim Collection
© 2006 The Solomon R. Guggenheim Foundation, New York.
All rights reserved.

ISBN 0-89207-349-7 (hardcover)
ISBN 0-89207-350-0 (softcover)

Guggenheim Museum Publications
1071 Fifth Avenue
New York, New York 10128

Design: Eileen Boxer / BoxerDesign
Production: Jonathan Bowen, Melissa Secondino
Project editor: Edward Weisberger

Printed in Germany by GZD

Cover: Franz Marc, *Stables* (1913, detail of plate 41)

Pages 2–3: Solomon R. Guggenheim Museum, New York; 4–5: *The Global
Guggenheim: Selections from the Extended Collection*, 2001, New York (works
shown include plates 1, 64, and 75)

Pages 6–7: Peggy Guggenheim Collection, Venice; 8–9: permanent collection
galleries, Venice (works shown include plates 93 and 96)

Pages 10–11: Guggenheim Museum Bilbao; 12–13: Anna Gaskell photographs
included in *Moving Pictures: Contemporary Photography and Video from
the Guggenheim Museum Collections*, 2003–04, Bilbao (works shown include
plates 169, 171, and 173)

Pages 14–15: Deutsche Guggenheim, Berlin; 16–17: *Rachel Whiteread:
Transient Spaces*, 2001, Berlin (work shown: plate 163)

Contents

Preface

The Solomon R. Guggenheim Foundation is in a singular position. It is not only one of the most important institutions of modern and contemporary art, but with its five locations it has attained an exemplary worldwide presence. In addition to its flagship museum in New York, the foundation maintains branches in Venice, Bilbao, Berlin, and Las Vegas. There has been much debate about this international engagement in recent years, more often involving museum strategy rather than the art itself. ▬▬ *The Guggenheim Collection* focuses on the Guggenheim's extended collection. The exhibition provides a complete overview of developments in art from Impressionism and classic modernism to the present. Never before has it been possible to view the collection so thoroughly in a single show, and never before have we given so much room to an exhibition. Nearly 200 works have been gathered in Bonn, and thus it is possible to present not only single masterpieces but also multiple works by such groundbreaking artists as Vasily Kandinsky, Paul Klee, Robert Delaunay, Constantin Brancusi, Piet Mondrian, and Pablo Picasso. Its comprehensive holdings of certain artists are the Guggenheim's great strength and serve to document the collection's development. In its present form the collection reflects the commitment of a number of collectors, each with a different emphasis. Thus from various segments a whole was created that reflects all facets of modern and contemporary art, yet is still selective. ▬▬ It was Solomon R. Guggenheim who began the collection and defined its initial mission. He began collecting non-objective art systematically in 1929, after the German artist Hilla Rebay introduced him to the European avant-garde and encouraged his interest in this kind of art. Over time more than 150 works by Kandinsky alone would enter the Guggenheim's collection. In 1937 the Solomon R. Guggenheim Foundation was established and planning began for a museum. Two years later the Museum of Non-Objective Painting opened in Manhattan, in a former automobile showroom, with Rebay as its director. To make room for the rapidly growing collection, a mere four years later, in 1943, Frank Lloyd Wright was commissioned to design a new building. The structure was intended to match the mission of the Guggenheim Foundation, in accordance with the principles and spirit of non-objective painting. The spiral-shaped exhibition hall Wright designed met this requirement in an exemplary way. But it would take sixteen years before Wright's building was completed. Meanwhile the range of the collection expanded, and a new exhibition policy had been established. The man for whom the new museum was named did not live to attend its opening in October 1959; Solomon Guggenheim had died ten years earlier. Nor did the architect live to see it completed; Wright died in April, a few months before the opening. ▬▬ The first collection integrated into the Guggenheim Foundation's early holdings was that of the art dealer Karl Nierendorf in 1948, with more than 700 works, including many works by Paul Klee as well as examples of Expressionism and Surrealism. It was followed by a bequest from Katherine S. Dreier, with major works by Brancusi, Mondrian, and Kurt Schwitters. The important collection of Justin K. Thannhauser brought works of Impressionism and early modernism to the Guggenheim Foundation, extending the range of the collection back to the late nineteenth century. The next major expansion came with the collection

of Peggy Guggenheim, the founder's niece. She added roughly 300 works of modern art, including Surrealism and Abstract Expressionism, so that now American painting was also represented by outstanding works. A large portion of what was then perhaps the most important collection of works of Minimal and Conceptual art, which had been assembled by Giuseppe Panza di Biumo, was acquired in 1991—one more facet adding luster to the Guggenheim's collection. Along with the acquisition of these individual collections, the Guggenheim continued to purchase single works, and also commissioned works, for example, for the Deutsche Guggenheim in Berlin. The present exhibition represents all of this diversity. The most contemporary works—art since 1990—including pieces by Matthew Barney, Douglas Gordon, and Rachel Whiteread, are being shown at the Kunstmuseum Bonn. ▃▃▃ Anyone who wishes to tell the Guggenheim story must necessarily devote a chapter to architecture. The legendary museum in New York—itself an icon of modernism—is an essential part of twentieth-century architectural history. Frank Gehry's Guggenheim Museum Bilbao is equally novel and spectacular. In addition to these completed buildings, there are a number of projects that have been developed for proposed branches all over the world. *The Guggenheim Architecture*, a separate exhibition—conceived by Peter Noever, Director, Museum für Angewandte Kunst, Vienna—is also being held at the Kunst- und Ausstellungshalle der Bundesrepublik Deutschland. The architectural projects and competitions on display are all distinguished by innovation, an ability to rethink architecture, and the potential of becoming landmarks. ▃▃▃ We could never have realized an exhibition of this magnitude on our own. It has been made possible thanks to the generous support of Deutsche Telekom AG. We are extremely grateful to that corporation for its commitment, and would especially like to thank the Chairman of the Board, Kai-Uwe Ricke. We are also indebted to the Solomon R. Guggenheim Foundation and its Director, Thomas Krens. He has done everything possible to see that so many of the Guggenheim's treasures could travel to Bonn and has energetically supported *The Guggenheim Collection* at every stage. Of his colleagues, we especially thank Valerie Hillings, Assistant Curator. She and Karen Meyerhoff, Managing Director for Exhibitions, Collections, and Design, contributed greatly to the project's realization. Our thanks as well to Nicolas Iljine, the Guggenheim's Director of Corporate Development, Europe & Middle East. Kay Heymer, Curator and Project Manager, and Susanne Kleine, Curator and Project Manager, were responsible for the project at the Kunst- und Ausstellungshalle; together they arranged for the smooth coordination and realization of this complex exhibition. Volker Adolphs, Head of Exhibitions and Curator, was

Wenzel Jacob
Director, Kunst- und Ausstellungshalle der
Bundesrepublik Deutschland

Dieter Ronte
Director, Kunstmuseum Bonn

responsible for mounting the contemporary section at the Kunstmuseum Bonn. ▃▃▃ This generous selection of works from the Guggenheim—whose unique collection has its roots in Europe and owes its fame to America—will be on view in Germany for six months. It is hoped that large numbers of visitors will take advantage of this unparalleled opportunity.

Preface

When Wenzel Jacob, Director, Kunst- und Ausstellungshalle der Bundesrepublik Deutschland, invited the Guggenheim to take part in its series of exhibitions of the greatest museum collections, I immediately recognized that such a show would present a challenge. During our earliest conversations about the project, we discussed the fact that private art collections—those gifted and those purchased—have been the foundation of all museums' permanent collections. The Guggenheim is no exception in this regard: Solomon R. Guggenheim donated works from his collection to the Solomon R. Guggenheim Foundation, which he began in 1937 to support and promote non-objective art. In 1939, he established the Museum of Non-Objective Painting, which was renamed the Solomon R. Guggenheim Museum in 1952, and its signature Frank Lloyd Wright building opened on New York's Fifth Avenue in 1959. Over time, the Guggenheim has expanded the type of art that it exhibits and collects through the addition of other great collections—notably, those of Karl Nierendorf, Peggy Guggenheim, Justin and Hilde Thannhauser, and Giuseppe Panza di Biumo—as well as through opportunities that resulted from the institution's increasingly international focus in more recent decades. ▬▬ The Guggenheim today encompasses venues on two continents: the museum in New York, the Peggy Guggenheim Collection in Venice, the Guggenheim Museum Bilbao, the Deutsche Guggenheim in Berlin, and the Guggenheim Hermitage Museum in Las Vegas. Four of these museums have their own remarkable collections, and the fifth, the Guggenheim Hermitage Museum, provides an exhibition hall for viewing masterpieces from the Guggenheim and the State Hermitage Museum in St. Petersburg. ▬▬ The Guggenheim Foundation's extended collection exists within and among five museums, thereby transcending the traditional definition of a museum collection. In this sense, the Guggenheim still strives to realize the promise of its original vision of utopian optimism by playing a leading role in shaping the experience of culture in the interconnected world of the twenty-first century. ▬▬ To this end, the Guggenheim is pleased and honored to be co-organizers with the Kunst- und Ausstellungshalle of *The Guggenheim Collection*, the most comprehensive presentation of masterworks from our global collection to date. It is especially fitting to have this exhibition take place in Germany, which is not only home to the Deutsche Guggenheim but also a country that played a major role in the history of the Guggenheim family, of our founding director Hilla Rebay, and of such collectors as Nierendorf and the Thannhausers. ▬▬ The desire to formulate a unique and engaging picture of the collection led to a great deal of reflection and deliberation within the Guggenheim and among myself and the three other curators of this exhibition: the Guggenheim's Valerie Hillings and the Kunst- und Ausstellungshalle's Kay Heymer and Susanne Kleine. We concluded that a chronological presentation of key works from Impressionism to contemporary art would provide an art historical structure and simultaneously underscore a distinctive feature of the collection, namely, that it is not encyclopedic but is fundamentally characterized by long-term commitments to particular artists, such as Vasily Kandinsky, Constantin Brancusi, Paul Klee, Pablo Picasso, Robert Rauschenberg, Dan Flavin, Richard Serra, Bruce Nauman, Lawrence Weiner, and Matthew Barney, among others. ▬▬ It was evident that

the specific works chosen needed to say something about the Guggenheim's institutional history as it relates to the history of art. Consequently, we chose to begin with a rich selection of paintings by Kandinsky, whose work has been a cornerstone of the collection since its inception. In the 1930s, Rebay encouraged Solomon Guggenheim to collect Kandinsky's non-objective paintings in depth, and more than 150 works by the artist would enter the collection throughout the years. ▬▬▬ We chose to trace the evolution of art history from Impressionism to contemporary art through a presentation of multiple works by a selection of artists and, in the cases of Picasso, Rauschenberg, and Serra, through monographic rooms devoted to their work. This approach illuminates the development of given art movements across time and underscores defining aspects of the collection. With contemporary art, we selected nine artists with whom the Guggenheim has developed important relationships. This section reflects the direction of the Guggenheim's acquistions in recent years, which have had an emphasis on installation, video, and photography rather than on painting. ▬▬▬ A separate exhibition at the Kunst- und Ausstellungshalle, *The Guggenheim Architecture*, will shed light on the ways in which existing and imagined spaces have played a complex and central role in the Guggenheim's history. Because the relationship between art and architecture is of paramount importance, we are especially pleased to have the chance to investigate this key topic alongside the rich presentation of masterworks from the Guggenheim's collection. ▬▬▬ Many individuals at the Guggenheim deserve recognition for their contributions to the realization of this exhibition. In New York, I would like to thank Lisa Dennison, Director, Solomon R. Guggenheim Museum, for her constant support and her essential help with the development of the checklist. Other members of our senior staff were also instrumental in this project, including Marc Steglitz, Chief Operating Officer, and Anthony Calnek, Deputy Director for Communications and Publishing. I am grateful to Nicolas Iljine, Director for Corporate Development, Europe & Middle East, for his help in making this exhibiton happen. Karen Meyerhoff, Managing Director for Exhibitions, Collections, and Design, and Valerie Hillings, Assistant Curator, deftly and expertly managed all aspects of the exhibition. Valerie must also be acknowledged for her dedicated work as one of the show's curators. I am particularly grateful for the support of Juan Ignacio Vidarte, Director General, Guggenheim Museum Bilbao, and Philip Rylands, Director, Peggy Guggenheim Collection. ▬▬▬ Sincere thanks are owed to our colleagues at the Kunst- und Ausstellungshalle for their enthusiasm for and commitment to *The Guggenheim Collection*. I would like to acknowledge in particular my friend Wenzel Jacob for his decisive role in making this show possible. The Kunst- und Ausstellungshalle's curators and project managers Kay Heymer and Susanne Kleine were thoughtful and intelligent partners in the complex process of selecting the works for the checklist and in coordinating the project in Bonn. I am also grateful to Dieter Ronte, Director, Kunstmuseum Bonn, for granting us space in his museum for the very important presentation of contemporary art. ▬▬▬ Finally, I join Wenzel and Dieter in thanking Deutsche Telekom AG, and especially Kai-Uwe Ricke, Chairman of the Board, without whose generous support this exhibition would not have been possible.

Thomas Krens
Director, Solomon R. Guggenheim Foundation

Acknowledgments

Over the course of a year, the Solomon R. Guggenheim Foundation and the Kunst- und Ausstellungshalle der Bundesrepublik Deutschland have had the privilege of working together to develop the checklist and curatorial concept for *The Guggenheim Collection*. We wish to take this opportunity to acknowledge the invaluable contributions of our colleagues from various departments in the process of realizing this project. ▬▬▬ We are grateful in particular to a number of people at the Solomon R. Guggenheim Museum in New York, who generously gave their input regarding the selection of artworks: Lisa Dennison, Director; Nancy Spector, Curator of Contemporary Art and Director of Curatorial Affairs; Susan Davidson, Curator; Tracey Bashkoff, Associate Curator; and Ted Mann, Assistant Curator for Collections. Kevin Lotery, Project Curatorial Assistant, provided support for all aspects of the project and must be commended for his unwavering commitment and hard work. ▬▬▬ We also thank Susan Cross, former Associate Curator at the Guggenheim and now Curator at the Massachusetts Museum of Contemporary Art, for the important curatorial role she played during the exhibition's early planning stages. Friedhelm Hütte, Global Head of Deutsche Bank Art, who works closely with the Guggenheim on the Deutsche Bank's contemporary art commissions for the Deutsche Guggenheim in Berlin, as well as on exhibitions held there, has generously provided insight into and documentation of Deutsche Guggenheim's exhibition history. At the Guggenheim Museum Bilbao, Petra Joos, Director of Museum Activities, and Daniel Vega, Subdirector of Planning and Organization, gave input and assistance on various issues. Additionally, we recognize Volker Adolphs, Head of Exhibitions and Curator, Kunstmuseum Bonn, for his collaboration in the presentation of contemporary art from the Guggenheim's collection hosted by his museum. ▬▬▬ The expertise of our superlative conservation departments has been much appreciated. We acknowledge the tireless and passionate dedication at the Guggenheim in New York of Lisa Barro, Photography Conservator; Julie Barten, Conservator, Exhibitions; Gillian McMillan, Senior Conservator, Collection; Nathan Otterson, Conservator, Sculpture; Carol Stringari, Senior Conservator, Contemporary Art; and Jeffrey Warda, Assistant Conservator, Paper; at the Guggenheim Museum Bilbao of Silvia Lindner, Conservator, and Ainhoa Sanz, Conservator; and of the Guggenheim's Chief Conservator and Technical Director for International Projects, Paul Schwartzbaum. And we are thankful for the contributions of Ulrike Klein, Head Conservator, Kunst- und Ausstellungshalle, and her team of conservators. ▬▬▬ We have relied on the tremendous professionalism of our registrars in New York: Seth Fogelman, Associate Registrar for Collection Exhibitions, and Janet Hawkins, Project Registrar; and in Bonn: Marla B. Manna, Registrar. Together they have coordinated the complex shipping arrangements that made this exhibition possible. For their assistance, we are also grateful to Meryl Cohen, Director of Registration and Art Services, and Jill Kohler, Associate Registrar for Collection Management, at the Guggenheim in New York; Sandra DiVari, Registrar, at the Peggy Guggenheim Collection in Venice; and Sonia Nuñez, Collection Registrar, at the Guggenheim in Bilbao. ▬▬▬ Even the strongest selection of artworks benefits from the vision of an exhibition designer and the

talents of installation, art handling, lighting, and graphic design teams. We were fortunate in New York to have had Ana Luisa Leite, Manager of Exhibition Design, as our partner in determining the look of this show, and at the Kunst- und Ausstellungshalle to have had Michael Haacke, Exhibition Designer, and Axel Wupper, Technician, to help with managing the design and installation in Bonn. Gerd Graef, Lighting Specialist, has used his artistry to help us show the chosen masterworks to their best advantage. ▬▬ At the Guggenheim in New York, David Bufano, Manager of Art Services and Preparations, provided leadership in coordinating many logistical aspects, and we acknowledge his team of art handlers and preparators, including Jeffrey Clemens, Derek DeLuco, Elisabeth Jaff, and Colin O'Neil. We are also grateful for the expertise of Paul Kuranko, Media Arts Specialist. We extend our thanks to Marcia Fardella, Chief Graphic Designer, and Concetta Pereira, Production Supervisor, for their help in developing the exhibition's graphic look and to Francine Snyder, Manager of Library and Archives, for her assistance with archival materials for the show. ▬▬ A number of documentary films have been made in connection with this exhibition, and Ulrich Best, Head of Technical Media, Kunst- und Ausstellungshalle, contributed his expertise and leadership for all of them. In New York, interns Noepy Testa and Elodie Tripon provided assistance with coordination of these films. ▬▬ We especially thank Eileen Boxer for her sensitive design of the exhibition catalogue. This publication would not have been possible without the hard work of members of the Guggenheim's New York staff. Elizabeth Levy, Director of Publications, led a talented and committed team that included Jonathan Bowen, Associate Production Manager, Elizabeth Franzen, Managing Editor, David Grosz, Associate Editor, Stephen Hoban, Assistant Managing Editor, Melissa Secondino, Production Manager, and Edward Weisberger, Senior Editor. Kim Bush, Manager of Photography and Permissions, supplied images. In addition, we are grateful to the authors: Jennifer Blessing, Julia Brown, Anthony Calnek, Susan Davidson, Lisa Dennison, Matthew Drutt, Michael Govan, Ted Mann, and Diane Waldman. ▬▬ At the Kunst- und Ausstellungshalle, we thank Maria Nusser-Wagner, Head of Public Relations and Marketing, Stephan Andreae, Forum, Folker Metzger, Educational Services, and Maja Majer-Wallat, Press Officer, for their dedication and outstanding work on this project. At the Guggenheim in New York, Anthony Calnek, Deputy Director for Communications and Publishing, and Betsy Ennis, Director of Public Affairs; in Bilbao, Alicia Martinez, Deputy Director for Communications and Images, and Ana Lopez de Munain, Communications Coordinator; in Venice, Alexia Boro, Officer for Press and Communications; in Berlin, Svenja Gräfin von Reichenbach, Gallery Manager, and Sara Bernshausen, Associate Gallery Manager; and members of their staffs—all deserve our sincere thanks for their contributions to the exhibition. MaryLouise Napier, Deputy Chief of Staff, Katerina Bernstam, Assistant to the Director, and Sarah Cooper, Administrative Assistant, in Thomas Krens's office, and Jana Hummelova and Heidrun Küpfer, in Bonn, gave us invaluable support. ▬▬ To those whose names we have not enumerated here, we also extend our heartfelt thanks for a job well done.

Valerie Hillings
Assistant Curator, Solomon R. Guggenheim Museum

Kay Heymer
Curator and Project Manager,
Kunst- und Ausstellungshalle der Bundesrepublik
Deutschland

Susanne Kleine
Curator and Project Manager,
Kunst- und Ausstellungshalle der Bundesrepublik
Deutschland

Thomas Krens
Director, Solomon R. Guggenheim Foundation

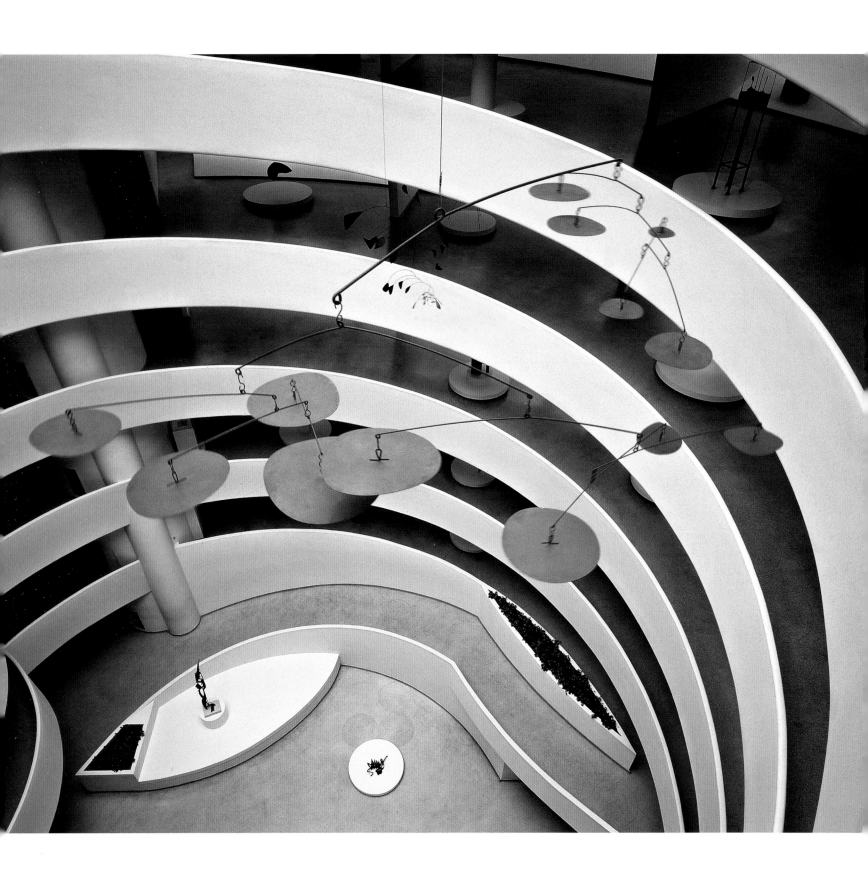

ANTHONY CALNEK

The Guggenheim Is Not a Place

For many years, Thomas Krens, the longtime Director of the Solomon R. Guggenheim Foundation, has displayed on his wall a computer-generated poster with the message "The Guggenheim is not a place" (fig. 23). With its hip graphics and unexpected aphorism, the poster tends to intrigue his visitors, hanging, as it does, in an office annexed to one of the most famous places in the world: the Solomon R. Guggenheim Museum on Fifth Avenue. The Frank Lloyd Wright building defies the statement on Krens's wall; or is it that the statement defies the Wright building? ▬▬ It would be hard to deny that the idea of place is central to the history of the Guggenheim Foundation, since so many legendary structures have come to be part of the institution's chronology. Twenty years before the Wright building opened, there was the Museum of Non-Objective Painting, which opened in 1939 as the first of the foundation's New York venues for the display of art. The unusual gallery—designed by Lewis Muschenheim at the behest of Hilla Rebay, the foundation's curator and the museum's director—was built in a former automobile showroom on East Fifty-fourth Street in Manhattan.[1] With its exhibitions of Solomon Guggenheim's somewhat eccentric art collection, the Museum of Non-Objective Painting provided many visitors their first encounter with great works by Vasily Kandinsky—such as *In the Black Square* (June 1923, plate 2)—as well as lesser works by his followers. Hung low to the ground on walls covered with thick drapery, these paintings were to be surveyed while the music of Bach and Chopin played on the sound system. ▬▬ Within a few years, in 1942, a different Guggenheim, Peggy, was responsible for another highly experimental, and memorable, place. Her gallery-museum Art of This Century, on West Fifty-seventh Street, designed by Frederick Kiesler, provided even more opportunity for a space to upstage the art exhibited within it.[2] Peggy, Solomon's niece (and an entirely independent soul), launched Art of This Century by showing the extraordinary Surrealist and European abstract work she had collected. But over the next four years, she would mount a series of exhibitions—of emerging American artists, such as Robert Motherwell, Mark Rothko, and most important, Jackson Pollock—that transcended Kiesler's visionary architecture. ▬▬ Other places followed. In 1949, Peggy Guggenheim acquired a fabulous palazzo on the Grand Canal in Venice and installed her collection there; she would remain aloof from anything to do with her uncle's foundation for decades.[3] The Museum of Non-Objective Painting moved into a townhouse at 1071 Fifth Avenue (and then one on East Eighty-second Street), while it awaited the construction of the Frank Lloyd Wright building. Along the way, Solomon Guggenheim died, Rebay was replaced as director, and the permanent collection swelled. By the time

facing page:
1. Alexander Calder
Red Lily Pads, 1956

31

Wright's building opened in 1959, the Guggenheim name had been associated with many places. But now it had a world-famous building as its home and symbol.

"Are they allowed to do that on Fifth Avenue?"

The need for a permanent building to house Solomon Guggenheim's art collection was evident in the early 1940s; by this time, an elderly Solomon (he was born in 1861) had amassed a vast number of avant-garde paintings. In his middle age, he and his wife Irene had formed an undistinguished collection of old master paintings. In 1927, though, his tastes changed dramatically when he entered into a close relationship with the German-born Rebay. Smitten with Rebay and her ideas about non-objective art, Guggenheim put his considerable resources toward buying works by the artists Rebay anointed; her favorites were Rudolf Bauer and Vasily Kandinsky. Rebay accompanied the Guggenheims to Europe, where they bought paintings directly from Kandinsky, Paul Klee, László Moholy-Nagy, and others. Recent scholarship has shown that Guggenheim recognized the particular vulnerability of artists persecuted by the Nazis and supported several by buying their works.[4]

After a decade, Guggenheim was prepared to give the collection to the public, through the means of an educational foundation chartered by the New York State Board of Regents. The Solomon R. Guggenheim Foundation was established in 1937 for the "promotion and encouragement and education in art and the enlightenment of the public." Solomon gave the foundation his entire collection, and supported it financially. The Guggenheim Foundation pursued its mission vigorously, by organizing exhibitions of its holdings and showing them in other locations in the United States and Europe; by purchasing art from artists as a means to support them; and by organizing exhibitions of emerging artists who pursued non-objective painting. Through it all, Rebay was a force to be reckoned with. As a young avant-garde artist in Germany, she had exhibited at the famous Galerie Der Sturm in Berlin. In America, she was best known as an ardent proponent of purely abstract art, which she dubbed "non-objective"—an inexact English translation of the German word "gegenstandslos," which more accurately translates as "objectless." For many decades, Rebay's reputation was compromised because she had mixed her personal and artistic aspirations to a questionable degree. Once she became Solomon Guggenheim's art adviser, she persuaded him to buy hundreds of paintings by Bauer, a second-rate artist who also happened to be her lover. She also used her directorship of the Museum of Non-Objective Painting to advance her own art, featuring her paintings and drawings in several exhibitions. As a result, in America she was not taken as seriously as she should have been. After Solomon died in 1949, she fell more and more out of favor with the trustees of the Guggenheim Foundation and was forced to retire in 1952. She spent the last fifteen years of her life almost entirely disconnected from the museum she had played a key role in founding. But history has been kinder to Rebay, both as an artist and a patron of the arts. She has rightly been credited with giving Wright one of his greatest commissions, and she played a key role in the lengthy design process. Rebay, however, did not come to the opening of the building,

fig. 1 Solomon R. Guggenheim

fig. 2 Hilla Rebay

fig. 3 Peggy Guggenheim

fig. 4 Vasily Kandinsky paintings included in
Tenth Anniversary Exhibition, 1949, Museum
of Non-Objective Painting, New York

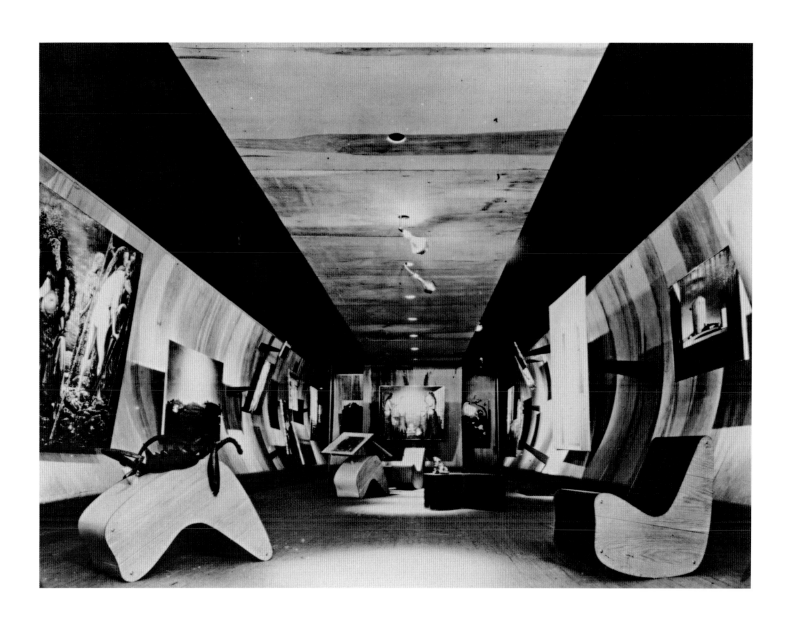

fig. 5 Surrealist gallery at Art of
This Century, New York, 1942

nor was her artwork the subject of an exhibition there until 2005, when her paintings, drawings, and collages were shown in a Rebay retrospective that received extraordinarily good reviews and rehabilitated her reputation.[5] ▬▬▬ In commissioning Wright in 1943, Rebay penned one of the most famous lines ever to an architect: "I want a temple of spirit, a monument!" To sweeten the request, she told Wright, "I need a fighter, a lover of space, an originator, a tester and a wise man."[6] Over the next twelve years, Wright would create seven designs for the museum, but even though he visited the construction site and was even photographed on the ramps giving his comments to the builder, he died several months before his most famous structure was completed. ▬▬▬ The opening of the Solomon R. Guggenheim Museum on October 21, 1959, was a watershed event in the foundation's history. Immediately greeted with a certain degree of skepticism—*Newsweek* headlined its review of the building "Museum or a Cupcake?" while the *New Yorker* ran myriad cartoons about it, including Alan Dunn's hilarious depiction of a fur-clad lady of a certain age commenting to her husband as they drive by, "Are they allowed to do that on Fifth Avenue?"[7] (fig. 7)—within a decade it was firmly established as one of the city's great architectural landmarks. ▬▬▬ Henceforward, "Guggenheim" would become synonymous with this singular work of architecture, eclipsing all of the name's previous connotations. For many decades, the Guggenheim name had been associated mostly with one of America's most successful families, which was attaining, through various charitable foundations, an enormous reputation in the philanthropic realm. Before 1959, "Guggenheim" might conjure up the image of silver and copper mines, the assets that made the Swiss-German family the richest Jewish family in the United States; after 1959, "the Guggenheim" evoked the giant nautilus shell rising from the otherwise predictable grid of New York City. Eventually, the family's fortunes would fade, but on the strength of this building, its name has been assured immortality.[8]

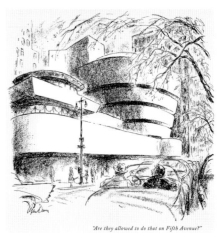

"Are they allowed to do that on Fifth Avenue?"

Non-Objective Painting and Beyond

The rechristening of the Museum of Non-Objective Painting was Wright's idea. Politically astute, he proposed that Solomon's primary heir, Harry Frank Guggenheim, would be more likely to devote himself to the construction of the building if it were named for his uncle rather than for an arcane art movement. Once it shed its narrowly focused name—and Rebay had resigned as director—the Solomon R. Guggenheim Museum was poised to grow well beyond the original intention of its founders. At several points in its history, the Guggenheim overcame its own historical limitations to make quantum leaps forward. Indeed, the ability to grow is perhaps the institution's most distinctive and impressive quality. ▬▬▬ At the beginning, the collection of non-objective paintings amassed by Solomon Guggenheim and Rebay gave the Guggenheim Foundation a sharply focused identity. With a messianic fervor, Rebay promoted the idea that non-objective art was uniquely able to help mankind achieve a higher spiritual plane. Guggenheim was apparently a true believer as well, and his intention was that Rebay and her vision should be supported after his death. But the foundation's charter contains extremely broad language: the institution's mission is, simply, for the

fig. 6 Solomon R. Guggenheim, Hilla Rebay, and Frank Lloyd Wright, ca. 1945

fig. 7 Alan Dunn, *New Yorker* cartoon, November 8, 1958

facing page:
fig. 8 Solomon R. Guggenheim Museum, New York, on opening day, October 21, 1959

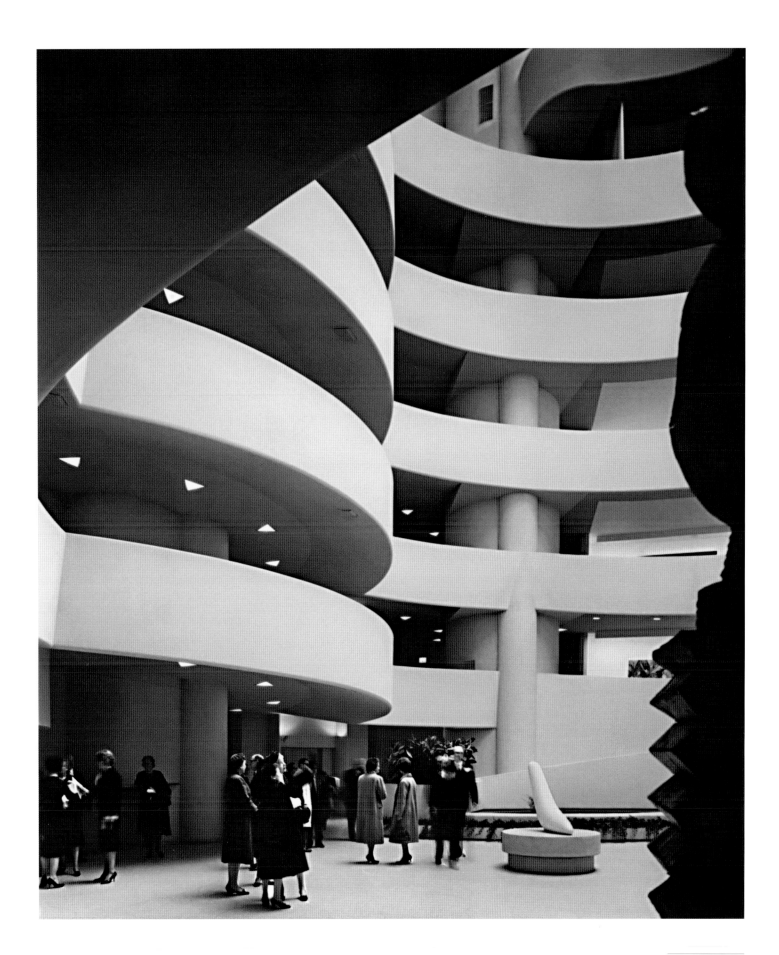

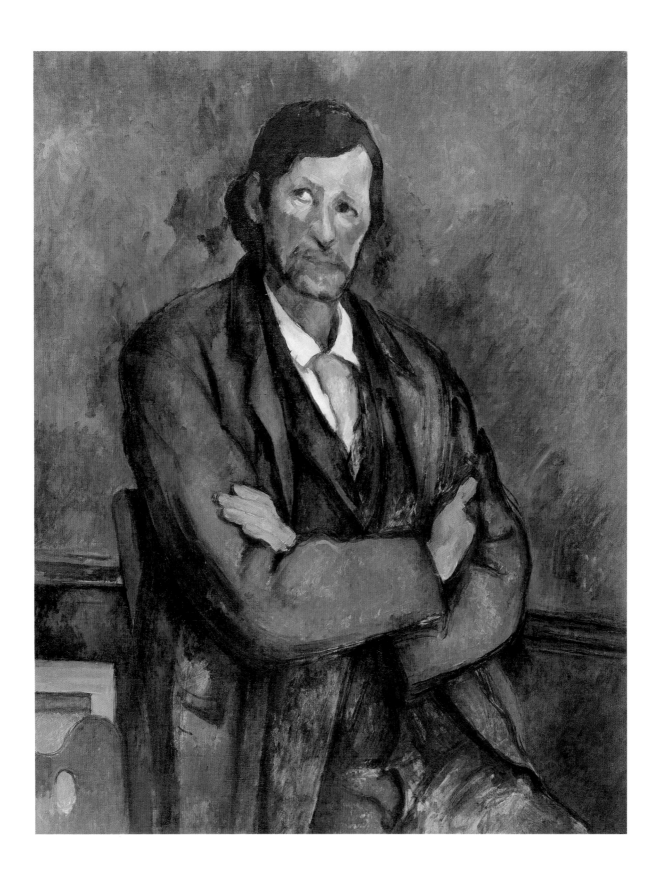

3. Paul Cézanne
Man with Crossed Arms | Homme aux bras croisés, ca. 1899

promotion of art; the modifier "non-objective" doesn't appear anywhere in the document. The charter also includes the directive that the foundation should realize its "purposes and objectives" through the "establishment, maintenance, and operation of a museum or museums, or other proper place or places, for the public exhibition of art . . . either within or anywhere without the State of New York."[9] A museum or museums. In New York State or anyplace else. ▬▬▬ One of the great truisms is that museums show only a fraction of their permanent collections at any one time. Moreover, permanent collections are rarely static and grow through a constant stream of acquisitions of groups of works, punctuated by single masterpieces that occasionally enter the collection as gifts or purchases. Almost as soon as Solomon Guggenheim began acquiring non-objective paintings, he found that he was unable to show them all. To begin with, he displayed many of his prized canvases in his residential suite in the Plaza Hotel in New York. More works went on display at the Museum of Non-Objective Painting after it opened in 1939, but still only a sampling of the complete collection could be shown. ▬▬▬ Until Guggenheim's death, his collection was continually growing. We now refer to the paintings Solomon bought and donated to his foundation as the "founding collection." The guiding principle was to collect the most important examples of non-objective art available, like Kandinsky's *Composition 8* (July 1923, plate 78), the first of scores of important works he bought by the Russian master; Fernand Léger's *Contrast of Forms* (1913, plate 59); and Robert Delaunay's *Simultaneous Windows (2nd Motif, 1st Part)* (1912, plate 30). But Solomon's tastes were not as narrowly limited as one might expect, considering his adviser Rebay's ardent passion for art with mystical potential. Many of the most famous and beloved masterpieces Solomon gave to the foundation cannot be described as non-objective: for example, Marc Chagall's *Paris Through the Window* (1913, plate 50) and *Green Violinist* (1923–24, plate 51). What all the artworks collected by Solomon had in common was that they were paintings, and that they reflected advanced tendencies.[10] ▬▬▬ In 1948, the Guggenheim Foundation's collection expanded greatly with the purchase of the entire estate of Karl Nierendorf, a New York art dealer who specialized in German paintings. This acquisition enriched the collection by some 730 objects, including eighteen Kandinskys, 110 works by Paul Klee, two by Joan Miró, six Chagalls, twenty-four Lyonel Feiningers, and one of Oskar Kokoschka's legendary paintings, *Knight Errant* (1915, plate 6). The foundation now possessed a rich array of major Expressionist and Surrealist works, and it has added other significant examples over the years, such as Max Beckmann's *Paris Society* (1931, plate 7). ▬▬▬ Following Rebay's resignation, the institution's collecting boundaries were extended by its new director, James Johnson Sweeney, formerly the director of the Department of Paintings and Sculpture at the Museum of Modern Art. In 1953, only a year after his appointment, he rejected Rebay's dismissal of sculpture by acquiring Constantin Brancusi's *Adam and Eve* (1921, plate 4), thus opening the way for the acquisition of works by other great modernist sculptors, including Jean Arp, Alexander Calder, Alberto Giacometti, and David Smith. And, in 1954, with the acquisition of Paul Cézanne's *Man with*

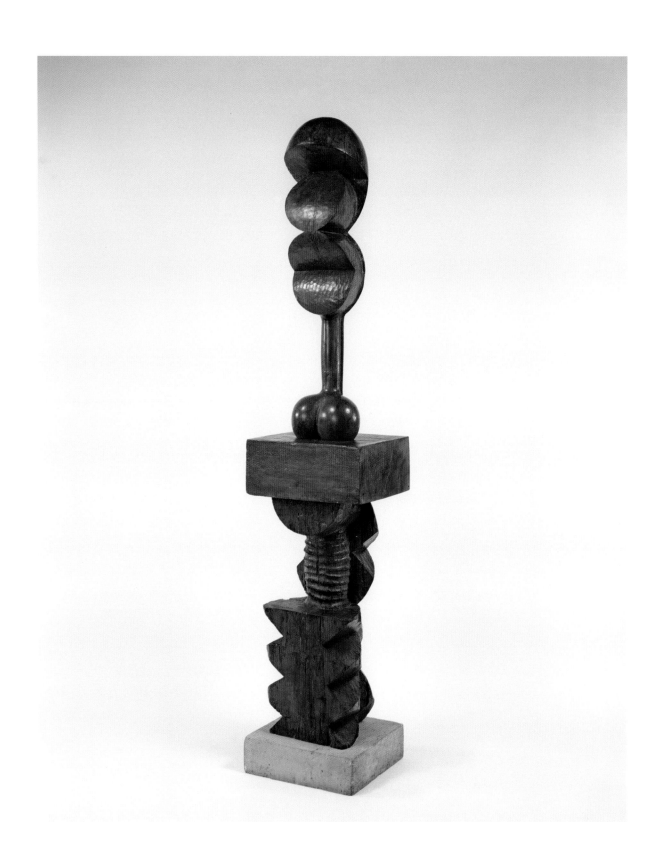

4. Constantin Brancusi
Adam and Eve | Adam et Eve, 1921

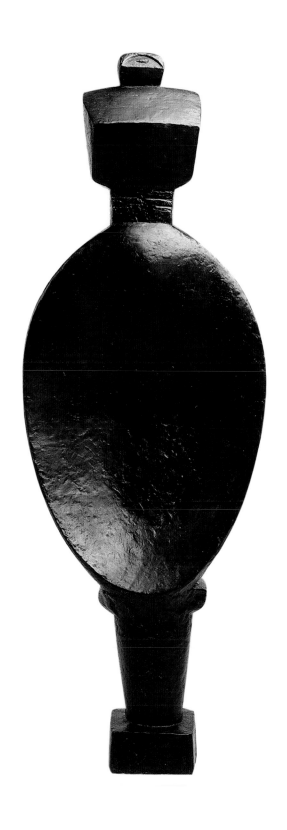

6. Oskar Kokoschka
Knight Errant | Der irrende Ritter, 1915

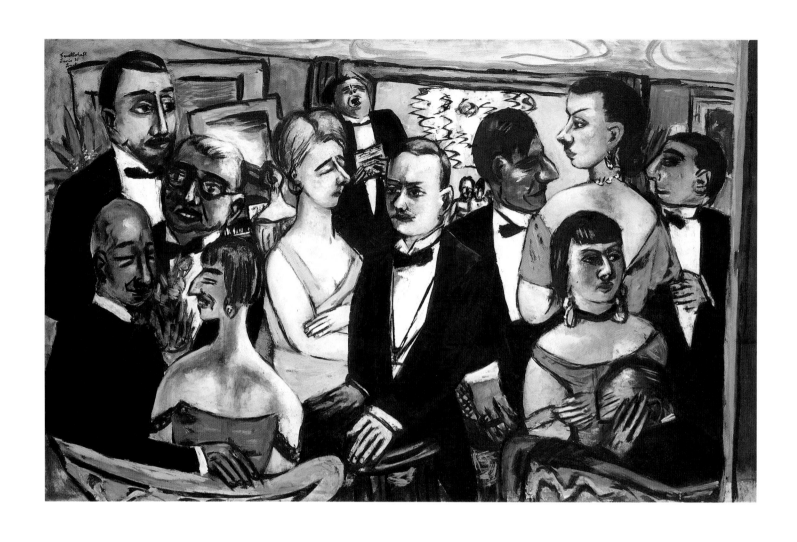

7. Max Beckmann
Paris Society | Gesellschaft Paris, 1931

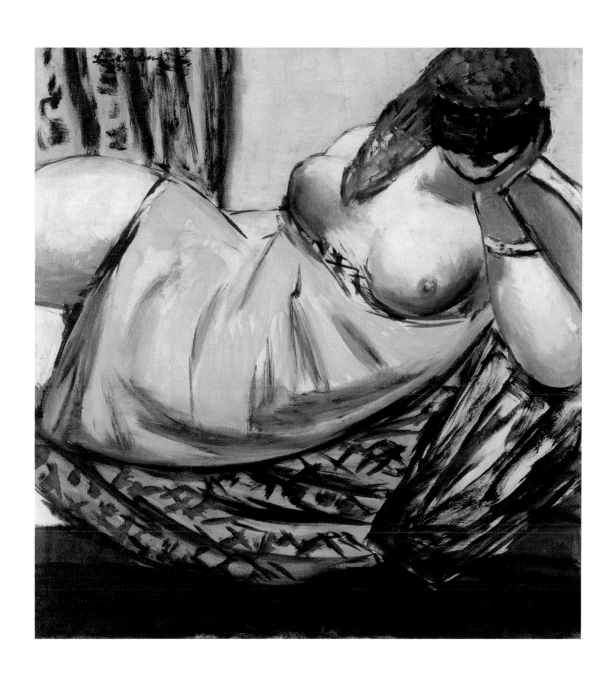

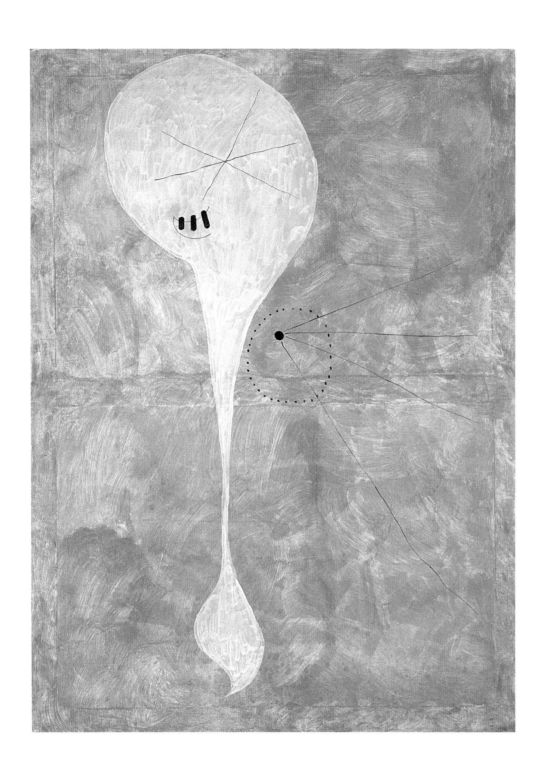

9. Joan Miró
Personage | *Personnage*, summer 1925

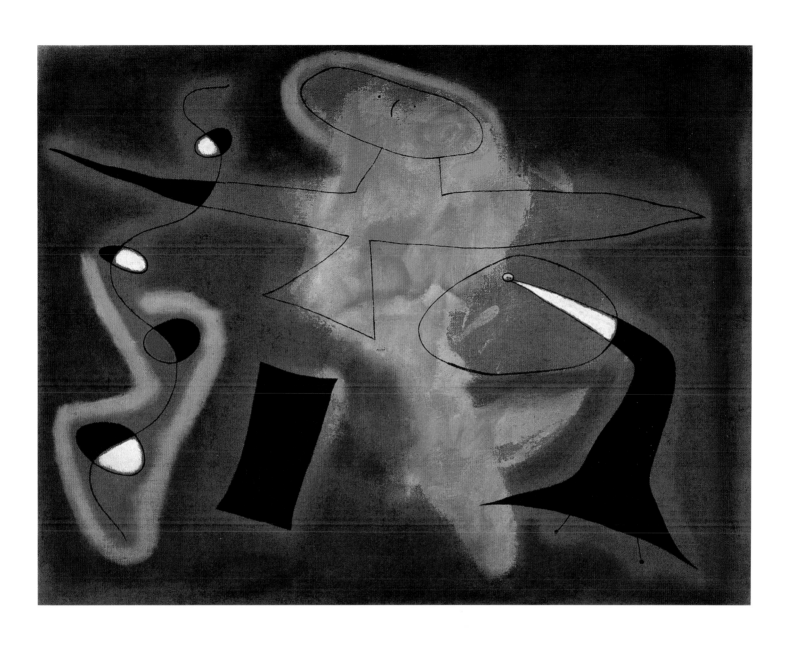

Crossed Arms (ca. 1899, plate 3), Sweeney dispensed with the notion that the Guggenheim collection needed to be limited to twentieth-century art. ▬▬ The next leap forward occurred in 1963, when Thomas M. Messer, who had succeeded Sweeney as director two years earlier, acquired a large group of works from art dealer Justin K. Thannhauser's private collection of Impressionist and Post-Impressionist masterpieces, which came to the Guggenheim first as a long-term loan and then as a bequest.[11] The Thannhauser Collection—which also includes donations made by Hilde Thannhauser, Justin's wife—contains many important works such as Vincent van Gogh's *Mountains at Saint-Rémy* (1889, plate 25), a celebrated painting that was exhibited at the 1913 Armory Show; Edouard Manet's intimate *Before the Mirror* (1876, plate 21); Paul Gauguin's Tahitian idyll *Haere Mai* (1891, plate 27); and Camille Pissarro's glorious *Hermitage at Pontoise* (fig. 32), which pushed the starting point of the Guggenheim's permanent collection back to 1867, where it remains. With the Thannhauser Collection, which now numbers seventy-three works, the Guggenheim Foundation's holdings gained significant historical depth. Among this trove are thirty-two paintings and works on paper by Pablo Picasso, such as *Le Moulin de la Galette* (1900, fig. 11), the first painting made by the young Spaniard in Paris; *Woman Ironing* (1904), one of the most moving paintings of the artist's Blue Period; and *Woman with Yellow Hair* (December 1931, plate 17), a portrait of Marie-Thérèse Walter that has become one of the Guggenheim's emblematic works. Solomon Guggenheim had acquired paintings by Picasso, but only examples of his Analytic Cubist—and therefore most abstract—style, including the important *Accordionist* (summer 1911, plate 48). With the Thannhauser acquisition, the Guggenheim Foundation could boast of having one of the greatest public collections of Picasso's paintings. And over the years, each Guggenheim director has added exemplary Picassos through purchase, gift, or exchange. ▬▬ During Messer's twenty-seven-year tenure the collection grew through a constant flow of high-quality purchases and gifts, the fruits of the Czech-born director's highly developed diplomatic skills and charm. But in the 1970s, he surpassed his earlier achievement in bringing the Thannhauser Collection to the Guggenheim by convincing Peggy Guggenheim, by then an elderly woman living in Venice, to donate her palazzo and her entire collection—more than 300 important abstract and Surrealist works—upon her death.[12] The Peggy Guggenheim Collection, which continues to be housed at the palazzo, includes major paintings by Max Ernst (to whom Peggy had briefly been married) such as *The Antipope* (1941–42, plate 99); Marcel Duchamp's *Nude (Study), Sad Young Man on a Train* (1911–12, plate 60), a study for his iconic *Nude Descending a Staircase (No. 2)* (1912, fig. 41); a rare Kazimir Malevich Suprematist painting of ca. 1916 (fig. 57); various Picasso masterpieces, such as the massive *On the Beach* (February 12, 1937, fig. 63); and sculptures by Arp, Brancusi, and Giacometti. Perhaps most important, the Peggy Guggenheim Collection includes eleven works by Pollock, perhaps America's greatest painter, whom Peggy discovered and showed at her Art of This Century gallery. ▬▬ The next expansion of the Guggenheim Foundation's holdings occurred in 1991, with the addition of the Panza Collection. These works of the 1960s and 1970s were acquired from the vast collection

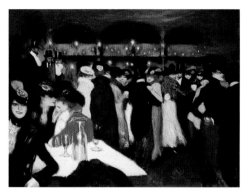

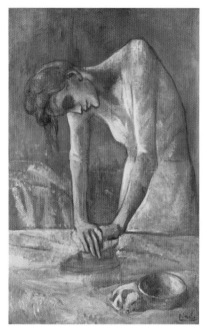

fig. 11 Pablo Picasso, *Le Moulin de la Galette*, autumn 1900. Oil on canvas, 88.2 x 115.5 cm. Solomon R. Guggenheim Museum, New York, Thannhauser Collection, Gift, Justin K. Thannhauser 78.2514.34

fig. 12 Pablo Picasso, *Woman Ironing* | *La Repasseuse*, 1904. Oil on canvas, 116.2 x 73 cm. Solomon R. Guggenheim Museum, New York, Thannhauser Collection, Gift, Justin K. Thannhauser 78.2514.41

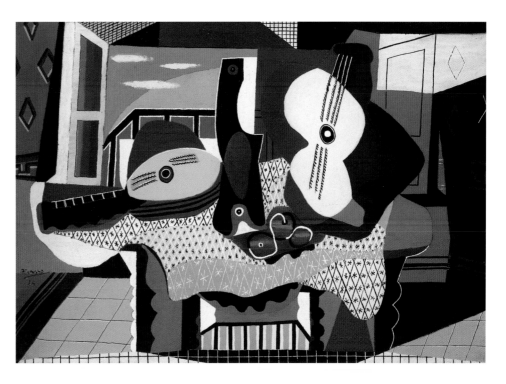

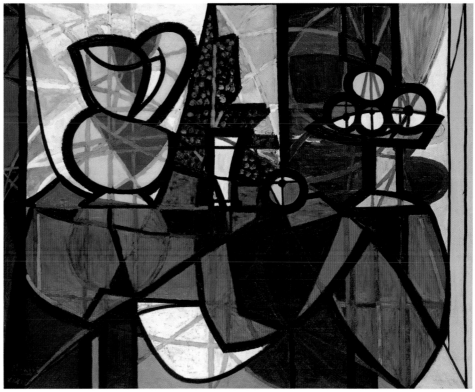

11. Pablo Picasso
Mandolin and Guitar | *Mandoline et guitare*, 1924

12. Pablo Picasso
Pitcher and Bowl of Fruit | *Pichet et coupe de fruits*, February 1931

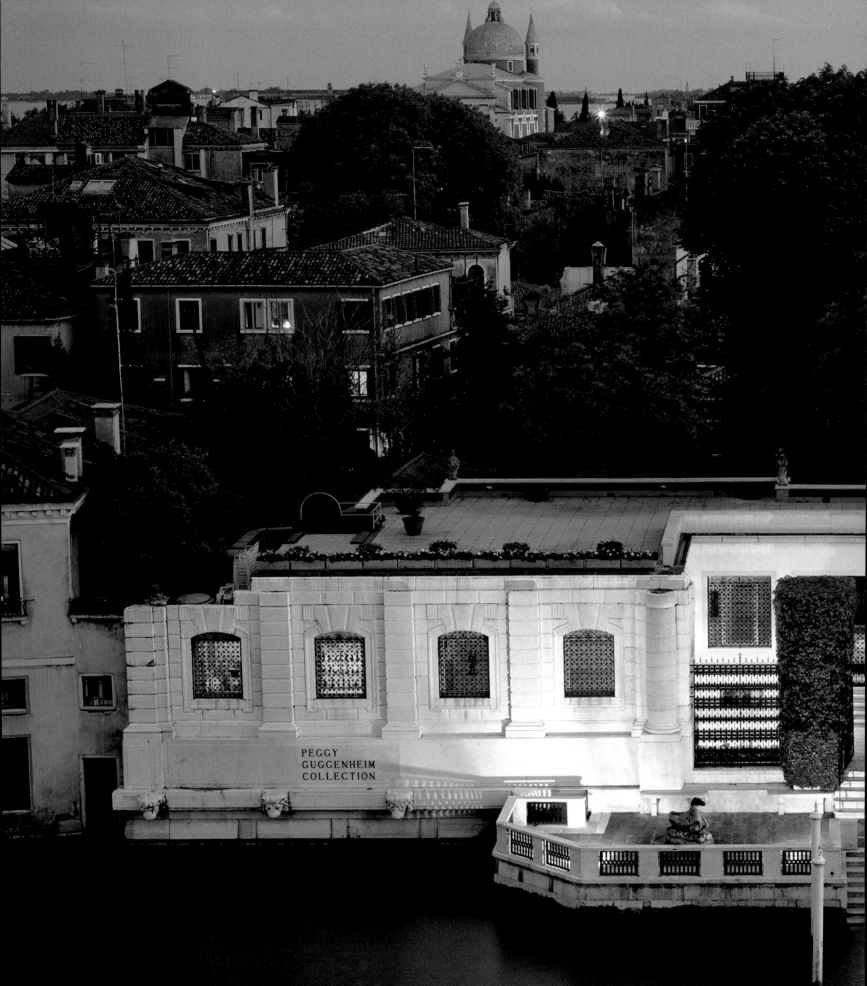

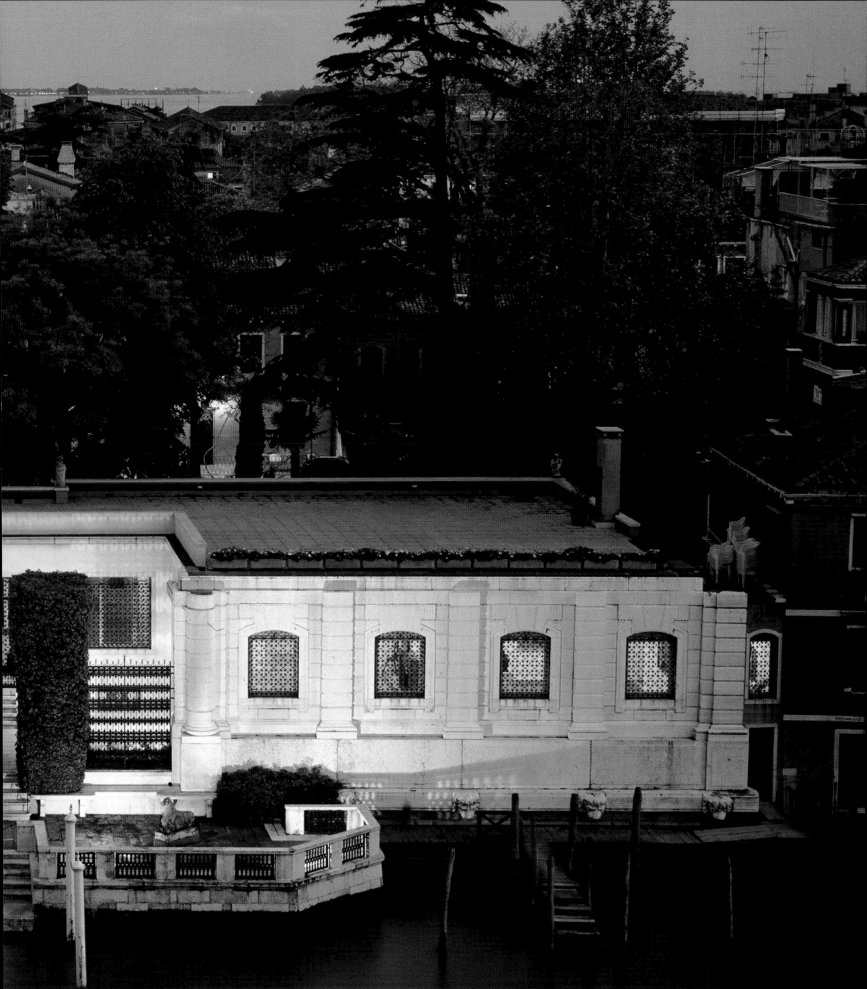

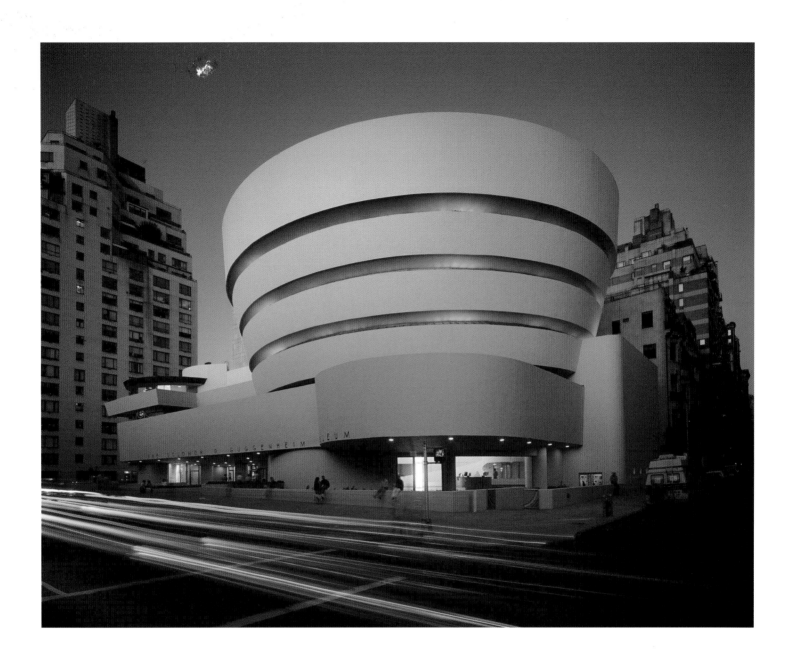

preceding two pages:
fig. 13 Peggy Guggenheim Collection, Venice

above:
fig. 14 Solomon R. Guggenheim Museum
during *Dan Flavin* exhibition, 1992

assembled by Count Giuseppe Panza di Biumo in collaboration with his wife, Giovanna Panza. The Panza Collection was the first major acquisition by Thomas Krens, who became director in 1988, and its emphasis on abstract sculpture and painting was a natural fit within the historical parameters of works acquired by the foundation. The Panza Collection includes many definitive examples of Minimalist sculptures by such artists as Carl Andre, Dan Flavin, and Donald Judd; equally strong examples of Minimalist paintings, by Robert Mangold, Brice Marden, and Robert Ryman; and a rich array of Post-Minimal, Conceptual, and perceptual art by Robert Morris, Richard Serra, James Turrell, and Lawrence Weiner, among others. These works complement the singular acquisitions made over the years of important American artists such as Serra and Ellsworth Kelly. ▬▬ During the course of the 1990s, Krens oversaw a greater than fifty-percent increase in the Guggenheim Foundation's collection overall. Perhaps more important than the quantity of acquisitions has been the broadening of the collection's scope to include contemporary photography, which had been all but ignored by the foundation, and multimedia art. Indeed, by the beginning of the next decade, the Guggenheim had gained a reputation as a leading supporter and collector of photography and multimedia art. ▬▬ This great expansion was initiated through major gifts from the Robert Mapplethorpe Foundation and the Bohen Foundation. In 1992, the Robert Mapplethorpe Foundation gave the Guggenheim Foundation 200 of Mapplethorpe's finest photographs and unique objects. In addition to making the Guggenheim the single largest holder of this important American artist, the gift also catalyzed the institution's photography program. Coming just at the time when photography began to play a central role in contemporary art practice, this new direction has allowed the Guggenheim to maintain a leading role in defining and preserving the most important art of the present. Its collection now has great depth in work by many major artists who employ photography, including Gregory Crewdson, Anna Gaskell, Nan Goldin, Roni Horn, Sally Mann, Hiroshi Sugimoto, Catherine Opie, and Wolfgang Tillmans.[13] ▬▬ In 2001, the Bohen Foundation, a private charitable organization that commissions new works of art with an emphasis on film, video, and new media, gave the Guggenheim its entire holdings, including 277 works by 46 artists. Ranging from important photographs by Sophie Calle, Sugimoto, and Sam Taylor-Wood to room-sized installations incorporating video by Pierre Huyghe, Iñigo Manglano-Ovalle, Shirin Neshat, and Pipilotti Rist, the collection provides a refreshing reminder that art of the present is ever-changing.

"Imagine a museum with no walls"

The Guggenheim Foundation today is very different from the entity that was chartered in 1937, yet its current structure has emerged as a logical development in its history. For almost seventy years, the foundation has operated many distinctive spaces for the display of art and for the special exhibitions it has organized, and since 1978—when Peggy Guggenheim donated her palazzo on the Grand Canal in Venice—it has operated more than one place at the same time. Throughout the 1980s, this became an increasingly important part of the foundation's identity. Though based in

fig. 15 Robert Mapplethorpe, *Ken and Tyler*, 1985. Platinum print, edition 2/3, sheet 65.7 x 56.5 cm. Solomon R. Guggenheim Museum, New York. Gift, Robert Mapplethorpe Foundation 96.4373

fig. 16 Sam Taylor-Wood, *Soliloquy II*, 1998. Two C-prints, edition 2/6, 208.9 x 256.5 cm overall. Solomon R. Guggenheim Museum, New York. Gift, The Bohen Foundation 2001.285

13. Richard Serra
Right Angle Prop, 1969

14. Ellsworth Kelly
White Angle, 1966

15. Ellsworth Kelly
Dark Blue Curve, 1995

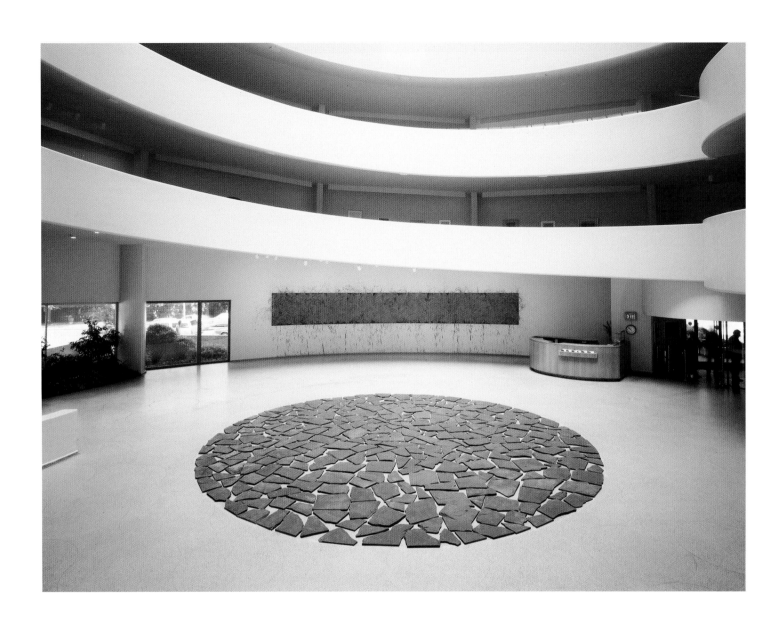

16. Richard Long
Red Slate Circle, 1980

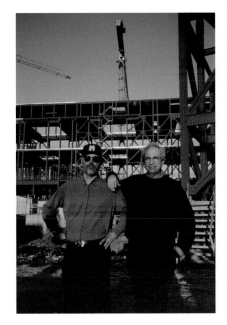

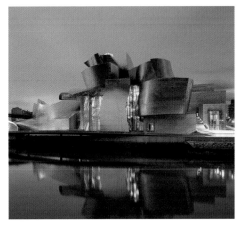

New York, the Guggenheim began to refer to itself in marketing materials as "the American museum with a European face." In 1986, the foundation increased its presence in Venice by purchasing, from the Museum of Modern Art in New York, the American Pavilion in the Venice Biennale. ▬▬ When Krens assumed the directorship of the Guggenheim Foundation in 1988, one of his first major initiatives was to build on the institution's distinctive international presence. A plan that would have made Salzburg, Austria, the third city to become home to a Guggenheim museum was not realized, but it inspired the Basque government to propose that Bilbao become the site for such a museum. In 1991, the California-based architect Frank Gehry was selected to design the building. Following the path first laid out by Wright and Rebay, Gehry and Krens embarked on a complex, lengthy, and celebrated architect-client relationship, meeting dozens of times in the years between the awarding of the commission and the museum's completion in 1997. Perhaps the most telling notion Krens had was this: "The idea was that the museum had to be able to accommodate the biggest and heaviest of any existing contemporary sculpture on the one hand, and a Picasso drawing on the other hand."[14]

▬▬ When it opened in 1997, the Guggenheim Museum Bilbao—a spectacular structure made of titanium, glass, and limestone, sited on the banks of the Nervión River—was greeted with glowing praise from critics around the world, and Bilbao became a major destination on the international art circuit. The Guggenheim Museum Bilbao swiftly gained an audience comparable to the Solomon R. Guggenheim Museum in New York, and the two venues have shared many major exhibitions, including *Robert Rauschenberg: A Retrospective*; *China: 5,000 Years*; *The Art of the Motorcycle*; *The Worlds of Nam June Paik*; *The Aztec Empire*; and *RUSSIA!* By having two major museums available for its exhibitions, the Guggenheim Foundation realizes significant synergies and cost-savings, which have allowed it to expand its programming dramatically and reach a vastly larger audience. (Today, the combined attendance at all five Guggenheim museums worldwide exceeds 2.5 million annually.) ▬▬ Since 1992, the Guggenheim Foundation has mounted more than 250 special exhibitions at its constituent museums. The vast majority are based on the institution's core competency: modern and contemporary art from the mid-nineteenth century through the present. On occasion, exhibitions have been presented on related subjects, such as twentieth-century architecture, design, and fashion, as well as the art of non-Western cultures and the historical antecedents to modernism. Guggenheim exhibitions fall into eight broad categories: major retrospectives; focused monographs on specific chapters in an artist's career; aspects of the permanent collection; thematic modern art surveys; contemporary art surveys and installations; historical surveys; architecture and design; and private collections. ▬▬ The Guggenheim Museum Bilbao's permanent collection, selected by the Guggenheim Foundation's curators in collaboration with the Bilbao staff, complements the foundation's holding, with particular strength in postwar American and European art, and significant examples of Basque and Spanish contemporary art. In 2005, the Bilbao museum unveiled its greatest single acquisition: Richard Serra's *The Matter of Time*, a major site-specific commission comprised of eight large-scale steel sculptures.[15] ▬▬ Only a month

fig. 17 Thomas Krens and Frank Gehry at construction site of Guggenheim Museum Bilbao

fig. 18 Guggenheim Museum Bilbao

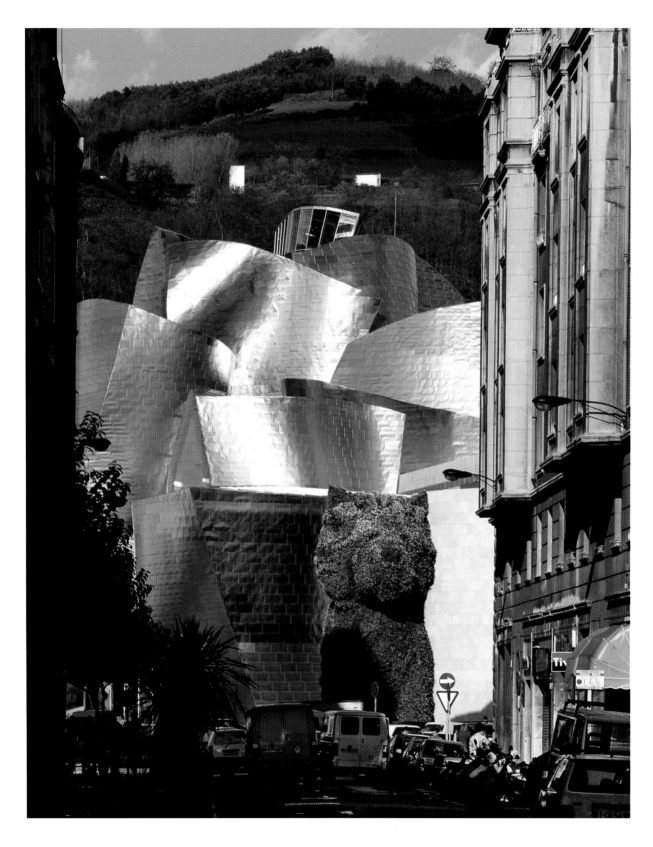

fig. 19 Guggenheim Museum Bilbao with Jeff
Koons's *Puppy* (1992) installed on museum's plaza

facing page:
fig. 20 Richard Serra's installation *The Matter of
Time* (2005) at Guggenheim Museum Bilbao

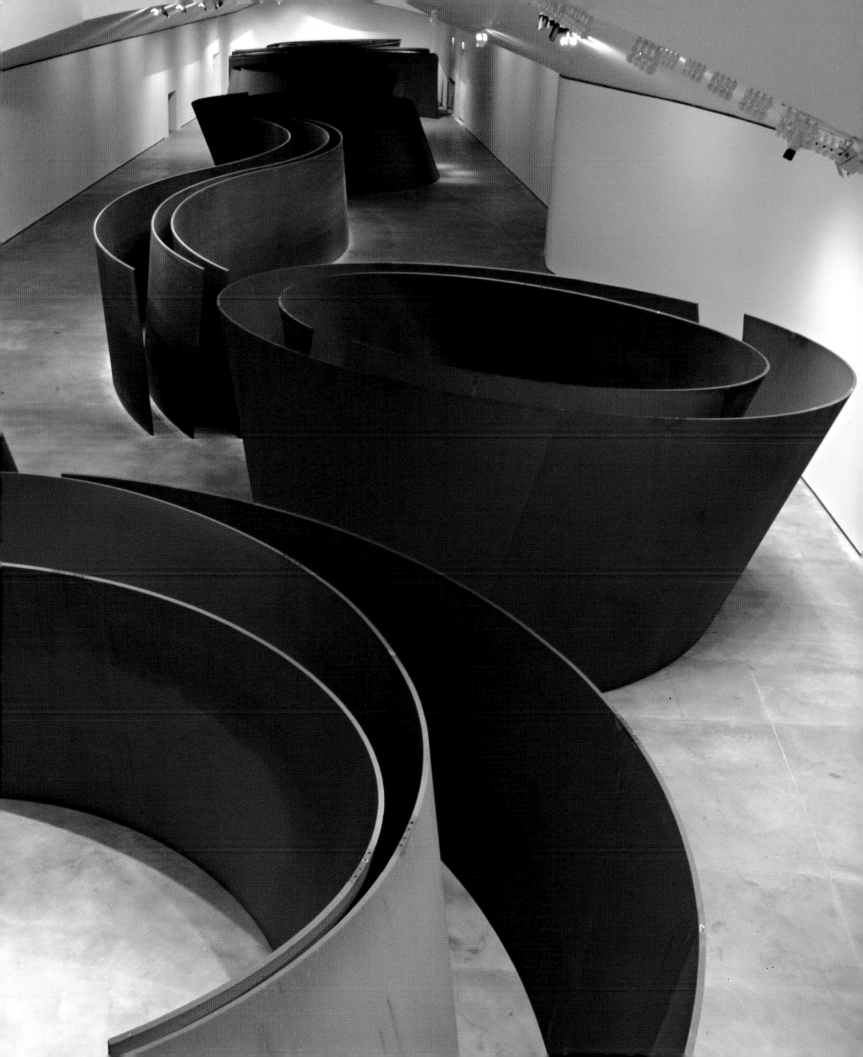

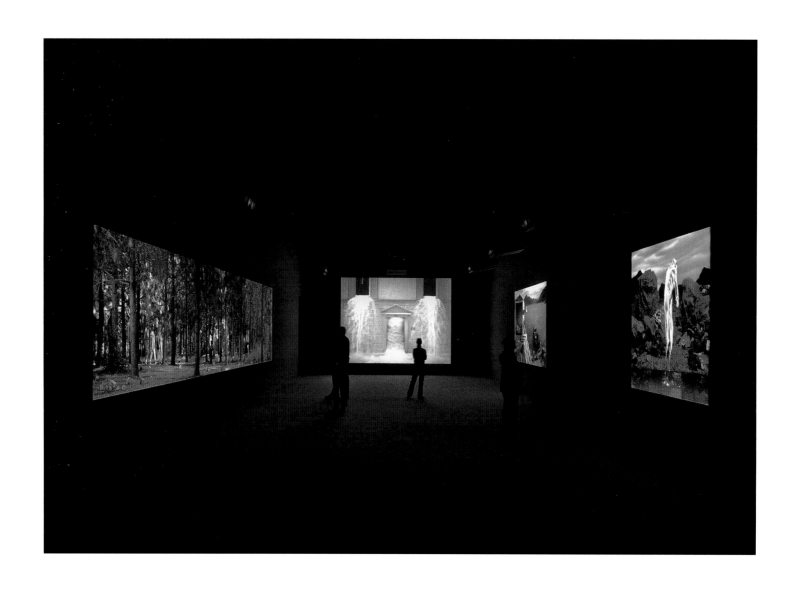

fig. 21 *Bill Viola: Going Forth By Day*,
2002, Deutsche Guggenheim, Berlin

fig. 22 *Masterpieces and Master Collectors: Impressionist and Early Modern Paintings from the Hermitage and Guggenheim Collections*, 2001, Guggenheim Hermitage Museum, Las Vegas

Anthony Calnek **63**

after the opening of the Guggenheim Museum Bilbao, the Guggenheim Foundation further expanded its reach by collaborating with Deutsche Bank on an exhibition space in Berlin that is Bilbao's antithesis. Designed by the American Minimalist architect Richard Gluckman on the street level of Deutsche Bank's headquarters in Berlin, the Deutsche Guggenheim is modest, rectilinear, and presents only small-scale exhibitions. Some of the foundation's most scholarly exhibitions—including *Amazons of the Avant-Garde*; *Kazimir Malevich: Suprematism*; *Robert Mapplethorpe and the Classical Tradition*; and *No Limits, Just Edges: Jackson Pollock Paintings on Paper*—have premiered in Berlin before touring to other Guggenheim venues. ▬▬▬ Deutsche Guggenheim's distinction is its unique commissioning program. Deutsche Bank assumes all costs for an ongoing series of major commissions by contemporary artists selected by Guggenheim curators, which premiere at the museum in Berlin. Several major contemporary artists have created some of their best recent work as a result of this program: James Rosenquist's *Swimmer in the Econo-mist* (1997–98; see plates 40 and 41) is comprised of three mural-sized paintings that update his Pop masterpiece *F-111* (1964–65); Jeff Koons's *Easyfun-Ethereal* (2000), a suite of seven paintings, is among the artist's most important series of the past decade; and Bill Viola's epic *Going Forth By Day* (2002) demonstrates that video installation has reached its full maturity as an art form. ▬▬▬ In Las Vegas in 2001, the Guggenheim opened the Guggenheim Hermitage Museum, a collaboration with the State Hermitage Museum in St. Petersburg. This small space, designed by Rem Koolhaas is dedicated to exhibiting masterpieces from the Hermitage and from the Guggenheim's extended collection. In 2000, the two museums had entered into a contractual alliance agreement, whereby they would share collections, exhibitions, and expertise, and also further each other's strategic goals. The Guggenheim and the Hermitage have come together over the past five years to create several joint exhibitions and, together with the Kunsthistorisches Museum in Vienna—which joined the alliance in 2001—they have established a new model of international cultural collaboration. ▬▬▬ Another poster in Krens's office reads "Imagine a museum with no walls" (fig. 24). The Guggenheim Foundation's unique array of museums has been referred to as a "constellation" or a "network." Krens, however, likes to refer to the totality of the enterprise as a single museum with discontiguous galleries. Each constituent museum is unique in terms of its architecture and programming, yet taken as a whole, they operate from a single curatorial perspective. Today, there are five Guggenheims in four countries, and the foundation is currently seeking partnerships that will allow it to open additional museums in Latin America and Asia. With its unique ability to grow, a distinctive art collection comprising modern art from 1867 to the present, an unsurpassed record of special exhibitions, and alliance partners with their own collections of unparalleled depth, the Guggenheim's future is truly limitless.

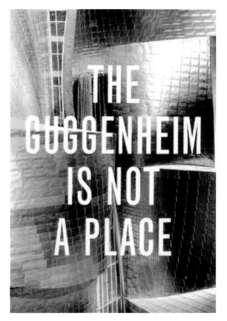

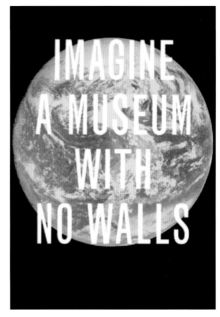

figs. 23 and 24 Guggenheim concepts by Arnell Group

NOTES

1. For a detailed description of the Museum of Non-Objective Painting and the early years of the Solomon R. Guggenheim Foundation, see Joan M. Lukach, *Hilla Rebay: In Search of the Spirit in Art* (New York: George Braziller, 1983).

2. See Susan Davidson and Philip Rylands, eds., *Peggy Guggenheim and Frederick Kiesler: The Story of Art of This Century*, exh. cat. (Venice: Peggy Guggenheim Collection, 2004).

3. There have been many biographies of Peggy Guggenheim. The most recent, and best, is Mary V. Dearborn, *Mistress of Modernism: The Life of Peggy Guggenheim* (New York: Houghton Mifflin, 2004).

4. Jo-Anne Birnie Danzker, "The Art of Tomorrow," in *Art of Tomorrow: Hilla Rebay and Solomon R. Guggenheim*, exh. cat. (New York: Guggenheim Museum, 2005), pp. 180, 183.

5. The exhibition was entitled *Art of Tomorrow: Hilla Rebay and Solomon R. Guggenheim*. See note 4.

6. *The Solomon R. Guggenheim Museum* (New York: Guggenheim Museum, 1994), p. 5.

7. See Anthony Calnek, *The New Yorker Visits the Guggenheim* (New York: Guggenheim Museum, 2005).

8. See Irwin Unger and Debi Unger, *The Guggenheims: A Family History* (New York: HarperCollins, 2005).

9. From time to time, the Guggenheim Foundation's trustees have revised the institution's mission statement. The most recent iteration, adopted in 2004, reads: "The mission of the Solomon R. Guggenheim Foundation is to promote the understanding and appreciation of art, architecture, and other manifestations of modern and contemporary visual culture; to collect, preserve, and research art objects; and to make them accessible to scholars and an increasingly diverse audience through its network of museums, programs, educational initiatives, and publications."

10. The Guggenheim Foundation has published several books about its collection. The most current overview is Nancy Spector, ed., *Guggenheim Museum Collection: A to Z*, 2nd, rev. ed. (New York: Guggenheim Museum, 2003).

11. For a history and overview, see Matthew Drutt, ed. *Thannhauser: The Thannhauser Collection of the Guggenheim Museum* (New York: Guggenheim Museum, 2001).

12. For an account of Messer's multiyear negotiations with Peggy Guggenheim, see Thomas M. Messer, "The History of a Courtship," in Karole P. B. Vail, *Peggy Guggenheim: A Celebration*, exh. cat. (New York: Guggenheim Museum, 1998), pp. 127–51.

13. An extensive selection of the Guggenheim's holdings is reproduced in *Moving Pictures: Contemporary Photography and Video from the Guggenheim Collection*, exh. cat. (New York: Guggenheim Museum, 2003).

14. Coosje van Bruggen, *Frank O. Gehry: Guggenheim Museum Bilbao* (New York: Guggenheim Museum, 1997), p. 115.

15. See Richard Serra, Hal Foster, and Carmen Giménez, *Richard Serra: The Matter of Time*, exh. cat. (Bilbao: Guggenheim Museum Bilbao; Gottingen: Steidl, 2006).

MATTHEW DRUTT

A Showcase for Modern Art:
The Thannhauser Collection

On the evening of April 29, 1965, several hundred distinguished guests from around the world gathered at the Solomon R. Guggenheim Museum for a momentous black-tie affair: the unveiling of a new wing containing one hundred masterpieces of modern art from the collection of Justin K. and Hilde Thannhauser.[1] It was an evening filled with accolades and a sense of great accomplishment. The Thannhausers had presented a large portion of the works to the Guggenheim as a gift, to be transferred to the museum after Justin's death. For the Guggenheim, this marked the first time that a major private collection had been bequeathed to the institution since Solomon R. Guggenheim's holdings had been endowed to the foundation he established in 1937. Moreover, the gift provided the museum with a core collection of Impressionist, Post-Impressionist, and early School of Paris works, allowing its more expansive holdings of nonobjective art to be seen in a broader historical context and shifting the character of the overall collection. ▬▬▬ For Justin Thannhauser, the bequest to the Guggenheim was his crowning achievement after more than half a century as one of Europe's most influential and distinguished collectors and dealers. His father, Heinrich, had established a gallery in Munich in 1909, and with Justin's involvement the business had flourished, adding branches in Lucerne and Berlin before it had been forced into less conspicuous operation due to Nazi persecution. After years of hardship and uncertainty, the bequest to the Guggenheim guaranteed that the Thannhauser name and reputation would finally be preserved for posterity. Yet in spite of this accomplishment, the occasion carried a trace of melancholy. Justin had no heirs. Both of his children, Heinz and Michel, had died at tragically young ages, and the business that he and his father had built up was now a matter of history. The gift being left to the museum contained brilliant works, but it was a collection formed largely after World War II, with many great works originally in the collection having been lost or stolen. At the time the gift was announced, in 1963, Justin, ever mindful of the hardships he had endured, observed: "My family, after five hundred years of living in Germany, is now extinguished. That is why I am doing what I am with my collection."[2] ▬▬▬ Indeed, the story of the Thannhausers is an odyssey of visionary accomplishments undone by sudden and unexpected tragedy, circumstances common to the European cultural community, which was subjected to the upheavals of two world wars in the space of twenty-odd years. Nonetheless, the Thannhausers wielded enormous influence in their day, and their impact on modern art persists in public collections around the world that include artworks whose provenance can be traced back to them. For Heinrich and Justin Thannhauser were among the elite cadre of dealers in the early

facing page:
17. Pablo Picasso
Woman with Yellow Hair | Femme aux cheveux jaunes,
December 1931

18. Paul Cézanne
Still Life: Plate of Peaches | Assiette de pêches, 1879–80

twentieth century—along with Paul Cassirer, Alfred Flechtheim, Daniel-Henry Kahnweiler, Paul and Léonce Rosenberg, Ambroise Vollard, and Herwarth Walden—who helped forge the reputations of Max Beckmann, Paul Cézanne, Edgar Degas, Paul Gauguin, Vasily Kandinsky, Paul Klee, Edouard Manet, Henri Matisse, Pablo Picasso, Pierre Auguste Renoir, and Vincent van Gogh, thus helping to define Modern art as we know it today. ▬▬ In late 1904, Heinrich Thannhauser, in partnership with his friend Franz Josef Brakl, a local opera singer and cultural impresario, opened the gallery Moderne Kunsthandlung (Brakl und Thannhauser) at Goethestrasse 45.[3] Born in 1859 to Jewish parents, Heinrich had been trained as a tailor and apparently enjoyed a good reputation in this capacity for a number of years.[4] How he made the transition into the art world remains a mystery, but he displayed a swift and enduring talent for the profession. Brakl and Thannhauser's initial program was almost indistinguishable from that of the competition. They specialized in German painting and artists of the Munich Secession, and for a number of years identified themselves as supporters of the so-called Scholle Circle, which included among its members Reinhold Max Eichler, Max Feldbauer, and Adolf Höfer. But by 1908 the gallery had expanded its repertoire to include Neo-Impressionism, offering paintings by Kees van Dongen, Charles Guérin, and Georges Léon Dufrenoy. Brakl and Thannhauser's status grew. In 1908, they held the first solo exhibition of van Gogh's work in Germany; organized by the Paul Cassirer gallery in Berlin in cooperation with Galerie Bernheim-Jeune in Paris, it included around one hundred works formerly from the collection of Theo van Gogh. Moderne Kunsthandlung began to distinguish itself by giving the latest trends in French art a platform alongside German painting. ▬▬ Heinrich Thannhauser ventured out on his own the following year, opening his Moderne Galerie in November 1909. From the beginning he was apparently assisted by Justin, though his son's involvement at this time probably added up to little more than an apprenticeship; born in 1892, Justin would only have been seventeen years old when the gallery opened.[5] By most accounts, the Moderne Galerie was one of the largest and most beautiful art galleries in Munich. On the eve of its opening, the local art critic and author Georg Jacob Wolf ventured, "Munich can boast of a distinguished new venue for selling art. To artists it offers a new forum for exhibiting their work, while art lovers will find it an intimate place to study and enjoy truly valuable art from Germany (primarily Munich) and abroad. The interiors of the new gallery are superb."[6] Designed by local architect Paul Wenz, of the firm Heilmann & Littmann, Moderne Galerie was located in the grandiose glass-domed Arcopalais at Theatinerstrasse 7 in the heart of Munich's shopping district. It occupied more than 2,600 square feet divided between two floors, with nine exhibition rooms on the ground floor and an open, skylit gallery on the second floor that alone measured about 984 square feet. The physical disposition of the gallery gave Heinrich the flexibility to mount several shows of varying character at the same time. ▬▬ Moderne Galerie's opening exhibition was a powerful indicator of the versatile program that the Thannhausers would build in the ensuing years. More than two hundred works in painting and sculpture by German and French artists filled the gallery. The Germans were represented by the

fig. 25 Justin and Hilde Thannhauser with Harry Guggenheim, then President of the Solomon R. Guggenheim Foundation, 1963

more classical artists of the period: Fritz Erler, Max Liebermann, Hans Pellar, Leo Putz, Fritz von Uhde, and Hugo von Habermann, among others. But the highlight of the exhibition was fifty-five French Impressionist works, which Heinrich had brought together in cooperation with Rudolf Meyer-Riefstahl in Paris. Included were in-depth selections of masterworks by Mary Cassatt, Degas, Manet, Claude Monet, Camille Pissarro, Renoir, and Alfred Sisley. This was the most comprehensive presentation of French Impressionism to be shown in Munich up to that point, and a special catalogue was devoted to this part of the exhibition.[7] As one critic extolled, "We feel like we're in the art-trading department of some worldwide corporation and marvel at the fact that [the gallery] lives up to the expectations of an international audience in a way that is quite unparalleled in Munich. Though it lacks a specific character, especially in terms of local color … this has an otherwise fortunate effect, as it introduces us to masters whose works are rarely shown in Munich. … It seems poised to quickly develop into an important center of the Munich art market."[8] ▬▬▬ In December, Heinrich surprised Munich again, this time not with an overwhelming presentation of French modernism, but rather with a group of works by Germany's emerging generation of cutting-edge abstract painters, when the gallery hosted the first exhibition of the Neue Künstlervereinigung München (NKVM). Organized under the leadership of Kandinsky, who had originally moved to Munich to study with the Jugendstil painter Franz von Stuck, the group was an early voice of Expressionism, taking modern German art in a direction influenced by an amalgam of French Fauvism and Bavarian folk art and waging an ideological battle against the sort of conservative trends in Munich seen in the very work that Heinrich had featured so prominently the month before. Among those included in the NKVM show were founding members Adolf Erbslöh, Alexei Jawlensky, Kandinsky, Gabriele Münter, and Marianne von Werefkin. The exhibition was controversial, provoking one critic to write, "It is a sensation, a premature carnival prank in the dead of the pre-Christmas season. The scene may well resemble the Impressionists' first exhibition on the boulevard des Capucines. … They are not beginners but completers, students of Gauguin and van Gogh, rebellious, strange students who pick out their teachers' personal expression and repeat it in an impersonal manner."[9] In just two months, Heinrich had captured the local playing field, demonstrating an extraordinary ability to present the highest-quality works from a broad and diverse field.

▬▬▬ The exhibition calendar for 1910 continued to cast a wide net. Impressive solo exhibitions were held for German artists Lovis Corinth, Max Klinger, Christian Rohlfs, and Max Slevogt, to name but a few, but the year's highlights belonged again to the French. The year began with a show of young French landscape painters, including Matisse and Maurice de Vlaminck. In May, there was a major Manet exhibition, organized in conjunction with Galerie Bernheim-Jeune and Galerie Durand-Ruel in Paris and Paul Cassirer in Berlin (and shown also at these three venues). Comprised of thirty-five paintings, pastels, and drawings culled from the distinguished Auguste Pellerin collection,[10] the exhibition was an absolute jewel, displaying many of the most famous of Manet's paintings, including *A Bar at the Folies-Bergère* (1881–82, fig. 26). The deluxe illustrated catalogue, with

an essay by Georg Jacob Wolf praising Manet as "the founder of an important school,"[11] further distinguished Heinrich's style of presentation from that of other gallerists in its scholarly emphasis and aspirations to connoisseurship and curatorial acumen. In Munich's cultural press, critic M. K. Rohe wrote of having looked forward to the show "with great anticipation" and described it as "[an exhibition] that should be shown in Berlin, Paris, London and New York."[12] According to Justin, however, the exhibition "found the greater part of the visitors, and especially some of the best appreciated art critics, absolutely unprepared to accept [the works] or even to take them seriously."[13]

Nonetheless, the Thannhausers sold many of the pictures, including *Luncheon in the Studio* (1868), which was acquired by Munich's Neue Pinakothek, and *A Bar at the Folies-Bergère*, which they placed in the distinguished private collection of Eduard Arnhold in Berlin.[14] ▬▬▬ In August, a show of twenty-six works by Gauguin from the private collection of A. W. Heymel was held. In spite of the fact that Gauguin's work had appeared in other Munich galleries, such as Kunsthandel Zimmermann, which had shown a small collection of his work in 1908, the pictures from the Heymel collection struck a revelatory chord. Through these works, Rohe noted, "a fuller picture of this peculiar master emerges.... The exhibition is particularly interesting because it documents the immense distance between the master's intensely personal and spiritual manner and all those modern artists who may have learned to emulate his way of clearing his throat and spitting but are entirely devoid of his sublime powers of perception."[15] ▬▬▬ The second NKVM exhibition took place in September. By now, the group had expanded its ranks beyond Germany, to include Georges Braque, André Derain, Vlaminck, Picasso, Georges Rouault, and van Dongen, attesting to the importance that French art held for German artists as well as signifying the international spirit that was characteristic of modernism by this time. Perhaps due to the presence of the French, who were beginning to be viewed with derision as the seeds of World War I were being sown, or simply to shifting winds in a still conservative city, the exhibition was publicly reviled. Rohe, who had praised previous Thannhauser shows, lambasted this one as "an absurdity by incurable madmen ... an event by con artists who have tried to capitalize on a market trend and enrich themselves by charging astronomical prices."[16] Kandinsky later recalled, "The press raged against the exhibition, the public railed, threatened, spat at the pictures.... We exhibitors could not understand this indignation.... We were only amazed that in Munich, the 'city of the art,' nobody except [Hugo von] Tschudi had given a word of sympathy."[17] Tschudi, who had purchased Manet's *Luncheon in the Studio* from the Thannhausers as director of the Neue Pinakothek, had recently been appointed director of all museums in Bavaria. ▬▬▬ Despite the general derision for the NKVM show, the fall season ended the year positively on a French note. A large exhibition of work by van Gogh traveled from Cassirer's Berlin gallery in October. Curiously, even though it contained some of the artist's finest works, such as *Cypresses* (1889, fig. 27), none were sold. Perhaps Munich was experiencing van Gogh overload at this point, as Brakl had held an exhibition of his work in 1909. Also in the fall, Heinrich paired a powerful selection of thirty-three works by Pissarro with a dozen paintings by Sisley. The exhibition,

fig. 26 Edouard Manet, *A Bar at the Folies-Bergère | Un Bar aux Folies-Bergère*, 1881–82. Oil on canvas, 96 x 130 cm. Courtauld Institute of Art Gallery, London

fig. 27 Vincent van Gogh, *Cypresses*, 1989. Oil of canvas, 93.3 x 74 cm. The Metropolitan Museum of Art, New York, Rogers Fund, 1949 (49.30)

which was held in the spacious second-floor gallery, was praised as "a collection of consistently first-rate works by the two Paris Impressionists."[18] Amounting to the first major overview anywhere since the painter's death in 1903, the Pissarro presentation was especially impressive and favorably reviewed as "a sublime exhibition"[19] that embodied a "complete penetration to the innermost essence."[20] ▬ During 1911, Moderne Galerie had an even more robust schedule, with exhibitions of work by Matisse, Franz Marc, Ferdinand Hodler, Liebermann, Käthe Kollwitz, and Klee. The Klee exhibition, which was held in June and consisted of thirty drawings, was the artist's debut solo presentation in Germany. Klee's work would continue to be shown and sold successfully by the Thannhausers over the years. Also in 1911, having established a friendship with Theo van Gogh's widow, Johanna van Gogh-Bonger, and son, Vincent, the Thannhausers mounted another important van Gogh exhibition, "this time with sales results coming up."[21] The third NKVM exhibition was held in December, but the group's complexion had changed due to a disagreement that had erupted over the issue of abstraction. Otto Fischer led a faction that retreated into Jugendstil and expressive Fauvism, while Kandinsky, Jawlensky, and Münter progressed toward an increasingly abstract mode of painting. Together with Marc,[22] the latter artists had departed and formed a rival group, Der Blaue Reiter, that embarked upon a path of Expressionist painting imbued with a more spiritual or metaphysical bent. In a display of mercurial showmanship, Heinrich exhibited the work of the newly formed group alongside the NKVM show, once more demonstrating his capacity for a program embracing opposing aesthetics. The first exhibition of Der Blaue Reiter, which included works by French, German, and Russian artists, was as decidedly international as Moderne Galerie's program (see figs. 28 and 29). Robert Delaunay, who also lent two works by Henri Rousseau, was the sole living representative from France, attesting to the affinity that his particular approach to Cubism had with German Expressionism. ▬ That same year, Heinrich sent Justin abroad to further his academic studies in art history, philosophy, and psychology, which he undertook in Munich, Berlin, Florence, and especially Paris. Among those with whom Justin studied were Henri Bergson, Adolf Goldschmidt, and Heinrich Wölfflin. Young Thannhauser befriended and later brought Wölfflin to the Munich gallery for the distinguished historian's first series of private lectures. With other eminent guests from the international community invited to hold similar lectures over the years, Justin helped his father turn Moderne Galerie into a fashionable salon, a crossroads of vanguard culture in provincial Munich. His time abroad also served to enhance business contacts with artists and other dealers, including Kahnweiler and Wilhelm Uhde, many of whom had an auspicious impact on the gallery. ▬ Justin returned to Munich in 1912 and began working full-time with his father. A show of forty-one works by Renoir opened the 1912 season, followed by a large exhibition of works by the Norwegian painter Edvard Munch. Further forays into Expressionism continued with an exhibition by Die Brücke artists Cuno Amiet and Max Pechstein and a solo show by August Macke. The short-lived group Sema, which was devoted to the art of drawing and counted Karl Caspar, Robert Genin, Klee, and Carl Schwalbach among its members, had its first exhibition in the

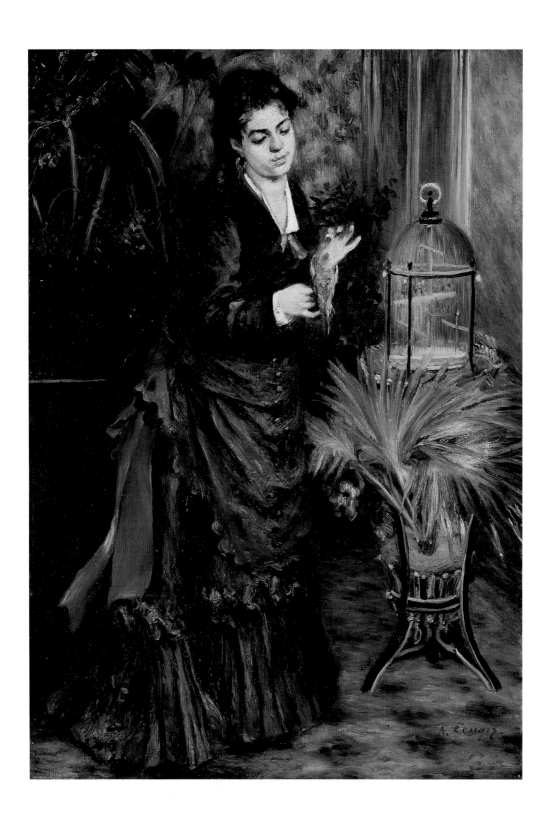

20. Pierre Auguste Renoir
Woman with Parrot | La Femme à la perruche, 1871

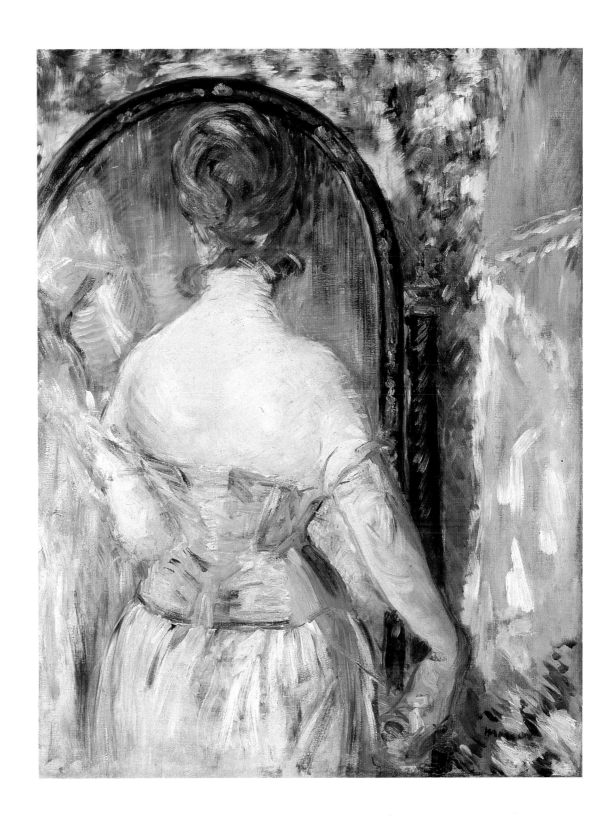

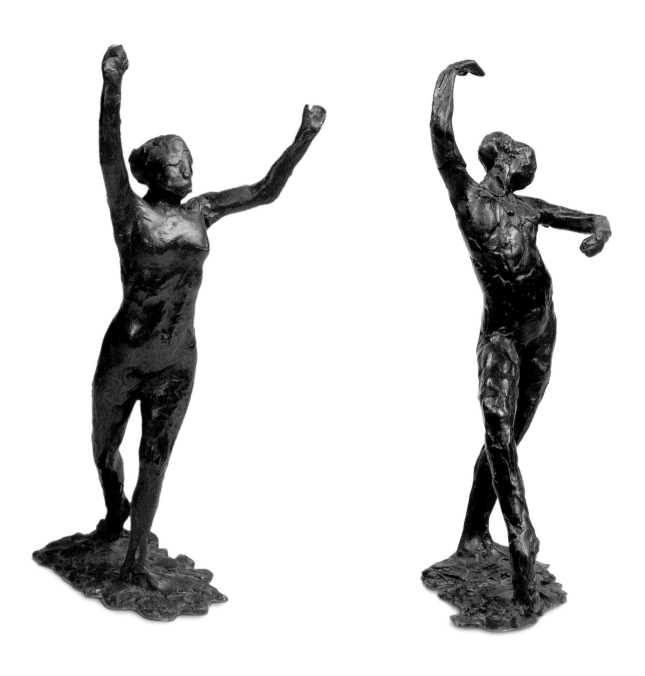

22. Edgar Degas
Dancer Moving Forward, Arms Raised | Danseuse s'avançant, les bras levés, 1882–95, cast posthumously 1919–26

23. Edgar Degas
Spanish Dance | Danse espagnole, 1896–1911, cast posthumously 1919–26

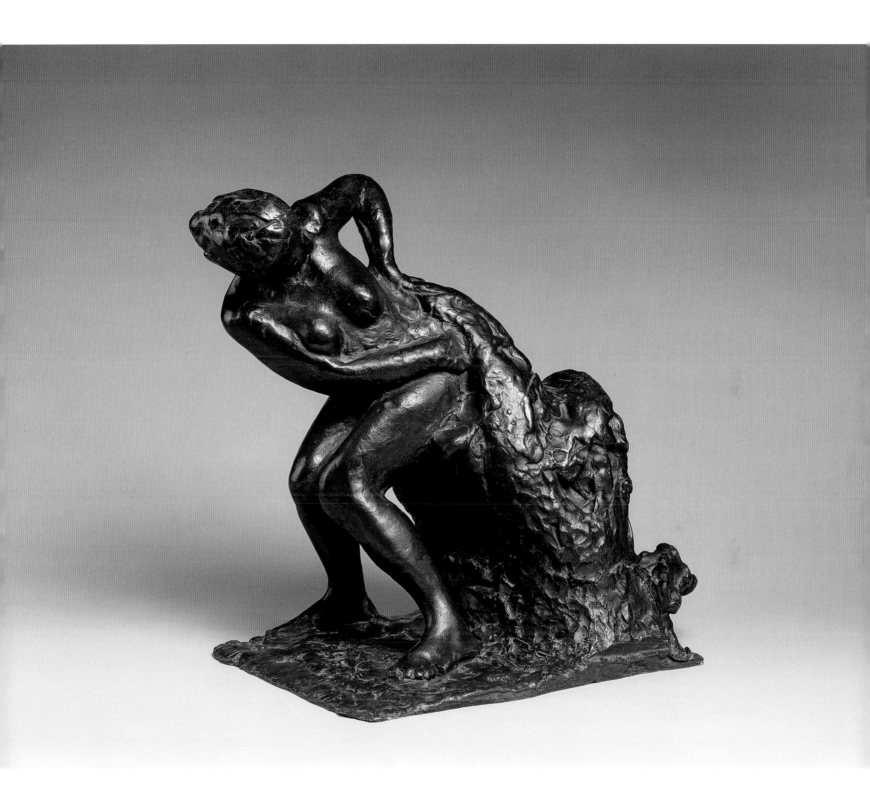

24. Edgar Degas
Seated Woman, Wiping Her Left Side | Femme assise, s'essuyant le côté gauche, 1896–1911,
cast posthumously 1919–26

Matthew Drutt **77**

spring. That summer saw the kind of grand survey of Munich modernism mixed in with French avant-garde painting that the gallery had become known for by that time. But in October and November, the Thannhausers held an unprecedented exhibition—at least insofar as Munich was concerned—of works by the Italian Futurists, represented by Umberto Boccioni, Carlo Carrà, Luigi Russolo, and Gino Severini. Although the show had been put together in Paris by Galerie Bernheim-Jeune and had traveled to Herwarth Walden's Galerie Der Sturm in Berlin, it apparently had also come about through Justin's acquaintance with the Futurists' leader, F. T. Marinetti. Though no reviews have come to light, one can imagine the response. Justin later recalled that there were "many controversies at that time!!"[23] The year ended on a spectacular note: a refined selection of fifteen paintings by Cézanne, along with an exhibition of works by Beckmann. ▬▬▬ By the following year, 1913, the gallery was more commonly known as Moderne Galerie Heinrich Thannhauser. Among the notable exhibitions in 1913 were solo presentations by Cézanne, Corinth, Degas, Hodler, Marc, and van Dongen, and, coming out of left field, a show of Italian Baroque painting. At the invitation of Walt Kuhn and Walter Pach, the Thannhausers also participated in the watershed exhibition that introduced European modernism to the United States, lending at least eight works to the landmark *International Exhibition of Modern Art* (popularly known as the Armory Show) held in New York before traveling to Boston and Chicago.[24] ▬▬▬ However, by far the most important project of the year was the first major exhibition of works by Picasso, from his Blue Period through the latest iterations of Cubism. Held in February and organized with the assistance of Kahnweiler, Picasso's Parisian dealer, the show was not the first exhibition ever of the artist's work, but it was certainly the largest, most comprehensive, and most critically selected to date, with seventy-six paintings and thirty-eight drawings, watercolors, and etchings executed between 1901 and 1912. Justin, who wrote the introduction to the accompanying catalogue, would recall later that the "show went immediately on to other places like Prague, Cologne, etc. . . . Picasso himself always considered it as the beginning of his appreciation in the world."[25] Justin's catalogue introduction positioned Picasso's work as "the first inducement to the whole Expressionist, Cubist, and Futurist movement. Picasso's actual involvement in all that consists in nothing more than having provided the initial inspiration, which also describes the extent to which he wishes to be involved."[26] Among the many works in the exhibition were *Woman Ironing* (1904), which Justin eventually acquired in the 1930s for his own collection and kept with him until bequeathing it to the Guggenheim. The exhibition was the beginning of a close personal and professional relationship between Justin and Picasso, which lasted until the artist's death in 1973. Of the seventy-three works now in the Guggenheim's Thannhauser Collection, thirty-two are by Picasso, and these works amply reflect the character of their friendship over the years. ▬▬▬ With the outbreak of World War I in 1914, the gallery's vigorous program suddenly came to a relative standstill. Justin was called into military service and returned to Munich shortly after being wounded in 1916.[27] While some exhibitions were held during these years—such as solo shows by Kandinsky and Klee in 1914, an exhibition of war paintings in 1916, and a large

figs. 28 and 29 First exhibition of Der Blaue Reiter, Moderne Galerie, Munich, December 1911; works shown include Franz Marc's *Yellow Cow* (1911, plate 40) and Robert Delaunay's *The City* (1911, plate 57)

survey of late-nineteenth-century Munich artists in 1918—Moderne Galerie Heinrich Thannhauser kept a relatively low profile, gradually downplaying its relationship to French art as it fell increasingly out of favor with a nationalist German audience. However, of particular note are the three large volumes published by the gallery that catalogued a selection of inventory, which reflected the broad program that Heinrich and Justin had developed in the years preceding the war. The first volume, which was published in 1916, begins with a twenty-two-page introduction by Wilhelm Hausenstein offering an overview of the gallery's activities to date and providing a historical context for many of the pictures in the inventory. Referring to Moderne Galerie Heinrich Thannhauser as "das Institut," Hausenstein celebrated Heinrich's achievement in forming a gallery that was more of a public service than a private business, a place more like a museum or salon, where people could learn and be exposed to great works of art. He also praised Heinrich for having placed so many major works of art in public and private collections, adding to Germany's cultural heritage.[28] The catalogue contains 174 masterpieces of French and German art, including Renoir's *Woman with Parrot* (1871, plate 20), which the Thannhausers had apparently acquired for a short time before selling it, only for Justin to reacquire the work again in the 1920s. The real gem, however, was Picasso's renowned *Family of Saltimbanques* (1905; now in the collection of the National Gallery of Art, Washington, D.C.), which Justin acquired for the gallery for the princely sum of 12,500 gold francs in March 1914 at an auction of the Peau de l'Ours collection in Paris. ▬▬▬ By 1918, Justin was married to his first wife, Kate, who gave birth to their first child, Heinz, in the same year; their second son, Michel, would be born in 1920. With the political and economic situation in Germany at a crisis point and the market for French art in particular decline, Justin decided to move his family to neutral ground in Switzerland, opening a branch of Moderne Galerie/Thannhauser—as it now came to be known—in Lucerne in 1919. Justin ran that business until 1921, when he was compelled to return to Munich. His father, who had developed a serious condition in his larynx, was forced into sudden retirement and turned over complete control of Moderne Galerie/Thannhauser's operations to Justin. The Lucerne gallery continued to be under Justin's direction until September 1928, when his cousin Siegfried Rosengart assumed control and changed its name to Galerie Rosengart.[29]

▬▬▬ While it never boasted as robust an exhibition schedule as the Munich gallery, the Lucerne branch provided a venue that periodically acted as a safe haven for selling works found unfavorable in Germany. Moreover, the notion of an expanded operation had been on Heinrich's mind as early as 1911, when he entertained plans to open a branch in Cologne, deterred only by limited finances; it would therefore be incorrect to suggest that the notion of expansion was based solely on circumstances created by the war. The Thannhausers were ambitious businessmen, and in the eighteen years following the war, that ambition was to see their business's program and facilities expand far beyond the scope of its prewar operation. ▬▬▬ After assuming responsibility for the gallery in Munich, Justin renamed the business Galerien Thannhauser (retaining Moderne Galerie/Thannhauser as the proper name of the Munich headquarters until the end of 1926) to

more accurately reflect its multi-operation profile, and he set out to build back the gallery's international program and sales. He moved carefully, however, advertising the business as specializing in graphic art and in German masters, and beginning 1922 with exhibitions of work by Corinth and Emanuel Spitzer, along with other conservative shows of German paintings and works on paper. In February, the gallery's schedule ventured cautiously into the avant-garde with a large Picasso exhibition: twenty-seven oil paintings and eighteen pastels, gouaches, and drawings. The accompanying catalogue's ten-page interpretive essay by Paul Rosenberg, who had taken over from Kahnweiler as Picasso's Paris dealer, was one of the first comprehensive overviews of the artist's career. Moving from Synthetic Cubism through the more classical works of the early 1920s, the exhibition picked up where the Thannhausers' previous Picasso project in 1913 had left off, a fitting point of reference for the gallery's postwar resurgence. Justin wrote in the catalogue's preface, "This new opportunity for taking a comprehensive look at [Picasso's] work of the past several years will certainly be welcomed by many devotees of the fine arts."[30] Indeed, Rosenberg's essay situated Picasso at the peak of a high modernist tradition: "He is enthusiastic about the works of Ingres, Géricault, Delacroix, Corot, Courbet. He is discovering the Impressionists, Cézanne, van Gogh, and Gauguin, whom he's beginning to love with all his soul."[31] Rosenberg went on to trace the different styles and sources explored by Picasso over the previous twenty-two years, including his interest in the arts of Africa. Thus the exhibition attempted to reestablish the combination of connoisseurship and scholarship that had characterized the Thannhausers' program before the war. In July, Justin mounted a large exhibition of recent works by Kandinsky, some ten years after his first appearance at the gallery. The year closed with exhibitions of drawings, prints, and posters by Henri de Toulouse-Lautrec and a show of thirty paintings and works on paper by Derain, the latter of which passed more or less without notice in the press. ▬▬▬ In fact, the program for the ensuing years retreated into the safe haven of mostly German masters, suggesting that the cultural climate in postwar Munich, even more conservative than prewar Munich, did not allow for the kind of shows that the Thannhausers had pioneered before 1914. A few exceptions are worth noting, however. Probably in July or August 1923, an exhibition of works by contemporary American artists was held, sponsored by an American, Mrs. E. H. Harriman, and possibly organized as an outgrowth of the Thannhausers' assistance in lending work to the Armory Show in 1913. An exhibition of paintings by Vlaminck took place in 1925. In July and August 1926, Moderne Galerie/Thannhauser was the second venue for a major traveling exhibition of works by Degas, which originated at Flechtheim's Berlin gallery in May and continued on to Galerie Arnold in Dresden in September.[32] Composed of twenty-five pastels and drawings and seventy-two bronzes, it was the largest exhibition of Degas's work since his death in 1917 and the first showing of all of his bronzes, which were cast posthumously from models found in his studio.[33] The sculptures in the Guggenheim's Thannhauser Collection (plates 22–24) appeared in this show, as did the pastel *Dancers in Green and Yellow* (ca. 1903, fig. 30).[34] Also in 1926, Justin held exhibitions of work by George Grosz and Otto Dix. The Dix exhibition, held in June and July and

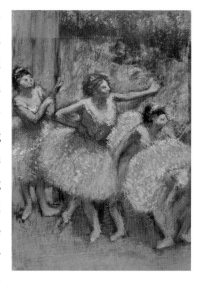

fig. 30 Edgar Degas, *Dancers in Green and Yellow | Danseuses vertes et jaunes*, ca. 1903. Pastel on several pieces of paper, mounted on board, 98.8 x 71.5 cm. Solomon R. Guggenheim Museum, New York, Thannhauser Collection, Gift, Justin K. Thannhauser 78.2514.12

fig. 31 Justin and Kate Thannhauser in their home at 165 East Sixty-second Street, New York, ca. 1940s

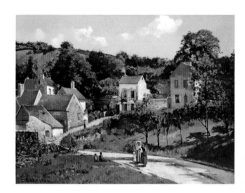

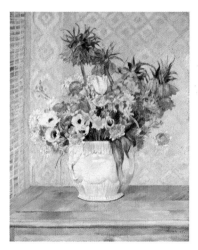

organized in cooperation with Galerie Nierendorf in Berlin, was particularly daring. Of the twenty-five paintings, fifteen drawings, and twenty-four prints made by the artist between 1913 and 1926, the majority belonged to his phase as an adherent of Neue Sachlichkeit.[35] ▬▬▬ Indeed, the Grosz and Dix exhibitions were a fair indication that Justin still harbored ambitions of supporting the avant-garde. Those ambitions were finally realized in 1927, when he opened a third gallery, this time in Berlin, the center of vanguard activity in Germany during the postwar period. For years, he had been doing business with dealers there—Cassirer, Flechtheim, and Walden among them—all of whom handled the leading modernists of the period. In a move calculated to reinvigorate his business, Justin staged the first of two *Sonderausstellungen* (special exhibitions) that January, in a temporary space, the Berliner Künstlerhaus (Berlin Artists Association), located at Bellevuestrasse 3 in the city's Tiergarten district. The exhibition was a major undertaking, containing 263 masterpieces of French painting by such artists as Pierre Bonnard, Braque, Cézanne, Gustave Courbet, Degas, Eugène Delacroix, Gauguin, Fernand Léger, Manet, Matisse, Monet, Picasso, Pissarro, Renoir, and van Gogh, to name just the highlights, most of whom were represented in depth. The quality of the works on display and their range were breathtaking, and both the critical and popular response was tremendous. A generously illustrated fifteen-page review by noted art historian Julius Meier-Graefe celebrated the show in the popular art journal Der Cicerone in February: "In the home of the Berlin Künstlerhaus, art has made a surprise appearance, sweeping away the clubhouse's evil spirits with one triumphant stroke. . . . Germany has not seen an exhibition of this caliber since Paul Cassirer's heyday; even in the Paris art trade, events of this magnitude are unusual."[36] ▬▬▬ Justin's gamble was off to an excellent start. Many of the works later bequeathed to the Guggenheim appeared in the exhibition, including Manet's *Before the Mirror* (1876, plate 21), Pissarro's *The Hermitage at Pontoise* (ca. 1867, fig. 32), Renoir's *Woman with Parrot* and *Still Life: Flowers* (1885, fig. 33), and van Gogh's *Mountains at Saint-Rémy* (July 1889, plate 25). There were also numerous works of note that are now in other public collections, including Cézanne's *The Card Players* (1890–92; now in the collection of the Barnes Foundation, Merion, Pennsylvania) and the van Gogh *Cypresses* (fig. 27) that had been exhibited by Heinrich in 1910. *Cypresses* was in the Thannhauser inventory from 1923/24 until at least 1929 and was sold back to Justin in 1949, the year he in turn sold it the Metropolitan Museum of Art. ▬▬▬ The second *Sonderausstellung* was held from the middle of February through the end of March, and this time a large selection of German art was featured, including works by Corinth, Hodler, Wilhelm Lehmbruck, Liebermann, Adolph von Menzel, Max Slevogt, and Fritz von Uhde. Together, these two major exhibitions—which amounted to a summary of the gallery's original program in Munich—thrust Justin into the midst of Berlin's art world. ▬▬▬ Having achieved this success, Justin acquired and renovated an old Berlin mansion just down the block from the Künstlerhaus, opening Galerien Thannhauser, Berlin, at Bellevuestrasse 13 in June 1927. The inaugural exhibition was an encyclopedic showing of 356 works by mostly German masters, new and old, including Ernst Barlach, Beckmann, Corinth, Dix, Lyonel Feininger, Grosz, Klee,

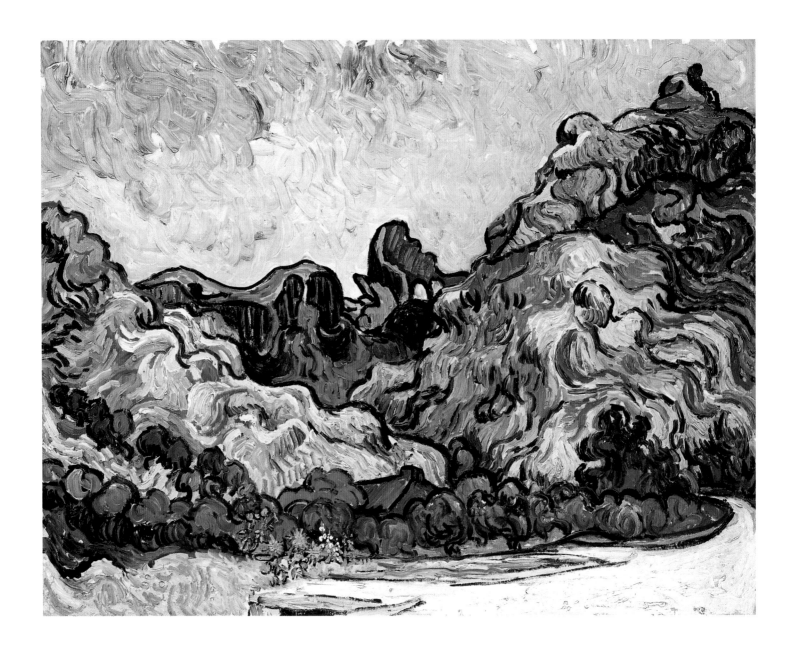

25. Vincent van Gogh
Mountains at Saint-Rémy | Montagnes à Saint-Rémy, July 1889

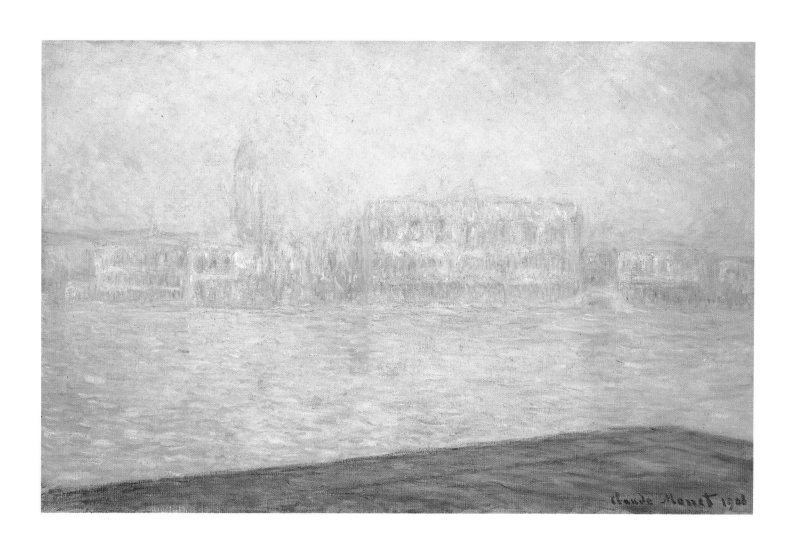

26. Claude Monet
The Palazzo Ducale, Seen from San Giorgio Maggiore | Le Palais Ducal vu du Saint-Georges Majeur, 1908

Oskar Kokoschka, Liebermann, Marc, and Menzel. � At the Munich gallery, the *Multinationale Ausstellung* opened in January 1928. The catalogue included a foreword by Roger Fry, who stated, "For artists and art lovers alike, [national borders] are entirely meaningless: at most, they're an impediment. Of course it is true that art is national in a sense that science is not; but if it is unavoidably national in its results it certainly is not in its intentions."[37] Sponsored by Mrs. E. H. Harriman, the same patron who had assisted Justin with his show of American art in 1923, this exhibition included works by, among others, Arthur B. Davies, Charles Demuth, and Max Weber (United States); Beckmann, Dix, and Pechstein (Germany); Fry, Duncan Grant, and Paul Nash (England); Braque, Derain, and Léger (France); Emil Rivas (Mexico); Albert Kohler (Switzerland); and Picasso and Valentin Zubiaurre (Spain). ▬ The exhibition seemed designed to capitalize on the prior year's successes in Berlin and to steer the Munich gallery toward a less provincial program once more, but this never transpired: the remainder of the year's exhibitions in Munich reverted to the German masters whose works had been featured there for the previous fourteen years. At year's end, the gallery—the toast of the progressive art world in Munich before the war—was finally closed. Justin now focused completely on Berlin, with the branch in Lucerne becoming increasingly independent under Rosengart. ▬ The 1928 season in Berlin began with a memorial Monet exhibition and accompanying catalogue, which noted that this occasion marked "the first time that works from all periods of the master's oeuvre have been presented in Germany."[38] The exhibition, which opened in February and ran through mid-March, was a major affair, with seventy paintings borrowed from private and public collections, including the Städtische Galerie Frankfurt (*Breakfast*, 1868) and the Musée Luxembourg in Paris (*Regatta in Argenteuil*, 1874, and *Rouen Cathedral*, 1894). It was a political coup as well, organized with the assistance of the French ministry of fine arts. Justin later recalled that France's former premier Georges Clemenceau offered to travel to Berlin to deliver a memorial speech at the gallery, only to be prevented at the last minute due to illness. Among the works shown was *The Palazzo Ducale, Seen from San Giorgio Maggiore* (1908, plate 26), which Thannhauser purchased during the course of the exhibition from Wildenstein & Co., New York.[39] According to one review, which took note of the concurrent Manet exhibition being held at Galerie Mathiessen, the overall effect of the Monet presentation captured "the genius of an era." It continued, "When beautiful paintings are shown we delight in the divine gift without first asking questions about the artist's nationality or whether the current political constellation permits our devotion. Above all we experience pure pleasure and for that we are grateful."[40] ▬ The end of the 1928 season was no less spectacular, with a major Gauguin retrospective. Filling the gallery were 230 works, again borrowed from private and public collections, in various mediums and covering every phase of the artist's career, from his first period in Brittany beginning in 1884 through his last sojourn in Tahiti, which ended with his death in 1903. Included was *In the Vanilla Grove, Man and Horse* (1891, fig. 34), which Justin would acquire for his collection in 1942. The catalogue's introduction by Wilhelm Barth, director of the Kunsthalle Basel and a Gauguin scholar, underscored the

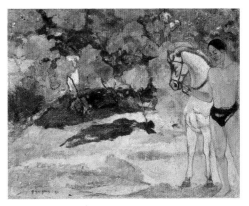

fig. 34 Paul Gauguin, *In the Vanilla Grove, Man and Horse | Dans la Vanillère, homme et cheval*, 1891. Oil on burlap, 73 x 92 cm. Solomon R. Guggenheim Museum, New York Thannhauser Collection, Gift, Justin K. Thannhauser 78.2514.15

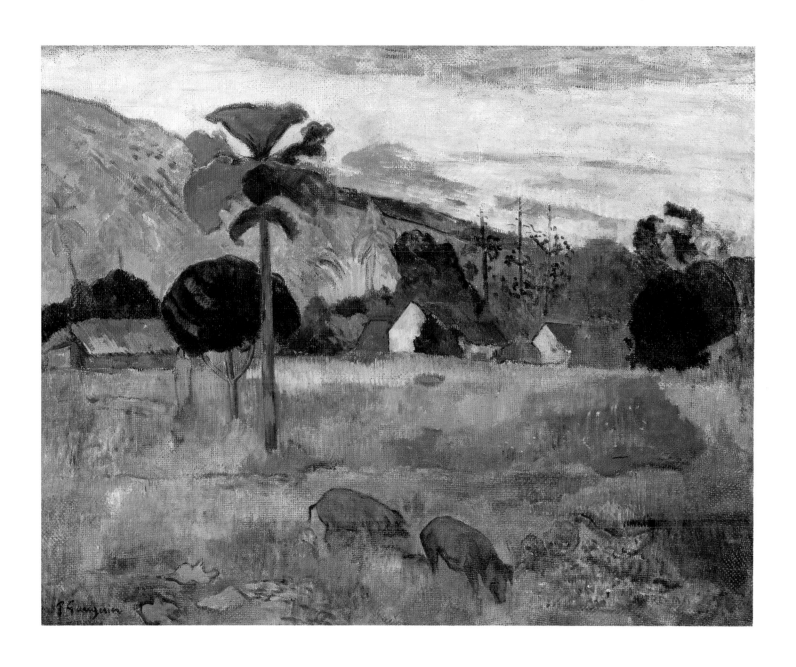

museumlike status of the exhibition.[41] Justin's unsigned text in the catalogue also reminded audiences of the Thannhausers' commitment to the artist, whose work they had shown in a major presentation twenty years earlier in Munich. ▬▬▬ Nothing is currently known of the 1929 season; no doubt there were exhibitions, but the press records are sparse and ongoing research has failed to turn up events of any significance. Even Justin's own notes mostly skip forward to 1930, for this was the year of his greatest, and perhaps ultimate, achievement in the Berlin space. In February and March, he presented the largest exhibition of works by Matisse ever held in Germany up to that time. With 265 works made between 1896 and 1929, it was the most comprehensive overview of the artist's career yet assembled: eighty-three paintings, twenty sculptures, fifty-five drawings, and 107 prints. Justin later recalled, "It had a sensational effect everywhere in the [old and new] worlds, and brought—like the other shows—thousands and thousands of visitors; whole classes of students from Germany and other (Scandinavian, etc.) countries."[42] Indeed, the exhibition was noteworthy enough to merit a review in an American periodical, *The Art News*, which raved, "Here is no trickery, no sentimentality, but a freshness and sureness of execution which prove Matisse a master in his chosen field. Indeed, nobody but a master could venture to group such boldly contrasting color structures and such daringly arranged elements of form."[43] Matisse, whom Justin had met as far back as 1911 in Paris, cooperated in the organization of the exhibition, making works from his own collection available; these were shown alongside distinguished examples from other private collections in France and Germany. The show was accompanied by a catalogue, with a brief introductory essay by the artist Hans Purrmann, and by a special folio of eighty paintings and drawings, with a text written by Gotthard Jedlicka, which was published in an edition of 250 in cooperation with Editions Chronique du Jour in Paris. ▬▬▬ It is here that Galerien Thannhauser's history begins to fade for several years. Though the Berlin gallery remained in operation until 1936 or 1937,[44] its activities from this point forward are unknown. In 1932, Justin assisted with two important Picasso exhibitions, one at Galerie Georges Petit in Paris followed by another at the Kunsthaus Zürich.[45] By 1933, the situation in Germany had become so difficult that Justin took a small apartment in Paris, which would later serve as the means by which he moved belongings slowly, though legally, out of the country. In 1934, Heinrich, who had lived his entire life in Munich, was persuaded to emigrate to Switzerland and live with Rosengart in Lucerne in order to avoid persecution by the Nazis. He never made it. Apparently harassed as he attempted to cross the border between Germany and Switzerland, he died of a heart attack.[46] That same year in October, Justin helped organize an exhibition of seventy-six works by Picasso for Galeria Mueller in Buenos Aires, consisting of loans from museums around the world as well as from his own collection and those of Kahnweiler and Rosenberg.[47] One wonders if Justin viewed this as a means of exporting certain works out of the country for safekeeping, since in 1939 Galeria Mueller would be a conduit for getting some of his collection into the United States. ▬▬▬ In April 1937, when circumstances in Germany were no longer bearable, Justin moved with his wife and two children to Paris. They took up residence in a

fig. 35 Justin K. Thannhauser

fig. 36 Sitting room of Justin and Kate Thannhauser's home at 12 East Sixty-seventh Street, New York, ca. 1957

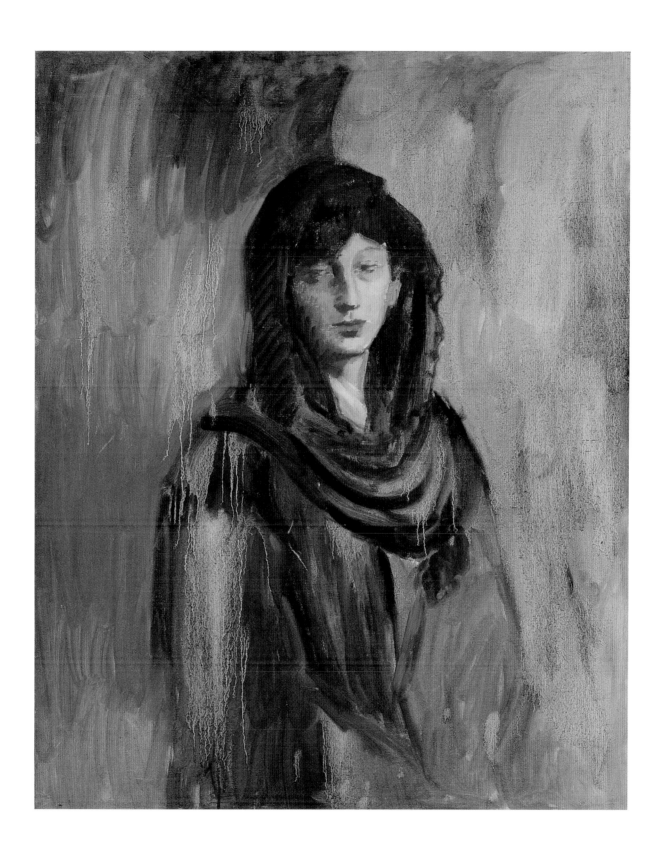

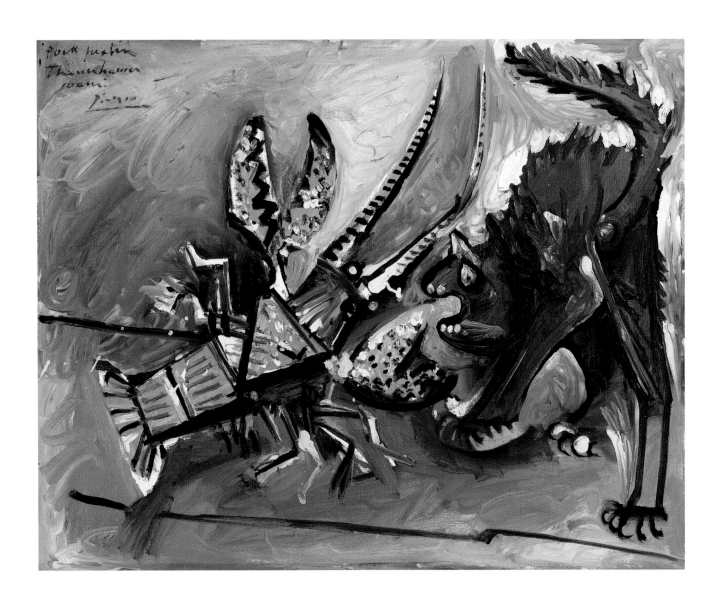

29. Pablo Picasso
Lobster and Cat | Le Homard et le chat, January 11, 1965

rented house at 35, rue de Miromesnil, where Justin operated a private gallery until 1939. Having paid a steep export tax, he was permitted to bring with him his library and the gallery's archives dating back to 1909, as well as many important works of modern art considered "degenerate" by the Nazi government and therefore of no interest to the German state. However, he was forced to liquidate the family's considerable inventory and collection of classic German art, which had been an important part of the business since its inception, in order to meet the financial demands placed upon him. Thus, one of the defining components of the inventory and collection, which had evolved over nearly thirty years, was simply dispersed. ▬▬▬ Little of Justin's years in Paris is known. On October 14, 1937, he was voted into the Syndicat des Editeurs d'Art et Négotiants en Tableaux Modernes, the professional society of art dealers active in Paris at the time; its members included legends like the Bernheim-Jeunes, Pierre Loeb, and Paul and Léonce Rosenberg. Justin continued to lend works and to give other means of assistance to exhibitions in France and elsewhere. He also continued to acquire art, such as two works by Picasso, *Still Life: Flowers in a Vase* (1906) and *Woman with Yellow Hair* (December 1931, plate 17), both of which he bought in 1937 from the artist, whom he saw regularly. However, much of what he owned in the way of art, books, musical instruments, and collectible furnishings would soon be lost. ▬▬▬ On August 10, 1939, Justin and Kate traveled to Geneva with their friends, the Edward G. Robinsons of Hollywood fame, to see an exhibition of paintings on loan from the Museo Nacional del Prado in Madrid.[48] While they evidently planned to be there for some time, judging from a postcard Justin sent to Picasso on July 18 in which he invited the artist to join them,[49] they could not have imagined that they would never return to Paris. Following the outbreak of war in September, the Thannhausers took refuge once again in Switzerland. When the Germans occupied France in June 1940, they gave up hope of returning there, and in December they made their way to Lisbon, where they boarded a ship bound for New York. The house in Paris would be completely looted during the war, and the precious objects in their collection transported back to Germany by Nazi soldiers. The archive of the Galerien Thannhauser dating all the way back to its founding year was largely destroyed.[50] Fortunately, Justin had shipped nine important works to Buenos Aires in May 1939 for an exhibition,[51] and these, along with several others, including Picasso's *Fernande with a Black Mantilla* (1905–06, plate 28), made their way to safety with him in the United States. ▬▬▬ Once in New York, the Thannhausers acquired a town house at 165 East Sixty-second Street, and Justin began to operate a private gallery with the intention of building up the business one more time. He maintained contact with his friends in Europe, including Picasso, whom he invited to New York to stay with them at their "*petite maison*."[52] He was counting on his oldest son, Heinz, who had trained as an art historian, to run a gallery with him after the war, as he had done with his own father. But disaster struck on August 15, 1944, when Heinz was killed in combat while fighting with the American Air Force for the liberation of France.[53] Despondent over this loss, still uncertain about the disposition of the house in Paris (which he would only later learn had been looted), and concerned about the health of his younger son,

Michel, who was gravely ill and would die in 1952, Justin canceled his immediate plans to open a public gallery. Instead, he placed a large number of works from his collection up for auction at Parke-Bernet Galleries in New York in April 1945.[54] In a letter to the auction house, he wrote, "The great majority of these paintings has not been seen in the United States, as I formerly intended to open an exhibition gallery in New York."[55] The artists whose works were made available ranged from Bonnard, Cézanne, Corot, and Degas to Gauguin, Manet, Matisse, and Picasso, but nothing in the entire lot rivaled the quality of what he had kept for himself. In spite of the grave disappointments encountered at this point in his life, Justin was not without hope; in the same letter, he explained, "I may reorganize this business in the near future on a more restricted scale."[56] Indeed, earlier that year he had helped Curt Valentin's Buchholz Gallery in New York organize a show of works by Degas,[57] which included the bronze *Seated Woman Wiping Her Left Side* (1896–1911, plate 24). ▬▬▬ In 1946, the Thannhausers moved to a larger home at 12 East Sixty-seventh Street, where Justin remained until 1971. While his ambition to open a gallery in the United States would never be realized, he continued to operate privately, and his life was hardly quiet. He traveled frequently to Europe, and continued to assist museums and galleries with exhibitions and acquisitions. The home on Sixty-seventh Street became a meeting place for cultural luminaries from around the world, with frequent soirées and evenings of musical entertainment. Among the visitors were Peter Lawson-Johnston, then President of the Solomon R. Guggenheim Foundation, and Thomas M. Messer, then Director of the Solomon R. Guggenheim Museum. It was through such visits and a rich correspondence that the seeds for the Thannhauser gift to the Guggenheim were sown.[58] ▬▬▬ During his years in the United States, Justin also continued to collect art, acquiring Cézanne's *Still Life: Flask, Glass, and Jug* (ca. 1877, fig. 38) and Picasso's *Head of a Woman (Dora Maar)* (March 28, 1939) and *Two Doves with Wings Spread* (March 16–19, 1960), among other works. Shortly after the Thannhausers purchased the latter picture during a visit to Europe in September 1960, Kate passed away. Justin married Hilde two years later, and in honor of their marriage, Picasso presented them with the painting *Lobster and Cat* (January 11, 1965, plate 29).[59] ▬▬▬ After years of pondering his options, Justin decided in 1963 to bequeath the essential works of his collection to the Guggenheim. It was not the first nor last time he made a gift to a museum; indeed, over the years he had given works to institutions around the world, and, as he later put it, "regretted only where the donations are not being shown."[60] But the bequest to the Guggenheim was different. The number of works and overall quality was unparalleled by any gift he had made or would make again. Moreover, the terms of the bequest called for the works to be permanently installed in a designated space with tight restrictions on their loan, thus guaranteeing that they would be publicly accessible and would become a destination for visitors from around the world. The announcement of the gift, in October 1963, made the front page of *The New York Times* in an article that highlighted the collection's large number of works by Picasso.[61] ▬▬▬ To house the Thannhauser gift, the Guggenheim converted space on the second floor of the Monitor building (the smaller building adjacent to the main

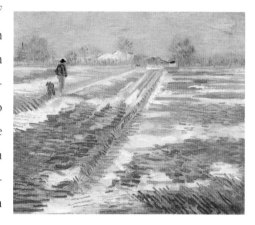

fig. 38 Paul Cézanne, *Still Life: Flask, Glass, and Jug | Fiasque, verre et poterie*, ca. 1877. Oil on canvas, 45.7 x 55.3 cm. Solomon R. Guggenheim Museum, New York, Thannhauser Collection, Gift, Justin K. Thannhauser 78.2514.3

fig. 39 Vincent van Gogh, *Landscape with Snow | Paysage enneigé*, late February 1888. Oil on canvas, 38.2 x 46.2 cm. Solomon R. Guggenheim Museum, New York, Thannhauser Collection, Gift, Hilde Thannhauser 84.3239

rotunda). When the renovations were completed, in April 1965, the critical reception was exactly what Justin and the museum had hoped it would be, one writer exclaiming, "Thannhauser's paintings fit so well into the museum's formerly limited collection that in one stroke they make the Guggenheim a showcase for modern art."[62] ▬▬ In 1971, Justin and Hilde sold their home in New York and retired to Switzerland, setting up residence in Bern and spending their vacations at their mountain chalet in Gstaad or visiting friends throughout Europe. On May 7, 1972, on the occasion of Justin's eightieth birthday, a party was held for him at the Guggenheim Museum with a special concert given by his friend, pianist Rudolf Serkin. Moreover, the wing containing his bequest had been renovated, with the Monitor building's central light well exposed according to Frank Lloyd Wright's original design, and reinstalled. In 1973, Justin gave four masterpieces, including two Picassos, to the Kunstmuseum Bern, honoring the country that had been a safe haven for him throughout difficult points in his life.[63] Having lived to see his family name memorialized and collection celebrated, Justin died in Gstaad on December 26, 1976, at the age of eighty-four. ▬▬ After Justin's death, Hilde continued the work he had begun and made additional gifts to institutions over the years. Through her efforts, in 1978, the same year that Justin's original gift vested to the Guggenheim, a memorial exhibition was held at the Kunstmuseum Bern, honoring him and his gifts to that institution, along with an additional four works given by Hilde on the occasion of the show.[64] In 1981, Braque's *Guitar, Glass, and Fruit Dish on Sideboard* (early 1919) was purchased by the Guggenheim with funds made possible by an exchange with Hilde, which she followed up with a gift of two additional works in 1984, van Gogh's *Landscape with Snow* (late February 1888, fig. 39) and Picasso's *Still Life: Fruits and Pitcher* (January 22, 1939). At that time, Hilde also announced her intention to bequeath ten additional works to the Guggenheim upon her death. In recognition of the distinction and generosity that the Thannhausers' gifts had reflected upon the institution, the Monitor building was named for them in 1989. ▬▬ On July 25, 1991, Hilde Thannhauser died in Bern. The ten works she bequeathed to the Guggenheim transferred ownership, and when the museum reopened in 1992 after a complete renovation of its Frank Lloyd Wright–designed building, they were featured in the newly installed and restored Thannhauser galleries. Since that time, they have remained on view in rotation along with Justin's original bequest to the museum (the entire collection is never on view at one time). Though subject to the same restrictions on travel as the works given by Justin, over the years exceptions have been made, and they have joined distinguished exhibitions around the world. Otherwise, the Thannhausers' works reside permanently within the museum, a testimony to the spirit and desires of their benefactors. The collection indeed fulfills Justin Thannhauser's wishes, expressed at the time he decided to donate his works, in 1963: "I feel strongly that these ... pictures represent a unity you do not find in other museums. They cover 75 to 100 years and I see one coming from the other. I want to show them as a unity. ... I hope it will be appreciated. It's my whole life."[65]

NOTES

Unless otherwise noted, all translations are mine.

1. Justin Thannhauser's gift was announced in October 1963, but the works were not placed on view at the Solomon R. Guggenheim Museum until 1965, when the Thannhauser Wing opened. They were on permanent loan until 1978, two years after Thannhauser's death, when they formally entered the museum's collection. Although there were one hundred works on view when the Thannhauser Wing opened, Justin's bequest contained seventy-four objects. The deed of gift lists seventy-five works, but that is because the two-panel *Place Vintimille* (1908–10) by Edouard Vuillard is counted as two separate objects. Since then, fourteen works have been deaccessioned, including twelve that were sold in May 1981 at a special sale held at Sotheby's New York. Three more works were acquired by the museum through Hilde Thannhauser, Justin's second wife, one in 1981 and two in 1984, with another ten works bequeathed in 1991 following her death. Thus the total number of works in the Thannhauser Collection now counts seventy-three.

2. Justin Thannhauser, quoted in Richard F. Shepard, "Collector's Gift Reflects His Life," *New York Times*, October 25, 1963.

3. The opening of the gallery is generally given as 1904–05, which I have interpreted to mean opening late in 1904, perhaps December, with an exhibition that continued into 1905. The business was known as Moderne Kunsthandlung, but was also referred to as Brakl und Thannhauser in the press, so at some point the names may have been combined. After Heinrich Thannhauser left to start his own business in 1909, the gallery became known as Brakls Moderne Kunsthandlung.

4. This information was culled from Karl-Heinz Meissner, "Der Handel mit Kunst im München," in Rupert Walser and Bernhard Wittenbrink, eds., *Ohne Auftrag: zur Geschichte des Kunsthandels* (Munich: Walser & Wittenbrink, 1989), p. 97, n. 81. I have found little else to flesh out Heinrich's biography.

5. Writing in the third person, Justin later recalled that his duties included: "Help in organisation of the Exhibitions his father Heinrich undertook in the Munich Galleries.... Assistance in such shows since 1909." See Justin Thannhauser, notes to Guggenheim trustee Daniel Catton Rich, probably 1972, Solomon R. Guggenheim Museum Archives, New York (hereafter cited as Thannhauser, notes). These and other notes in the archive were written by Justin in an informal manner; some are handwritten and others are typescripts with handwritten corrections.

6. G[eorg] J[acob] W[olf], "Kunst," *München AugsburgerAbendzeitung*, November 8, 1909, unpaginated.

7. See *Impressionisten-Ausstellung*, exh. cat. (Munich: Moderne Galerie, 1909).

8. U.–B., "München," *Der Cicerone*, no. 22 (1909), pp. 706–07.

9. F., "München," *Der Cicerone*, no. 1 (1910), p. 30.

10. The catalogue carries entries for works numbered one through thirty-six, but there is no number seven. There were twenty-three oil paintings, ten pastels, and two watercolors in the exhibition. See *Edouard Manet (aus der Sammlung Pellerin)*, exh. cat. (Munich: Moderne Galerie, 1910).

11. Georg Jacob Wolf, in ibid., unpaginated.

12. M. K. R[ohe], "München," *Der Cicerone*, no. 20 (1910), p. 280.

13. Thannhauser, notes.

14. Arnhold owned many of Manet's great works at the time. *Bar at the Folies-Bergère* would reenter the Thannhauser inventory around fourteen years later, appearing regularly in the gallery's sales catalogues until it was eventually sold to Samuel Courtauld in London; it is now in the collection of the Courtauld Institute of Art, London.

15. M. K. R[ohe], "München," *Der Cicerone*, no. 41 (1910), p. 565.

16. M. K. Rohe, quoted in Andreas Hüneke, ed., *Der Blaue Reiter: Dokumentation einer geistigen Bewegung* (Leipzig: P. Reclam, 1986), p. 29.

17. Vasily Kandinsky, quoted in translation in Kandinsky and Franz Marc, eds., *The Blue Rider Almanac*, ed. Klaus Lankheit (London: Thames & Hudson, 1974), p. 12.

18. U.–B, "München," *Kunst und Künstler* 9, no. 4 (1911), p. 205.

19. M. K. Rohe, "München," *Der Cicerone*, no. 59 (1910), p. 819.

20. Thannhauser, notes.

21. With regard to this van Gogh exhibition, Justin continued, "Sale of Arlesienne to Carl Sternheim, 13,000 Mark. He resold it—before the first World war to Mrs. Von Goldschmidt-Rothschild for many times this amount." See Thannhauser, notes.

22. According to various records, Heinrich was responsible for introducing Marc and Kandinsky. Justin later mentioned "whole correspondence from Marc, urging Heinrich to bring him together with Kandinsky—with all his reasons—and after H. T. [Heinrich Thannhauser] had responded and brought them together at his Gallery, letter of profuse thanks by Marc, with numerous highly interesting details"; see Thannhauser, notes. This correspondence is among the materials confiscated by the Nazis in the 1940s and presumed destroyed. Kandinsky stated that he and Marc met as a result of the outrage over the NKVM exhibition in 1910: "[Heinrich] Thannhauser showed us a letter from an unknown Munich painter, who congratulated us on the exhibition and expressed his enthusiasm in eloquent words. This painter was a 'real Bavarian' named Franz Marc"; quoted in Klaus Lankheit, *Franz Marc im Urteilseiner Zeit* (Cologne: Verlag M. Dumont-Schauberg, 1960), p. 46.

23. Thannhauser, notes.

24. See *International Exhibition of Modern Art*, exh. cat. (New York: Association of Painters and Sculptors, 1913), which lists eight works as having been lent by Justin.

25. Thannhauser, notes.

26. Justin Thannhauser, introduction to *Pablo Picasso*, exh. cat. (Munich: Moderne Galerie Heinrich Thannhauser, 1913), unpaginated.

27. Most sources give 1918 as Justin's return date, but a brochure distributed by the Silva-Casa Foundation, Bern (dated August 14, 1996/February 22, 2000), includes a history of the Thannhauser family that lists it as 1916. (After Hilde Thannhauser's death in 1991, the Silva-Casa Foundation was set up as a philanthropy in accordance with her wishes.) In conversation with the author in September 2000, Max Ludwig confirmed the 1916 date; Ludwig, a legal advisor to Justin and Hilde beginning in 1971, is a member of the Silva-Casa Foundation's council and executor of the Thannhauser Estate.

28. Wilhelm Hausenstein, introduction to *Katalog der Modernen Galerie Heinrich Thannhauser München* (Munich: Moderne Galerie Heinrich Thannhauser, 1916), p. VII. The two subsequent volumes were published in 1917 and 1918.

29. See announcement in "Handel and Verkehr," *Luzerner Tagblatt*, September 12, 1928, p. 4. However, see *Henri Matisse*, exh. cat. (Berlin: Galerien Thannhauser, 1930), p. 3, where Lucerne is still listed as part of the Thannhauser network. The Lucerne gallery continues to operate today under the name Angela Rosengart.

30. Justin Thannhauser, preface to *Pablo Ruiz Picasso*, exh. cat. (Munich: Moderne Galerie/Thannhauser, 1922), p. 3.

31. Ibid., p. 6.

32. Another Degas exhibition, in 1923, is cited in Walser and Wittenbrink, *Ohne Auftrag: zur Geschichte des Kunsthandels, München*, p. 260, but I have not been able to substantiate whether this second exhibition ever took place.

33. For a concise summary of these circumstances, see Vivian Endicott Barnett, text on *Dancer Moving Forward, Arms Raised*, in *Guggenheim Museum: Thannhauser Collection*, (New York: Guggenheim Museum, 1992), p. 111.

34. See *Edgar Degas Pastelle/Zeichnungen, das plastische Werk*, exh. cat. (Munich: Galerien Thannhauser, 1926).

35. Among the paintings shown in the Dix exhibition were *The Match Vendor* (1920, Staatsgalerie Stuttgart), *Portrait of the Artist's Parents* (1924, Niedersächsisches Landesmuseum Hanover), and *Self-Portrait* (1926, Leopold-Hoesch-Museum, Düren).

36. Julius Meier-Graefe, "Die Franzosen in Berlin," *Der Cicerone* 25, no. 2 (1927), p. 43.

37. Roger Fry, foreword to *Multinationale Ausstellung*, exh. cat. (Munich: Galerien Thannhauser, 1928), unpaginated.

38. *Claude Monet 1840–1926: Gedächtnis-Ausstellung*, exh. cat. (Berlin: Galerien Thannhauser, 1928), p. 4.

39. Justin paid $5,500 to Wildenstein & Co., New York. See sales receipt, dated February 15, 1928, Silva-Casa Foundation.

40. Karl Scheffler, "Monet: Zur Ausstellung in der Galerie Thannhauser," Kunst und Künstler 26, no. 2 (1928), pp. 267–68.

41. Barth was the organizer of a Gauguin exhibition that was shown at the Kunsthalle Basel from July to August the same year. Since there is considerable overlap between the two checklists, it is unclear whether the Thannhauser exhibition was part of this project or an independently organized showing, though in his introduction in the Thannhauser catalogue, Barth constantly referred to the project as "unser Ausstellung"; see *Paul Gauguin 1848–1903*, exh. cat. (Berlin: Galerien Thannhauser, 1928), pp. 3–5.

42. Thannhauser, notes.

43. F. T. D., "Thannhauser Shows Matisse," *The Art News*, March 8, 1930, p. 6.

44. In a few notes and pieces of correspondence in the Solomon R. Guggenheim Museum Archive, Justin stated that the galleries in Berlin and Lucerne closed in 1937, but press accounts differ, some dating his departure for France as early as 1933. However, the date is given as 1936 in E. W. Kornfeld, "Die Galerie Thannhauser und Justin K. Thannhauser als Sammler," in *Sammlung Justin Thannhauser*, exh. cat. (Bern: Kunstmuseum Bern, 1978), p. 16, and Meissner, "Der Handel mit Kunst im München," p. 54 and p. 99, n. 98. Meissner based his dating on Nazi decrees forbidding Jews from owning or operating businesses. In conversation with the author in September 2000, Max Ludwig clarified the discrepancies as follows. Justin had a small apartment in Paris, which he used as an address for exporting works from Germany and as a toehold in France. The exact date for when he began to rent his house in Paris, at 35, rue de Miromesnil, is unknown, but it is known that he moved there in April 1937. Galerie Thannhauser in Lucerne was legally operated by Justin until 1928 when Siegfried Rosengart assumed control.

45. See Justin Thannhauser to Daniel Catton Rich, March 8, 1974, Solomon R. Guggenheim Museum Archive.

46. Kornfeld, "Die Galerie Thannhauser und Justin K. Thannhauser als Sammler," p. 16.

47. See *Picasso*, exh. cat. (Buenos Aires: Galeria Mueller, 1934).

48. See "Bequests: Redressing a Spiral Showcase," *Time*, May 7, 1965, p. 86.

49. Justin Thannhauser to Pablo Picasso, postcard, July 18, 1939, Dossier Thannhauser, Musée Picasso, Paris.

50. Several pictures and documents that had been in a safe of the Bank Rothschild in Paris, however, were eventually returned to Justin. See Kornfeld, "Die Galerie Thannhauser und Justin K. Thannhauser als Sammler," p. 16.

51. The exhibition, *La pintura francesa de David a nuestros días*, was shown at the Museo Nacional de Bellas Artes, Buenos Aires, July–August 1939, and then traveled to the Ministerio de Instrucción Pública, Montevideo, April–May 1940, and the Museu Nacional de Belas Artes, Rio de Janeiro, June 29–August 15. Among Justin's paintings shipped to Buenos Aires for the exhibition were Gauguin's *Haere Mai* (1891, plate 22), Monet's *The Palazzo Ducale, Seen from San Giorgio Maggiore* (1908, plate 26), Pissarro's *The Hermitage at Pontoise* (ca. 1867, fig. 32), and Renoir's *Woman with Parrot* (1871, plate 20), all of which are now in the Guggenheim's Thannhauser Collection.

52. Justin Thannhauser to Pablo Picasso, postcard, September 27, 1944, Dossier Thannhauser.

53. See Justin Thannhauser to Pablo Picasso, postcard, October 9, 1944, Dossier Thannhauser.

54. See *Modern and Other French Paintings, Drawings, Prints, Bronzes, Property of J. K. Thannhauser, New York* (New York: Parke-Bernet Galleries, 1945).

55. Justin Thannhauser to Parke-Bernet Galleries, Inc., February 15, 1945, ibid., reproduced as frontispiece.

56. Ibid.

57. See *Edgar Degas: Bronzes, Drawings, Pastels*, exh. cat. (New York: Buchholz Gallery, 1945).

58. The correspondence between Messer and Justin Thannhauser is contained in the Thomas Messer Papers, Solomon R. Guggenheim Museum Archive.

59. In a letter to Justin dated September 6, 1965, Picasso wrote, "I have given my painting 'Homard et chat' to my friend, Justin K. Thannhauser, in appreciation of our old friendship and of his assistance in the acquisition of my painting by the Munich museums." This suggests that the painting may have been given to Justin in lieu of a monetary commission. The letter is in the collection of the Silva-Casa Foundation.

60. Thannhauser, notes.

61. John Canaday, "Guggenheim Gets Major Artworks," *New York Times*, October 24, 1963, pp. 1, 30.

62. "Bequests: Redressing a Spiral Showcase," p. 86. See also François Daulte, "Une Donation sans Précédent: La Collection Thannhauser," *Connaissance des Arts*, May 1965, pp. 58–69.

63. See *Sammlung Justin Thannhauser*, exh. cat. (Bern: Kunstmuseum Bern, 1978), pp. 8, 19–28. Justin gave the following four works to the Kunstmuseum Bern in 1973: Edgar Degas, *Landscape and Horses* (ca. 1858); Vincent van Gogh, *Tête de Paysanne* (1885); and Pablo Picasso, *Dans la Loge* (1921) and *La Famille* (1923). Additional works were placed on extended loan.

64. See ibid. Hilde gave the following four works to the Kunstmuseum Bern in 1978: Ernst Ludwig Kirchner, *Two Female Nudes* (1911); Pablo Picasso, *Femme assise, les mains croisées* (1922); Pierre Auguste Renoir, *Femme nue accoudée* (ca. 1884–85); and Henri Toulouse-Lautrec, *Mme Misia Natanson* (1897). Five additional works were donated to the Kunstmuseum Bern following Hilde's death in 1991: Paul Cézanne, *Chateau de Marines* (1888–90); Max Liebermann, *Portrait of Heinrich Thannhauser* (1916); Pablo Picasso, *Femme assise en bleu et rose* (1923) and *Menerbes* (1946); and Louis Valtat, *Louis Valtat et son fils* (1909). These gifts were made with the advice of Max Ludwig.

65. Shepard, "Collector's Gift Reflects His Life."

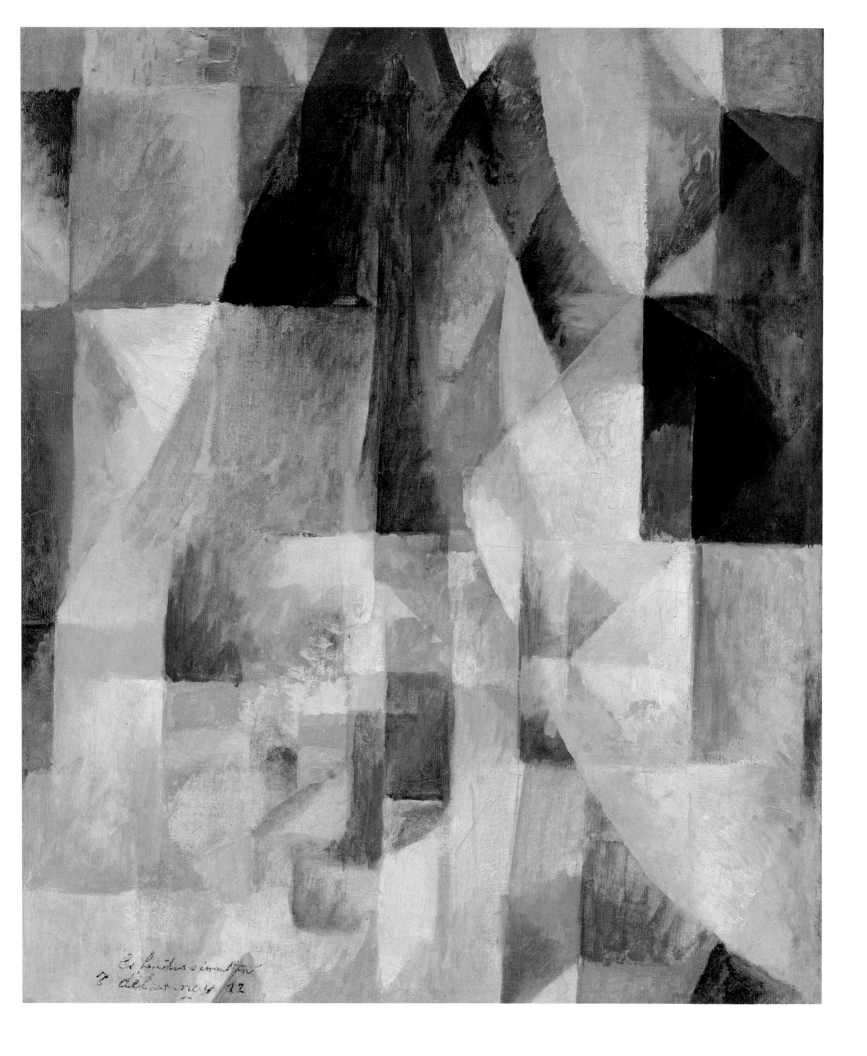

LISA DENNISON

1912

"Paris in 1912! What could be more wonderful for a painter? A believer in signs might say that this was surely the mark of a predestined career. The year 1912 is perhaps the most glorious in the history of painting in France. This was the apogee of Cubism, and Cubism is identified with Paris, is Paris itself, the real Paris, Paris without artifice. . . . Yes, 1912 is the most Parisian moment in painting; it is a moment which will never again be recaptured."[1] These words were written by French critic and art historian Michel Seuphor to describe Piet Mondrian's arrival in Paris from Amsterdam at the very beginning of what would indeed prove to be a landmark year in the history of modern art.[2] Seuphor suggests that Mondrian's encounter with the art of Georges Braque and Pablo Picasso at this pivotal time crystallized the Dutchman's ambition to create "a pure plastic art" through the discovery of an underlying sense of order and harmony in Analytic Cubism at its most hermetic stage. He argues that out of the chaos of Cubism, Mondrian would begin on the path to pure abstraction: "Henceforward his values would be order, discipline, sobriety . . . recording in clear logic the whole teaching of Cubism at the very moment when the great Cubist painters halted or went backwards."[3]

▬▬▬ Although Seuphor oversimplifies Mondrian's move toward abstraction, his recognition of 1912 as a watershed moment, representing both an apogee and a crisis point in the development of Cubism, is accurate. In this year, Cubism achieved full recognition at three major Parisian exhibitions: the Salon des Indépendants, the Salon d'Octobre, and most important of all, the artist-organized Salon de la Section d'Or.[4] This last exhibition, consisting of more than 180 works by thirty-two painters, was devoted exclusively to Cubism in all its manifestations and traveled to London, Berlin, Amsterdam, Vienna, Dresden, and Moscow, spreading its influence to a wide international audience. In this same year, several other factors—especially additional exhibitions in Paris (including the first presentation outside of Italy of Futurist painting, held at Galerie Bernheim-Jeune[5]) and other European centers, the release of several now-historic publications, and the support of Guillaume Apollinaire, who acted as Cubism's public champion—assured the indomitable strength of the movement. Apollinaire proclaimed that "the Cubists, no matter to which faction they belong, appear to all of us who are concerned with the future of art to be the most serious and interesting artists of our time."[6] ▬▬▬ Despite the growing recognition and internationalism of Analytic Cubism, its formal possibilities were narrowing rather than expanding, having reached the summit of a development that had begun in the 1890s with the work of Paul Cézanne. By late 1911, Braque and Picasso had each gone as far as possible in their analyses of both objects and space—so far that the

facing page:
30. Robert Delaunay
Simultaneous Windows (2nd Motif, 1st Part) |
Les Fenêtres simultanées (2ᵉ motif, 1ʳᵉ partie), 1912

fracturing and faceting of their subjects into small rectangular planes threatened to engulf the subject, presaging allover abstraction and undermining their commitment to Cubism as an art of representation. But it was precisely out of this environment of crisis in 1912 that innovations occurred; from here, the revolution that Cubism had sparked quickly led in new directions—not only in France but also in Italy, the Netherlands, and Russia—that would have vast implications for twentieth-century art. Elsewhere that year, the more expressionistic manifestations of art in Germany and Austria were at an equally radical stage. ▬▬▬ It is no coincidence that some of the greatest masterpieces in the holdings of the Guggenheim date from 1911–13, but especially 1912. Works created in each of the major art centers—Moscow, Munich, and Paris—in and around 1912 by Braque, Robert Delaunay, Marcel Duchamp, Vasily Kandinsky, Fernand Léger, Kazimir Malevich, Mondrian, and Picasso, among others, provide ample evidence of the richness and complexity of this fertile period.

Imagine the exhilaration that Mondrian must have felt upon settling in the French capital in January 1912, the year that Seuphor described as "an incomparable theater for the exhibition of innovations in a climate which knew no extremes."[7] As Roger Shattuck points out in *The Banquet Years*, a cultural history of the emergence of the avant-garde in France from 1885 to World War I, this climate was in large part fostered by the interchange and dissemination of ideas in the cafés, which in the 1860s and 1870s had been the unofficial headquarters of the Impressionists. By the end of the century, the café ritual became not only a factor in stimulating the creation of art but also a source of its iconography. This atmosphere of communal activity, in which "painters, writers, and musicians lived and worked together and tried their hands at each other's arts in an atmosphere of perpetual collaboration,"[8] carried forward into the prewar years, when the heart of artistic activity moved to Picasso's Montmartre studio in the Bateau-Lavoir. ▬▬▬ Although Picasso and Braque were an essential part of this creative esprit de corps, frequenting galleries and museums and mixing with a wide circle of writers, painters, and sculptors, the two nonetheless shared a particular self-sufficiency that isolated them from the artistic community as a whole. They rarely took part in any of the Salons or other group exhibitions. In fact, until late in 1912 neither had much contact even with the other Cubists, who for the most part lived across the Seine on the Left Bank as well as in the suburbs of Paris. Artists and writers met to formulate and promote their ideas in the Puteaux studio of Jacques Villon on Sunday afternoons, at the Courbevoie studio of Albert Gleizes on Monday evenings, at many cafés, and at the Closerie des Lilas on the Boulevard Montparnasse, which was frequented by many of the most influential younger critics, including Apollinaire and André Salmon. The circle of Frenchmen Gleizes, Henri Le Fauconnier, Léger, Jean Metzinger, and Villon was soon widened to include Roger de La Fresnaye, Marie Laurencin, Francis Picabia, Villon's two brothers, Marcel Duchamp and Raymond Duchamp-Villon, as well as the Ukrainian Alexander Archipenko, the Spaniard Juan Gris, and the Czech František Kupka. ▬▬▬ Appropriate to the spreading

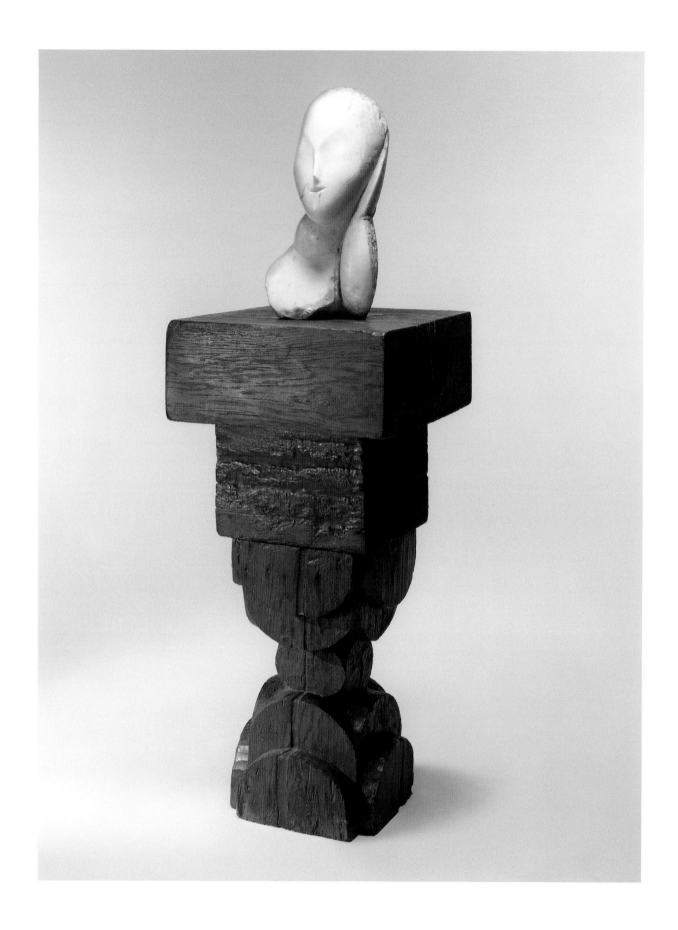

32. Constantin Brancusi
Muse | La Muse, 1912
shown on: *Oak Base*, 1920

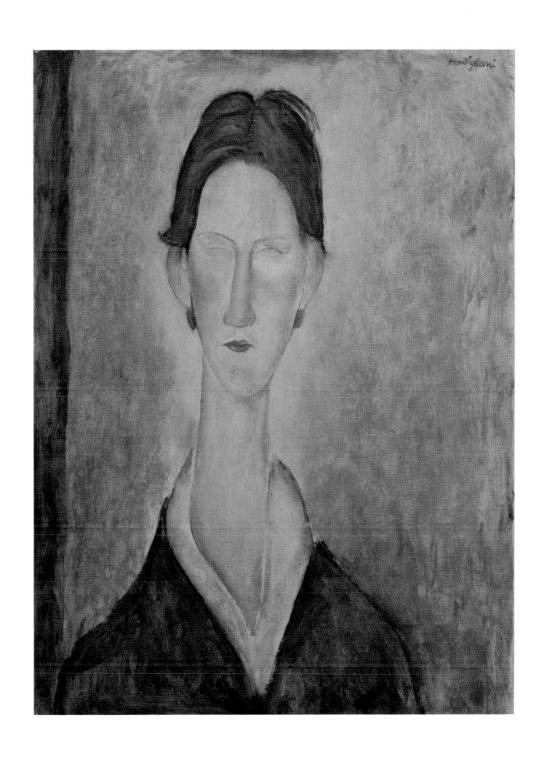

33. Amedeo Modigliani
Portrait of a Student | *L'Étudiant*, ca. 1918–19

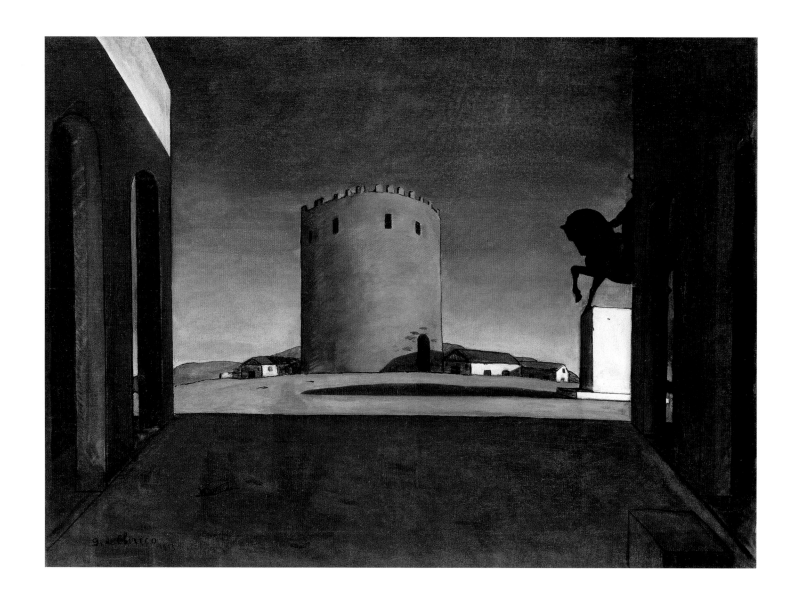

34. Giorgio de Chirico
The Red Tower | La Tour rouge, 1913

facing page:
35. Giorgio de Chirico
The Nostalgia of the Poet | La Nostalgie du poète, 1914

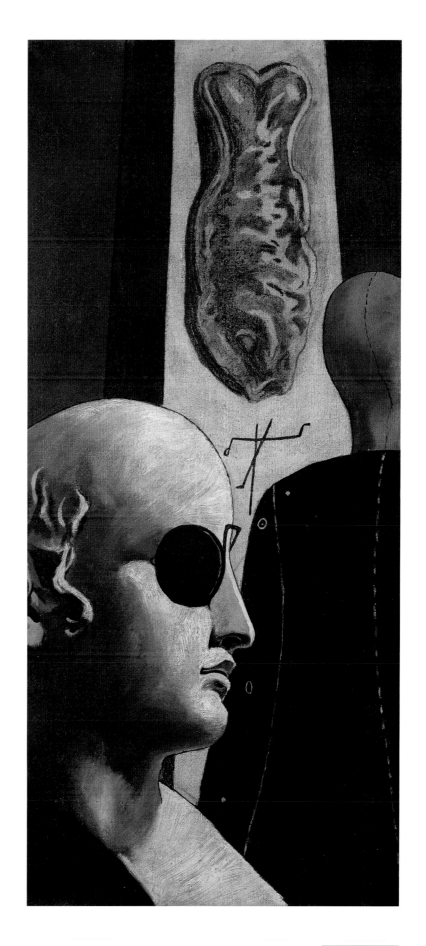

internationalism of the period, it was Apollinaire—born in Rome to a Swiss-Italian father and Polish-Italian mother—who became the most enthusiastic supporter of the new French art. His "magnetism, his all-embracing enthusiasm, his very ubiquity in prewar Paris made him beyond a doubt the main impresario of the avant-garde,"[9] as well as the most respected poet/critic of his generation. Responsible for introducing Braque and Picasso in 1907, Apollinaire organized the first coherent group presentation of Cubism (the famous "Salle 41" at the 1911 Salon des Indépendants), established a liaison between the Montmartre and Puteaux Cubists, baptized Delaunay's art as "Orphism," and in turn became its principal advocate.[10] Among the many artists attending Apollinaire's weekly gatherings were the Romanian Constantin Brancusi and the Italian Amedeo Modigliani, who became friends while both were living in Montparnasse. Another regular visitor, and another Italian, was Giorgio de Chirico, whose *The Red Tower* (1913, plate 34) and *The Nostalgia of the Poet* (1914, plate 35) are among the works he painted as a resident of Paris during 1911–15.

▬▬▬ As a critic for the Paris daily *L'Intransigeant* from 1910 to 1914, Apollinaire reported on the Salons and gallery shows in his column "La Vie artistique" during these formative years of modern art. In 1912, he became the principal editor of the newly founded magazine *Les Soirées de Paris* and joined a new journal, *Montjoie!*, when it was established the following year. Some of his foremost articles on Cubism appeared in these important periodicals prior to the 1913 publication of his book *Les Peintres cubistes: Méditations esthétiques*, which, along with Salmon's 1912 *La Jeune Peinture française*, pressed the notion of the style as a conceptual and intellectual one as opposed to the physical and sensory basis of Impressionism. ▬▬▬ Central to the discourse of the period was Cubism's relation to reality. Both Apollinaire and Salmon agreed that Cubism was an art of *representation* of a new reality, and that change, rather than permanence, was a vital element of this reality. They diverged, however, in that Apollinaire believed that this reality is not drawn from nature but from the transcendental truth that subsists beyond the scope of nature, with complete abstraction as the ultimate goal. Salmon, on the other hand, stressed the dynamic nature of reality, postulating that through intellect the Cubist artists could create a new and better reality that would be able to reflect change and progress in the world. ▬▬▬ The belief that change is a vital element of reality was an essential concept of philosopher Henri Bergson, who developed the concept of *la durée* ("the continuous progress of the past which gnaws into the future and which swells as it advances"[11]) to express his notion of the continuous flux of time. He wrote, "The universe *endures*. The more we study the nature of time, the more we shall comprehend that duration means invention, the creation of forms, the continual elaboration of the absolutely new."[12] His ideas became the common property of critics such as Salmon and his avant-garde contemporaries, who found Bergson's approach to a reality in which the past was captured in present experience to be of great significance to the formulation of and a rationale for new pictorial and literary modes. In the words of Apollinaire, "The painter must encompass in one glance the past, the present, the future."[13] ▬▬▬ At the meetings of the Puteaux group, conversations centered on the latest ideas in the realms of not

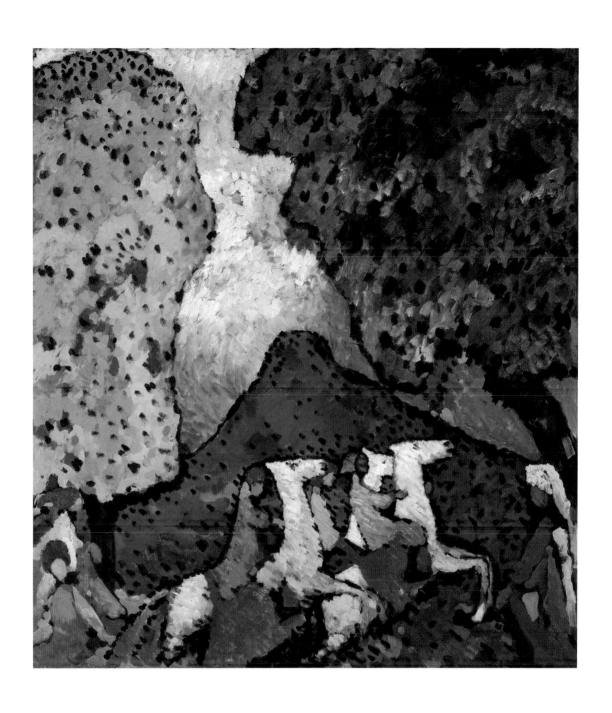

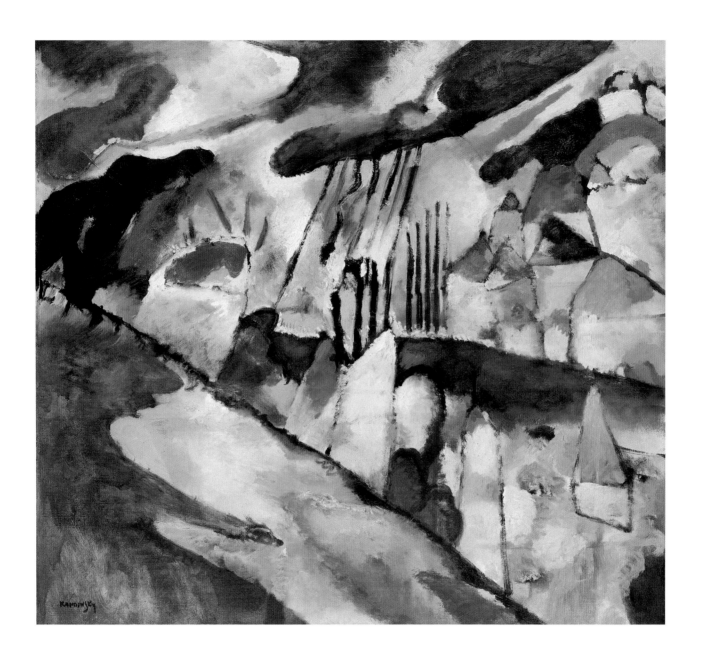

37. Vasily Kandinsky
Landscape with Rain | *Landschaft mit Regen*, January 1913

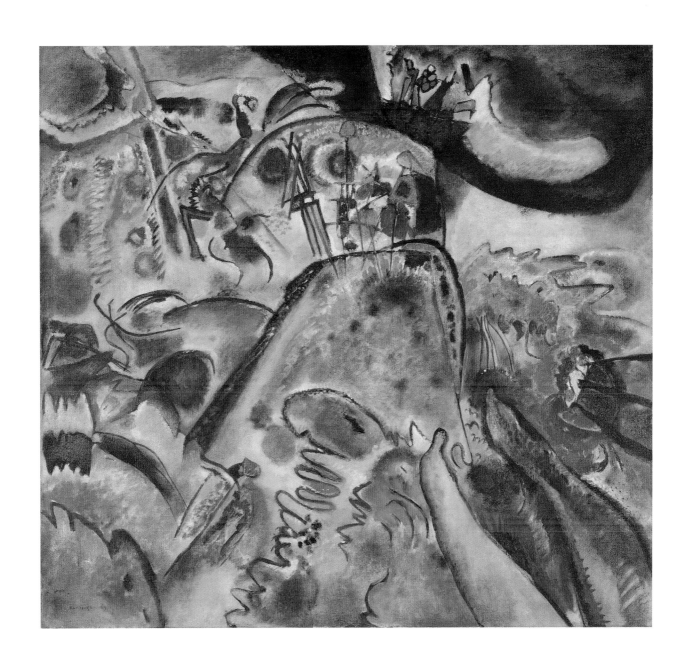

only philosophy but of music, literature, politics, psychology, mathematics, and science, and on the analogies among these fields. It should be understood that many artists and critics who were intoxicated by the dynamic concept of the artist's role as creator of a new reality would not come to any common understanding about this reality despite the accelerated exchange of ideas in the fervid intellectual climate of 1912. Rather, the interpretations of new theories were to a great degree superficial, motivated principally by an attempt to establish an a priori basis for an art that they considered intellectual. The paintings of the Cubists were not about changing the world; rather, they were the visualizations of these changes. Ultimately, Cubism is best understood as a formal development founded on empirical process, not theoretical principle. ▬▬▬ Yet public controversy generated by Cubism's radicalism prompted others in addition to Apollinaire and Salmon to publish a wide range of articles and books to explain and defend the variety of styles within the movement. Many of the artists themselves—Gleizes and Metzinger most saliently in their important volume *Du cubisme*, published in Paris in December 1912—attempted to provide a theoretical basis for the movement, while the emergence of two other influential types of publications, the aesthetic manifesto in Italy and Russia and the almanac in Germany, also gave credence to the theoretical underpinnings of modernist tenets. Futurism was initially conceived as a literary concept; the first Futurist manifesto, written by F. T. Marinetti, was published in 1909 in the Paris newspaper *Le Figaro*. In 1910, a second manifesto laid the foundations of Futurism's visual expression, and manifestos of sculpture, music, noise, photography, theater, architecture, cinema, and politics proliferated in the next few years.[14] In Moscow in 1912, David Burliuk and his contemporaries issued their own manifesto, in which poets were encouraged to create new words from archaic word forms and fragments. Entitled *A Slap in the Face of Public Taste*, the book also included the first important Russian essay on Cubism. ▬▬▬ Drawing on the work of the Symbolists and linking often extreme emotional sentiments with images derived from the visible world, German and Austrian artists were creating works characterized by violent, unnatural colors. In December 1911, Kandinsky and Franz Marc were among the artists who formed Der Blaue Reiter after resigning from the Neue Künstlervereinigung München (NKVM). The group's first exhibition, held that month at Heinrich Thannhauser's Moderne Galerie in Munich, also included, at Kandinsky's solicitation, the work of Delaunay and Henri Rousseau. The show traveled to Cologne, Berlin (where Walden added works by Alexei Jawlensky and Paul Klee), Bremen, Hagen, and Frankfurt. The second exhibition, in 1912, again featured an international roster, including Braque, Delaunay, Natalia Goncharova, Klee, Mikhail Larionov, Malevich, and Picasso. Edited by Kandinsky and Marc, the almanac *Der Blaue Reiter* was published in 1912—only a few months after Kandinsky's *Über das Geistige in der Kunst*[15]—as a showcase for the latest art from Paris, Moscow, Berlin, and Milan, as well as a forum for the arts in different mediums and from different periods and cultures. The almanac and Kandinsky's treatise articulated the search for a common spiritual basis in the arts. ▬▬▬ By 1912, Delaunay had been visited in his Paris studio by Klee, August Macke, and Marc. Klee returned to Berlin deeply impressed by what he had seen; his

Flower Bed (plate 43) of the next year reveals the influence of Cubism and Delaunay in its allover pattern of faceted forms and brilliant coloration. Marc later described Delaunay's *Window* paintings to Kandinsky as "pure tonal fugues"[16] and was himself influenced by the superimposed zones of transparent colors, adapting this technique in works such as *Stables* (1913, plate 41) to express the spirituality and harmony of the cosmos in his pantheistic vision of nature. ▬▬ Many other links between major cities were established by artists, critics, dealers, and collectors during this period, so that national borders were transcended in an atmosphere of exchange and collaboration. In 1912, Delaunay exhibited at the Moderner Bund in Zurich along with Jean Arp, Klee, Kandinsky, Marc, and Henri Matisse. Gino Severini, who lived in Paris, was an important liaison with his Futurist compatriots in Rome, Milan, and Turin. The interchange of artistic influence was also broadened by certain individuals who were instrumental in bringing the most advanced art of their time to their homelands. Among them were the painter and critic Conrad Kickert, whose Moderne Kunstkring in Amsterdam held annual art exhibitions of avant-garde French painting; Herwarth Walden, founder of the avant-garde Berlin gallery Der Sturm, where German Expressionism was shown alongside School of Paris works, and the eponymous journal, in which Futurist manifestos were published concurrently with Kandinsky's writings and a translation of Apollinaire's *Les Peintres cubistes*; and the Muscovite collectors Ivan Morozov and Sergei Shchukin, who bought seminal examples of the latest French painting.

One key to understanding this period of tremendous creativity and mutual inspiration on an international scale is the concept of simultaneity, which was new in the period.[17] In its broadest definition, simultaneity became a central theme, as well as a formal and structural principle, for some of the greatest creators of the time. Simultaneity was at once a concept, a theory, an experience, a style of painting and literature, a method of musical composition, an aesthetic system, a temporal event, and a spatial event. As Virginia Spate explains in her study of Orphism, simultaneity was an attempt to embody a change of consciousness in response to a belief that sequential modes of thought and expression were inadequate to realize the fullness and complexity of modern urban life.[18] The Simultanists thus tried to represent a sense of the unity of all beings—the interrelatedness of all things, mental events, and feelings, which might be widely separated in time and space but were brought together by the mind. ▬▬ The development of the concept of simultaneity was stimulated by the impact of the technical revolution, whose advances in the realms of communication (telephone, telegraph, and cinema) and transportation (automobile and airplane) literally transformed perceptions about time and space and made a reality of the simultaneity of experience.[19] The Eiffel Tower—itself a feat of modern engineering used for radio transmission—was a soaring testimony to modernity and was celebrated by artists such as Delaunay, Marc Chagall, the Futurists, and poets Apollinaire and Blaise Cendrars. As Stephen Kern writes in *The Culture of Time and Space 1880–1918*, "The present was no longer limited to one event in one place, sandwiched tightly

39. Franz Marc
White Bull | Stier, 1911

40. Franz Marc
Yellow Cow | Gelbe Kuh, 1911

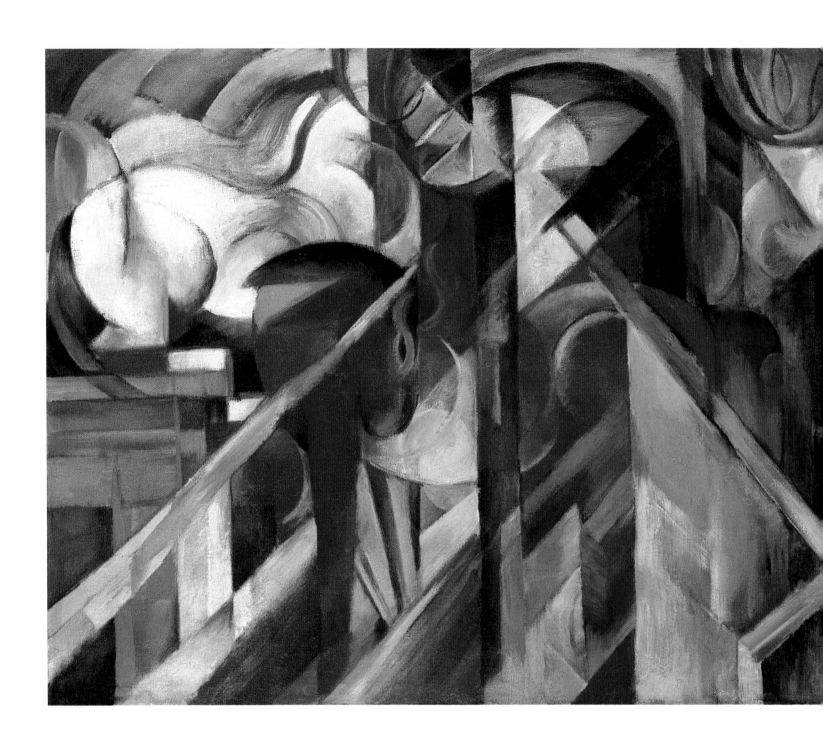

41. Franz Marc
Stables | Stallungen, 1913

42. Franz Marc
Broken Forms | Zerbrochene Formen, 1914

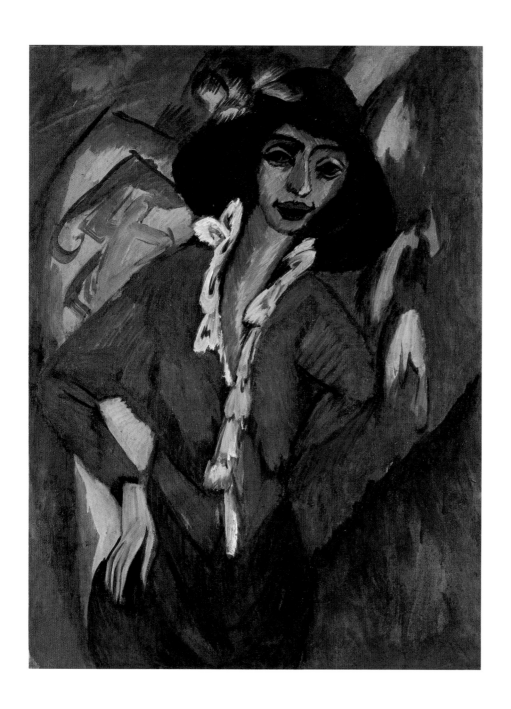

44. Ernst Ludwig Kirchner
Gerda, Half-Length Portrait | Frauenkopf, Gerda, 1914

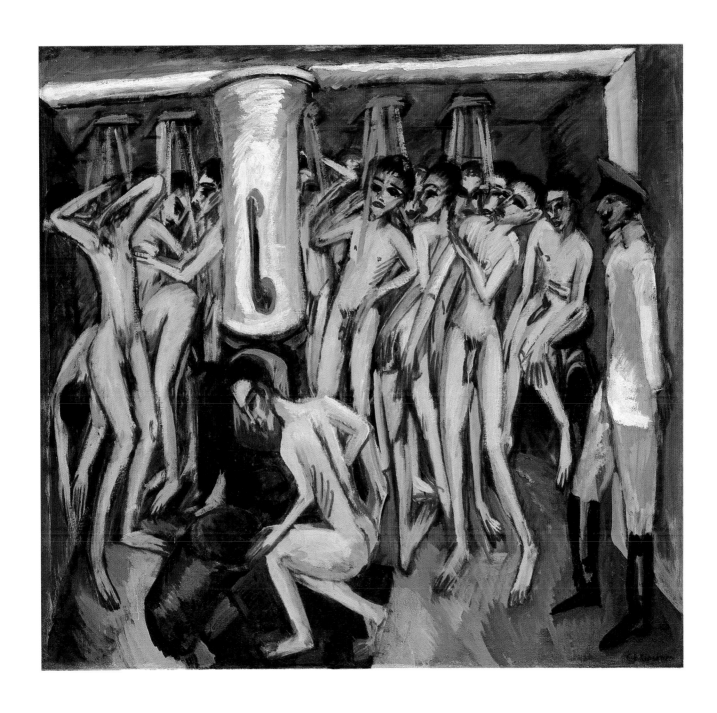

45. Ernst Ludwig Kirchner
Artillerymen | Das Soldatenbad, 1915

between past and future and limited to local surroundings. In an age of intrusive electronic communication 'now' became an extended interval of time that could, indeed must, include events around the world."[20] ▬▬ The manifold developments in the various arts of the period nourished each other as well. One of the most important models for simultaneous art and poetry was found in opera when, for example, two or more voices sing separate lyrics at once, or in musical counterpoint, where different melodies play concurrently. Composers such as Béla Bartók, Claude Debussy, and Richard Strauss created simultaneities involving music in completely different tonalities, and American composer Charles Ives even experimented with sections of the orchestra playing to different tempos at the same time.[21] ▬▬ In poetry, Apollinaire, Henri-Martin Barzun, and Cendrars each expressed simultaneity through different methods, exploiting the Cubist notion of fragmentation in terms of ruptured syntax and abrupt juxtapositions. In 1912 and 1913, Apollinaire wrote poems such as "Zone" and "Liens," in which distant places and times are overlapped and woven together into present experience. Also in 1912, Barzun founded a journal to present his poems and his theory of simultaneity, and, in early 1913, Cendrars published the first "simultaneous" book, *La Prose du Transsibérien et de la Petite Jehanne de France*, a poem more than six feet long that was printed in varying colors and typography on an abstract colored background designed by Sonia Terk Delaunay. By 1914, Apollinaire was typographically arranging his *calligrammes* to create abstract patterns and simple graphic images; this exploitation of the visual and grammatical possibilities of poetry to reflect those ideas being explored in paint is reflective of the deep bond between artists and writers of this generation.[22] ▬▬ Perhaps one of the greatest models of simultaneity of the period is the Cubism of Braque and Picasso. Cubism embodied simultaneity in its juxtaposition of multiple views of an object in a single image, as if the artist has moved completely around his subject and reconstructed all of these views into one on the flat plane of the picture surface. Also prevalent in the masterful canvases of 1911 and 1912, the apogee of Analytic Cubism, is the tension established between the simultaneous plasticity of the subject and the flatness of the picture plane. In works such as *Accordionist* (summer 1911, plate 48), Picasso portrayed the figure faceted into small planes in order to define volume more vividly and at the same time to relate his subject more firmly to the flat picture plane. Plasticity emerged both from shading and from the rhythms created by the abutment of adjacent flat paint marks. In order to keep his depicted objects anchored to the picture plane, he also fractured the backgrounds into small planes, and confined his palette to small touches of muted colors such as ochers, browns, and grays that blurred—but did not obliterate—distinctions of form and setting. By 1912, Picasso's figures were barely decipherable within his compositions of fragmented rectilinear and curvilinear forms, leading to conclusions that would open a new chapter in the evolution of Cubism. ▬▬ In such works as *Paris Through the Window* (1913, plate 50), Chagall accounts not only for that which is seen but also for that which is remembered or associated through physical or psychological relation. The simultaneous indoor and outdoor views in the flattened picture space, the two-headed man who looks in two directions at once, and the Chagallian

device of the composite figure—here a human-faced cat—speak of discontinuity and coexistence. Chagall moved to Paris in 1910, and there he was closely associated with Robert Delaunay and Apollinaire. Apollinaire described Chagall's Cubist-influenced works of 1911–13, in which he joined together elements of his Russian-Jewish heritage with more specifically French references, as *surnaturel* in their temporal and spatial relationships. ▬▬▬ Perhaps the most prominent application of simultaneity in painting is in the work of Delaunay, who evolved a style of painting that he called *Simultanisme* and claimed was a "new aesthetic system representative of our epoch."[23] Two of Delaunay's most important subjects prior to 1912 were the Eiffel Tower (such as plate 56) and the city, both favorite literary and artistic symbols for simultaneous experience in their embodiment of the dynamism of modern life. In his *La Ville* paintings of 1911–12 (for example, plate 57), Delaunay treated each canvas primarily as a vehicle for experiments in constructive color. He introduced in them checkerboard zones of color applied with a pointillist brushstroke, as well as semitransparent planes of pure color that would become the hallmark of his next major stylistic advance. ▬▬▬ In April 1912, around the time of Klee's visit to Delaunay on Kandinsky's recommendation, Delaunay—whose first solo exhibition had been held in Paris in February and March—embarked on a new series of *Window* paintings. These works were groundbreaking for their unprecedented emphasis on color suffused with light as the sole means of pictorial construction. Delaunay based his experiments on the work of color theorist Michel-Eugène Chevreul, who, in *De la loi des contrastes simultanées des couleurs* (1839), outlined a system that became fundamental to Georges Seurat (see plates 52–54) and his colleagues. Delaunay focused in these paintings on the simultaneous interaction of juxtaposed colors. "At this time, I had ideas about a kind of painting which would exist only through color—chromatic contrasts developing in temporal sequence yet simultaneously visible. I borrowed Chevreul's scientific term: 'simultaneous contrasts.'"[24] ▬▬▬ *Simultaneous Windows (2nd Motif, 1st Part)* (1912, plate 30) is one of Delaunay's twenty-two versions of this theme. Echoing the multipaned structure of windows, the artist fuses inside and outside in a continuum of color planes. Rhythmically alternating between opaque and transparent, light and dark, the zones of color are meant to be perceived simultaneously and as such create both the image and space of these compositions. Although one can discern vestiges of the triangular form of the Eiffel Tower in *Simultaneous Windows (2nd Motif, 1st Part)*, these works are not meant to be descriptive or symbolic of the natural world. Instead, they are about pure optical experience. In Delaunay's words, "I have dared to create an architecture of color, and have hoped to realize the impulses, the state of a dynamic poetry while remaining completely within the painterly medium, free from all literature, from all descriptive anecdote."[25] ▬▬▬ Delaunay proposed a dynamic art because light, in its constant movement and change, produces color shapes. Conversely, he believed that certain combinations of colors, in harmonic contrast with one another, can reproduce this movement of light. The viewer would then apprehend the direct pictorial effect of color and light in a single instant, as a single experience, simultaneously. ▬▬▬ The Puteaux circle, supported by the writings of Gleizes

and Metzinger, were bound in their theory and practice to seek a "dynamism of form" in contrast to the more static compositions of Braque and Picasso. Léger's works demonstrate a close affinity to Delaunay's dynamic interpretation of Cubism; he, too, shared the similar goal of creating an autonomous picture structure. ▬▬▬ In a densely structured, important transitional work, *The Smokers* (December 1911–January 1912, plate 58), Léger adopts Delaunay's device of the picture plane as a window looking out onto the cityscape, in which multiple viewpoints of figure and setting, foreground and background, are deeply interpenetrated. Interpretations vary as to whether Léger is representing two figures or two different phases of movement of a single figure, but in spite of the ambiguity the effect of movement is obvious, reinforced by the ascension of sculptural billows of smoke. The painting reveals further similarities to Delaunay's *Eiffel Towers* in its predominant vertical axis. In the *Contrast of Forms* series (for example, plate 59), begun in the latter half of 1912, Léger for the first time eliminates the distinction between representational and nonrepresentational in favor of an active surface pattern of contrasting circular and geometric shapes. Though verging on abstraction, the hierarchical arrangement of forms still contains vague suggestions of external references. ▬▬▬ At a lecture held in conjunction with the Section d'Or exhibition, Apollinaire coined the term Orphism to describe the works of Delaunay, Duchamp, Léger, and Picabia, all of whom he claimed were moving toward "pure painting."[26] Encouraged by requests from Kandinsky, Delaunay accompanied his new pictorial experiments with two theoretical essays written between the summer and fall of 1912, "Light" ("La Lumière") and "Note on the Construction of the Reality of Pure Painting" ("Note sur la construction de la réalité de la peinture pure"). The former was sent to Klee, who translated it and published it in *Der Sturm*, while the latter was edited by Apollinaire for the December issue of *Les Soirées de Paris*. "Note on the Construction of the Reality of Pure Painting" drew heavily on Leonardo's treatises, providing the theoretical basis for Delaunay's abstraction as well as the source for Apollinaire's own ideas on Orphism and pictorial simultaneity. This is only one instance in which Delaunay and Apollinaire found mutual inspiration in each other's work. Delaunay's essays manifest strong poetic affinities to Apollinaire in form and style, whereas Apollinaire wrote one of his most renowned poems, "Windows" ("Les Fenêtres"), based on Delaunay's paintings of that theme. Apollinaire's poem ends with these lines: "Oh Paris / From red to green all the yellow languishes / Paris Vancouver Hyères Maintenon New York and the Antilles / The window is opening like an orange / The beautiful fruit of light."[27] ▬▬▬ The search for a pictorial expression of simultaneity was perhaps best realized by the Futurists, who extended the notion temporally so that successive stages of movement were seen simultaneously, or so that successions of events were collapsed into a single image. Celebrating the machine, the city, and the speed, force, and energy of modern life in a burgeoning industrial age, the Futurists used what they called "force-lines" to depict the trajectory created by the movement of an object, of light, or of sound, or even the way an object would decompose according to the tendencies of its forces. They revealed the essential dynamic sensation of being, for example, in works such as Giacomo Balla's

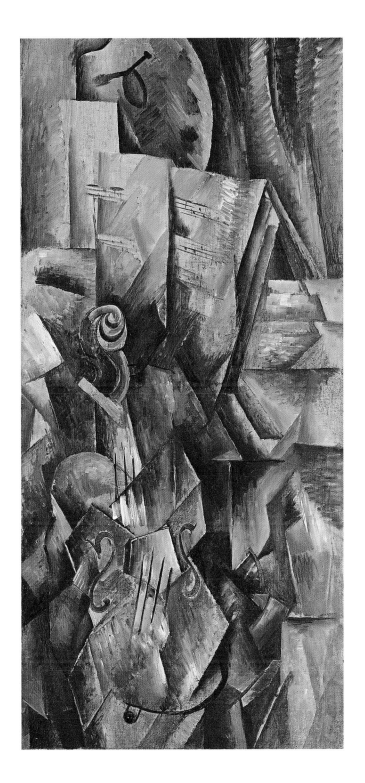

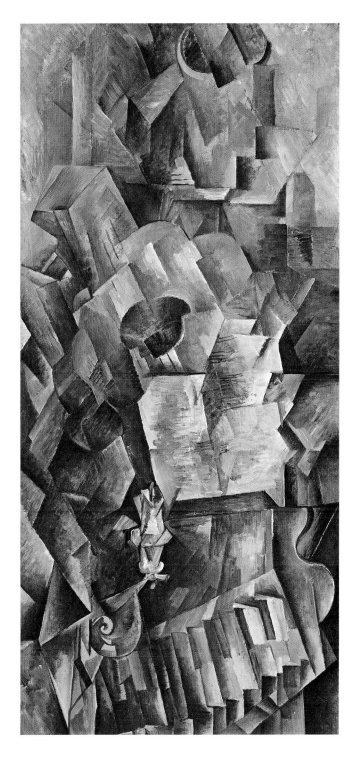

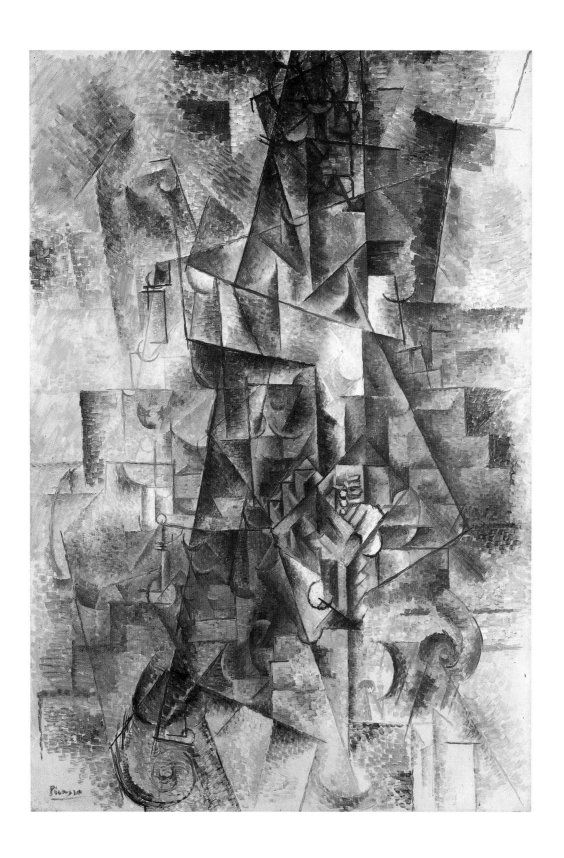

48. Pablo Picasso
Accordionist | *L'Accordéoniste*, Céret, summer 1911

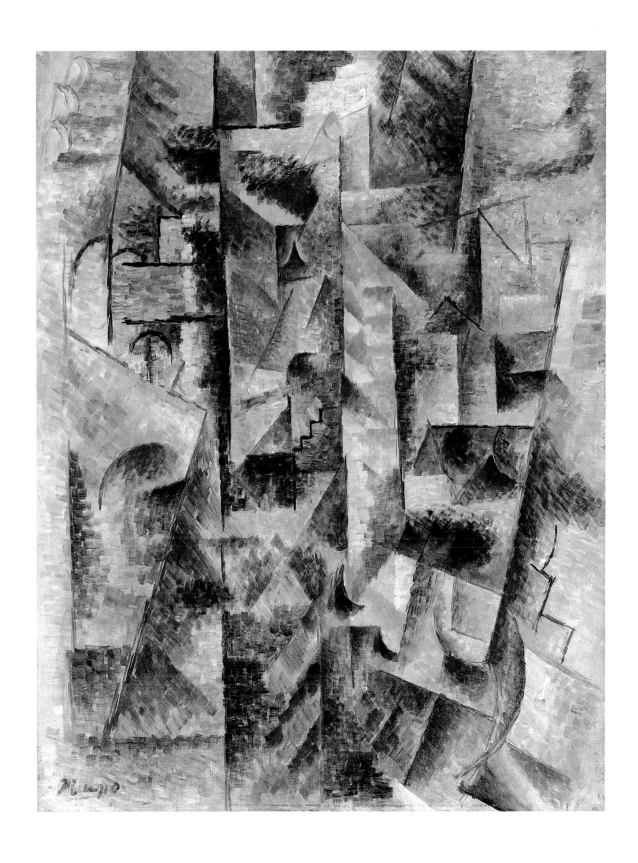

49. Pablo Picasso
Landscape at Céret | Paysage de Céret, summer 1911

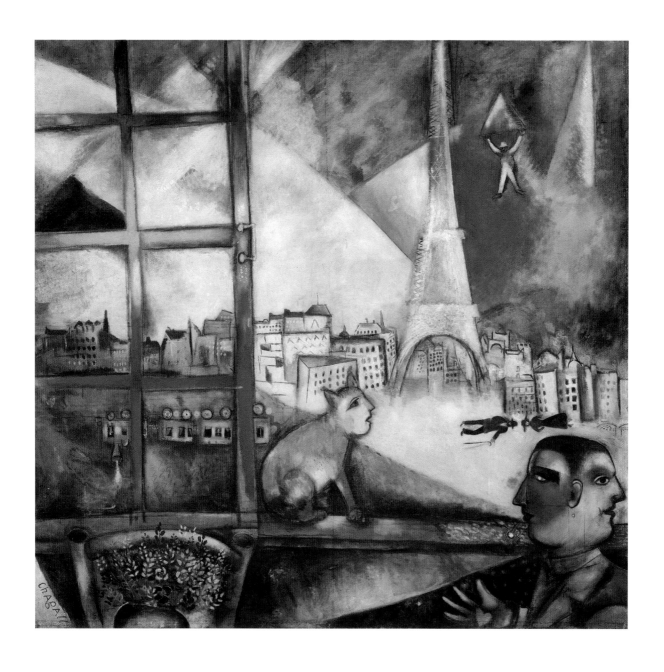

50. Marc Chagall
Paris Through the Window | Paris par la fenêtre, 1913

facing page:
51. Marc Chagall
Green Violinist | Violiniste, 1923–24

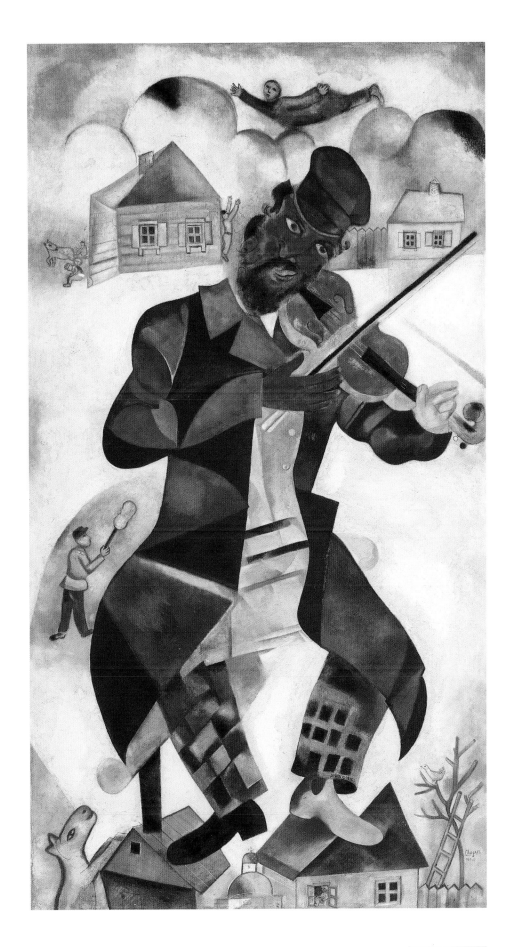

Abstract Speed + Sound (1913–14, fig. 40), a brightly colored composition on the theme of a speeding racing car. ▬▬▬ One of the most explicit articulations of Futurist principles and the concept of simultaneity was espoused by Umberto Boccioni in his introduction to the 1912 Futurist exhibition catalogue at Galerie Bernheim-Jeune in Paris: "The simultaneousness of states of mind in the work of art: that is the intoxicating aim of our art.... In order to make the spectator live in the center of the picture, as we express it in our manifesto, the picture must be the synthesis of what one remembers and of what one sees."[28] This exhibition included Boccioni's fellow Milanese artists Carlo

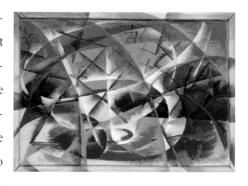

Carrà and Luigi Russolo as well as resident Parisian Severini. ▬▬▬ Delaunay strenuously objected to what the Futurists called "the painting of states of mind," fueling an existing polemic between the Cubists and their Italian counterparts. Drawing inspiration from Bergson, Delaunay emphasized the dynamic fluxing quality of existence, which could be portrayed through the simultaneity of contrasting colors on a painting's surface. The Futurists upheld a somewhat different interpretation of Bergson, emphasizing how the mind gathers together diverse experiences, merging successive memories of past and present events and phenomena. The debate did not end there, however. The Futurists, in seeking to repudiate the political ineffectuality of earlier art, lambasted the classicism and "obstinate attachment to the past" of the French artists, while Apollinaire, stubbornly upholding a nationalism that persisted despite the melting pot that Paris had become, proclaimed Futurism an awkward Italian imitation of Fauvism and Cubism. ▬▬▬ Like the Futurists, Duchamp had been involved since the previous year with portraying successive images of a figure in motion, culminating in his controversial *Nude Descending a Staircase (No. 2)* (1912, fig. 41), which he withdrew from the Salon des Indépendants after members of the hanging committee objected to its title.[29] In two important studies, including *Nude (Study), Sad Young Man on a Train* (1911–12, plate 60),[30] Duchamp encompasses both the forward motion of the train and that of the figure itself (identified by Duchamp as a self-portrait). On the surface, the work seems to borrow elements from Analytic Cubism, Futurism, and chronophotography. However, in a later interview, Duchamp minimized the relationship to Futurism, stating that "my interest in painting the *Nude* [*Descending a Staircase (No. 2)*] was closer to the Cubists' interest in decomposing forms than to the Futurists' interest in suggesting movement, or even to Delaunay's Simultanist suggestions of it. My aim was a static representation of movement—a static composition of indications of various positions taken by a form in movement—with no attempt to give cinema effects through painting."[31] The work's perceived radicalism was also due to the fact that the nude had been excluded as a legitimate theme by the Cubists because it was not considered part of the iconography of modern life; in an ironic twist, Duchamp returns the nude to the liturgy in his own rejection of traditional subject matter. ▬▬▬ Apart from *Nude Descending a Staircase (No. 2)*, 1912 was a pivotal year in Duchamp's career, in particular because he abandoned traditional painting thereafter in favor of more experimental art forms, including mechanical drawings and readymades.[32] He was, in 1912, an active participant in the Cubist circle around his brothers in Puteaux, and he visited the Futurist exhibition at

fig. 40 Giacomo Balla, *Abstract Speed + Sound | Velocità astratta + rumore*, 1913–14. Oil on board, 54.5 x 76.5 cm, including artist's painted frame. Peggy Guggenheim Collection, Venice 76.2553.31

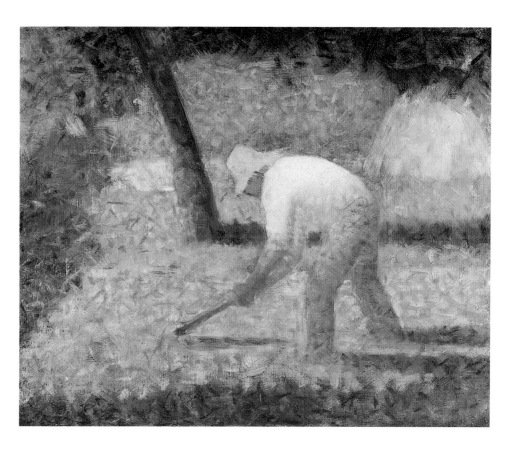

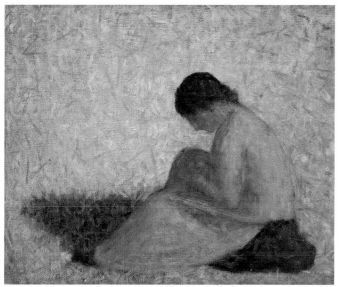

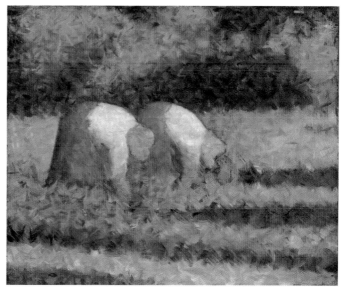

52. Georges Seurat
Peasant with Hoe | Paysan à la houe, 1882

53. Georges Seurat
Peasant Woman Seated in the Grass | Paysanne assise dans l'herbe, 1883

54. Georges Seurat
Farm Women at Work | Paysannes au travail, 1882–83

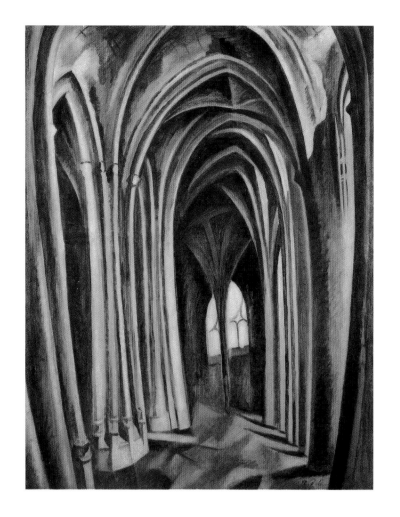 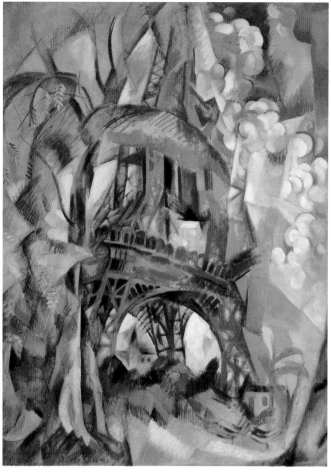

55. Robert Delaunay
Saint-Séverin No. 3, 1909–10

56. Robert Delaunay
Eiffel Tower with Trees | *Tour Eiffel aux arbres*, summer 1910

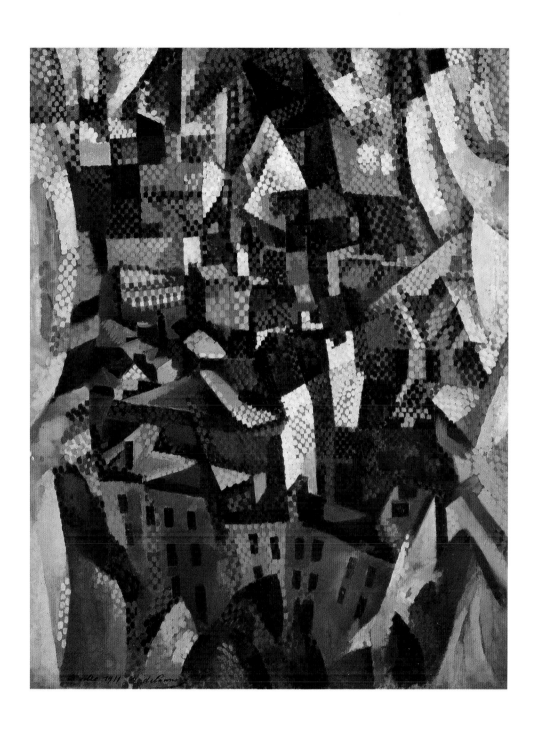

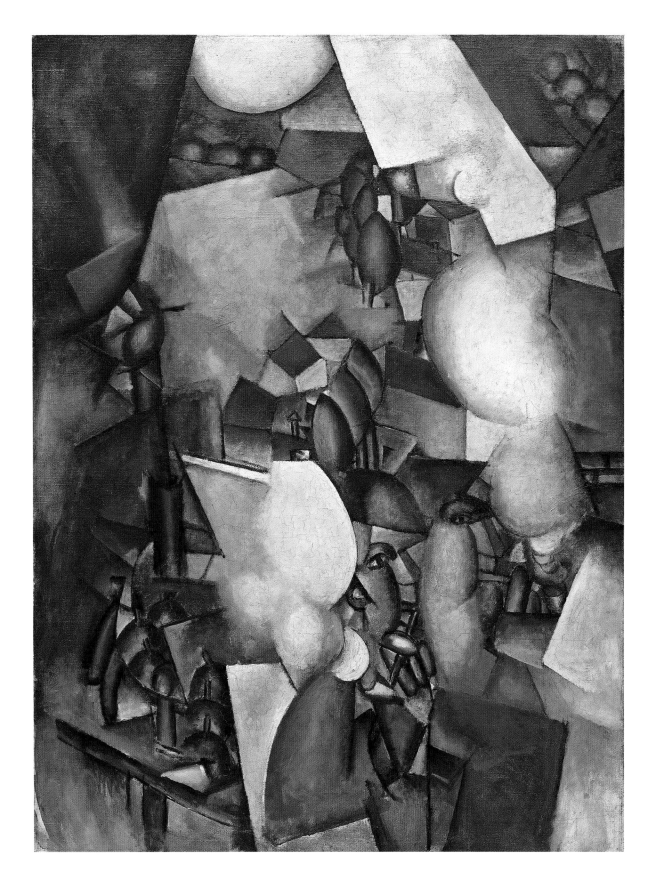

58. Fernand Léger
The Smokers | Les Fumeurs, December 1911–January 1912

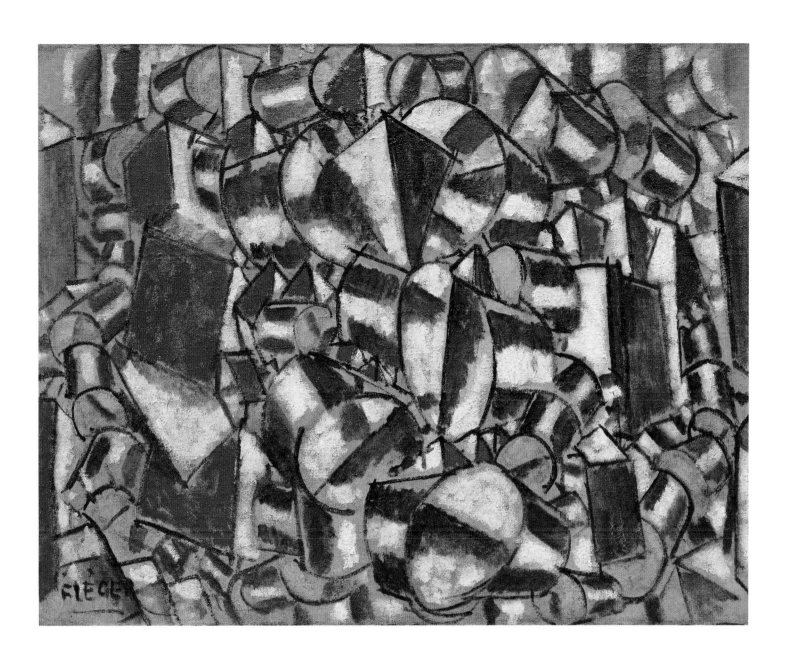

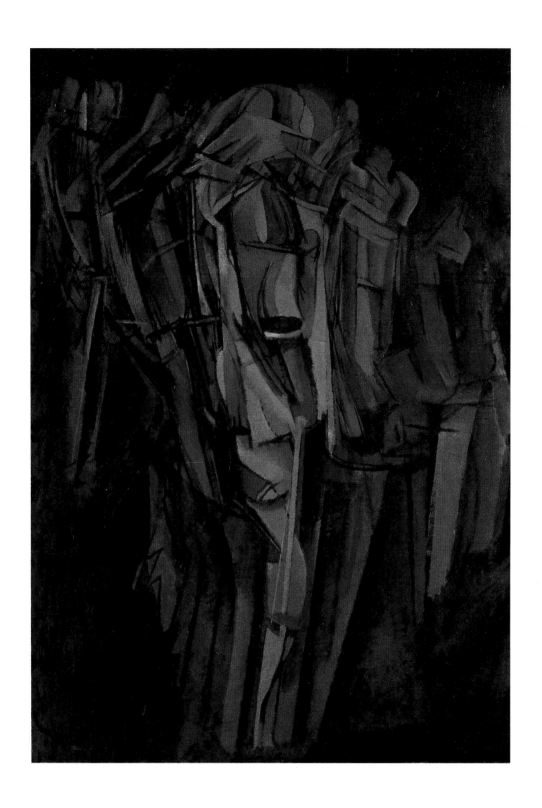

60. Marcel Duchamp
Nude (Study), Sad Young Man on a Train | Nu (esquisse), jeune homme triste dans un train, 1911–12

Galerie Bernheim-Jeune on several occasions. However, neither Cubism nor Futurism were ultimately extreme enough for Duchamp, who wanted "to get away from the physical aspect of painting" and "to put painting once again at the service of the mind."[33] His early association with Picabia also dates from this period, and the challenging stance they took anticipated the official founding of Dada in 1916. ▬▬▬ The Dada movement would have been unthinkable without the invention of collage in 1912. While 1912 marked the end of a long evolutionary phase of Cubism, it was also the year that ushered in a critical new phase of the Cubist aesthetic, which would culminate in the development of Synthetic Cubism. The first appearance of collage in Picasso's oeuvre was *Still Life with Chair Caning* (fig. 42), executed in May of that year. In September, Braque glued imitation wood-grain wallpaper to his drawings, thus creating the first papiers collés. ▬▬▬ Braque's *The Clarinet* (summer–autumn 1912, fig. 43), is the Guggenheim work that best exemplifies several of the tremendous innovations of this transitional stage of Cubism. Most salient among these is the use of the trompe-l'oeil technique of painted imitation wood graining. In addition, the stenciled lettering, oval format, and the incorporation of sand into the paint are all devices that subtly define spatial relationships. In this painting, the picture plane is noticeably shallower than the densely penetrated space of Braque's canvases of the previous year. The compositional planes also fall into a roughly parallel alignment with the picture plane, suggesting the new order and simplification that would emerge in Synthetic Cubism's spatially compressed, flat, and unmodulated shapes and areas of bright color. ▬▬▬ The iconography, much of which is still tied to the artist's atelier, is made even more explicit by the inclusion of typography. The painted letters are neither in front of nor behind the illusionistic surface; rather, their position serves to define the actual two-dimensional picture plane. They exist as elements in and of themselves, not subject to pictorial distortion. And beyond that, the letters serve an associative value, providing clues to the reconstruction of the subject of the painting. Braque's and Picasso's practice of incorporating lettering or words into their works conveys a touch of the personal, humorous, or even political, importing a new level of reality to their canvases. Similarly, the inclusion of tangible elements of everyday reality onto the surface of the canvases—scraps of newspaper, tickets, labels, and cigarette wrappers—also made specific references to the period and, in particular, to events of popular culture. The invention of collage in 1912, and its further development by Braque brought the artists a step closer to the idea of integral instead of disintegrated forms. The use of *passage*, one of the hallmarks of Analytic Cubism, gave way to contrast. A breakdown in sculptural illusion gave way to an increase in sculptural presence. It is indeed one of the seemingly contradictory implications of collage that it immediately led in two directions—to the flattened space of Synthetic Cubist painting and to relief sculpture. ▬▬▬ Breaking with the monolithic tradition of carved or modeled sculpture, Picasso advanced the notion of collage into relief in his cardboard, string, and wire *Guitar* (now in the collection of the Museum of Modern Art, New York) sometime in the spring of 1912.[34] This construction was not predicated on a volumetric conception, but rather on the juxtaposition of almost entirely flat metal

shapes, with varying degrees of shallow space between them. ━━━ Although it was a short-lived phenomenon, planar sculpture was variously interpreted by artists in France, Italy, and Russia. Drawing on Picasso's achievement, those artists all employed a simple vocabulary of geometric forms and a means of describing volume through intersecting planes. Their work, drawing on everyday rather than precious materials, was rough at the edges, almost makeshift, and not meant to endure. ━━━ In Paris, the sculptures of Duchamp-Villon and the mixed-media constructions of Archipenko (for example, *Médrano II*, 1913–14, fig. 44), Henri Laurens, and Jacques Lipchitz reflected the impact of Cubism. And in Milan, Boccioni—whose *Manifesto tecnico della scultura futurista* was published on April 11, 1912—began to make sculptures in 1912. True to the precepts he espoused, such works as *Dynamism of a Speeding Horse + Houses* (1914–15, fig. 45) consist of a medley of incongruous elements, which he used in his attempts to make his extension of objects into space "palpable, systematic, and plastic," because "no one can any longer believe that an object ends where another begins."[35] The Futurists found in the collages and constructions of Picasso the means by which to express their belief in the ideas of the modern world, and in this respect so did the artists of the Russian avant-garde. In 1913, after having seen Picasso's work in Paris, Vladimir Tatlin began to make his first abstract painterly reliefs in Moscow out of metal, glass, and wood, pushing to its logical extreme the idea of Cubist collage. Duchamp-Villon's work culminated in *The Horse* (1914, fig. 46), which was influenced by Futurism as well as Cubism.

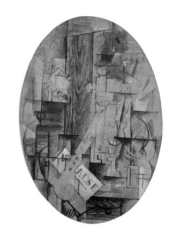

A dizzying succession of events in 1912 would herald an equally momentous year in 1913. But for the continuation of this story, one must look beyond Paris. Whereas Seuphor recognized that "1912 is the most Parisian moment in painting," developments in other capitals were equally significant and revolutionary in the movements they provoked. As we have seen, 1912 in Paris represented both an apogee and a crisis point—perhaps the most drastic consequence being the development of collage, which opened to artists everywhere a wide range of aesthetic strategies that changed the course of art in the twentieth century. The year 1912 in Munich and Moscow represents an equally significant turning point, the eve of an all-important breakthrough to abstraction, the consequences of which would also be revolutionary for the art of this century. While the orientation toward non-objective art was a rather widespread and simultaneous development in several countries, many of its first manifestations appeared outside of Paris in 1913. ━━━ To return to the notion of simultaneity, one need only look at a particular month, specifically March 1912, when three exhibitions were held that testify both to the radicalism of the moment and the rich cross-fertilization of the arts. These exhibitions—the Salon des Indépendants in Paris, the showing of Der Blaue Reiter in Munich, and the showing of the Donkey's Tail in Moscow—shared a number of common contributors of all nationalities.[36] Yet they demonstrate the different types of pictorial revolutions that arose out of the social and political climates from which they were born. ━━━ In Moscow, the Donkey's Tail was a group of artists whose mission it was to declare an independent Russian school to

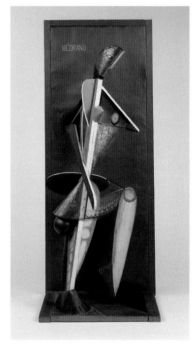

fig. 43 Georges Braque, *The Clarinet | La Clarinette*, summer–fall 1912. Oil with sand on oval canvas, 91.4 x 64.5 cm. Peggy Guggenheim Collection, Venice 76.2553.7

fig. 44 Alexander Archipenko, *Médrano II*, 1913–14. Painted tin, wood, glass, and painted oilcloth, 126.6 x 51.5 x 31.7 cm, Solomon R. Guggenheim Museum, New York 56.1445

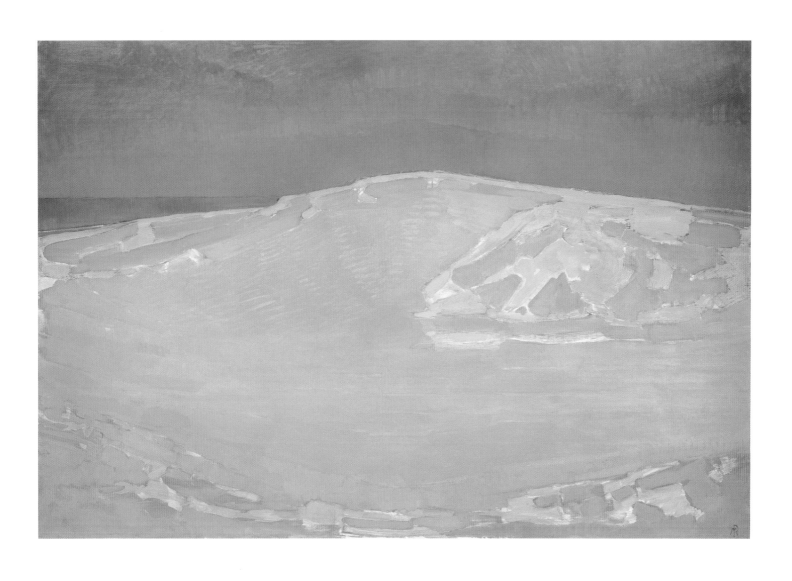

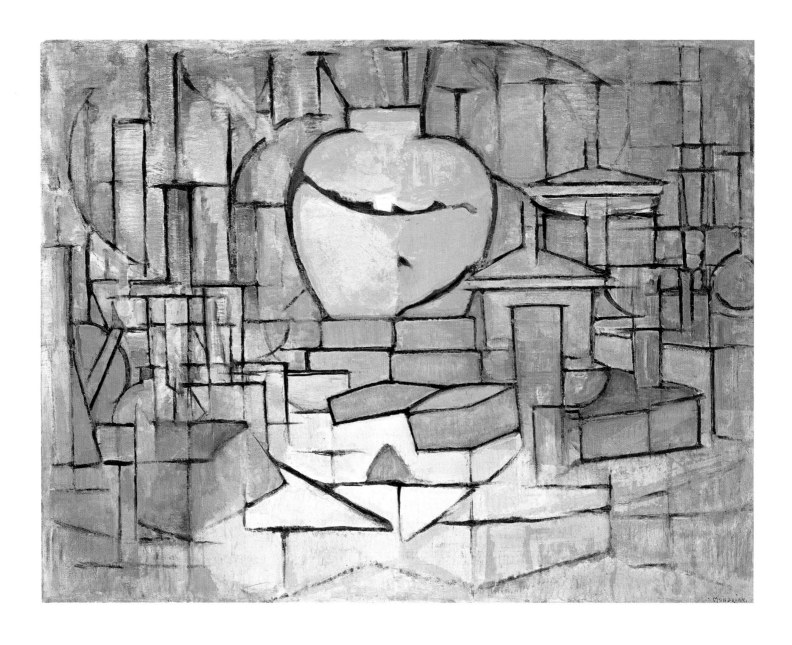

62. Piet Mondrian
Still Life with Gingerpot II | Stilleven met gemberpot II, 1912.
Oil on canvas, 91.5 x 120 cm. Solomon R. Guggenheim
Museum, New York L294.76. © 2006 Mondrian/Holtzman
Trust c/o HCR International, Warrenton, VA, USA

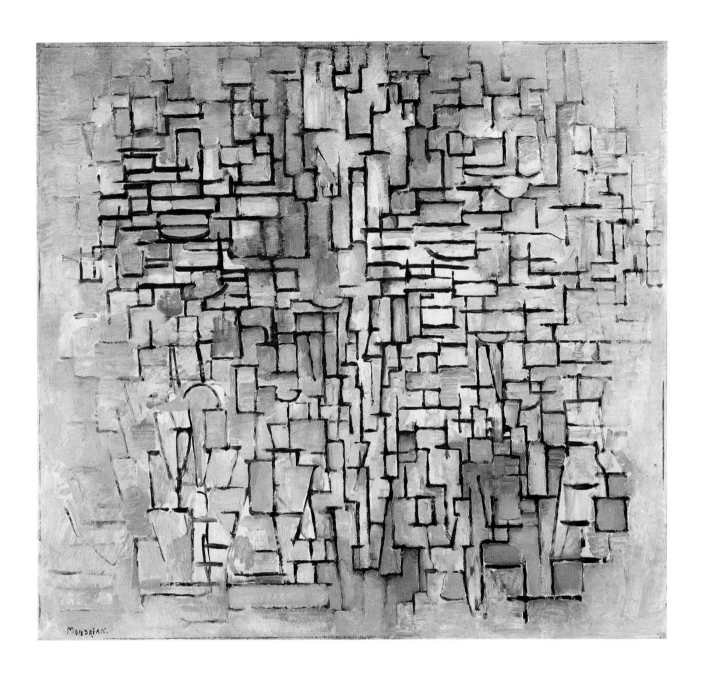

displace the European dominance in avant-garde art. The association was formed in reaction to the Jack of Diamonds exhibitions, which first took place in 1910 (bringing together contemporary works by French, German, and Russian artists, such as Gleizes and Le Fauconnier, Kandinsky and Jawlensky, and Larionov and Goncharova) and then in January 1912 (featuring works by Erich Heckel, Ernst Ludwig Kirchner, and Max Pechstein, and a larger contingent of Parisians, including Braque and Léger). Because of the prominence and attention given to French art, Larionov and Goncharova withdrew their entries from the second exhibition, and founded the Donkey's Tail, whose 1912 exhibition consisted of 307 works by themselves, Chagall, Malevich, Tatlin, and minor members of the Moscow avant-garde.[37] Similar to the furious storm of criticism unleashed against the Cubists in their first group showing—in Salle 41 of the 1911 Salon des Indépendants—the public reaction to this new art was one of intense indignation and derision. Many works were in fact censured and confiscated. ▬ Although the Russians assimilated the new artistic ideas advanced in Western Europe by the Cubists and Futurists, they also drew on traditional sources such as folk art and icon painting in order to create "a native modern idiom" to reflect the social, political, and aesthetic preoccupations of their age. Larionov's short-lived but important Rayist style of 1912–13 drew together elements of Impressionist depiction of light, Cubist fracturing, and Futurist lines of force. Like contemporaneous art movements, Rayism called for the depiction of simultaneous motion, of dynamism, and of the speed of the urban world. Yet in works such as *Glass* (1912, fig. 47) Larionov was especially focused on depicting the spatial forms that arose from the intersection of the reflected rays of different objects. ▬ Malevich's early works were also heavily influenced by those same Western European sources. His Cubo-Futurist style of 1912, typified by *Morning in the Village after Snowstorm* (fig. 48), recalls Léger's paintings of the period, which Malevich could have known from an exhibition of work by the French master held in Moscow in February 1912, or through reproductions. But the geometricized images of peasants, depicted as solid, tubular figures set in the deep landscape space of a Russian village, and the non-naturalistic metallic color and light, are not yet completely disassociated from his Neo-Primitive style. ▬ "In 1913 [*sic*], trying desperately to liberate art from the ballast of the representational world, I sought refuge in the form of the square," Malevich recalled, referring to *Black Square* (1915, fig. 56), his radically abstract painting of a black square on a white ground.[38] So marked the beginnings of the stylistic and theoretical development of what became known in 1915 as Suprematism, a pure abstract formal language based on geometry, which sought to express a universal cosmic order. ▬ In this period, Kandinsky, too, strove to reach a point "at which the human state of being touches the more universal cosmic order."[39] He believed that the purpose of the highest art was to express inner truth, and that this could only be achieved by moving away from the representation of the objective world. The process that carried Kandinsky into the realm of the non-objective was a long and thoughtful one that he began in Murnau in 1908, and he reached his goal with the completion of his great *Improvisations* and *Compositions* between 1910 and the outbreak of

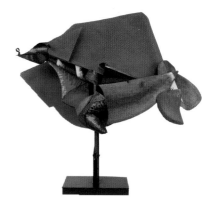

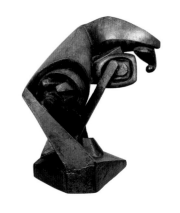

fig. 45 Umberto Boccioni, *Dynamism of a Speeding Horse + Houses | Dinamismo di un cavallo in corsa + case*, 1914–15. Gouache, oil, paper collage, wood, cardboard, copper, and coated iron, 112.9 x 115 cm. Peggy Guggenheim Collection, Venice 76.2553.30

fig. 46 Raymond Duchamp-Villon, *The Horse | Le Cheval*, 1914, cast ca. 1930. Bronze, 43.6 x 41 cm. Peggy Guggenheim Collection, Venice 76.2553.25

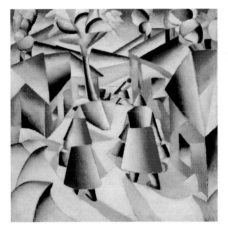

World War I. The year 1913 was for Kandinsky, as it was for Malevich, a period of breakthrough to truly non-objective painting, in which his theory of correspondences between emotional experience and the formal elements of colors, forms, lines, and sounds reached its true fruition. ▄▄▄ A discussion of the emergence of abstraction would not be complete without returning to Mondrian, who we left in Paris at the threshold of 1912. Like the artists of the Puteaux circle, Mondrian assimilated the language of Cubism and made of it a style that was singularly his own. Mondrian's predisposition to the principles of flatness, frontality, and geometric form were very much a part of his Dutch heritage. Unique to his engagement with Cubism, however, was his subversion from the outset of its sculptural qualities—its simultaneous oscillation between flatness and plasticity—which he saw as a residue of naturalism in Cubist practice. Two paintings in the Guggenheim's collection demonstrate the dramatic impact that Paris in 1912 had on his development. In *Still Life with Gingerpot I* (1911), a work that Mondrian began in the Netherlands and finished in Paris, objects that relate to his atelier are still identifiable, and light and shading are naturalistic. In remaining securely attached to external reality, the painting is traditional in appearance; indeed, its iconography relates it to seventeenth-century Dutch still lifes. However, Mondrian has begun to cautiously organize his composition in a manner that approaches Cubist practice. In the second version, *Still Life with Gingerpot II* (1912, plate 62)—painted when he had become firmly entrenched in the Parisian scene—the sense of volume and the realistic scale of objects, as well as the local functions of contour and structure seen in the first version, are gone. The focus on the linear structure of the composition is greatly intensified: around the now truncated shape of the ginger pot, Mondrian has built a schematic network of predominantly straight lines in which the strictly balanced horizontals and verticals dominate. ▄▄▄ Although Mondrian undermined sculptural tendencies and distilled the horizontal and vertical components of his subject matter in this important work of 1912, his first strides in the development out of Cubism and toward a truly nonrepresentational art began in the following year, for example, in *Tableau No. 2/Composition No. VII* (plate 63), and continued into 1914. It is in his *Pier and Ocean* series, begun in 1914 after Mondrian returned to the Netherlands, that all objective references have been obliterated and all curved and diagonal lines banished. Using short fragments of lines spread at fairly regular intervals across the canvas, Mondrian has in essence abstracted the Cubist grid and has made it alone the subject of the picture. ▄▄▄ Apollinaire is the only major critic who wrote specifically about Mondrian's work during this period. In his review of the 1913 Salon des Indépendants, he acknowledges the new direction that Mondrian had taken: "Mondrian, an offshoot of the Cubists [Picasso and Braque], is certainly not their imitator."[40] Apollinaire is prescient in recognizing the profound scope of these advances at the moment they were occurring. What we see even more clearly now by studying the simultaneity of artistic phenomena in the pivotal year of 1912 is that this was indeed not a period marked by imitation but rather a moment of collaboration, interchange, synthesis, and, above all, radical innovation at every turn.

NOTES

1. Michel Seuphor, *Piet Mondrian: Life and Work* (New York: Harry N. Abrams, 1956), p. 93.

2. Mondrian was invited to Paris by Conrad Kickert in December 1911, arrived in January 1912, and established his permanent residence there in May of that year.

3. Seuphor, p. 96.

4. The *28e Société des artistes indépendants* was held at the Quai d'Orsay from March 20 to May 16. The Salon de la Section d'Or was held at the Galerie de la Boëtie (64 bis, rue La Boëtie) from October 10 to 30. The Salon d'Octobre was held from October 1 to November 8.

5. *Les Peintres futuristes italiens* was held at Galerie Bernheim-Jeune (15, rue Richepance) from February 5 to 24. It had an enormous impact on artists such as Marcel Duchamp and Fernand Léger. It subsequently traveled to the Sackville Gallery, London, Galerie Der Sturm, Berlin, and Galerie Georges Girous, Brussels.

6. This quote appeared in the first and only issue of the journal *La Section d'Or*, which accompanied the exhibition.

7. Roger Shattuck, *The Banquet Years: The Origins of the Avant-Garde in France, 1885 to World War I* (New York: Vintage Books, Random House, 1958; rev. ed., 1967), p. 28.

8. Ibid.

9. Leroy C. Breunig, "Introduction," in Breunig, ed., *Apollinaire on Art: Essays and Reviews 1902–1918 by Guillaume Apollinaire* (New York: Viking Press, 1972; Da Capo Press, 1988), p. xvii.

10. Shattuck, p. 280.

11. Stephen Kern, *The Culture of Time and Space 1880–1918* (Cambridge: Harvard University Press, 1983), p. 43.

12. Christopher Gray, *Cubist Aesthetic Theories* (Baltimore: Johns Hopkins University Press, 1953), p. 69.

13. Kern, p. 85.

14. Max Kozloff, *Cubism/Futurism* (New York: Charterhouse, 1973), p. 121.

15. *Über das Geistige in der Kunst* was first published by Piper of Munich in December 1911, although it was dated 1912. The second edition was published in Munich in April 1912. See *Kandinsky in Munich: 1896–1914*, exh. cat. (New York: Solomon R. Guggenheim Museum, 1982), p. 305.

16. Klaus Lankheit, *Unteilbares Sein, Aquarelle und Zeichnungen von Franz Marc* (Cologne: M. DuMont, 1959), p. 19. Quoted in Gustav Vriesen and Max Imdahl, *Robert Delaunay: Light and Color*, trans. Maria Pelikan (New York: Harry N. Abrams, 1969), p. 50.

17. There are three excellent and important discussions of simultaneity in this period, to which many of the ideas here are indebted. They are in Kern, Shattuck, and Virginia Spate, *Orphism: The Evolution of Non-Figurative Painting in Paris 1910–1914* (New York: Oxford University Press, 1978; Oxford: Clarendon Press, 1979).

18. Ibid., p. 20.

19. Shattuck, p. 314.

20. Kern, p. 314.

21. Ibid., p. 75.

22. James Joyce's *Ulysses* (1922) has been recognized as the work that perhaps best epitomizes the expression of simultaneity in literature, particularly as it applies to sequential time. In abandoning causal sequence in favor of a synchronicity of events in time and space, Joyce invites the reader to entertain concurrently and without synthesis various contradictory propositions and events, improvising film "montage techniques to show the simultaneous action of Dublin as a whole, not a history of the city but a slice of it out of time, spatially extended and embodying its entire past in a vast expanded present." Kern, p. 77.

23. Robert Delaunay, *Du cubisme à l'art abstrait*, ed. Pierre Francastel (Paris: S.E.V.E.P.N., 1957). Translated from the French by the author.

24. Robert Delaunay in his notebook, 1912, quoted in François de la Tourette, *Robert Delaunay* (Paris: C. Massin & Cie., 1950), p. 17.

25. Delaunay, *Du cubisme à l'art abstrait*, p. 98, quoted in Vriesen and Imdahl, p. 42.

26. Although much has been written about the emergence of abstraction in the works of Delaunay and the Orphists, Spate is very clear in making the distinction that "pure painting" did not necessarily mean nonrepresentational painting. Rather, it signified a type of painting that had its own internally coherent structure independent of naturalistic structural devices. See Spate, pp. 160–61.

27. Excerpted in Francis Steegmuller, *Apollinaire, Poet among the Painters* (New York: Farrar, Straus and Company, 1963), p. 241.

28. Quoted in Herschel B. Chipp, *Theories of Modern Art: A Source Book by Artists and Critics* (Berkeley: University of California Press, 1968), pp. 295–96. Boccioni's triptych *States of Mind* (1911–12), which was shown in the Bernheim-Jeune show in Paris, synthesizes the principles elucidated in this manifesto.

29. Duchamp recalled: "On the day before the opening Gleizes asked my brothers to go and ask me at least to change the title because he thought, after conferring with Delaunay, Le Fauconnier, and Metzinger, that it was not Cubistic in their sense.... A nude never descends the stairs—a nude reclines, you know. Even their little revolutionary temple couldn't understand that a nude could be *descending* the stairs.... So I said nothing. I said all right, all right, and I took a taxi to the show and took my painting and took it away. So it never was shown at the Indépendants of 1912, although it's in the catalog." Quoted in William C. Seitz, "What's Happened to Art? ..." (interview with Duchamp), *Vogue*, Feb. 15, 1963, pp. 110–13, 129–31. Also quoted in Arturo Schwarz, *The Complete Works of Marcel Duchamp* (New York: Harry N. Abrams, 1969), p. 16.

30. Duchamp's *Nude (Study), Sad Young Man on a Train* is a complicated picture that raises manifold art-historical questions, not the least of which is its relationship to *Nude Descending a Staircase (No. 2)*, and whether it is a sketch, study, or a version thereof. Angelica Zander Rudenstine, in *Peggy Guggenheim Collection, Venice: The Solomon R. Guggenheim Foundation* (New York: Harry N. Abrams, 1985), accepts William Rubin's argument that *Nude (Study)* and another work, *Nude (No. 1)*, are two distinctly different studies or explorations of the problem of depicting motion. For a more detailed discussion of this debate, as well as other issues raised by this painting, see her analysis on pp. 261–68.

31. Marcel Duchamp, "Eleven Europeans in America," *The Museum of Modern Art Bulletin* 13, nos. 4–5 (1946), pp. 19–20. Quoted in Rudenstine, p. 263.

32. The year 1912 was also an important period of travel for Duchamp, who visited Barcelona on the occasion of an exhibition of his work there, and then Munich (where he painted *The Passage from the Virgin to the Bride* and *The Bride*), and finally Prague, Vienna, Dresden, and Berlin.

33. Schwarz, p. 18.

34. Recent scholarship has established that Picasso's papiers collés postdate his cardboard constructions. For a complete discussion of the dating of *Guitar*, see William Rubin, *Picasso and Braque: Pioneering Cubism*, exh. cat. (New York: Museum of Modern Art, 1989), pp. 30–32.

35. Quoted in Chipp, p. 300.

36. For instance, Maurice de Vlaminck and Delaunay exhibited in both the Salon des Indépendants and Der Blaue Reiter exhibition; Marc Chagall in the Salon des Indépendants and the Donkey's Tail exhibition; and Natalia Goncharova and Kazimir Malevich in the Donkey's Tail and Der Blaue Reiter exhibitions.

37. The Donkey's Tail exhibition opened in March at the Moscow College of Painting, Sculpture, and Architecture. Also, the second Jack of Diamonds exhibition opened in Moscow on January 12 and included works by Kandinsky, Braque, Delaunay, Léger, Picasso, Marc, Matisse, and Le Fauconnier.

38. Kazimir Malevich, "Suprematism," in *The Non-Objective World* (Chicago: Theobald, 1959), pp. 67–100, paraphrased in Chipp, p. 342. Although Malevich here recalls the creation of this painting as 1913, the dating is by no means certain, although it was definitely completed by December 1915, when it was shown in the *0.10* exhibition. Dmitrii Sarabianov states: "We do not know exactly when the first Suprematist paintings were painted, including the *Black Square*, although they were shown at the '0.10' exhibition in 1915. However, one can hardly assume that all of these works were painted on the eve of the exhibition, so the date for *Black Square* is not necessarily 1915, just as Malevich's own designation of the year 1913 cannot be considered definitive. On the other hand, the date is not so very important when compared with the revolution the *Black Square* brought about." Sarabianov, "Kazimir Malevich and His Art, 1900–1930," in *Kazimir Malevich*, exh. cat. (Leningrad: Russian Museum, 1988), p. 70.

39. Paul Vogt, "The *Blaue Reiter*," in *Expressionism: A German Intuition 1905–1920*, exh. cat. (New York: Solomon R. Guggenheim Foundation, 1980), p. 197.

40. Quoted in Breunig, p. 289.

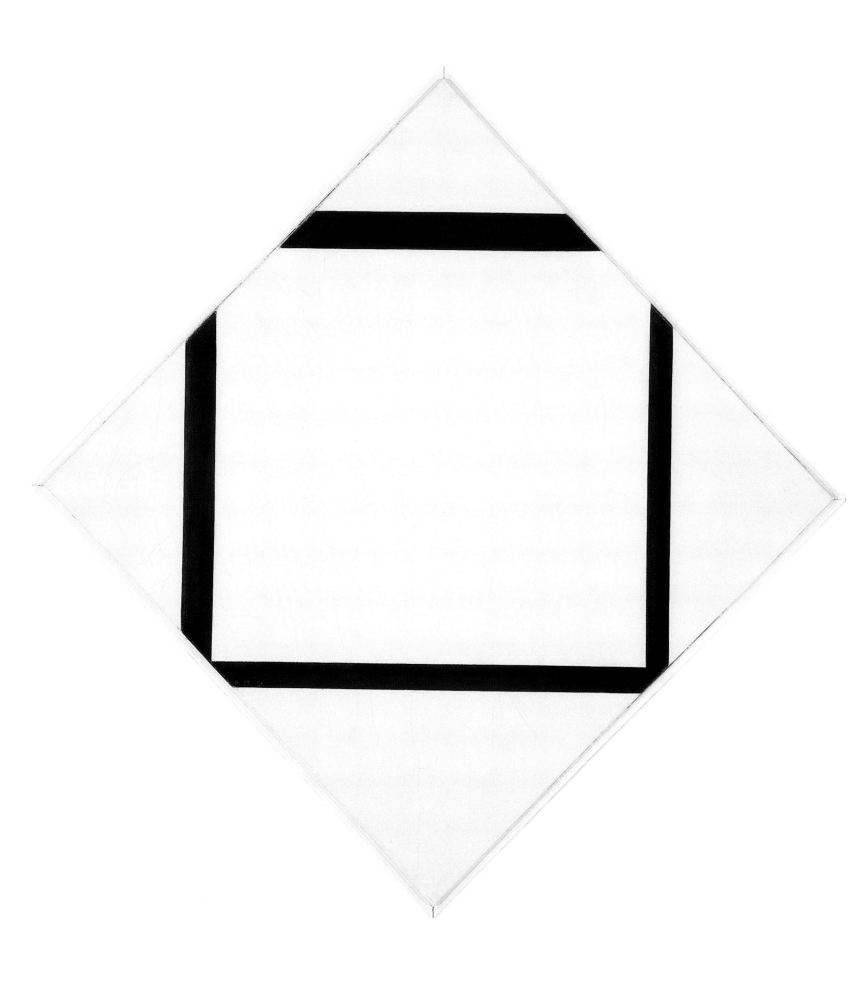

MICHAEL GOVAN

Technology and the Spirit:
The Invention of Non-Objective Art

"Non-Objectivity will be the religion of the future," wrote Hilla Rebay in 1937, the year the Solomon R. Guggenheim Foundation was chartered. "Very soon the nations on earth will turn to it in thought and feeling and develop such intuitive powers which lead them to harmony."[1] Rebay, the artist and adviser who assembled Guggenheim's collection of modern art, had a zealous faith in the power of non-objective painting to transcend the boundaries of language and experience. She encouraged her patron to establish a museum unlike any other. In contrast to the Museum of Modern Art, founded contemporaneously in New York under the direction of the erudite Alfred H. Barr, Jr. as an encyclopedic history of the modern movement, Guggenheim's museum was based on an idea: the spiritually redemptive power of abstract painting. ▬▬▬ With Rebay as its first director, the Museum of Non-Objective Painting, as the Guggenheim was then called, opened in 1939 in a former automobile showroom on East Fifty-fourth Street in Manhattan. To heighten the lofty effect of the paintings, Rebay placed them in oversized frames and hung them low to the plush-carpeted floors on velour-curtained walls. The music of Bach and Beethoven was piped into the galleries through a modern sound system, accompanied by the scent of incense. ▬▬▬ Rebay had an even more all-enveloping experience of art and environment in mind when, in 1943, she commissioned Frank Lloyd Wright to design a permanent building for the museum, one that would be "a temple to non-objectivity."[2] Wright's design—a single cantilevered spiral ramp encircling a one-hundred-foot-tall atrium beneath a broad skylighted dome—offered a metaphor for the abstract mysteries of nature and the cosmos. The building's famous inverted ziggurat structure, which the architect described as "pure optimism,"[3] has become emblematic of the utopian ideals espoused by Rebay and Guggenheim. ▬▬▬ Non-objective painting's most articulate proponent was Russian-born painter Vasily Kandinsky. His seminal treatise *Über das Geistige in der Kunst* (written in 1911) became a guiding light for Rebay. Guggenheim's collection grew to include over two hundred of Kandinsky's works; it also included several hundred by German painter Rudolf Bauer, a minor follower of Kandinsky who had an intimate and influential relationship with Rebay. ▬▬▬ The term *gegenstandslos* (literally "without object") was used in Kandinsky's writings and Bauer's many letters to Rebay. She translated it as "non-objective," and tried to popularize the use of the term.[4] Purely non-objective painting had a special distinction for Rebay, as it did for Kandinsky. It was only through the rejection of representation—the renunciation of any vestiges of the exterior material world—that painting could at once access the depth of inner life and the height of the heavenly cosmos, thus

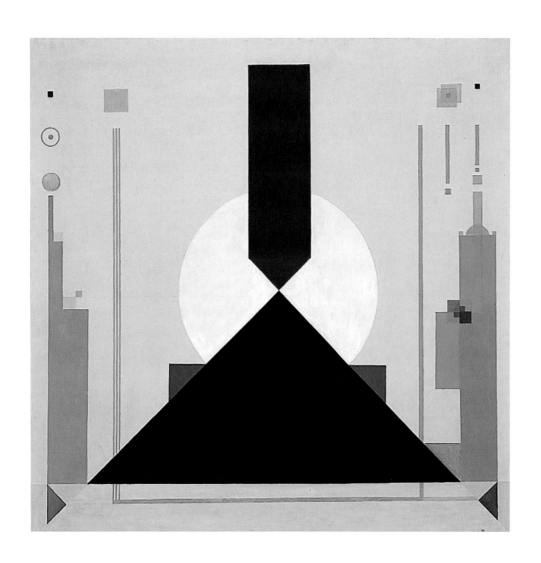

65. Rudolf Bauer
Blue Triangle, 1934

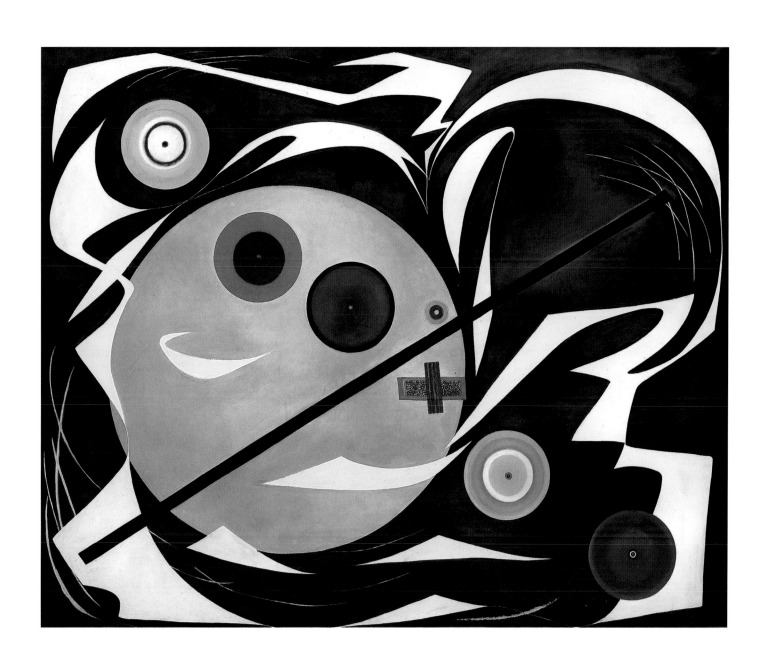

inspiring the joy of spiritual life. She wrote: "This is what these masterpieces in the quiet absolute purity can bring to all those who learn to feel their unearthly donation of rest, elevation, rhythm, balance, and beauty."[5] Rebay's dogma was pure. Sculpture was excluded from her canon because of its weighty and earthly character—however, she granted an exception to the work of Alexander Calder, whose hanging mobiles eschewed the ground and bases traditional to that medium.[6] ▬▬ Rebay's and Kandinsky's quasi-religious sensibilities may seem naïve to the contemporary reader. Yet they capture the ambition of many artists searching for a visual language that could transcend the volatile and challenging cultural environment they saw around them. Before abstraction, photography had threatened to render painting altogether obsolete; the Impressionists had already discarded the rules of representational perspective for a more direct rendering of natural phenomena; the Symbolists had emphasized the representation of an internal realm of emotions over that of a more accessible visible world; and, with their invention of Cubism, Georges Braque and Pablo Picasso (both of whom never came to embrace the idea of non-objective painting) had, almost unwittingly, opened a door to a world of visual imagery that had never before been seen. ▬▬ Around 1913, pure abstraction emerged and forever changed the course of art history. To study the moment of the invention of abstract painting is to see both the world and the artists' perception of it undergoing convulsions of mind and body. Modern painters distorted, fractured, rearranged, and recolored the picture surface until it reemerged—no longer a Renaissance window on reality, but a vision unto itself as an object of contemplation and psychological effect. ▬▬ Kandinsky's paintings of 1913 reveal a transition from the use of recognizable images to pure abstraction. For example, in *Painting with White Border* (plate 67) of May 1913, a central figure in a landscape is identifiable, while *Black Lines* (fig. 49), painted in December, eludes such decoding. Although *Black Lines* was long considered the earliest non-objective painting, no "first" abstract painting can be identified as a model. The roots of abstraction are as diverse as its manifestations. Non-objective painting emerged simultaneously in Moscow, Paris, and the Netherlands, in each place with a different character. At first, abstraction developed among the ranks of the avant-garde. By the 1920s, however, some of its proponents found themselves leading mainstream institutions. Kandinsky, Kazimir Malevich, and other leaders of the Russian avant-garde were placed in charge of schools intended to advance the ideals of the October Revolution. In the Netherlands, Piet Mondrian's theories were spread through the publications of the De Stijl group, whose members included Theo van Doesburg and Georges Vantongerloo. And in Germany, at the Bauhaus (founded by Walter Gropius in 1919), Kandinsky taught his theories of abstraction, as did Swiss painter Paul Klee, Hungarian artist László Moholy-Nagy, and other major proponents of the new style. Klee, however, used representational and abstract styles throughout his career (see plates 68–72). ▬▬ While some of abstract art's pioneers returned to figurative and representative styles by the late 1920s and early 1930s (most notably Malevich), and while non-objectivity could certainly not be characterized, as Rebay proposed, as "the religion of the future," the idea of non-objective art did become the most dominant

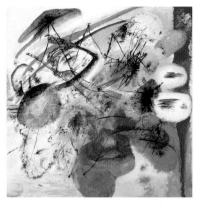

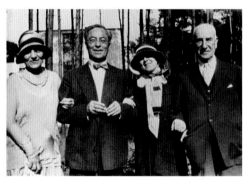

fig. 49 Vasily Kandinsky, *Black Lines | Schwarze Linien*, December 1913. Oil on canvas, 129.4 x 131.1 cm. Solomon R. Guggenheim Museum, New York, Gift, Solomon R. Guggenheim 37.241

fig. 50 Irene Guggenheim, Vasily Kandinsky, Hilla Rebay, and Solomon R. Guggenheim, 1930

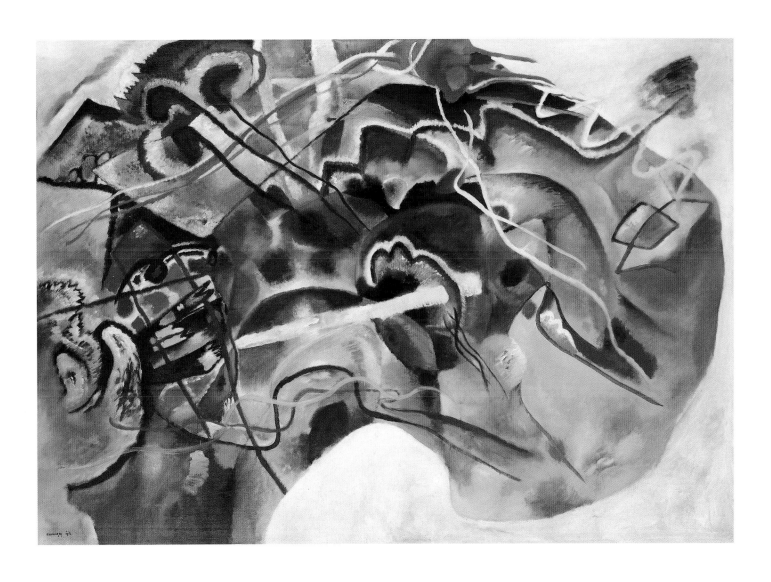

67. Vasily Kandinsky
Painting with White Border | Bild mit weissem Rand, May 1913

and innovative force in twentieth-century art. During and after World War II, many of abstraction's European champions, like the German Hans Hofmann, Mondrian, Moholy-Nagy, and the Russian brothers Antoine Pevsner and Naum Gabo, emigrated to the United States, where they influenced a new generation of artists. Encouraged by Rebay's and Guggenheim's crusade, as well as by exhibitions of European painting at the Museum of Modern Art and Peggy Guggenheim's Art of This Century gallery, the Europeans helped create an atmosphere in New York City that produced the Abstract Expressionists, whose work most directly launched a new chapter in non-objective art.

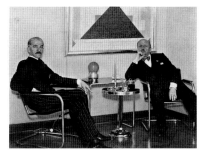

▬▬▬ Yet for all of its influence, little effort has been made by art historians to examine the invention of abstraction through an analysis of the unique cultural psychology of the early twentieth century. By the late-nineteenth century, the world had been turned upside down: the industrial revolution promised the greatest change in human life since the invention of agriculture; the theories of Friedrich Engels and Karl Marx suggested revolutionary social changes to follow suit; and Friedrich Nietzsche had pronounced God dead. The dramatic invention of abstract art—along with the utopian, spiritual, philosophical, and social theories that accompanied it—might be considered the single most revealing insight into the radical changes that shaped twentieth-century culture. Implicit in the leap from images representing natural appearance to images of a non-objective sort is a radical change in artists' philosophical understanding of the world around them. Why did these artists turn their eyes away from visible phenomena? What sparked that revolution in thinking? And what can be revealed about the fundamental character of the past century through an examination of the invention of non-objective art? ▬▬▬ Kandinsky's early writing, like that of many of his contemporaries, reveals the modernists' preoccupation with the uniqueness of their era and their responsibility as artists to reject models of the past—to invent a new vocabulary of forms to express their world view. Ironically, the search for new forms began not with an embrace of the aesthetic of the new industrial age, but rather with a kind of regression: Kandinsky wrote of being "in sympathy" spiritually "with the Primitives."[7] Much has been written about the influence around the turn of the century of "primitive" forms of art on the advent of modernism, especially in the work of Constantin Brancusi, Paul Gauguin, Henri Matisse, Picasso, the German Expressionists, and the Russian Neo-Primitivists. Brancusi's carved-wood sculptures (for example, plates 4 and 74) provide compelling testament to the inspiration "primitive" art played in reshaping the visual language of modern art. "Like ourselves," explained Kandinsky, the "primitives" "sought to express in their work only internal truths, renouncing in consequence all consideration of external form."[8] ▬▬▬ Kandinsky's turn *inward* was an essential step in the development of his non-objective painting; this direction was anticipated in the work of the Symbolist painters, like Gauguin, who separated fields of color from descriptive function to express an emotional presence beyond the representation of nature. According to Symbolist poet Gustave Kahn, writing in 1886, "the essential aim of our art is to objectify the subjective (the externalization of the Idea) instead of subjectifying the objective (nature seen through the eyes of a temperament). Thus we carry the analysis of the Self to the extreme, we

fig. 51 Rudolf Bauer and F. T. Marinetti at Bauer's private museum Das Geistreich, Berlin, 1930s; work shown: Bauer's *Blue Triangle* (1934, plate 65)

fig. 52 Hilla Rebay, 1935

let the multiplicity and intertwining of rhythm harmonize with the measure of the Idea."[9] As Gauguin had sought refuge in Tahiti from a dehumanized material world, Kandinsky sought inner life as an alternative to the "nightmare of materialism"[10] of the modern world. ▬▬ Mondrian, the Dutch pioneer of non-objective painting, shared Kandinsky's concern for an inner, and *abstract*, modern life. In more cerebral terms than Kandinsky, Mondrian described an abstract inner reality of mind: "Natural (external) things become more and more automatic, and we observe that our vital attention fastens more and more on internal things. The life of the truly modern man is neither purely materialistic nor purely emotional. It manifests itself rather as a more autonomous life of the human mind becoming conscious itself."[11] Mondrian, whose own non-objective art emerged around 1913, developed a systematic language of abstraction that has become, more than any other, synonymous with the reductivist aesthetic we associate with modernism. Constraining the elements of line and color to essential ingredients—black horizontal and vertical lines on a white ground bounding rectangular fields of the primary colors red, yellow, and blue—Mondrian sought to represent the essence of reality rather than its particular natural appearance: "To love things in reality is to love them profoundly; it is to see them as a microcosmos in the macrocosmos. *Only in this way can one achieve a universal expression of reality.* Precisely on account of its profound love for things, nonfigurative art does not aim at rendering them in their particular appearance."[12] ▬▬ Mondrian's search for pure essential forms might be likened to Plato's parable of the cave, in which cave dwellers see only shadows of the real forms of the world outside, as in our world we see only particular manifestations projected from the realm of universal forms beyond. Plato's philosophy of universal forms was also an important source for artists of the Renaissance, who (not unlike Mondrian) were trying to reconcile in an aesthetic theory the particular imperfections of our earthly existence with their faith in a perfect universal truth. Mondrian revised Renaissance aesthetics that were Neoplatonic with his own theory of the "Neo-Plastic," in which he also tried to give visible form to the invisible ideal structures of nature. Mondrian tried to synthesize the microcosmos and the macrocosmos, the inner and the beyond, in one universal, plastic language.

The synthesis of inner feeling with the cosmos beyond was the primary ambition of the religious/philosophical movement known as theosophy, of which both Mondrian and Kandinsky were students. Popularized by its cofounder, the Russian Helena Petrovna Blavatsky, in such tomes as *The Secret Doctrine: The Synthesis of Science, Religion, and Philosophy* (1888), theosophy deeply influenced, and perfectly reflected, the sensibility that sparked Mondrian's and Kandinsky's invention of non-objective painting. Mondrian joined the Theosophical Society in 1909, knew and read Blavatsky's texts, and practiced theosophical meditation. Rebay developed an interest in theosophy as early as age fourteen, when she attended classes held by Rudolf Steiner, theosophy's most accessible teacher and theorist. ▬▬ Loosely translated from the Greek, "theosophy" means "divine wisdom," its central concern being the understanding and health of the human spirit in an

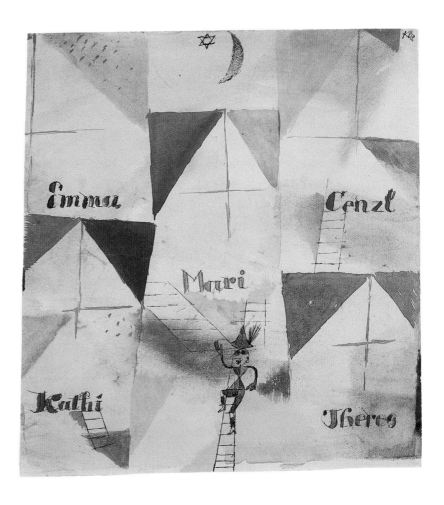

68. **Paul Klee**
The Bavarian Don Giovanni | Der bayrische Don Giovanni, 1919.116

69. **Paul Klee**
Night Feast | Nächtliches Fest, 1921.176

facing page:
70. **Paul Klee**
Singer of Comic Opera | Sängerin der komischen Oper, 1923.118

71. **Paul Klee**
Barbarian Sacrifice | Barbaren-Opfer, 1932.12

72. **Paul Klee**
Rocks at Night | Felsen in der Nacht, 1939.83

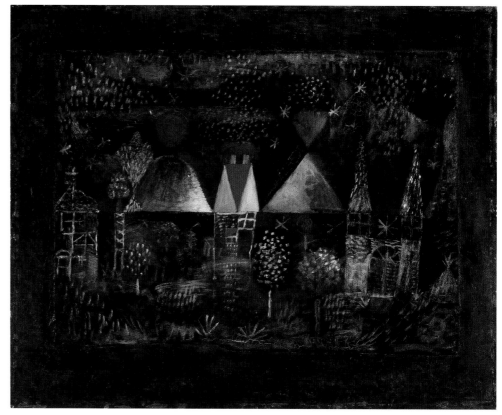

73. Jean Arp
Constellation with Five White Forms and Two Black, Variation III |
Constellation aux cinq formes blanches et deux noires, variation III, 1932

facing page:
74. Constantin Brancusi
King of Kings | Le Roi des rois, ca. 1938

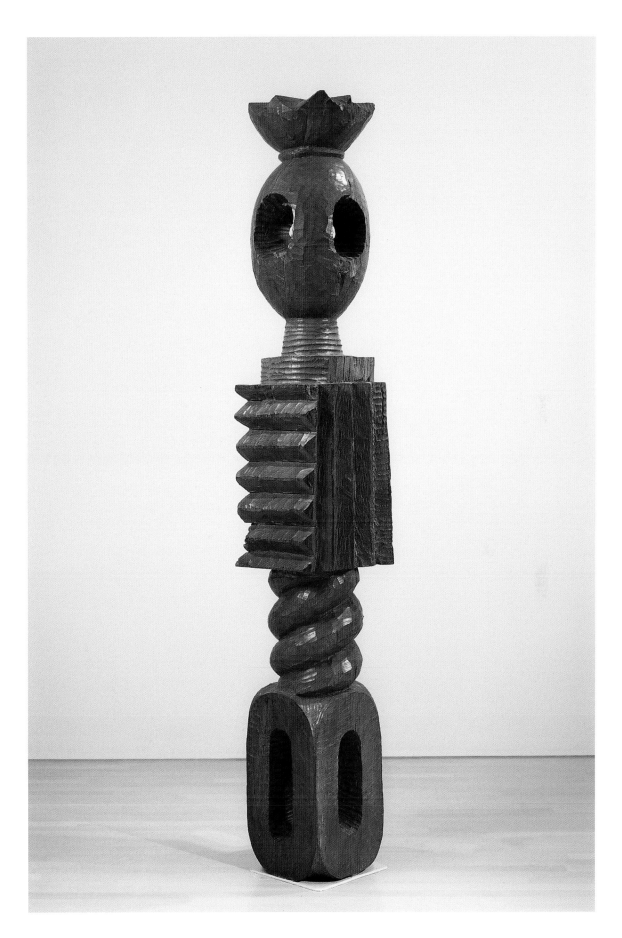

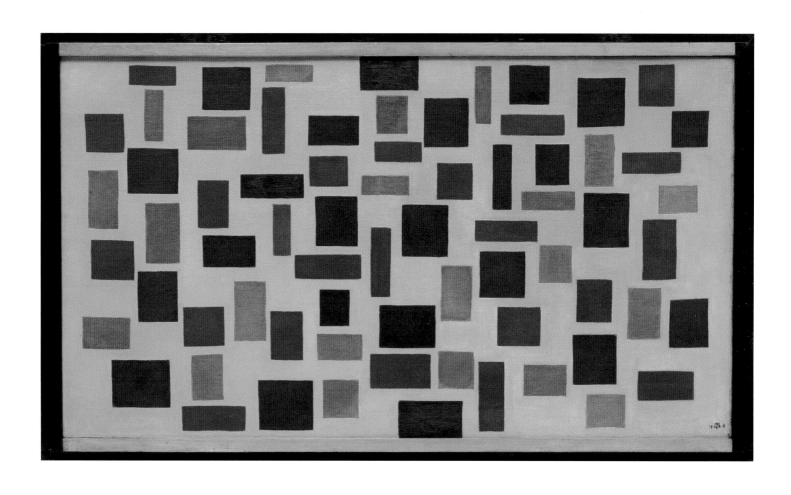

75. Theo van Doesburg
Composition XI | Compositie XI, 1918

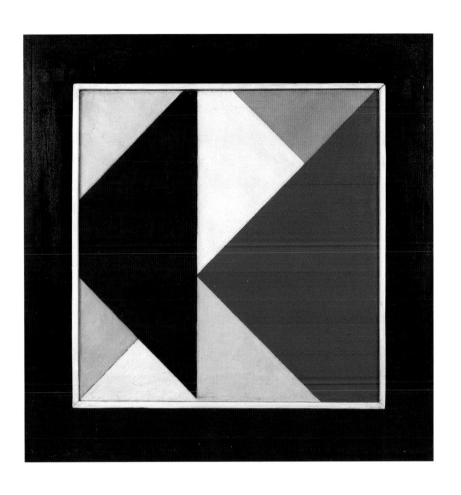

individual and collective sense. The doctrine of theosophy (related to Georg Wilhelm Friedrich Hegel's more complex speculative universalism) is especially interesting in the context of the development of non-objective painting as a kind of modern mysticism in the midst of the onslaught of nineteenth-century science, from Charles Darwin's theory of evolution to Ernest Rutherford's theory of atomic structure. ■■■■ The visual metaphor of clairvoyance was central to theosophical teaching. "The first point which must be clearly comprehended," remarked clairvoyant theosophist Charles W. Leadbeater in the second chapter of *Man Visible and Invisible* (1902), "is the wonderful complexity of the world around us—the fact that it includes enormously more than comes within the range of ordinary vision."[13] ■■■■ Theosophy described a synthesis of science and the spirit in terms appropriated equally from ancient cultures and modern technology. Mimicking Rutherford's atomic science, Leadbeater's occult science explained that substances known as elements, like oxygen or hydrogen, are not truly elemental but ultimately can be broken down "to a set of units which are identical, except that some of them are positive and some negative."[14] These units of matter exist on several *planes of nature*, which ascend from the lowest plane, that of the physical world, to the astral and mental planes and beyond, progressively refined as they become more spiritual. Similarly, Leadbeater's experimentation in "thought-induced photography of astro-mental images," described in *Thought-Forms* (1901), a book he coauthored with his theosophical colleague Annie Besant, echoes Wilhelm Roentgen's 1895 experiments with the exposure of photographic plates to invisible X-rays as a means to visually capture phenomena beyond the visible world.

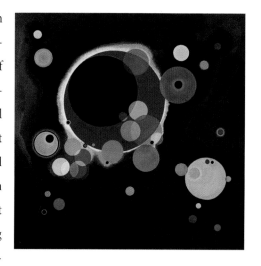

fig. 54 Vasily Kandinsky, *Several Circles | Einige Kreise*, January–February, 1926. Oil on canvas, 140.3 x 140.7 cm. Solomon R. Guggenheim Museum, New York, Gift, Solomon R. Guggenheim 41.283

■■■■ Leadbeater's and Besant's intriguing books were particularly important to the development of Kandinsky's abstract painting, as art historian Sixten Ringbom has documented.[15] Their theosophical books deal with "the general subject of the aura," the cloudlike substance that emanates from man's body and extends beyond its physical confines into the mental and astral planes. Thus: "Every thought gives rise to a set of correlated vibrations in the matter of this body, accompanied with a marvellous play of color, like that in the spray of a waterfall as the sunlight strikes it, raised to the nth degree of color and vivid delicacy. The body under this impulse throws off a vibrating portion of itself, shaped by the nature of the vibrations—as figures are made by sand on a disk vibrating to a musical note—and this gathers from the surrounding atmosphere matter like itself in the fineness from the elemental essence of the mental world. We have then a thought-form pure and simple, and it is a living entity of intense activity animated by the one idea that generated it."[16] Not only thoughts can be seen with theosophical clairvoyance, but also music: "Many people are aware that sound is always associated with color—that when, for example, a musical note is sounded, a flash of color corresponding to it may be seen by those whose finer senses are already to some extent developed.... Every piece of music leaves behind it an impression of this nature, which persists for some considerable time, and is clearly visible and intelligible to those who have eyes to see."[17] ■■■■ As a basis for his art, Kandinsky constructed an analogy to classical music, titling many of his works *Improvisation* or *Composition* (for example, plate 78). "A painter who finds no

satisfaction in mere representation," wrote Kandinsky, "naturally seeks to apply the methods of music to his own art. And from this results that modern desire for rhythm in painting, for mathematical, abstract construction, for repeated notes of color, for setting color in motion."[18] ▬▬ Kandinsky was not alone in his interest in the relationship between music and abstract painting. Mondrian loved jazz and its relation to painting, as evidenced in late works such as *Broadway Boogie Woogie* (1942–43, in the collection of the Museum of Modern Art, New York). What is relevant about Kandinsky's analogy to music is its relation, or lack thereof, to sight in the traditional sense. That is not to suggest that Kandinsky meant his paintings less for the eyes than other paintings, but perhaps he was implying that the visual sensation itself has other components that are not entirely visual. As smell is a major component of taste, could not hearing be part of seeing? Theosophically speaking, "sight" was not limited to the visible world. ▬▬ Both *Man Visible and Invisible* and *Thought-Forms* contain illustrations of "thought-forms" and images emanating from music, which, with their accompanying explanations, are obviously sources for the clouds of color around Kandinsky's lyrical abstract shapes (for example, in *Several Circles* [January–February 1926, fig. 54] and *Dominant Curve* [April 1936, plate 81]). Each book also includes an illustrated "Key to the Meanings of Colours," which certainly must have influenced Kandinsky's color theory and Mondrian's early Symbolist-inspired pictures. A passage in Leadbeater's text reads almost like a play for Mondrian's triptych *Evolution* (1910–11, in the collection of the Haags Gemeentemuseum): "Light blue marks devotion to a noble spiritual ideal, and gradually rises to a luminous lilac-blue, which typifies the higher spirituality, and is usually accompanied by sparkling golden stars, representing elevated spiritual aspirations."[19] ▬▬ Blavatsky placed the motto "There is no religion higher than Truth" at the beginning of *The Secret Doctrine*. Theosophy seeks to uncover the universal through a process that reveals the truth of structures—the sacred codes—beneath all visible reality. In theosophy, the traditional separation of the secular and the religious dissolves into manifestations of the same universal. The large crossed arms of the windmill Mondrian depicted in *Windmill at Night* (1907, in the collection of the Haags Gemeentemuseum), an early painting with a secular theme, is related to the cross in *Church at Domburg* (1914, the Haags Gemeentemuseum), which is further related to the abstract "plus" and "minus" marks of later, non-objective pictures. Mondrian worked through many of his ideas on the dissolution of forms in his sketchbooks of 1912–14; he also articulated them in his writing, for, like Kandinsky, he was a prolific theorist. He began to "discern the perpendicular in everything," Mondrian wrote. "The arms of the windmill are not more beautiful to me than anything else. Seen *plastically*, they actually have a disadvantage. To the shape of the cross, particularly when in the upright position, we readily attach a particular, rather *literary* idea. The cross form, however, is constantly destroyed in the New Plastic."[20] In other words, Mondrian erases the literary/religious reference of the cross, incorporating it into a more universal visual system of binary marks. The progression of his work leads to such essential abstractions as *Composition No. 1: Lozenge with Four Lines* (1930, plate 64). ▬▬ The age-old

fig. 55 Man Ray, *Untitled*, 1927. Rayograph, gelatin-silver print, 30.4 x 25.4 cm. Peggy Guggenheim Collection, Venice 76.2553.69b

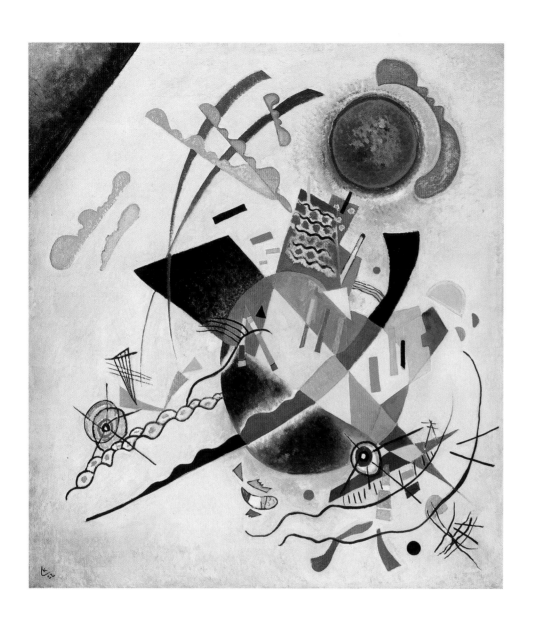

77. Vasily Kandinsky
Blue Circle | Blauer Kreis, 1922

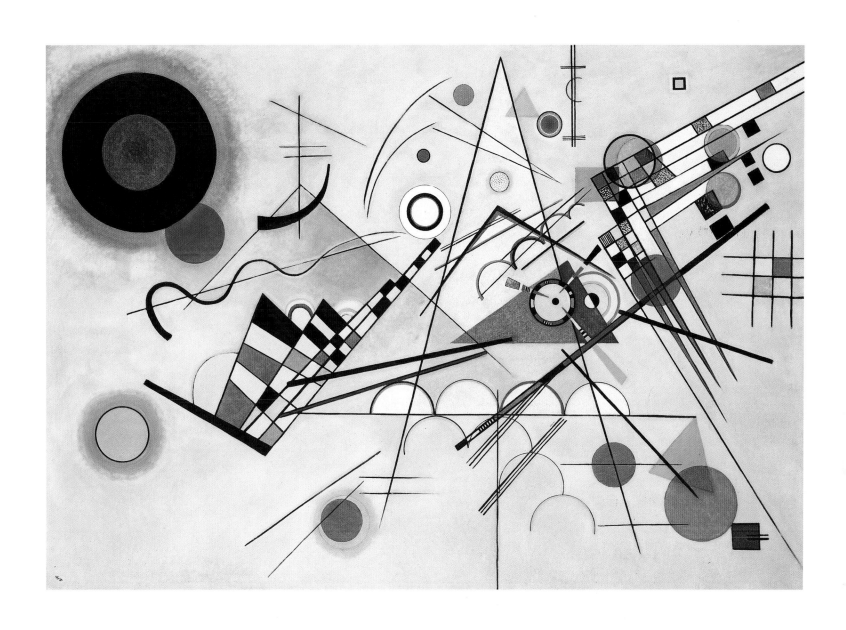

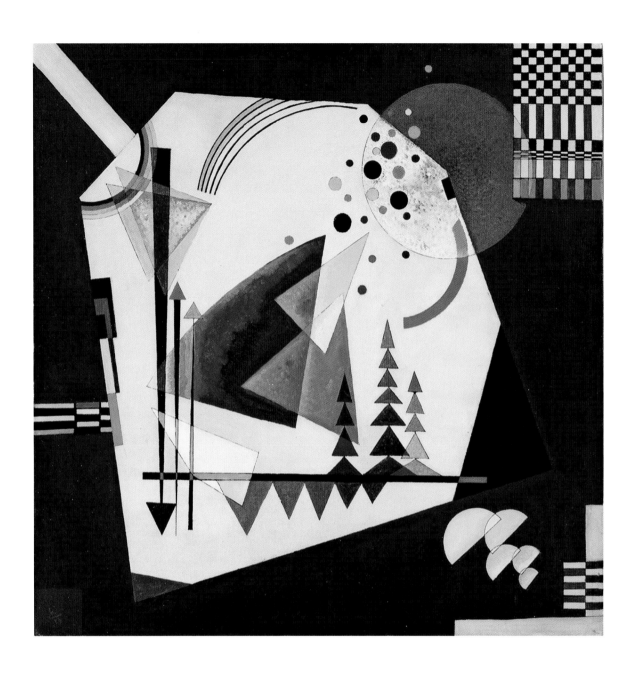

79. Vasily Kandinsky
Three Sounds | Drei Klänge, August 1926

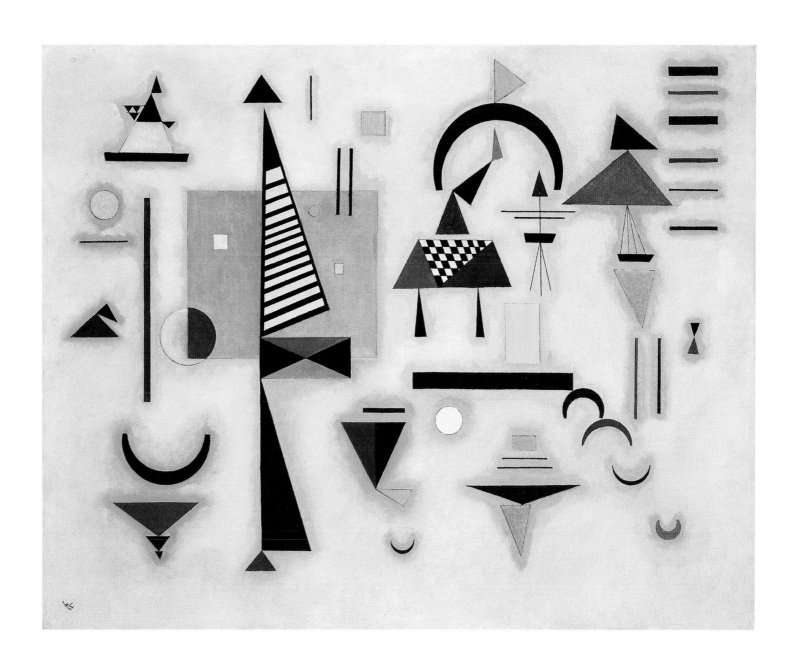

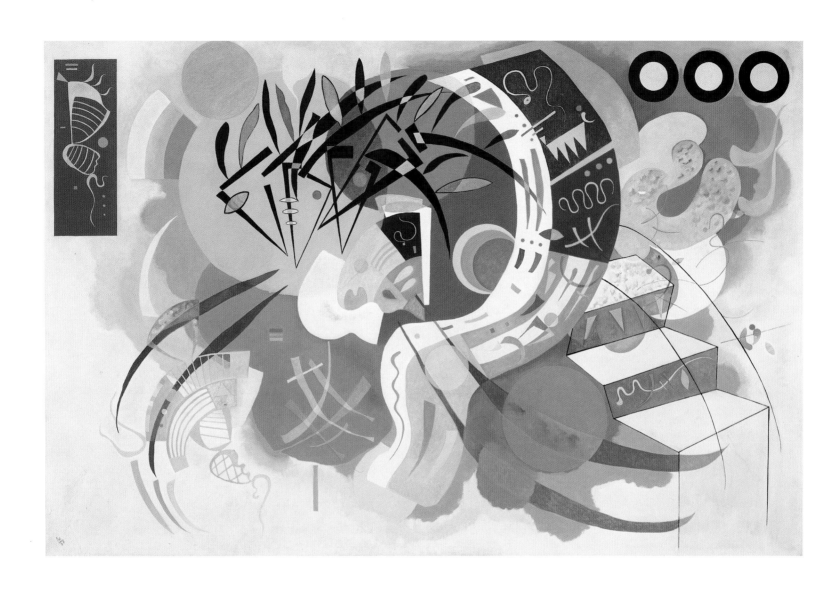

81. Vasily Kandinsky
Dominant Curve | Courbe dominante, April 1936

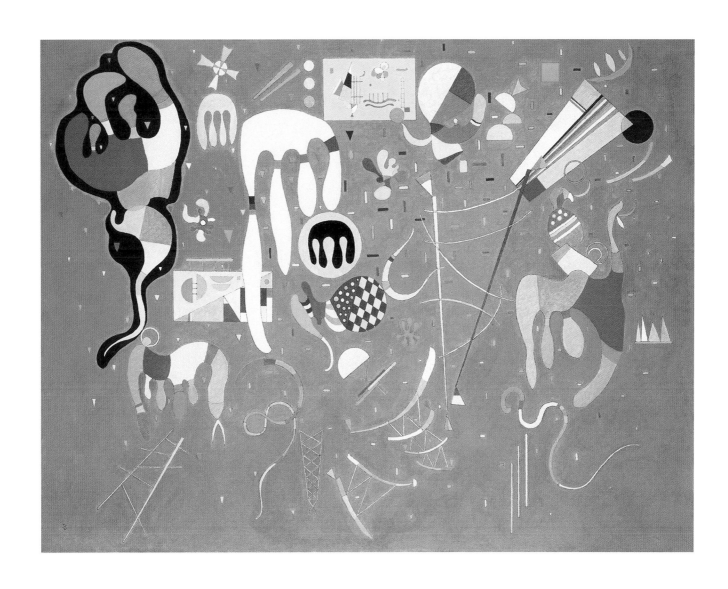

82. Vasily Kandinsky
Various Actions | Actions variées, August–September 1941

dichotomies between body and spirit, secular and sacred, science and religion, are at the heart of Kandinsky's and Mondrian's development of non-objective painting, as they are for the general psychology of the twentieth century. Yet the dynamic between science and the spirit reflected in non-objective art is ambiguous. On the one hand, technology posed a material challenge to artists: for example, the widespread use of photography, which demystified, simplified, and mechanized the production of images of things, may have challenged artists to seek a higher, more mystical, and uniquely human vision. On the other hand, science and invention yielded new visual metaphors for artists: in his Rayographs (for example, fig. 55), Man Ray capitalized on X-ray photography, which recorded images beneath the skin. Like the theosophical clairvoyance that inspired Kandinsky, X-ray photography suggested a new sense of vision beyond the images received by the eye. Similarly, Rutherford's 1911 description of the structure of atoms—a collection of positively charged protons orbited by negatively charged electrons—suggested an irreducible binary reality, paralleling Mondrian's painterly conception of the universe expressed in horizontal and vertical lines. Both Rutherford's and Mondrian's models reduced the particularity of the visible world to a reality of binary poles that could not be seen by the eye but could only be represented through abstract models and diagrams—or paintings. ▬▬ While science has always shaken religious dogma, it has also inspired a further mystical interest in the systems of nature. In the sixteenth century, Copernicus was excommunicated because his new astronomy suggested that the earth revolved around the sun, and therefore challenged the Church's order of the universe and man's place within it. Yet, as Rebay wrote in explaining non-objective painting, "Placing his vision outside the earth, [Copernicus] opened enormous vistas and brought to light new viewpoints with far-reaching consequences. The discovery of the possibility of placing oneself outside all former viewpoints concerning art is of equal importance to humanity."[21] Rebay rightly pointed out that the Copernican revolution is important not simply in terms of its factual results, but in terms of the mind-set that produced it. Copernicus's hypothesis (1543) was made possible by a visual system embodied in the Renaissance discovery of linear perspective. With perspectival means to map space and visual experience with illusionistic precision, artists developed the potential for a systematic, objective frame of reference, which is a prerequisite for any scientific thinking. ▬▬ Even in the Renaissance, artists had an uncertain relationship to science, especially as it intersected with matters of the spirit. Leone Battista Alberti's rules of perspective, set out in *On Painting* (1436) with scientific precision, were at first rarely employed by artists with scientific rigor or results. More often, the rules of perspective were bent in the creation of compositions to stress spiritual rather than material content. Furthermore, linear perspective, stemming as it was from mathematical order, took on symbolic value as a reflection of God's spiritual perfection[22] (not unlike M. H. J. Schoenmaeker's treatise, *Plastic Mathematics* [1916], which described a Platonic universal order and inspired fellow Dutchman Mondrian's Neo-Plasticism[23]). ▬▬ Copernicus's hypothesis concerning the movements of visible heavenly bodies might be compared to Rutherford's theories about the structure of

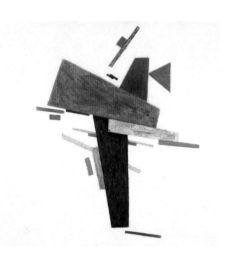

fig. 56 Kazimir Malevich, *Black Square*, 1915. Oil on canvas, 79.5 x 79.5 cm. State Tretyakov Gallery, Moscow

fig. 57 Kazimir Malevich, *Untitled*, ca. 1916. Oil on canvas, 53 x 53 cm. Peggy Guggenheim Collection, Venice 76.2553.42

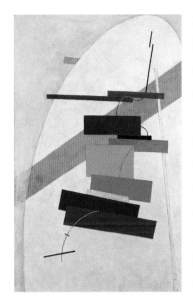

invisible atoms. To the extent that linear perspective in the fifteenth century defined a relation between the artist and the visible world, the advent of non-objective art in the twentieth century defined a relation between the artist and the *invisible* world. In both cases, advances in science and art had radical implications for the way in which the structure of the world was understood and represented. ▬▬ Modernism, embodied in the development of non-objective art, responded most directly to intertwined phenomena in the Western world at around the turn of the century, all of which might be considered outgrowths of overwhelming advancements in science and technology: the crisis in religious belief, Marxist revolutions, and the emergence of theosophy. Technology, according to twentieth-century philosopher Martin Heidegger, is both a means to an end and a human activity—in both the instruments, procedures, and methods that define it, and the attitude it reflects. Its essence lies in the process of classification and the development of models (representations) by which humanity achieves mastery over the substance of the world. It is the ability through scientific thinking to form a "world picture" as an objective model (a fundamentally subjective process) that coincides with the loss of belief embedded in Nietzsche's decree, "God is dead."
▬▬ Malevich's introduction of Suprematism in 1915 perfectly embodied the complex psychological condition within which non-objective art was born. *Black Square* (1915, fig. 56), the first Suprematist painting, was hung in the upper corner of a room, the place in a Russian home traditionally reserved for a religious icon. With it, Malevich presented, as he called it, a "single bare, frameless, icon of our times."[24] Malevich's Suprematism was, like Kandinsky's and Mondrian's art, a search for a universal language that resolved the conflict between a technological and a spiritual existence. In works such as *Untitled* (ca. 1916, fig. 57), Malevich fashioned his geometric constructions (inspired, like his colleague Vladimir Tatlin's Constructivist sculptures, by modern images of airplanes and factories) with deliberate, painterly marks, expressing the intuitive and spiritual aspects of his science. Malevich's square icon was both a substitute for traditional religious faith, in crisis as it was challenged by the new industrial, technological world, and a guardian of the human spirit in the face of such change. ▬▬ El Lissitzky, Gabo, and Pevsner took the relationship among science, technology, and art even further. Perhaps more than any other artists of the Russian avant-garde, they fully embraced the new industrial age. Lissitzky's early non-objective paintings—for example, *Untitled* (1919–20, fig. 58)—are indebted to Suprematism. Only a few years after the October Revolution, however, he expanded his artistic output to include sculpture, architecture, photography, and industrial, poster, and theater design, attempting to harness the power of abstract art to further the goals of the new Communist society. Sculptors Pevsner and Gabo also subscribed for a time to the tenet that art should be placed in service of the Revolution, and, like Lissitzky, were important members of the Constructivist group. Gabo's *Column* (ca. 1923, fig. 59) derives its architectural form from mathematical and scientific compositional devices. It is one of the first sculptures to utilize plastic—at the time, one of the newest material inventions of advancing technology.
▬▬ Moholy-Nagy's earliest experiments in plastic influenced his use of perspective and

fig. 58 El Lissitzky, *Untitled*, ca. 1919–20. Oil on canvas, 79.6 x 49.6 cm. Peggy Guggenheim Collection, Venice 76.2553.43

fig. 59 Naum Gabo, *Column*, ca. 1923 (reconstruction 1937). Perspex, wood, metal, and glass, h. 104.5 cm; diam. 75 cm. Solomon R. Guggenheim Museum, New York 55.1429

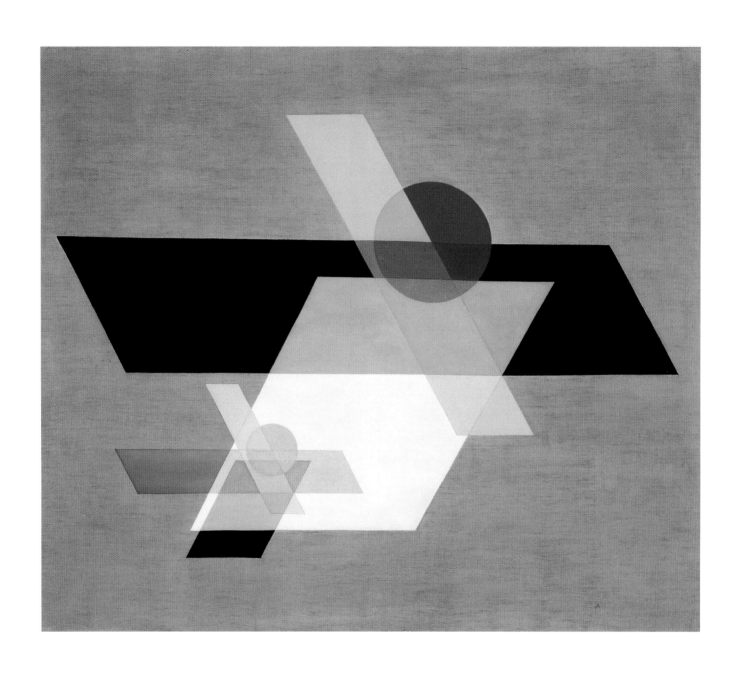

83. László Moholy-Nagy
A II, 1924

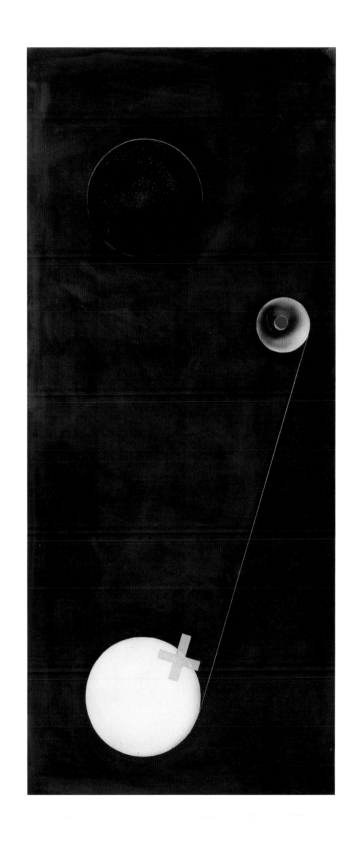

84. László Moholy-Nagy
T1, 1926

85. László Moholy-Nagy
Dual Form with Chromium Rods, 1946

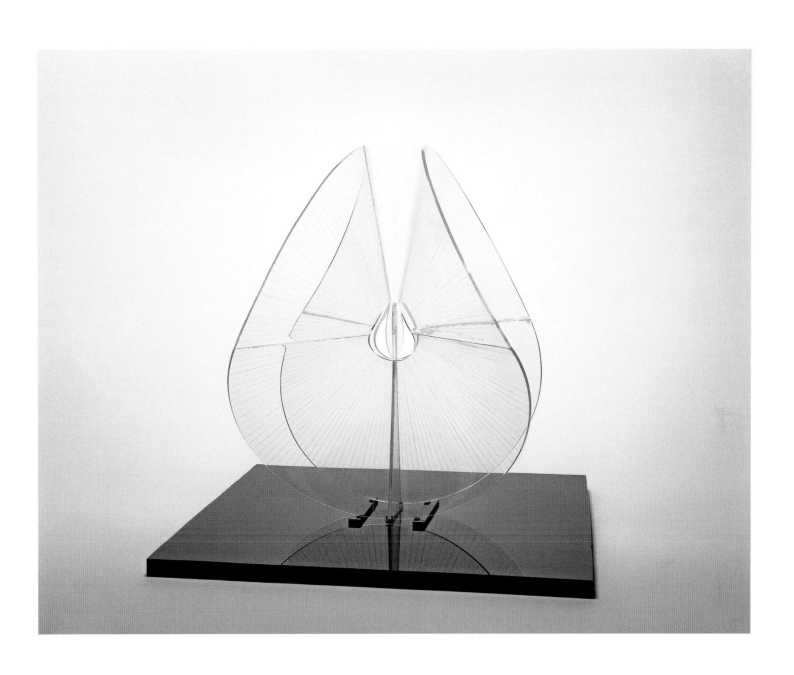

transparency in oil paintings such as as *A II* (1924, plate 83) and *T1* (1926, plate 84). The invention of Plexiglas in 1936 provided Moholy-Nagy with the ideal medium to realize his quasi-scientific exploration of the formal properties of light and space. He found that the malleable material could be bent, incised, and painted to form a hybrid of painting and sculpture that the artist called "space modulators." Ever-changing effects of transparency and the shadows cast by plastic forms in real space (for example, in *Dual Form with Chromium Rods*, 1946, plate 85) introduced new elements into his exploration of a human perception of the universe. Moholy-Nagy also carried his concerns about light and space into the realm of photography, capturing light, space, and time on the chemical surface of his "photograms."

Kandinsky inscribed the limits of the power of science and technology at the edge of matter, noting that no "principle can be laid down for those things which lie beyond, in the realm of the immaterial. That which has no material existence cannot be subjected to a material classification."[25] Instead, a "non-matter" related to the spirit can only be reached "by the way of *inner* knowledge."[26] For Kandinsky, theosophy's synthesis of scientific means and primitive religion provided a base from which to challenge materialistic science. ▬▬▬ Heidegger, in confronting the "danger" of technology, quotes the German Romantic poet Friedrich Hölderlin: "But where danger is, grows / The saving power also." Heidegger implies that the "saving power" may be pursued through the philosopher's *thought*, and through *art*: "Because the essence of technology is nothing technological, essential reflection upon technology and decisive confrontation with it must happen in a realm that is, on the one hand, akin to the essence of technology and, on the other hand, fundamentally different from it. Such a realm is art. But certainly only if reflection on art for its part, does not shut its eyes to the constellation of truth after which we are questioning."[27] ▬▬▬ By delineating the edge of matter and materialistic science and exploring its counterpart, found in thought and emotion (and in the cosmos beyond), Kandinsky's and Mondrian's non-objective painting touched the essence of technology and science: its vision. The essence of technology is, like theosophical clairvoyance, a kind of divine wisdom. ▬▬▬ Any systematic theory or world view, including theosophy, may fall prey to the danger of mastery over materials. In his theories, Kandinsky was careful to avoid the artist's natural mastery over substance or the escapism of art for art's sake, writing, "The artist must have something to say, for mastery over form is not his goal but rather the adapting of form to its inner meaning."[28] The process is an investigation rather than an exposition. And, as Heidegger states, "the more questioningly we ponder the essence of technology, the more mysterious the essence of art becomes."[29] ▬▬▬ The "subject" of Kandinsky's non-objective art is the inner being made manifest in the mysterious process of subjective inspiration by means of an intimate knowledge of pure color and form in painting. In developing his non-objective art, Kandinsky was attempting to retrieve the spirit without turning his back on the modern technological age.

NOTES

1. Hilla Rebay, "The Beauty of Non-Objectivity," in *Solomon R. Guggenheim Collection of Non-Objective Paintings: Second Enlarged Catalogue* , exh. cat., Philadelphia Art Alliance (New York: Solomon R. Guggenheim Foundation, 1937), p. 13.

2. Quoted in Joan M. Lukach, *Hilla Rebay: In Search of the Spirit in Art* (New York: George Braziller, 1983), p. 62.

3. Wright's discussion of his conception of the museum, as well as Rebay's responses, can be found in *Frank Lloyd Wright: The Guggenheim Correspondence*, selected by Bruce Brooks Pfeiffer (Fresno: The Press at California State University; Carbondale: Southern Illinois University Press, 1986).

4. Rebay rigorously used the term "non-objective" as opposed to "abstract" painting to refer to the art she espoused, thereby stressing the subtle but critical difference between the two. Abstraction, to Rebay and others, is derived from reality—a reduction of its content, but in the final analysis still a reference to specific things. On the other hand, non-objective painting has no real referent and therefore is pure and simple. Rebay did acquire abstractions, such as works by Picasso, but only as precursors to non-objective painting. The term "non-objective" never became commonplace in the vocabulary of art historians and critics, who have preferred the term "abstraction" to refer both to abstractions and compositions-without-object. Conceptually, the difference between the two terms is great, but in practice the line between abstraction and non-objectivity is thin—defined perhaps by an artist's intent rather than the visual impression. For the purposes of this essay, the distinction between a distortion or abstraction of reality and pure non-objectivity is critical. However, because "non-objective" remains cumbersome the terms "non-objective" and "abstraction" are used interchangeably.

5. Rebay, "The Beauty of Non-Objectivity," p. 13.

6. Rebay, however, did not acquire any Calders for the Guggenheim Museum. Sculptures by Calder, as well as by Brancusi, were added to the collection by the museum's second director, James Johnson Sweeney.

7. Wassily Kandinsky, *Concerning the Spiritual in Art*, trans. M. T. H. Sadler (New York: Dover Publications, 1977), p. 1.

8. Ibid.

9. Quoted in Herschel B. Chipp, *Theories of Modern Art: A Source Book by Artists and Critics* (Berkeley: University of California Press, 1968), p. 50

10. Kandinsky, p. 2.

11. Quoted in Chipp, p. 321.

12. Quoted in Chipp, p. 359.

13. C. W. Leadbeater, *Man Visible and Invisible* (Wheaton, Ill.: Theosophical Publishing House, 1987), p. 6.

14. Ibid., p. 7.

15. See Sixten Ringbom, *The Sounding Cosmos: A Study in the Spiritualism of Kandinsky and the Genesis of Abstract Painting* (Abo, Finland: Abo Akademi, 1970).

16. Annie Besant and C. W. Leadbeater, *Thought-Forms* (Wheaton, Ill.: The Theosophical Publishing House, 1969), p. 8.

17. Ibid., p. 67.

18. Kandinsky, p. 19.

19. Leadbeater, p. 69.

20. Piet Mondrian, "Natural Reality and Abstract Reality," in Harry Holtzman and Martin S. James, *The New Art–The New Life: The Collected Writings of Piet Mondrian* (Boston: G. K. Hall & Co., 1986), p. 99.

21. Hilla Rebay, "Definition of Non-Objective Painting," in *Solomon R. Guggenheim Collection of Non-Objective Paintings*, exh. cat., Gibbes Memorial Art Gallery, Charleston, South Carolina (Charleston: Carolina Art Association, 1936), p. 8.

22. See Samuel Y. Edgerton, Jr., *The Renaissance Rediscovery of Linear Perspective* (New York: Basic Books, 1975).

23. For a description of the relationship between the theories of Schoenmaeker and Mondrian, see H. L. C. Jaffe, *De Stijl 1917–1931, The Dutch Contribution to Modern Art* (Amsterdam: Meulenhoff, 1956), p. 57.

24. Quoted in Jane Sharp, "The Critical Reception of the 0.10 Exhibition: Malevich and Benua," in *The Great Utopia: The Russian and Soviet Avant-Garde, 1915–1932*, exh. cat. (New York: Guggenheim Museum, 1992), p. 44.

25. Kandinsky, p. 12.

26. Ibid., p. 13.

27. Martin Heidegger, "The Question Concerning Technology," in *The Question Concerning Technology and Other Essays* (New York: Harper and Row, 1977), pp. 34–35.

28. Kandinsky, p. 54.

29. Heidegger, p. 35.

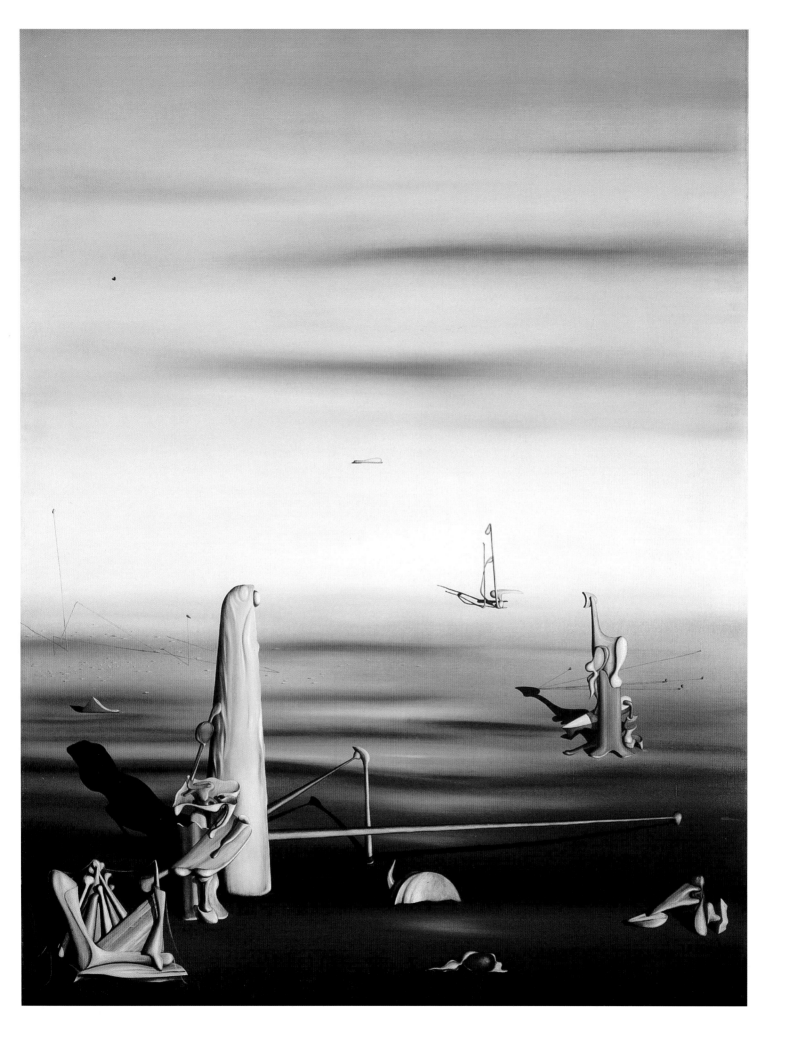

JENNIFER BLESSING

Peggy's Surreal Playground

Surrealism was the perfect playground for Peggy Guggenheim. Hemmed in by the proprieties of the New York Jewish aristocracy in which she was raised, Guggenheim escaped to Europe in 1920 and was in Paris to witness the birth of Surrealism. Her engagement with the movement in the 1920s was limited to social contacts with predominantly literary figures; it was not until she decided to open a gallery in London in 1938 that she became actively involved with the artistic community. ▬▬▬ The name of the gallery, Guggenheim Jeune, made punning reference to the established Galerie Bernheim-Jeune in Paris, while fostering the mistaken assumption that Peggy Guggenheim was the daughter of Solomon R. Guggenheim, an important collector of non-objective painting in New York, though in fact she was his niece. This joke was not at all appreciated by Solomon's very serious adviser, Hilla Rebay, who chided Peggy in the opening salvo of what was to be a long-running antagonism between the two women. "It is extremely distasteful at this moment, when the name of Guggenheim stands for an ideal in art, to see it used for commerce," Rebay wrote.[1] ▬▬▬ Guggenheim Jeune became a model for Peggy Guggenheim's history-making gallery in New York during World War II, Art of This Century. Many of her exhibitions in England became prototypes for American shows: at both galleries she favored Surrealists, showed the work of sculptors and emerging artists, and made no attempt to censor potentially controversial art, perhaps even seeking to promote it. ▬▬▬ In March 1939, Guggenheim decided to found a museum of twentieth-century art in London. When London became an untenable site, Guggenheim moved to Paris, intending to open her museum in a townhouse there. With a list of must-haves in hand, she went on a shopping spree, determined to "buy a picture a day" as the rest of Europe prepared for war.[2]

While Guggenheim insisted that her collection was to be "historical and unprejudiced,"[3] and that she personally preferred no particular style, her heart belonged to Surrealism, which was exactly what frightened the Rebay contingent. From André Breton's initial codification of the movement in 1924, when he published his notorious *Manifeste du surréalisme*, one of Surrealism's main goals was liberation from repression of all kinds: social, political, psychological, and sexual. Surrealism's transgression of established bourgeois norms, which was derived from Dada practices that resulted from post–World War I disillusionment, allowed for, in theory, the spontaneous expression of any repressed desire or whim. Guggenheim came of age in the adventurous atmosphere of 1920s Paris and took full advantage of the license that her wealth afforded her. She told an interviewer in 1976,

facing page:
87. Yves Tanguy
The Sun in Its Jewel Case | *Le Soleil dans son écrin*, 1937

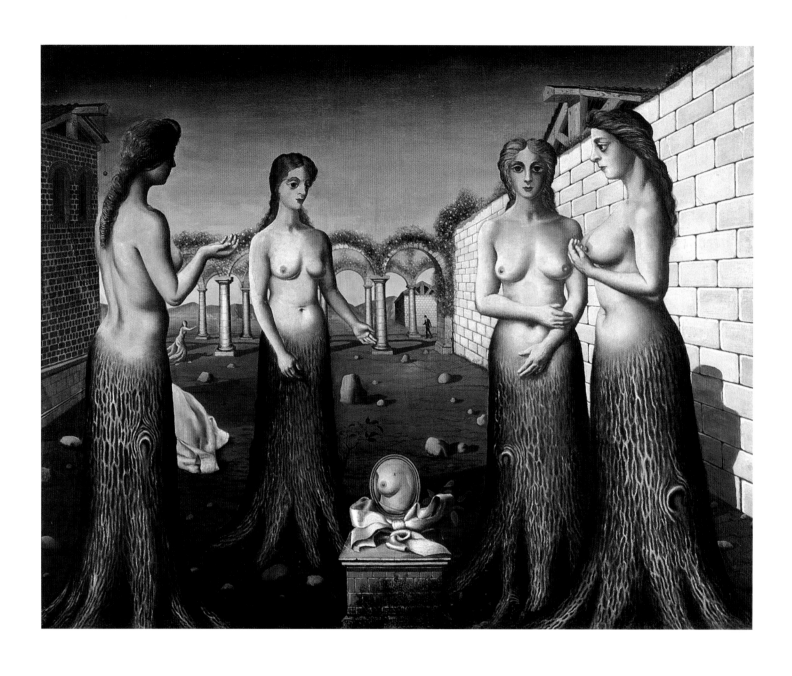

88. Paul Delvaux
The Break of Day | *L'Aurore*, July 1937

"I was the original liberated woman. . . . I did everything, was everything; I was totally free financially, emotionally, intellectually, sexually."[4] In the early 1920s, she attempted a modicum of conventional marriage and motherhood, but in 1928 she left her husband and children, eventually alighting in London. She shocked her mother, among others, when she lived with a succession of lovers and indulged in affairs with Surrealist artists such as E. L. T. Mesens and Yves Tanguy, and artist/art historian Roland Penrose. In England, Guggenheim obtained her reputation as a "voracious consumer of men,"[5] which was not a particular liability in Surrealist circles because many of their investigations focused on Woman and her sexual desire. ▬▬▬ Among the Surrealists' practical concerns were free love and women's liberation from domestic responsibility. Both were advocated as refutations of bourgeois restrictions, although organized protests of existing day-to-day conditions were frowned upon. The Surrealists focused instead on the mythopoeic concept of the marvelous woman. As art historian Whitney Chadwick has explained, they conceived of woman as *femme-enfant* (naïf, fairy princess, unconscious medium) or *femme fatale* (seductress, deceptive performer, sorceress).[6] Despite the limitations of Breton's theoretical model of a mythical muse, many women actively participated in the Surrealist movement as writers and artists, especially in the 1930s. The gamut of the roles for women that appealed to the Surrealists is illustrated by the sign for Breton's short-lived gallery, Gradiva, which he opened in 1937 and named after the protagonist—a sculpture that came to life—of a story analyzed by Freud.[7] Below each letter of Gradiva was the name of a female mascot. For example, "G comme Gisèle" stood for Gisèle Prassinos, a fourteen-year-old poet *femme-enfant*; A for artist Alice Paalen; D for photographer Dora Maar; and V for Violette Nozières, a condemned patricide whom the Surrealists defended.[8] Perhaps because women were believed to be more emotional and disposed to psychological disorders, they—along with "primitive" peoples, children, and the insane—were considered to have more integrated psyches, untouched by the rationality that society demanded of "civilized" adult males.[9] ▬▬▬ The Surrealists delighted in the marvelous—the exotic and erotic that stunned the senses through its unusualness, shocking the viewer into a new outlook or expanding the boundaries of his or her imagination. Seeking to integrate oppositions—the waking and dreaming states as well as the worlds of art and life—they proposed a new kind of existence, a new reality in surreality, which they visualized as a multifarious *gesamtkunstwerk*. While some male artists, such as Salvador Dalí, extended their art into life by conceiving of themselves as a kind of living performance spectacle, it was more often women who invented themselves as marvelous, dramatic extravagances.[10] Surrealist women artists frequently presented themselves as works of art, whether in self-portraits or for someone else's camera, suggesting that the creation of dramatis personae became a vehicle for women's expression (it continues to be manifested today in the work of artists such as Laurie Anderson, Eleanor Antin, and Cindy Sherman).[11] ▬▬▬ With a manner of dress that verged on the marvelous, a mode of behavior outside bourgeois boundaries in terms of her boldness and sexual libertinage, and a history of

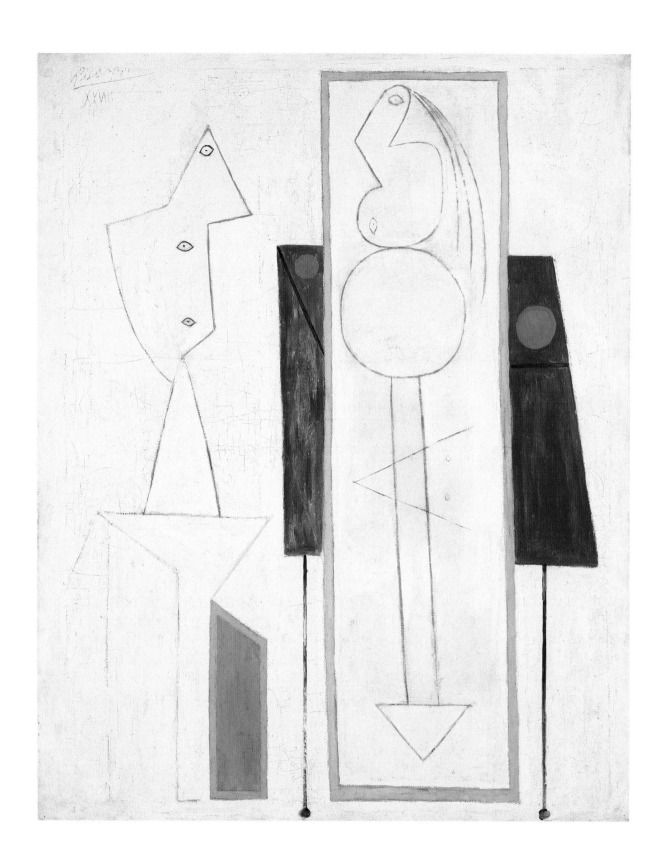

89. Pablo Picasso
The Studio | *L'Atelier*, 1928

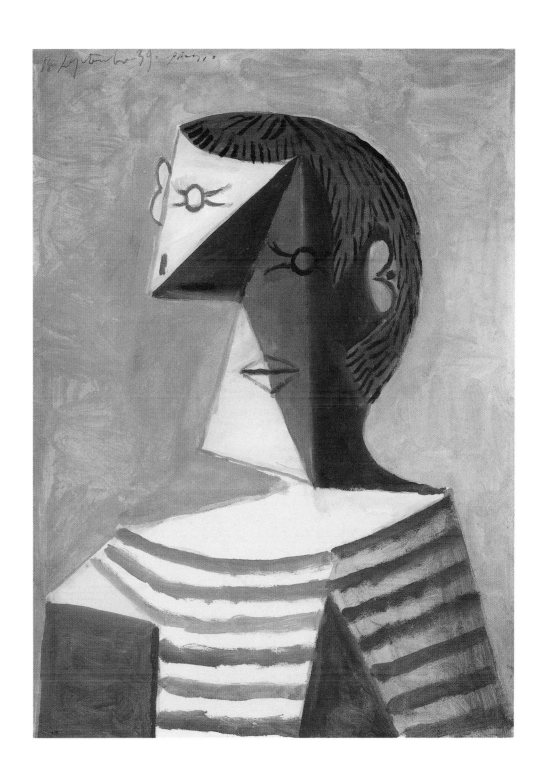

90. Pablo Picasso
Half-length Portrait of a Man in a Striped Jersey | Buste d'homme en tricot rayé,
September 14, 1939

insanity in her family, which she herself emphasized, Guggenheim participated in this spectacular masquerade, predisposing herself to the Surrealists and their art.[12] Although she also collected abstract work, she was not inclined to its spiritual program or its self-proclaimed spokesperson, Rebay. This disinclination became outright conflict when Guggenheim came to New York in 1942.

In the last months before Paris fell, Guggenheim combed artists' studios and received picture dealers in her hotel bedroom, working assiduously to amass a collection of important works exemplifying the period since 1910. An examination of Guggenheim's signal Surrealist works gives voice to the central concerns of the movement and perhaps also to the taste of its patron. ▬▬ The Surrealist collection that Guggenheim created, in toto, outlines a vast explosion of cultivated sexual obsession. A landscape of desire emerges in which the female body takes center stage, whether directly in a realistic rendition or obliquely through abstract references. Oscillating from the vaguely feminine biomorphic curves of a relief by Jean Arp to the anatomically complete depictions of women in paintings by Max Ernst or Dalí, Surrealism was grounded in the body, most often the female body. Underlying the movement's notions of the working of the unconscious and its machinations in the realm of sexual desire were the ideas of Freud, which were disseminated through various Surrealist journals and more popular media. Some artists were intimately familiar with Freud's original writings; for example, the work of Ernst, who had studied psychoanalytic texts, reflects an advanced understanding of Freudian concepts.[13] The crude sexual symbolism that pervades Freud's *The Interpretation of Dreams* (1900) is one of the hallmarks of Surrealist compositions. ▬▬

Dada artists had used sexual innuendo in their absurd mechanomorphic constructions—including works that Guggenheim acquired such as Francis Picabia's *The Child Carburetor* (1919, fig. 61)[14] and Ernst's *Little Machine Constructed by Minimax Dadamax in Person* (1919–20)—dryly equating the structure of a human body or the act of intercourse with tools and instruments, or engine parts. The ironic sexual play in Dada art was taken up by the Surrealists, along with its inherent ambivalence toward the machine and women.[15] The Surrealists, however, added a psychoanalytic dimension to the use of sexual metaphors. Frequently, they visualized the unconscious mind as a landscape in which desires and traumas are metaphorically embodied in the figures and objects inhabiting the fictive space. In Paul Delvaux's *The Break of Day* (1937, plate 88)[16] and Dalí's *Untitled* (1931, fig. 62), an uncanny sense of the real is maintained through conventional recession into space and the presence of familiar forms, which are unfamiliarly juxtaposed. In both canvases, the object of desire is a woman who is equated with nature: Delvaux repeats the same *femme-arbre* (tree-woman) four times, and Dalí's head of a woman is composed of a pile of seashells, her hair seeming to ooze into a molten mass. Dalí's desolate landscape echoes Tanguy's lunar terrain in *The Sun in Its Jewel Case* (1937, plate 87), but Tanguy departs from recognizable imagery, creating anthropomorphoid bodies that suggest individual beings. Tanguy preserves a sense of corporeality by the modeling of the abstract forms and the shadows they cast; the bone and antennae shapes ground the bodies in an

fig. 61 Francis Picabia, *The Child Carburetor* | *L'Enfant carburateur*, 1919. Oil, enamel, metallic paint, gold leaf, pencil, and crayon on stained plywood, 126.3 x 101.3 cm. Solomon R. Guggenheim Museum, New York 55.1426

fig. 62 Salvador Dalí, *Untitled*, 1931. Oil on canvas, 27.2 x 35 cm. Peggy Guggenheim Collection, Venice 76.2553.99

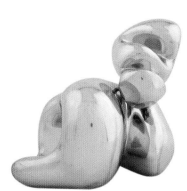

organic environment. Balls are couched in sockets; nodules make physical contact with corpuses, suggesting a primeval sexuality. The shadow-casting ray emanations of the figure in the right middle ground are reminiscent of Joan Miró's symbology of sexual evanescences, as well as of Marcel Duchamp's. ▬▬▬ Pablo Picasso's *On the Beach* (1937, fig. 63) schematically maintains the fictive space of "realistic" works by Surrealists such as Dalí, although here it is occupied by fantastic monster-women, their sculptural construction determined by erotic zones. These bodies are a mass of parts: projectile breasts, giant buttocks, looming wombs and vulvas. Despite the arcadian theme, their innocent visages, and their childlike play with a toy boat, the women's apparently gargantuan size, strange insectoid craning necks, fragmentation, and vestigial hands are vaguely threatening. The voyeur on the horizon, who embodies the viewer's fear, brings to mind the spectral man peaking from behind a rock in Dalí's *Untitled*.[17] The image of the male voyeur spying the abundant gifts of a nude female is a traditional theme, typically represented in morality tales such as Diana spied upon by Actaeon, or Susanna and the Elders. The peeker in these images is a stand-in for the male viewer of the picture; both have the exquisite delight of watching without being seen, which puts them in a position of power.[18] Freud's entire account of the genesis of sexuality in the individual is predicated on sight, specifically on the male child's discovery that the mother does not have a penis, thus introducing the fear of castration (his might be removed like mommy's was). Voyeurism yields the pleasure of reliving that moment of discovery, which is both frightening in its implicit threat and delightful in its reassertion that the male spectator is not himself "castrated" as the female subject appears to be.[19] ▬▬▬ Because it exists as a three-dimensional object, a sculpture broadens the participation of viewers, who can move around it, thereby experiencing a relationship between its mass and their own bodies. Guggenheim demonstrated the sensuality of the physical response to sculpture when she explained why she bought her first piece, Arp's *Head and Shell* (ca. 1933, fig. 64): "I fell so in love with it that I asked to take it in my hands. The instant I felt it, I wanted to own it."[20]

▬▬▬ Since the creation of the first Western sculptures-in-the-round, stone and bronze idols were equated with the human body. While this equation is obvious in naturalistic sculpture, abstract work maintains the correlation not only when it incorporates the suggestion of body parts but simply by the fact of its physical mass. Metaphors of presence and absence classically denote the male and female genitalia, as Freud's study of sexual symbolism sustains. And traditional sculpture, including many Surrealist objects, emphasizes the language of presence by its preoccupation with phallus forms that seem to serve as fetish objects warding against the fear of castration also described by Freud. Constantin Brancusi's *Bird in Space* (1932–40, plate 92), which the artist arrived at through working with images of a magic bird such as *Maiastra* (1912[?], plate 91), also operates as a phallic emblem.[21] ▬▬▬ Transgression against bourgeois norms of propriety and expected behavior was a central strategy of Surrealist practice that is grounded in Breton's Freudian-derived mandate to dredge up repressed traumas, dreams, and desires and expose them in art. In Surrealism, the transgressive act was most frequently literalized in the image of the nude female

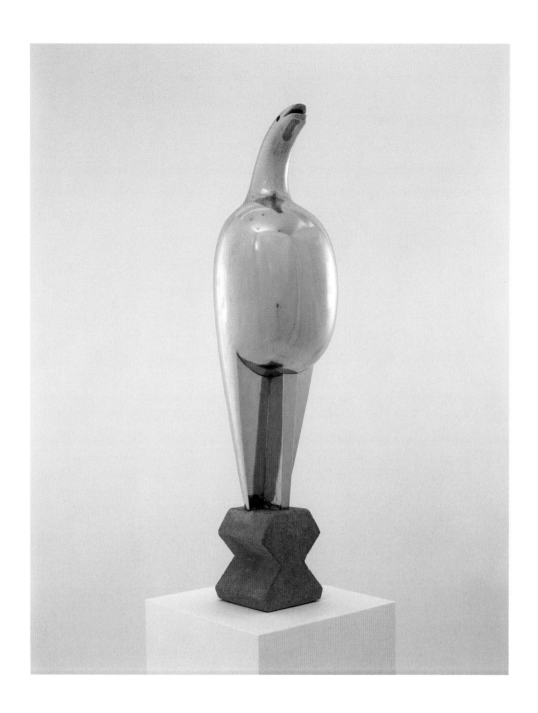

91. Constantin Brancusi
Maiastra, 1912 (?)

facing page:
92. Constantin Brancusi
Bird in Space | L'Oiseau dans l'espace, 1930s

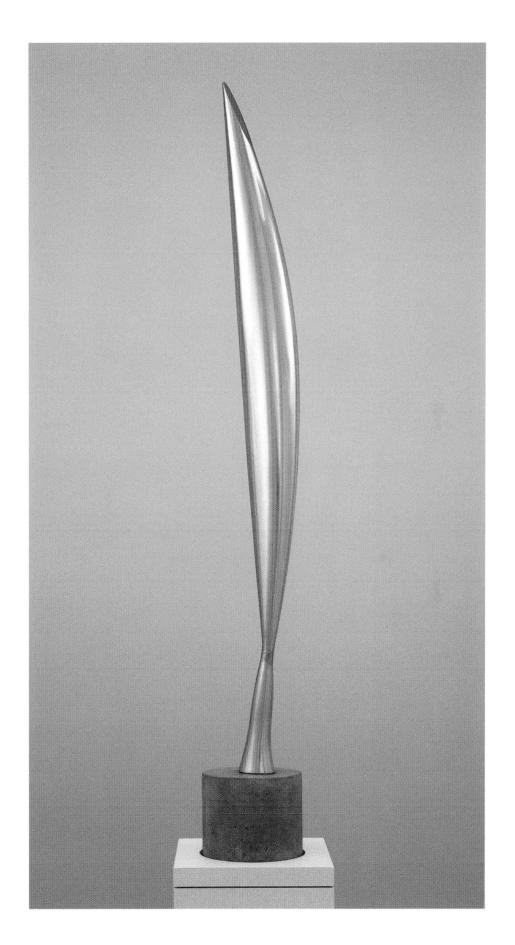

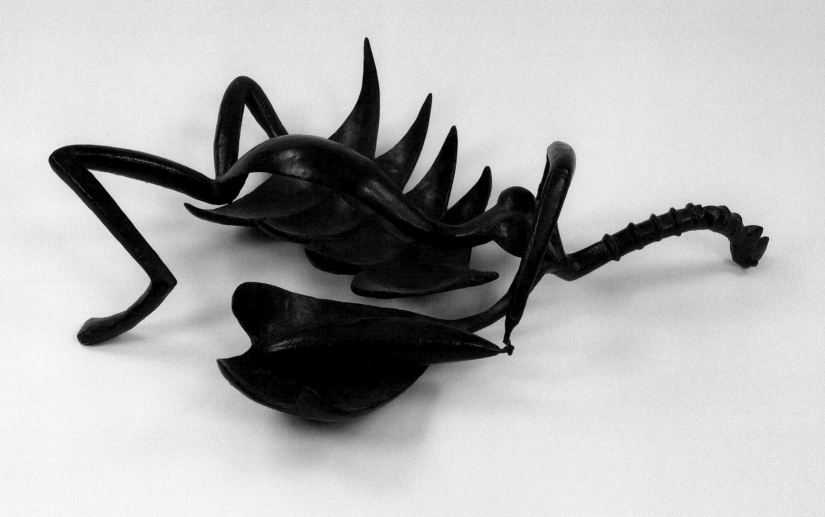

93. Alberto Giacometti
Woman with Her Throat Cut | Femme égorgée, 1932, cast 1940

facing page:
94. Alberto Giacometti
Standing Woman ("Leoni") | Femme debout ("Leoni"), 1947, cast November 1957

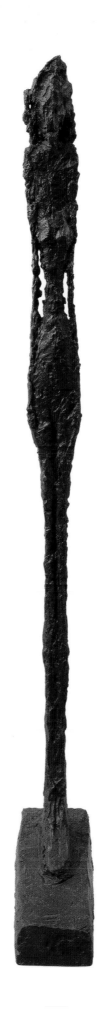

95. René Magritte
Voice of Space | *La Voix des airs*, 1931

body, perhaps because of a socially constructed notion of its sacrosanctity that would heighten the shock and titillation of representations of its violation.[22] Moreover, the Surrealists relied heavily on Freud, whose story of the genesis of sexuality was filled with images of brutality—the horror of castration, and its symbolization in the blinding of Oedipus, for example—that bound the thread of violence so tightly to sexuality. This climate promoted the *femme fatale* represented by the ultimate castrating figure, the female praying mantis, who eats her mate after copulation. Giacometti depicted the aftermath of a preventative annihilation of the mantis-woman in his *Woman with Her Throat Cut* (1932, cast 1940; plate 93), a headless insectoid that rests on the floor like a squashed bug.[23] The threat of castration also pervades much of Dalí's work. In *Birth of Liquid Desires* (1931–32, plate 96), a painting rife with Freudian implications, the central couple makes clear a motif repeated in the artist's work—a father figure sexually united with a muse who can be identified as both Gradiva and Gala, Dalí's lover.[24]

When Paris fell, Guggenheim was forced to flee to the south of France, where she arranged for the transfer of her collection and the move of her family to New York as the conflict was escalating. In addition, Breton, Jacqueline Lamba, and their daughter, as well as Ernst were able to leave Europe through her assistance. Ernst was a particularly difficult case since he had been interned in France as an enemy alien. It was at this time that Guggenheim and the artist began a liaison that eventually resulted in their short-lived marriage in New York, where they arrived on July 14, 1941. According to Guggenheim, Ernst's painting *The Antipope* (December 1941–March 1942, plate 99) is a manifestation of their complicated relationship.[25] Her identification of figures representing Ernst, herself, and her daughter Pegeen has been supplemented by the suggestion of the presence of a representation of Leonora Carrington, with whom Ernst was romantically involved. Ernst's axiomatic themes in this work have been described by Angelica Rudenstine as "the universal issues of power, manipulation, and potential destructiveness in sexual relations."[26] ▬▬ Settling in New York for the duration of the war, Guggenheim continued editing her collection catalogue, which she had begun in Europe. She also continued to purchase important modernist works such as Amédée Ozenfant's *Guitar and Bottles* (1920, plate 97). Determined to finally open the museum she had been planning, she hired the visionary architect Frederick Kiesler to design an environment appropriate to her collection, "a place where people who are doing something really new can show their work."[27] On October 20, 1942, her Art of This Century museum-gallery opened in the space that two tailors had occupied at 30 West Fifty-seventh Street, garnering national attention. ▬▬ By hiring Kiesler— whom she called "the most advanced architect of the century"[28]—Guggenheim faced off against her uncle and his adviser Rebay, who in 1939 had opened their Museum of Non-Objective Painting in a former car showroom at 24 East Fifty-fourth Street. In fact, in the 1930s Rebay had herself considered hiring Kiesler to design an exhibition space in Rockefeller Center. Perhaps Solomon's and Rebay's engagement in June 1943 of the world-famous architect Frank Lloyd Wright, whom they

commissioned to build a freestanding edifice to replace the Fifty-fourth Street venue, was precipitated by Peggy Guggenheim's museum-gallery success. By calling her space a museum (she charged admission for a while), enlisting the services of an architect known for his set design and theatrical window displays, and challenging him to devise a new method of exhibiting art, Guggenheim created a sensational splash that seemed to deliberately challenge her uncle and Rebay.[29] ▬▬ Kiesler designed four galleries for Art of This Century.[30] The most conventional—illuminated by daylight—served as the painting library, a study center for Guggenheim's "permanent collection," and the space for changing exhibitions. Kiesler felt that walls were repressive; thus, the partitions of the abstract gallery, consisting of ultramarine stretched-canvas sheets battened down with cord, appeared to float since they did not meet either the floor or ceiling. Paintings, mounted on tripods suspended by cord, seemed to hover in space, adding to the gallery's gravity-defying atmosphere. For an automatic-display or kinetic gallery, Kiesler designed various mechanisms that incorporated dynamic movement and allowed the viewing of art in limited space: an automatically activated, enclosed conveyor belt spotlighting individual Klee paintings at prescribed intervals, which the viewer could override by pushing a button; a giant wheel controlling the rotation of works from Duchamp's *Box in a Valise*, visible through a peephole; and a box with a viewer-controlled diaphragm that opened to reveal Breton's poem-object *Portrait of the Actor A. B.* This corridor area became notorious as the "penny-arcade peep show" section of the gallery,[31] an appropriate appellation since all of these devices involved the spectator in the act of voyeurism. ▬▬ Considered the most unconventional of the spaces, the Surrealist gallery exhibited frameless paintings mounted on "baseball bats"—Kiesler likened them to outstretched arms[32]—that protruded from the curving gumwood walls. A mind-altering experience was created by a tape recording of a roaring train; lights timed to alternately illuminate different sides of the black room further dislocated the visitor. Kiesler's sympathy for Surrealism's bodily metaphors is manifested in his rationale for the lighting, which he installed because "it's dynamic, it pulsates like your blood."[33] The Surrealists created this kind of disorienting environmental installation, an all-encompassing physical experience of surreality, for various exhibitions including the 1938 *Exposition internationale du surréalisme* in Paris and *First Papers of Surrealism*, which opened in New York less than a week before Art of This Century did. Surrealist art's shocking juxtapositions, which could be suggested through automatism, trances, or drugs, were magnified in these environments in which the visitor walked down a lane of macabre street-walking mannequins, trudged through leaves and twigs, used flashlights to see the art in the dark, became entangled in a web of string, or was surrounded by children playing ball. At Art of This Century, the viewer's physical experience was enhanced by a number of devices Kiesler created to respond to the "new aspect of correlating the visitor to the painting,"[34] among them specially designed movable chairs and display stands adjustable to eighteen positions. Although Guggenheim may have attempted to maintain impartiality by having both an abstract and Surrealist gallery in her "museum," most attention was given to Kiesler's surreal effects. Indeed, Art

facing page:
fig. 65 Max Ernst and Peggy Guggenheim in Surrealist gallery at Art of This Century, New York, ca. 1942

fig. 66 Abstract gallery at Art of This Century, 1942

98. Max Ernst
The Forest | La Forêt, 1927–28

99. Max Ernst
The Antipope, December 1941–March 1942

of This Century became known as "that madhouse of surrealism."[35] ▬▬ Art of This Century apparently caused a ripple of anxiety among Solomon Guggenheim's contingent, and the antagonism between the two Guggenheim camps went beyond mere competition for preeminence in the New York art world. During the period in which the two Guggenheim collections were formed, the contemporary art community—artists, collectors, critics, and curators—were struggling to name, categorize, and champion new developments. Rebay's and Guggenheim's rivalry—fueled by their desire to disseminate the art of their time in a particular package—mirrored the concerns of their constituencies. In 1936, the founding director of the Museum of Modern Art, Alfred H. Barr, Jr., had presented the young history of twentieth-century art as an inexorable drive to abstraction, which was divided into two different paths, "non-geometric abstract art," resulting from the strands of Expressionism, Surrealism, and Brancusi, versus "geometric abstract art," evolving from De Stijl and Neo-Plasticism, the Bauhaus, and Constructivism.[36] This scheme of categorization illuminates the nascent paradigm for thinking about modern art, which was at the core of the rivalry between Guggenheim and Rebay. ▬▬ The distinction between their two positions started at the etymological level, as evident in their descriptions of their respective collections. Hilla Rebay used the term "non-objective" to distinguish art that is generated directly from the artist's imagination, yet is not abstract in that it is not derived from the observable world. Surrealism was defined by Breton as "the future resolution of these two states, dream and reality, which are seemingly so contradictory, into a kind of absolute reality, a *surreality*."[37] Guggenheim refused to use the term "non-objective" even to describe the non-Surrealistic portion of her collection, preferring to call those works "non-realistic" or, occasionally, "abstract."[38] ▬▬ Apollonian non-objectivity was intended to illuminate, synthesizing through reason, using music as a model for clarity, and attempting to represent truth; Dionysian Surrealism was obsessed with the irrational and explored nocturnal fantasies and the most debased aspects of culture, whether that meant hunting at a flea market for objects to be "found" or representing excrement in a painting.[39] Non-objective artists strove for integration and synthesis in their work, while Surrealists used violent fragmentation to force a shock of guilty recognition upon the viewer. Vasily Kandinsky, whose ideas influenced Rebay's articulation of non-objectivity, wrote that paintings should appeal to the soul, their colors causing a "spiritual vibration"[40]; Breton, from whom Peggy Guggenheim commissioned an introduction to her collection catalogue, argued that Surrealism should liberate the unconscious and unleash the repressed. ▬▬ Non-objective philosophy focused on the lofty life of the mind in order to transcend corporeality and commune with the cosmos, seemingly conceiving of the body as an impediment. Surrealist art was grounded in the human form, through representing the figure as well as through the viewer's experience of the work of art in relation to his or her own body, which was especially emphasized in movable sculpture and participatory installations. Non-objective intentions were to be taken with dead seriousness, whereas Surrealism was often whimsical and humorous. As Rebay wrote, "The pictures of non-objectivity are the key to a world of unmaterialistic elevation. Educating humanity to respect

and appreciate spiritual worth will unite nations more firmly than any league of nations."[41] She saw her museum as "the Temple of Non-objectivity," while Guggenheim called hers "a research laboratory."[42] The Museum of Non-Objective Painting presented Rebay's idea of unequivocably pure paintings in soothing surroundings—gray velour-covered walls, plush carpeting, incense, and piped-in Bach. Guggenheim, on the contrary, mounted exhibitions such as *Natural, Insane, Surrealist Art*, in which she displayed driftwood, roots, and jawbone fragments (with teeth) in her cacophonous gallery, with its recorded train noise and flashing lights. ▬▬▬ Rebay refused to include sculpture in the collection of the Museum of Non-Objective Painting, while the subtitle of Guggenheim's catalogue reads *Objects-Drawings-Photographs-Paintings-Sculpture-Collages 1910 to 1942*.[43] Sculpture was too corporeal for Rebay's brand of non-objectivity. It could never transcend its material limitations and privilege the sublime realm of the higher faculties.[44]

Just as she had done in London, Guggenheim brought a number of firsts to New York: she held the premier exhibition of Arp's work and the first international collage show, just as she had mounted the first Kandinsky exhibition in London, among others. But she is perhaps best known for her financial subsidization and exhibition of the nascent New York School of Abstract Expressionists, giving solo shows to William Baziotes, David Hare, Hans Hofmann, Robert Motherwell, Jackson Pollock, Mark Rothko, and Clyfford Still, many of whom came of age as artists under Surrealism's influence. In fact, Guggenheim felt that her promotion of Pollock was her "most honorable achievement."[45] In 1981, Lee Krasner summarized Guggenheim's accomplishment: "Art of This Century was of the utmost importance as the first place where the New York School could be seen.... Her Gallery was the foundation, it's where it all started to happen. There was nowhere else in New York where one could expect an open-minded reaction. Peggy was invaluable in founding and creating what she did." In a 1977 interview, Hare remarked: "There were only three places in New York during the early 1940s: Julien Levy, Pierre Matisse, and Peggy. She was the only one who showed contemporary Americans: of course she was important. She gave people a chance to show, to see, to be seen ... she supported you, and it was vital."[46] ▬▬▬ Guggenheim envisioned "serving the future instead of recording the past,"[47] and with this mandate she exhibited the work of many young, undiscovered artists. While a number of these painters and sculptors gained lasting prominence, others have been forgotten or lost to history. Guggenheim set a precedent for showing the work of women in her gallery in London, which she continued in New York: almost 40 percent of the artists who exhibited at Art of This Century were female, and more than one-quarter of the solo shows were devoted to women. Many of these artists, however, are unknown today.[48] Among those Guggenheim exhibited who remain familiar are Louise Bourgeois, Leonora Carrington, Léonor Fini, Frida Kahlo, Louise Nevelson, Meret Oppenheim, and Dorothea Tanning. Despite well-known uncharitable statements about women, Guggenheim had long supported their artistic endeavors. She gave novelist Djuna Barnes a monthly stipend throughout her life and provided for Barnes in her will; she helped poet

and artist Mina Loy with a number of ventures; and she lent Berenice Abbott the money to open her first photography studio. ▬▬▬ Guggenheim held two exhibitions at Art of This Century devoted exclusively to the work of female artists. The juried *Exhibition by 31 Women*, the third show at the newly opened gallery, caused one journalist to remark, "Already this gallery is living up to its promise of uncovering troublesome new talents."[49] The second exhibition, *The Women*, took place at the end of the gallery's third season. A sampling of the reviews indicates the climate within which both shows were received. One journalist condescendingly suggested that "other all-female organizations should look in" on the exhibition; while another used cooking metaphors to describe the "giggly" endeavors of the group.[50] Much attention was given to the inclusion of Gypsy Rose Lee's surrealistic collage box construction, and many snipes connecting striptease, Eros, and art were made.[51] The typical reviewer used the occasion to disparage women artists—such as referring to the participants as the wives of famous artists—and to criticize Surrealism. One critic wrote: "Surrealism is about 70 percent hysterics, 20 percent literature, 5 percent good painting and 5 per cent is just saying 'boo' to the innocent public. There are . . . plenty of men among the New York neurotics but . . . still more women among them. Considering the statistics the doctors hand out, and considering the percentages listed above . . . it is obvious the women ought to excel at surrealism. At all events, they do."[52] ▬▬▬ Although Guggenheim's and her advisers' intentions may have been admirable, the ghettoization of women into exhibitions designated by the artists' sex rather than the nature of their art may have facilitated the journalists' focus on gender, rather than production. Georgia O'Keeffe, for one, sensed the disadvantages of a women's exhibition when she icily informed Peggy Guggenheim, "I am not a woman painter."[53] Guggenheim participated in the Surrealist's separatist categories in mounting the shows just discussed, as well as *Exhibition of Paintings and Drawings by Children*, *The Negro in American Life* (an exhibition of photographs of, not by, black Americans), and *Natural, Insane, Surrealist Art*, which perpetuated the axiomatic position of sane white adult males—who were not themselves categorized—as the standard from which the "others" diverged.[54] Nevertheless, Guggenheim regularly integrated the work of women into the group exhibitions at Art of This Century, and devoted solo shows to female artists, some of whom were important figures in the New York art world, among them Irene Rice Pereira, Janet Sobel, and Hedda Sterne. She also collected the work of women artists—including Fini's *The Shepherdess of the Sphinxes* (1941, fig. 67)—though much of this art was given away or sold over the years.[55]

As World War II drew to a close, Guggenheim yearned to return to Europe, which she had always preferred to the United States. Eventually settling in Venice, she brought to the city a wealth of art barely known in Italy, just as she had enlivened London's cultural backwater, and then New York's. In all of these places, she was subjected to the uncomprehending criticism of local guardians of conservative standards: in London, the director of the Tate Gallery denied that the sculptures arriving for one of her exhibitions were art, permitting British customs officials to tax them as raw

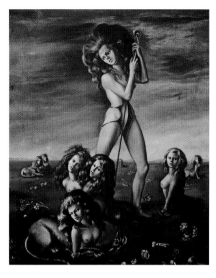

fig. 67 Leonor Fini, *The Shepherdess of the Sphinxes*, 1941. Oil on canvas, 46.2 x 38.2 cm. Peggy Guggenheim Collection, Venice 76.2553.118

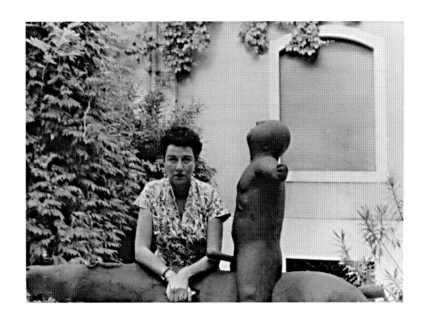

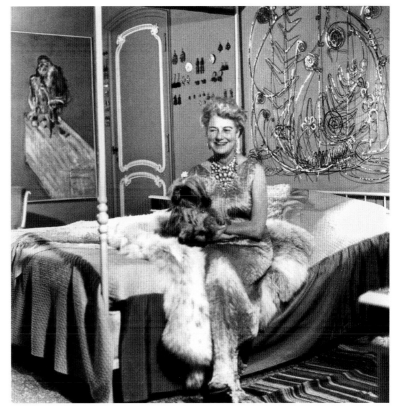

fig. 68 Peggy Guggenheim with Marino
Marini's *The Angel of the City*
(1948, cast 1950?)

fig. 69 Peggy Guggenheim on her bed with
Alexander Calder's *Silver Bedhead* (1945–46)

material[56]; in New York, supporters of domestic realist painting considered Surrealism to have "an unwholesome, if not pernicious, influence" on American art[57]; and in Italy, local officials rejected what they deemed her "arte degenerata" the day before her collection was slated to travel to Turin for an exhibition.[58] ▬▬ In Venice, Guggenheim raised eyebrows, as usual, for her profligate behavior. She bought a palazzo with an infamous past to house her collection, held court with an endless parade of celebrities, and generally behaved with her trademark wanton abandon. She continued to collect art, supporting local emerging artists as she had in London and New York. One of her most prized acquisitions was a sculpture of an ecstatic man on horseback, Marino Marini's *The Angel of the City* (1948, cast 1950?), which she placed prominently at the canal entrance to the house. The conspicuous, erect phallus of the rider was detachable—Guggenheim removed it on holy days in deference to the nuns who passed before the palazzo in floating processions, initiating rumors that she had replacement parts of various sizes.[59] A prized snapshot for tourists, the sculpture became a mascot for Guggenheim and her collection (see fig. 68). ▬▬ In Venice, she finally established the museum that had been her goal since 1939—the Peggy Guggenheim Collection—entertaining the hoards who came to look both at her Surrealist art and the marvelous woman who had brought it together. One of her favorite poses for photographs epitomizes Peggy Guggenheim's self-presentation as a fabulous, surreal woman: in it the collector is captured wearing a slinky Fortuny sheath in her boudoir, surrounded by her Alexander Calder marine headboard and her numerous earrings mounted on the wall as trophies of a modern fetishist (fig. 69).

NOTES

1. Peggy Guggenheim, *Out of This Century: Confessions of an Art Addict* (London: André Deutsch Limited, 1979), p. 171.

2. Ibid., p. 209.

3. Ibid., p. 214.

4. Quoted in John H. Davis, *The Guggenheims: An American Epic* (New York: William Morrow and Company, 1978), p. 434.

5. Davis, p. 408. He also mentions that Guggenheim claimed she slept with one thousand men before her younger sister Hazel reached that number only because she had "started earlier." When her autobiography *Out of This Century* was published in 1946, reviewers called Guggenheim "nymphomaniacal" and "'an urge on wheels' in quest of an 'orgasm a day.'" In addition, Herbert Read compared her to Casanova (all in Jacqueline Bograd Weld, *Peggy: The Wayward Guggenheim* [New York: E. P. Dutton, 1986], pp. 346–48 [note the adjective of the title]). Aline B. Saarinen called her "the appasionata of the avant-garde" in *The Proud Possessors* (New York: Random House, 1958), pp. 326–43.

6. My discussion is indebted to Whitney Chadwick, *Women Artists and the Surrealist Movement* (Boston: Little, Brown and Company, 1985). Chadwick (pp. 13–65) discusses the contradictions and discrepancies between Breton's stated goals and real actions vis-à-vis women. For an example of Breton's symptomatic attitude toward the female artist, note his characterization of Frida Kahlo as "a young woman endowed with all the gifts of seduction, one accustomed to the company of men of genius" (quoted in Chadwick, p. 87). Breton's goal was not so much the bettering of women's daily lives, but rather reducing competing demands so as to foster their undistracted concentration on the male genius. See also Tyler Stovall, "Paris in the Age of Anxiety," in Sidra Stich, *Anxious Visions: Surrealist Art*, exh. cat. (Berkeley: University Art Museum; New York: Abbeville Press, 1990), p. 214.

7. See Sigmund Freud, "Delusions and Dreams in Jensen's *Gradiva*," in *The Standard Edition of the Complete Psychological Works of Sigmund Freud*, vol. 9, ed. and trans. James Strachey (London: Hogarth Press, 1959), pp. 3–93.

8. See Chadwick, *Women Artists*, pp. 50–55; and also Chadwick, "Masson's *Gradiva*: The Metamorphosis of a Surrealist Myth," *Art Bulletin* 52 (Dec. 1970), pp. 415–22.

9. One example of this thinking is Alfred H. Barr, Jr.'s comment in his exhibition catalogue *Cubism and Abstract Art* (New York: Museum of Modern Art, 1936, p. 179) that the Surrealist artists "turned, rather, to primitive art as a revelation of unspoiled group expression and to the art of the insane and of children as the uninhibited expression of the individual."

10. Another masculine example is Marcel Duchamp's alter ego Rrose Sélavy. I would argue that the male artist's persona has been perceived as separate from his costume or disguise, while the female artist's identity has been derived from, or presumed to be equivalent to, the costume. In support of this assumption, note references to women's appearances in Surrealist histories, for example, Marcel Jean, with Arpad Mezei, *The History of Surrealist Painting*, trans. Simon Watson Taylor (New York: Grove Press, 1960), p. 280; as well as reproductions of photographs *of* female artists rather than works *by* them (see, for example, the entries on artists in Erika Billeter and José Pierre, *La Femme et le surréalisme*, exh. cat. [Lausanne: Musée Cantonal des Beaux-Arts, 1987]; and *La Femme surréaliste*, special issue of *Obliques* [Paris], nos. 14–15 [Oct.–Dec. 1977]). The female artist also takes on a costume or disguise as a conscious artistic gesture. A theoretical model for this reading can be found in Mary Ann Doane, "Film and the Masquerade: Theorizing the Female Spectator," in *Femme Fatales: Feminism, Film Theory, Psychoanalysis* (New York: Routledge, 1991), pp. 17–32.

11. Kahlo and Léonor Fini are just two of the Surrealists whose self-portraits and self-presentation suggest consciously created personas. Guggenheim respected both artists' work, if not Fini's "vedette manner." See Guggenheim, *Out of This Century*, pp. 235, 359. Fini's *The Shepherdess of the Sphinxes* (1941, fig. 67) was exhibited at Peggy Guggenheim's Art of This Century gallery.

12. Weld (p. 158) writes, "Peggy stood out in the crowd, gotten up in wild, extravagant, and often grotesque jewelry and dramatic, if not flattering, outfits." See also the description of Guggenheim and her party guests on p. 255. The first chapter of Guggenheim's autobiography is devoted to a review of her forebears' eccentricities. She begins (p. 2) with a comment about her grandfather, "Most of his children were peculiar, if not mad." She then outlines various strange behaviors: her aunt was a compulsive consumer of Lysol; an uncle chewed charcoal; another attempted to murder his family. Crimes of passion always fascinated the Surrealists. Two of the infant children of Guggenheim's sister Hazel apparently died under such circumstances (Weld, "Medea," pp. 78–81). According to Guggenheim, Tanguy called her sister "La Noisette" (Guggenheim, *Out of This Century*, p. 181).

13. See Elizabeth M. Legge, *Max Ernst: The Psychoanalytic Sources* (Ann Arbor, Mich.: UMI Research Press, 1989).

14. Peggy Guggenheim owned *The Child Carburetor* in the early 1940s. It is now in the collection of the Solomon R. Guggenheim Museum. For its provenance, see Angelica Zander Rudenstine, *The Guggenheim Museum Collection Paintings 1880–1945*, vol. 2 (New York: Solomon R. Guggenheim Foundation, 1976), p. 591.

15. Harold Foss Foster mentions this ambivalence in his discussion of the machinistic work of Duchamp, Ernst, and Picabia in "Surrealism in the Service of Psychoanalysis: A Reading of the Surreal as the Uncanny," unpublished Ph.D. dissertation, City University of New York, 1990, p. 169.

16. Guggenheim bought the painting from Mesens in London in 1938; see Angelica Zander Rudenstine, *Peggy Guggenheim Collection, Venice: The Solomon R. Guggenheim Foundation* (New York: Harry N. Abrams; Solomon R. Guggenheim Foundation, 1985), p. 215. In *Out of This Century* (p. 191), she recalled sleeping with Penrose under a similar Delvaux: "I was so thrilled; I felt as though I were one of the women."

17. That the voyeur is male is known from two preparatory drawings. See Rudenstine, *Peggy Guggenheim Collection, Venice*, pp. 624–25.

18. While in the fables of Diana and Susanna the perpetrators are punished, paintings usually downplay or ignore that episode of the stories.

19. See Sigmund Freud, "Medusa's Head," in *The Standard Edition of the Complete Psychological Works of Sigmund Freud*, vol. 18, pp. 273–74, and "Fetishism," in vol. 21, pp. 152–57.

20. Quoted in Melvin P. Lader, "Peggy Guggenheim's Art of This Century: The Surrealist Milieu and the American Avant-Garde, 1942–1947," Ph.D. dissertation, University of Delaware (available from University Microfilms International, Ann Arbor, Mich.), 1981, p. 26.

21. The various versions of Brancusi's *Princess X* and *Torso of a Young Man* are archetypal examples of fetishistic sculpture, which were considered obscene representations of penises when first shown. They both present the female form as phallic, supporting a Lacanian reading. Psychoanalyst Jacques Lacan, who associated with the Surrealists both professionally and personally, argued that woman herself represents the phallus (see Lacan, "The Meaning of the Phallus," in *Feminine Sexuality: Jacques Lacan and the école freudienne*, ed. Juliet Mitchell and Jacqueline Rose, trans. Rose [New York: W. W. Norton & Company; Pantheon Books, 1985], pp. 74–85).

22. See Susan Rubin Suleiman's analysis of transgression as a modernist literary device in her *Subversive Intent: Gender, Politics, and the Avant-Garde* (Cambridge: Harvard University Press, 1990), pp. 72–87.

23. See Rosalind Krauss's interpretation in "Giacometti," in *"Primitivism" in 20th Century Art*, vol. 2, ed. William Rubin, exh. cat. (New York: Museum of Modern Art, 1984), pp. 503–33.

24. Rudenstine, *Peggy Guggenheim Collection, Venice*, pp. 198–205, identifies the various figures in the painting and their relationship to Dalí's obsession with the Freudian conceptualization of castration and impotence.

25. Guggenheim, *Out of This Century*, pp. 261–62.

26. See Rudenstine, *Peggy Guggenheim Collection, Venice*, pp. 312–18, for the quote as well as an interpretation of the painting. On Guggenheim's first visit to Ernst's studio, in the winter of 1938–39, she purchased a work by Carrington, *The Horses of Lord Candlestick*, rather than one by Ernst (Guggenheim, *Out of This Century*, p. 216; this painting is no longer in the collection). In Ernst's *Attirement of the Bride* (1940, Peggy Guggenheim Collection), the bride (who has been associated with Carrington) wears a red-orange feathered cape reminiscent of Ernst's costume in Carrington's *Portrait of Max Ernst* (ca. 1939; see color plate 20 in Chadwick).

27. Guggenheim, quoted in Adelaide Kerr, "In House That Peggy Built, Paintings Dangle From the Ceiling, and the Walls Often Curve," *Times Dispatch* (Richmond, Va.), November 2, 1942.

28. Guggenheim, *Out of This Century*, p. 270.

29. Joan M. Lukach notes that Guggenheim's gallery name implied "a direct challenge to Uncle Solomon's 'Art of Tomorrow'" (part of Solomon Guggenheim's collection was exhibited in the 1939 show *Art of Tomorrow* at his Fifty-fourth Street museum). See Lukach, *Hilla Rebay: In Search of the Spirit in Art* (New York: George Braziller, 1983), p. 155. In *A Not-So-Still Life* (New York: St. Martin's/Marek, 1984, pp. 224–25), Jimmy Ernst, Max's son, claims that, through artists employed at "the 'Rebay' museum," he learned that Hilla Rebay was "interfering with Peggy's New York plans by threatening likely real estate firms if they cooperated with us in the search for a gallery location anywhere in midtown Manhattan."

30. For descriptions, see Cynthia Goodman, "Frederick Kiesler: Designs for Peggy Guggenheim's Art of This Century Gallery," *Arts* 51 (June 1977), pp. 90–95; Lader, pp. 115–25; Rudenstine, *Peggy Guggenheim Collection, Venice*, pp. 762–70; and Goodman, "The Art of Revolutionary Display Techniques," in Lisa Phillips, *Frederick Kiesler*, exh. cat. (New York: Whitney Museum of American Art in association with W. W. Norton & Company, 1989), pp. 57–83.

31. "Isms Rampant: Peggy Guggenheim's Dream World Goes Abstract, Cubist, and Generally Non-Real," *Newsweek*, November 2, 1942, p. 66. Goodman, "Frederick Kiesler," p. 94, notes the aptness of the peep-show analogy since Kiesler had been explicitly incorporating aspects of this mode of presentation in his work since the 1920s.

32. Goodman, "Frederick Kiesler," p. 93.

33. Quoted in "Isms Rampant," p. 66.

34. Goodman, "Frederick Kiesler," p. 93.

35. Gallery notice in *Cue*, January 16, 1943. Goodman, "Frederick Kiesler," p. 92, states that "Kiesler's design for Art of This Century was the major Surrealist architectural project built in the United States."

36. Barr's influential catalogue *Cubism and Abstract Art* included on its jacket an esoteric chart diagramming the diffusion of influence in early twentieth-century art. He extended this paradigm through the face-off of two important 1936 exhibitions, the aforementioned *Cubism and Abstract Art* and its antipode *Fantastic Art, Dada, Surrealism*. In the catalogue *Fantastic Art, Dada, Surrealism* (Alfred H. Barr, Jr., ed., exh. cat. [New York: Museum of Modern Art, 1936], p. 9), Barr wrote, "*Cubism and Abstract Art*, was, as it happens, diametrically opposed in both spirit and esthetic principles" to *Fantastic Art, Dada, Surrealism*. In Barr's framework, Surrealism, a secondary phenomenon, was subsumed under abstract art, not vice versa. Within Surrealism he made the formal distinction between automatic and dream painting, privileging the former.

37. André Breton, *Manifesto of Surrealism*, in *Manifestoes of Surrealism*, trans. Richard Seaver and Helen R. Lane (Ann Arbor: University of Michigan Press, 1969), p. 14. Rebay objected to Breton's conceptualization of reality when she stated, "Surrealism came in only recently, through such painters who invented this senseless title to stupefy the public. (Realism cannot be unearthly)." See Rebay, "The Beauty of Non-Objectivity," in *Solomon R. Guggenheim Collection of Non-Objective Paintings: Second Enlarged Catalogue*, exh. cat., Philadelphia Art Alliance (New York: Solomon R. Guggenheim Foundation, 1937), p. 8.

38. See, for example, Peggy Guggenheim, ed., *Art of This Century* (New York: Art of This Century, 1942), p. 9; and Guggenheim, *Out of This Century*, p. 276.

39. In *Cubism and Abstract Art* (p. 19), Barr identified Apollo with the lineage of abstraction and Dionysus with the trends resulting in Surrealism.

40. Wassily Kandinsky, *Concerning the Spiritual in Art* (1911), trans. M. T. H. Sadler (New York: Dover Publications, 1977), p. 24. The Solomon R. Guggenheim Foundation published its own translations of *Concerning the Spiritual in Art* and Kandinsky's *Point and Line to Plane* (1926) in 1946 and 1947, respectively. The latter publication was the first translation into English.

41. Hilla Rebay, "Definition of Non-Objective Painting," in *Solomon R. Guggenheim Collection of Non-Objective Paintings*, exh. cat., Gibbes Memorial Art Gallery, Charleston, South Carolina (Charleston: Carolina Art Association, 1936), p. 8. Conversely, she had the gravest doubts about the Surrealists' aspirations: "They effectively put together sensational attractions which are usually of decidedly bad taste" (Rebay, "The Beauty of Non-Objectivity," p. 8).

42. Quoted in Lukach, p. 62, and Lader, p. 126, respectively.

43. Guggenheim, ed., *Art of This Century*, title page.

44. The ethereal work of Alexander Calder was an exception to this injunction.

45. Guggenheim, *Out of This Century*, p. 347. She wrote, p. 303, that Pollock was the "spiritual offspring" of James Johnson Sweeney (who became the Solomon R. Guggenheim Museum's director in 1952) and herself.

46. The gallery was also significant to young American artists because it provided them with unusual access to European works. Motherwell said in 1982: "Peggy's place was unique in several ways. It could be treated as a place to browse, and it was designed to be treated that way. . . . You were invited to take the pictures in your hands—like a print or a book—and move them back and forth so that you could see a line or a surface more clearly in different kinds of light. It was a small place, intimate, and everything was meant to be used, and she felt strongly about that." The Krasner, Hare, and Motherwell quotes are cited in Rudenstine, *Peggy Guggenheim Collection, Venice*, p. 799.

47. October 1942 press release for the opening of Art of This Century, quoted in Lader, p. 126.

48. Only a small portion of this discrepancy can be ascribed to Guggenheim's inclusion of certain artists due to personal rather than professional reasons. In mourning the closing of Peggy's gallery in 1947, Clement Greenberg included a list of important

artists: "Her departure is in my opinion a serious loss to living American art.... In the three or four years of her career as a New York gallery director she gave first showings to more serious new artists than anyone else in the country (Pollock, Hare, Baziotes, Motherwell, Rothko, [Rudolph] Ray, [Robert] De Niro, [Virginia] Admiral, [Marjorie] McKee, and others). I am convinced that Peggy Guggenheim's place in the history of American art will grow larger as time passes and as the artists she encouraged mature" (in *The Nation*, May 31, 1947, quoted in Rudenstine, *Peggy Guggenheim Collection, Venice*, p. 798). It is interesting to note that both women on this list are not well-known. Chadwick's *Women Artists and the Surrealist Movement* acts as a corrective to the lack of notoriety of many of the female Surrealist artists.

49. R. F. [Rosamund Frost], "Thirty-Odd Women," *Art News* 41 (Jan. 15–31, 1943), p. 20.

50. *Art News* 44 (July 1–31, 1945), p. 26; and Robert M. Coates, "The Art Galleries," *New Yorker* 18 (Jan. 15, 1943), p. 56: "Thirty-one ladies ... have got together and cooked up a mess of paintings, collages, constructions, and so on, all highly spiced with surrealism.... The main attraction for many visitors will be the contribution of Gypsy Rose Lee, a sort of collage *en coquille*."

51. For example, Ben Wolf, "Bless Them," *The Art Digest* 19 (July 1, 1945), p. 13: "Gypsy Rose Lee, versatile daughter of Eros, originally scheduled to strip her soul in the above company."

52. Henry McBride, "Women Surrealists: They, Too, Know How to Make Your Hair Stand on End," *New York Sun*, January 8, 1943, p. 28.

53. Quoted in Jimmy Ernst, p. 236.

54. In 1939, at Guggenheim Jeune in London, Guggenheim had also held *André Breton Presents Mexican Art*, cited by Weld, p. 446.

55. Guggenheim notes in *Out of This Century*, pp. 344–45, that in 1950 her "basement was stacked with the overflow of" her collection. She mentions Virginia Admiral and Janet Sobel in the list of artists whose work she bought at Art of This Century shows, thus filling her cellar.

56. See Guggenheim, *Out of This Century*, pp. 172, 174; and Rudenstine, *Peggy Guggenheim Collection, Venice*, p. 750. The decision was eventually overturned after significant protest was voiced.

57. Painter George Biddle, quoted in Lader, pp. 78–79.

58. See Weld, p. 368; and Guggenheim, *Out of This Century*, pp. 330, 374.

59. Guggenheim, *Out of This Century*, pp. 334–35. Weld, p. 375, notes that eventually a phallus was permanently attached after the removable one was stolen.

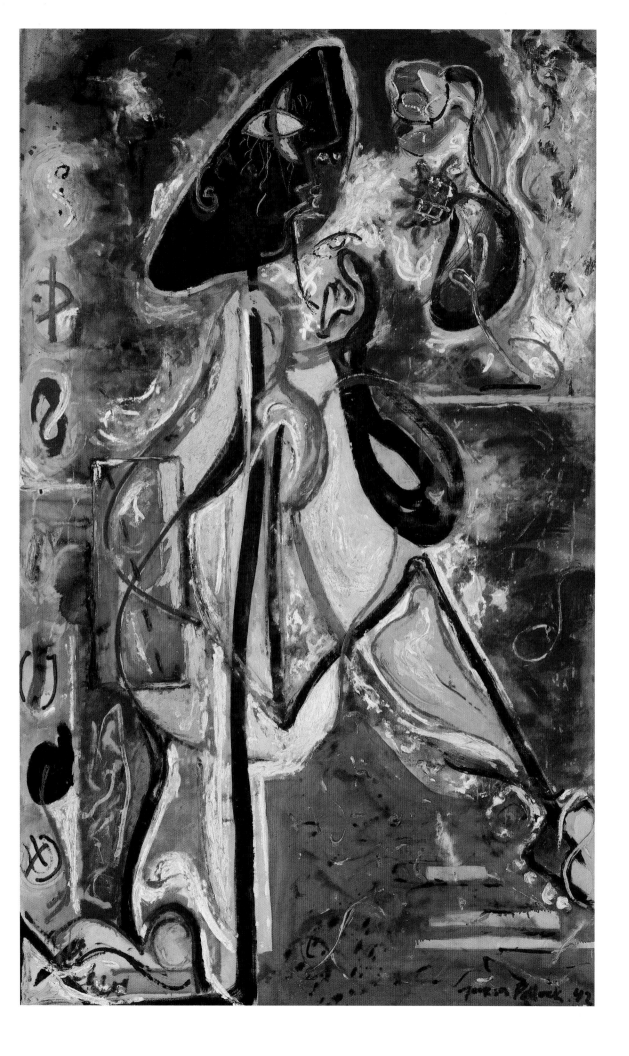

DIANE WALDMAN

Art of this Century and the New York School

In March 1939, a year and a half after she opened the Guggenheim Jeune gallery in London, Peggy Guggenheim decided to found a museum of modern art. She persuaded Herbert Read, a prominent critic and art historian, to give up his job as editor of *Burlington Magazine* and become the museum's director. Plans for an autumn opening were well under way when World War II erupted. Concerned about her collection, which included works by Robert Delaunay, Vasily Kandinsky, Paul Klee, André Masson, Joan Miró, and Pablo Picasso, among others, Guggenheim stored it for a brief period in Grenoble, France; in July 1941, she brought it to New York, where it became the foundation of a new enterprise—Art of This Century, which was to serve as a museum to display her collection and as a gallery dedicated to introducing artists to the public. Art of This Century opened in October 1942 to great fanfare and was an instantaneous, if controversial, success. It featured sensational spaces designed by the Romanian-born architect and designer Frederick Kiesler, a participant in the De Stijl movement, who had been brought to her attention by Howard Putzel. Putzel, a West Coast art dealer, was one of several people who advised her on her collection (the others being André Breton, Marcel Duchamp, Max Ernst, and Nellie van Doesburg, the widow of Theo van Doesburg). Kiesler installed the collection in two main galleries, one for Surrealism, the other for abstract and Cubist art. Unframed Surrealist paintings jutted out on baseball bats from curved walls, while the abstract and Cubist works were suspended on cords. Each gallery contained biomorphic-shaped wooden furniture, which Kiesler designed to be used for multiple purposes, including seating for visitors and pedestals for sculpture. ▬▬▬ The opening of Peggy Guggenheim's gallery and the presence in New York of legendary European painters and poets—such as Breton, Ernst, Masson, and the many others who had fled Europe because of the war—gave young, unrecognized American artists a taste of the heady international scene that prevailed in Paris before the war. Robert Motherwell, who met Guggenheim shortly after she opened her New York gallery, said that it was he who introduced her to William Baziotes. They and their colleague Jackson Pollock were invited by Guggenheim to participate in her *Exhibition of Collage*, which was held at the gallery from April 16 to May 15, 1943, although none had worked in the medium before. Baziotes made a collage entitled *The Drugged Balloonist* (now in the collection of the Baltimore Museum of Art) for the show, but the work remains an exception in his oeuvre. Motherwell recalled that he and Pollock worked together on collage in Pollock's studio and that "Pollock became more and more tense and vehement as he tore up papers, pasted them down, even burned their edges, splashed paint over everything, quite

facing page:
100. Jackson Pollock
The Moon Woman, 1942

literally like something in a state of trance."[1] While Pollock incorporated elements of collage in his drawings and paintings that postdate the exhibition, he produced relatively few independent works in that medium. Motherwell, however, went on to develop a substantial body of collages that, like his paintings, are poetic, sensual, and passionate. Many of the great themes that he developed in his paintings first began to take shape in the collages he produced beginning in 1943, such as *Personage (Autoportrait)* (1943, fig. 71). Collage became an integral part of Motherwell's oeuvre, separate in intent and meaning from his equally formidable paintings. ■■■■ In London before the war, Read had planned to hold a "Spring Salon" to encourage new talent. Peggy revived the concept for her New York gallery and selected a jury of such notable figures as artists Duchamp and Piet Mondrian; museum directors Alfred H. Barr, Jr., James Thrall Soby, and James Johnson Sweeney; Putzel; and herself. The first *Spring Salon for Young Artists* was held from May 18 to June 26, 1943, and included Baziotes, Matta, Motherwell, and Ad Reinhardt, among others. Persuaded by Mondrian that the young Pollock showed talent, and encouraged by Matta and Putzel, she offered him a one-year contract with the gallery; he would receive a modest stipend in exchange for work. Guggenheim also commissioned Pollock to paint a mural for her home, and thus provided him and his artist wife, Lee Krasner, with vital financial support during a difficult period in their lives. Guggenheim considered Baziotes, Motherwell, and Pollock the outstanding artists in the first *Spring Salon*. Between 1943 and 1946, she gave solo exhibitions to them as well as to other important Americans, including Mark Rothko and Clyfford Still. Guggenheim purchased work from these exhibitions and added an impressive collection of younger American painters and sculptors to her already substantial collection of European modern art. Her reputation for acquiring vast amounts of art in a short period of time was infamous. In her autobiography—first published as *Out of This Century: The Informal Memoirs of Peggy Guggenheim* in 1946—Guggenheim stated that when she lived in Paris in 1940, she set out to acquire a painting a day. Her appetite for art continued unabated in New York, as did her proclivity for moving in the fast lanes of the avant-garde.[2] Although she closed her gallery in May 1947 to return to Europe, Art of This Century filled a void at a critical time in the history of American art. ■■■■ Prior to Peggy Guggenheim's arrival, the New York art scene was in flux. Many of the younger Americans working in New York during the Depression years practiced a form of figuration known as Social Realism. Others were members of the American Abstract Artists, an association founded in New York in 1936 and dedicated to the principles of European geometric abstraction, in particular the work of Mondrian and the De Stijl movement; the association gained added prestige from Mondrian's presence in New York from 1940 until his death in 1944. Neither the politically and socially oriented Depression-era American-scene painting, which depicted the downtrodden urban masses and glorified rural life, nor the programmatic non-objective painting of the American Abstract Artists proved to have a lasting effect on the young American avant-garde working for the most part in New York City. Instead, they were increasingly impressed by two of this century's most important European movements, Cubism and Surrealism. The Cubist innovations of

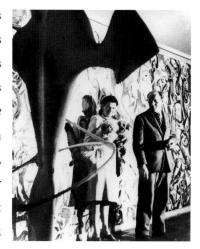

fig. 70 Peggy Guggenheim and Jackson Pollock, 1943

fig. 71 Robert Motherwell, *Personage (Autoportrait)*, December 9, 1943. Paper collage, gouache, and ink on board, 103.8 x 65.9 cm. Peggy Guggenheim Collection, Venice 76.2553.155

Picasso and Georges Braque were a particular source of inspiration. The Cubists' fragmentation of the figure and their emphasis on compressing volume into two-dimensional space had a great impact on the Americans, who were historically predisposed to flatness and frontality. However, it was the Surrealists who gained in importance, when many of the movement's leading figures, among them Breton, Ernst, Masson, and Matta took up residence in New York. Their active involvement in the New York art scene, their zealous commitment to the subconscious, and their belief in automatism (the suspension of the conscious mind in order to release subconscious imagery) influenced virtually every major painter and sculptor of the New York School. For the fledgling Americans it was an exhilarating time, which gave them the freedom and challenge they needed to invent a brilliant new American art. ▬▬▬ The Surrealist influence on the young American artists began to emerge in the early 1930s and grew in importance throughout the decade. As early as November 1931, the first significant Surrealist exhibition, *Newer Super-Realism*, was organized by A. Everett ("Chick") Austin, Jr. at the Wadsworth Atheneum in Hartford, Connecticut. The dealer Julien Levy showed some of the same works as the Wadsworth had in an exhibition entitled *Surréalisme* at his New York gallery in January 1932. Levy played a major role in establishing the movement in New York, presenting its leading figures throughout the 1930s and publishing the anthology *Surrealism* in 1936. That same year, Alfred H. Barr, Jr. presented the historic exhibition *Fantastic Art, Dada, Surrealism* at the Museum of Modern Art in New York. ▬▬▬ For Joseph Cornell and Arshile Gorky, Americans who were influenced by Surrealism in the early 1930s, the presence of the Surrealist artists and poets in exile in New York during the war years was particularly significant: the personal encouragement of Breton and others was invaluable to them at a critical time in their careers. Cornell's *Swiss Shoot-the-Chutes* (1941, fig. 72), like many of his box constructions, combines the Surrealists' fondness for chance with strange and unexpected juxtapositions of objects. Of all of the Americans, it was Cornell who most faithfully subscribed to the writings of a major Surrealist precursor, the Comte de Lautréamont. "Beautiful as the fortuitous meeting, on a dissection table, of a sewing machine and an umbrella,"[3] the celebrated passage from Lautréamont's fantasy novel *Les Chants de Maldoror* (1874), was interpreted by Cornell in his collages and box constructions. Yet while utilizing the Surrealist technique of disorientation in time and space, suggested by the random juxtaposition of objects and images, Cornell's box constructions of this period also reveal a disarming naïveté entirely at odds with the black humor and disturbing, often grotesque effects deliberately cultivated by many of the Surrealist painters and poets. Moreover, his appreciation of other European modernists like Mondrian and his fondness for the trompe-l'oeil still lifes of the nineteenth-century American painter William Harnett helped give his work its distinctive quality and separated him from mainstream Surrealism. ▬▬▬ Although Surrealist imagery, with its sexually charged subject matter and ambiguous thematic content, figured prominently in the work of Willem de Kooning, Motherwell, Pollock, and others, it was the

fig. 72 Joseph Cornell, *Swiss Shoot-the-Chutes*, 1941. Box construction, 53.8 x 35.2 x 10.5 cm. Peggy Guggenheim Collection, Venice 76.2553.127

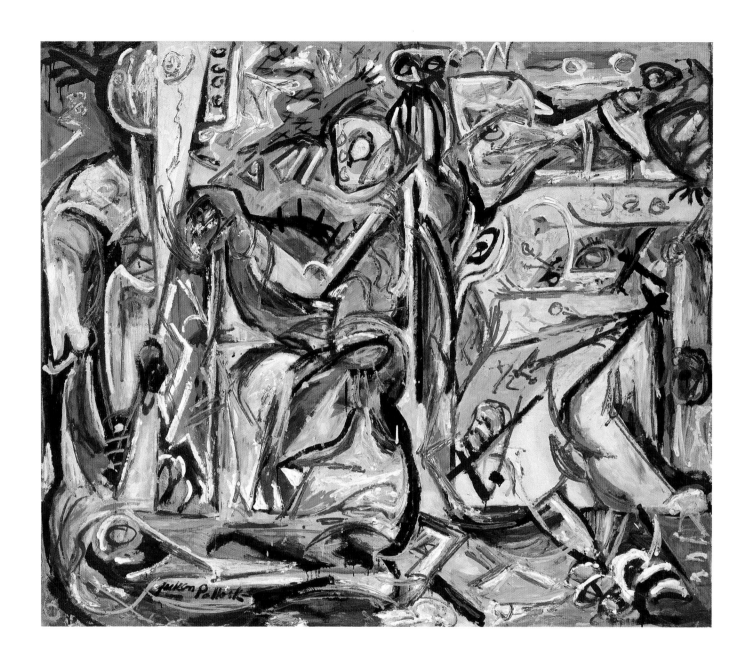

101. Jackson Pollock
Circumcision, January 1946

facing page:
102. Jackson Pollock
Enchanted Forest, 1947

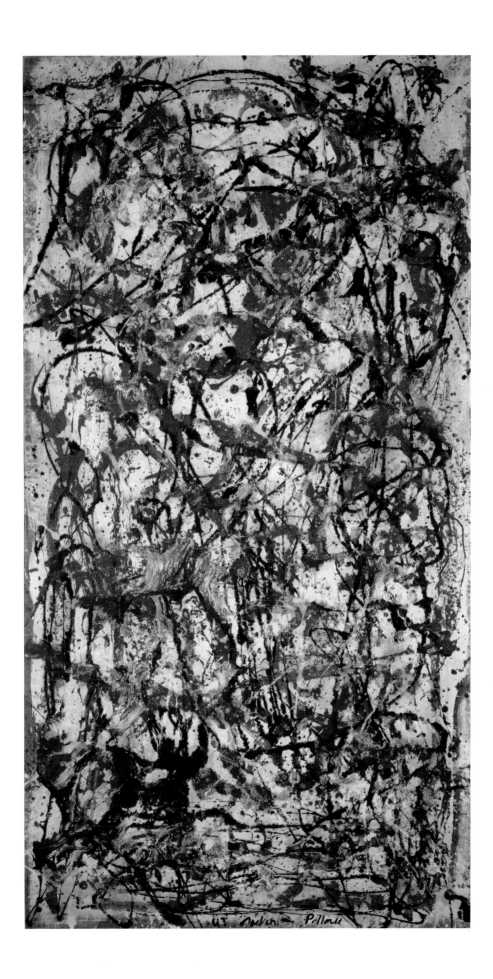

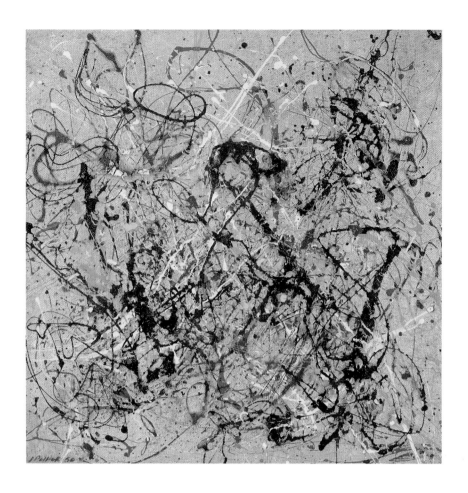

103. Jackson Pollock
Number 18, 1950

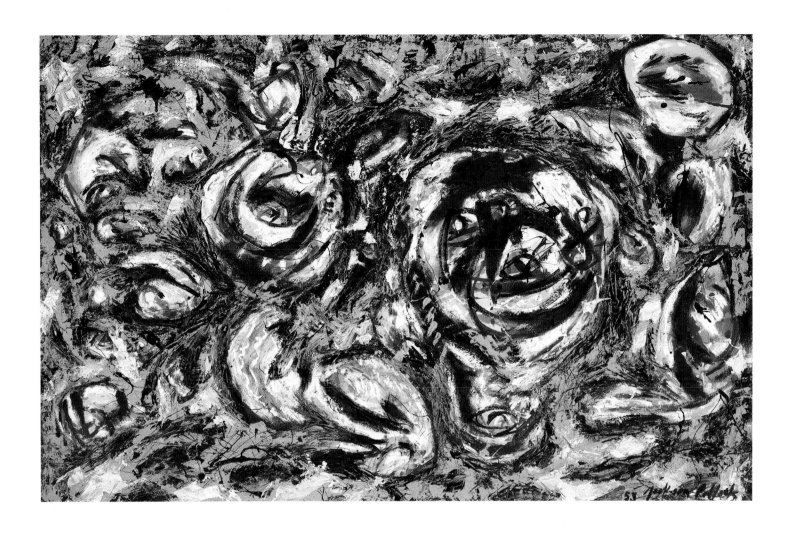

104. Jackson Pollock
Ocean Greyness, 1953

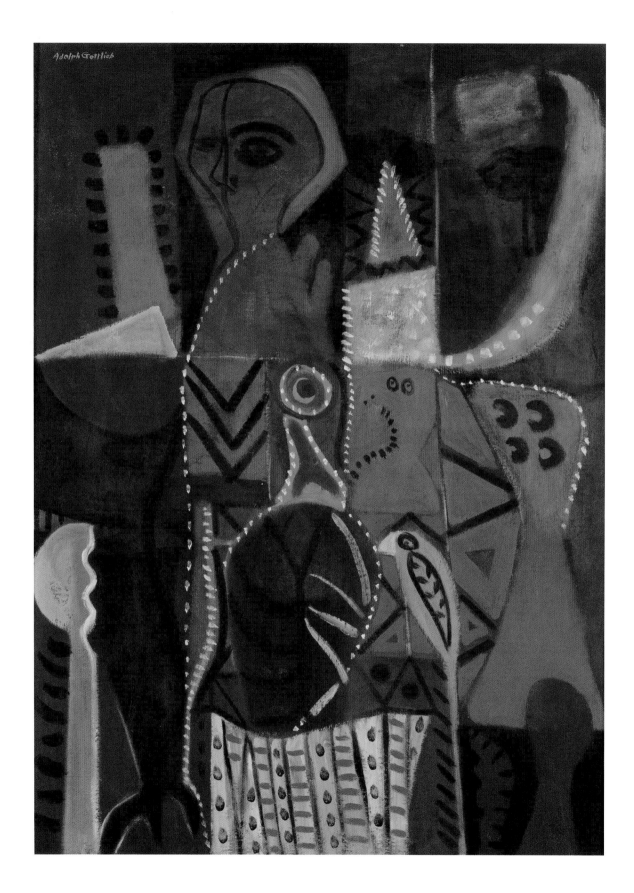

105. Adolph Gottlieb
The Red Bird, 1944

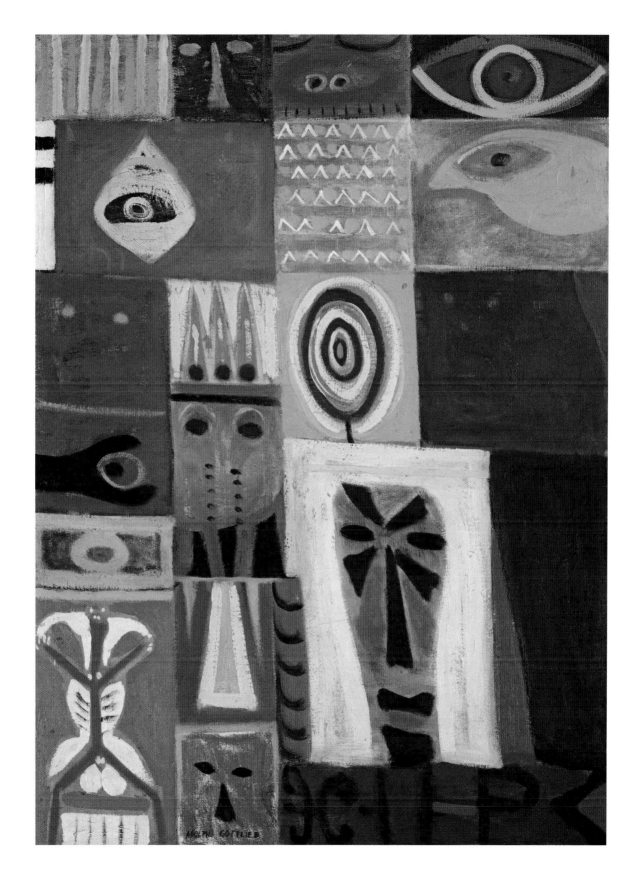

Surrealists' concept of automatism that radically altered the course of American art. Automatism, linked with Freudian notions of the subconscious, liberated the Abstract Expressionists from the external world of objective reality and freed them to explore in their own work the irrational, chance, and accident. Unlike the Surrealists, who remained committed to representation, narrative, and illusionism, many of the Abstract Expressionists used automatism as their point of departure in the formation of a radical new abstract imagery. Automatism made it possible for them to transcend representational subject matter, consolidate process and end product, and fuse inner vision and external phenomena. ▬▬ Gorky, too, made effective use of the Surrealist idiom, often linking sexually symbolic imagery with automatic drawing or painting. *Untitled* (1944, fig. 73) is in many ways different from his more painterly canvases. Here, Gorky adapted his leanest style to canvas, using a sort of rude drawing and giving scant attention to detail or exquisite effects. Line is urgent and abrupt in *Untitled*, while in many drawings and paintings of the period it is full of liquid grace; there is anger and defiance in the work, while in others there is harmony. Of this and related paintings of the same year, Gorky said, "Any time I was ready to make a line somewhere, I put it somewhere else. And it was always better."[4] *Untitled* is a tough and demanding work in which Gorky begins to explore line in a manner that anticipates by several years Pollock's allover imagery. ▬▬ Pollock's paintings of 1938–41 are filled with images of snakes, skulls, and plant and animal forms. An important image favored by him was the eye, which figures prominently in such paintings as *The Moon Woman* (1942, plate 100). Pollock's usage of eye imagery indicates his familiarity with its role in Surrealist iconography and Jungian philosophy as a symbol of the union between inner and external states of being. (The artist was in Jungian analysis for eighteen months beginning in 1939 and continued therapy until 1943.) Pollock continued to use archetypal symbols in the 1940s, as in such paintings as *Circumcision* (January 1946, plate 101). During the winter of 1946–47, Pollock began to drip and pour enamel and aluminum paint onto large unprimed canvases laid out on the floor of his studio. Pollock's drip technique involved his entire body as he circled his canvases, pouring and splashing paint from every direction. His methods eventually led him to favor mural-sized canvases over easel pictures. ▬▬ In his classic drip paintings of 1947–50, such as *Enchanted Forest* (1947, plate 102), Pollock created a sense of continuous movement and an illusion of shallow space that extends behind the picture plane and often laterally beyond the edges of the composition. At the same time, he called attention to the flatness of the field. There is implicit in many later canvases, such as *Ocean Greyness* (1953, plate 104), a vortex motion that may derive from the way in which he worked. This whirling or circular motion occurs despite Pollock's emphasis on flatness, and sets up a tension in many of his best drip paintings that relieves them of the stasis that would otherwise occur as the result of his allover imagery. Pollock used his revolutionary drip technique to capitalize to the utmost on chance and spontaneous effects. His allover drip paintings are remarkable for their powerful, dynamic abstract imagery and large scale. ▬▬ During the early 1940s, Rothko and Adolph Gottlieb also developed a body of archetypal images based upon the

fig. 73 Arshile Gorky, *Untitled*, summer 1944. Oil on canvas, 167 x 178.2 cm. Peggy Guggenheim Collection, Venice 76.2553.152

fig. 74 Mark Rothko, *Sacrifice*, April 1946. Watercolor, gouache, and india ink on paper, 100.2 x 65.8 cm. Peggy Guggenheim Collection, Venice 76.2553.154

Jungian theory of the collective unconscious. Like many of their fellow New York artists, both subscribed to the Surrealist belief in dream imagery and the power of the subconscious to reveal hidden truths. In keeping with these beliefs, Rothko created a series of images that, like *Sacrifice* (1946, fig. 74), indicate his interest in myth. In 1941, Gottlieb began a series of pictographs in which he used a grid pattern derived from Cubist scaffolding, combined with a highly charged vocabulary of signs and symbols. While Rothko was later to shift his emphasis from the visible world and mythic imagery to the inner world of the imagination, Gottlieb continued to employ the grid with its compartments of recognizable motifs throughout the 1940s. During the late 1940s and early 1950s, Gottlieb's work took on an increasingly abstract quality, but he never relinquished his interest in nature and organic phenomena. ▬▬ Certain of Still's works of the 1940s, such as *Jamais* (1944, fig. 75), are classic examples of Surrealist-inspired painting. Although Still ultimately rejected European tradition, the shape, color, and space evident in this canvas became the primary features of his subsequent work, as can be seen in *1948* (1948, fig. 76) and *Untitled* (1964, plate 107). For artists like Motherwell, the Surrealist concept of automatism translated easily into painterly gesture and symbolism. Motherwell's *Elegy to the Spanish Republic No. 110* (Easter Day, 1971, plate 108) is one of a series of nearly two hundred paintings that the artist began in 1948 to celebrate freedom and pay tribute to the Spanish people. Generally, the paintings contain ovoid forms balanced by linear forms, suggesting the female and male, respectively. These bold yet pliable shapes are a manifestation of human life and fragility. ▬▬ In 1946, the critic Robert Coates, writing for *The New Yorker*, used the term "abstract expressionism" to describe the work of some of the New York–based painters. The term stuck but was amplified by others. In 1952, the critic Harold Rosenberg invented the term "action painting" to emphasize the importance of the act of painting. Rosenberg described the canvas as an arena and the image that resulted from the act of painting as an event. Rosenberg wrote that the "new painting has broken down every distinction between art and life."[5] He furthermore believed that action painting was part of an existential experience that led to a struggle for self-creation and a crisis in painting. Self-creation could be achieved by capturing the primary experience, the moment of inspiration. Painting was to be direct, immediate, spontaneous. ▬▬ Although the term "action painting" became too unwieldy to describe artists as diverse in sensibility and method as Cornell and Gorky, de Kooning and Rothko, it is a valid measure of the belief in the creative act born at the moment of inspiration and the unfolding drama that takes place in the arena of painting. Action painting is an outgrowth of the belief in the subconscious and of automatism. The use of automatism as an art-making procedure was first proposed by the Surrealists and later became central to the practice of each of the artists of the New York School. The Abstract Expressionist movement constitutes the first truly international American style. The artists who emerged during this period were challenged by the possibility of forging a new and heroic American art. Their work exemplifies a spirit of adventure and a grandeur of vision unparalleled in earlier

fig. 75 Clyfford Still, *Jamais*, May 1944. Oil on canvas, 165.2 x 82 cm. Peggy Guggenheim Collection, Venice 76.2553.153

fig. 76 Clyfford Still, *1948*, 1948. Oil on canvas, 179.1 x 158.1 cm. Solomon R. Guggenheim Museum, New York, Fractional gift, Barbara and Donald Jonas 92.3986

107. Clyfford Still
Untitled, 1964

109. Mark Rothko
Untitled (Violet, Black, Orange, Yellow on White and Red), 1949

110. Mark Rothko
Untitled (Black on Grey), 1969/1970

twentieth-century American art. ▦ In general terms, two groups emerged whose work defines the period: the first, the action painters like de Kooning, Franz Kline, and Pollock, to whom gesture was essential; the second, the painters Barnett Newman, Rothko, and Still, who used color as metaphor. The painters in the latter group purified their art by rejecting the seductive qualities of paint and by ridding their canvases of complex relationships of color, form, and structure. Two works by Rothko—*Untitled (Violet, Black, Orange, Yellow on White and Red)* (1949, plate 109) and *Untitled (Black on Grey)* (1969/1970, plate 110)—exemplify the tendency among the group to reduce color to its essence and make it become volume, form, space, and light. Having emptied their paintings of the superfluous, these artists were able to express both the material reality of abstract painting and the incorporeal reality of the sublime. ▦ De Kooning is primarily known for his *Women* series of paintings, but they are bracketed by two other series, both comprised of abstract images, that complement his interest in the figure. Around 1946, he began a series of black paintings that incorporated symbolic forms with abstract shapes and silhouettes of subjects taken from everyday life. While de Kooning used Surrealist-inspired imagery in these and later works of the 1940s, he was never committed to that movement. Nor was his work ever totally abstract, because his subject matter remained wedded to the real world from which, for him, all imagery stemmed.

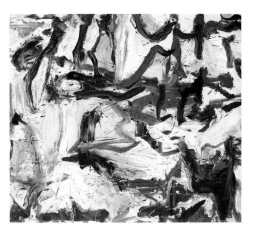

▦ Shortly after he completed his *Women* series, de Kooning began to search for a new theme. *Composition* (1955, plate 111) contains only marginal references to the female figure. Here, as before, she is torn apart and rearranged as part of an abstract image. Color and brushstroke are newly independent and all but freed from form. *Composition* is a highly original painting in that it signals the unique direction de Kooning's work was taking. In abandoning, if temporarily, the subject of the figure, he embraced abstraction without relinquishing his commitment to the visible world. By 1955, the image of the woman had virtually disappeared, replaced by landscape images based on urban and suburban themes. ▦ In 1961, de Kooning moved from his studio in New York to The Springs in East Hampton. There, he began a series of bold new paintings that differed dramatically from their predecessors. The beaches, marshes, scrub oaks, and potato fields of The Springs were the basis for these new paintings. In works like . . . *Whose Name Was Writ in Water* (1975, fig. 77), atmosphere fuses with and transfigures form. In these paintings, de Kooning's preoccupation with the sensations and reflections of color and light may be compared to that of Claude Monet late in his life. Yet even in such landscape-oriented paintings as these, fragments of the figure or of objects in the landscape are evident. Color may or may not suggest a figure, the grass, or the sky; freed from depiction, liberated from shape and contour, these paintings reveal a new dimension in de Kooning's oeuvre. Exuberant, free, and innovative, they are a late great flowering of his art. ▦ In canvases such as *Painting No. 7* (1952, plate 112), de Kooning's friend Kline produced a body of work in which he balanced a series of muscular black shapes against white grounds. Kline's fierce forms have often been compared to architectural structures, while his bold brushwork has been seen as a modern enactment of the drama of the New York skyline, with its

fig. 77 Willem de Kooning, ...*Whose Name Was Writ in Water*, 1975. Oil on canvas, 195 x 223 cm. Solomon R. Guggenheim Museum, New York 80.2738

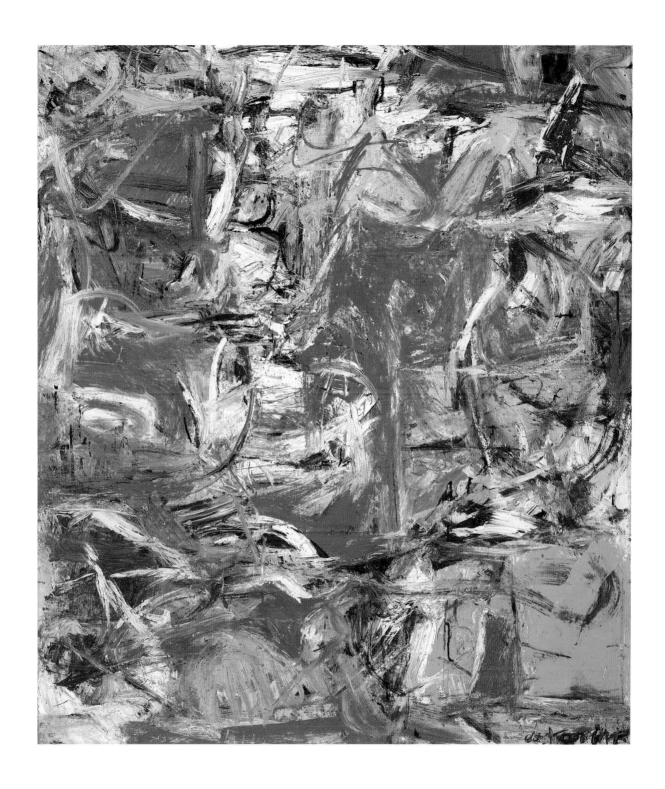

111. Willem de Kooning
Composition, 1955

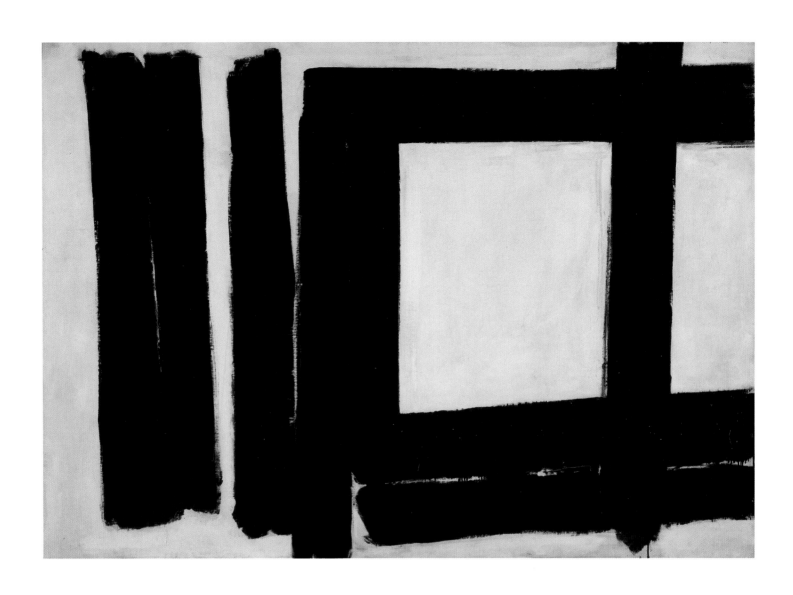

112. Franz Kline
Painting No. 7, 1952

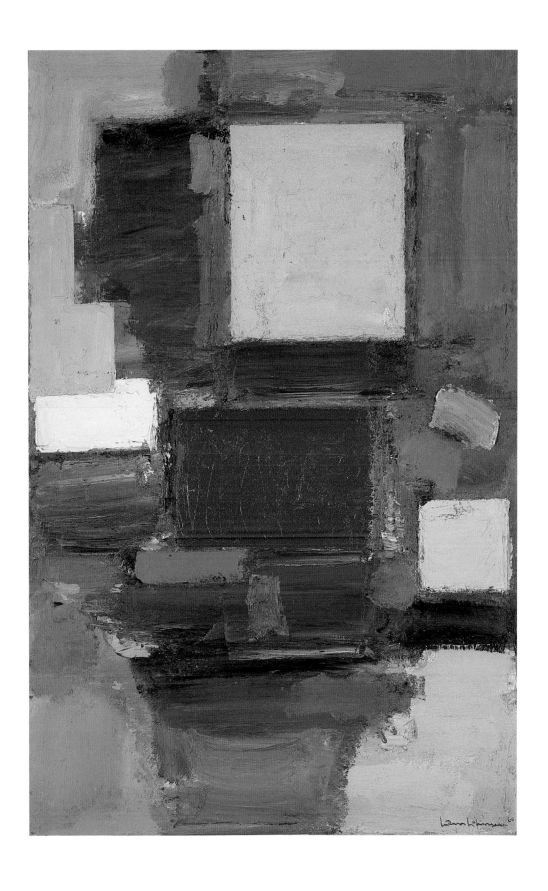

113. Hans Hofmann
The Gate, 1959–60

114. Ellsworth Kelly
Blue, Green, Yellow, Orange, Red, 1966

115. Tony Smith
For W.A., 1969

116. Agnes Martin
White Flower, 1960

117. Agnes Martin
White Stone, 1965

starkly silhouetted skyscrapers, massive steel girders, and strong contrasts of black and white. Kline and many of his colleagues—de Kooning, Motherwell, and Pollock among them—experimented with black and white because it afforded them a new opportunity to explore vital form relationships. Because gesture was either paramount or a coefficient of color for these painters, they retained the element of line and contour in their work. Newman, Rothko, and Still, on the other hand, down-played or eliminated line altogether in order to free color to act on its own. ▬▬ Hans Hofmann, an influential painter, teacher, and theorist, came to the United States from Germany in 1932 and worked and taught in New York and Provincetown, Massachusetts. In such paintings as *The Gate* (1959–60, plate 113), Hofmann created a vital dialogue between two seeming opposites, that of painterly expressionism and bold geometry. In this respect, his paintings stand somewhat apart from either of the two main tendencies of Abstract Expressionism, but in so doing they add anoth-er dimension to the painting of the New York School. Among his many students were Helen Frankenthaler, Lee Krasner, and Larry Rivers. ▬▬ Although the New York School produced fewer important sculptors than it did painters, the sculptors of the group—including Isamu Noguchi and David Smith—exemplify the spirit of adventure, lyricism, austerity, and, as Motherwell noted, a "spontaneity and lack of self-consciousness."[6] Noguchi's use of archetypal motifs and sensual materials is the result of Western and Eastern influences; his successful marriage of both traditions resulted in a body of sculpture that has a unique place among the art of the New York School. He was drawn to Surrealism and to what he called "the sublime rationality of the irra-tional,"[7] a trait that is also common to Eastern aesthetics, as noted by the critic Shuzo Takiguchi. Powerful and individualized, Smith's sculptures—culminating in his *Cubi* series (1961–65)— capture the heroic vision evidenced throughout the work of the New York School. ▬▬ Subsequent generations of artists amplified or challenged the vision of the Abstract Expressionists. Artists as diverse as Morris Louis, Robert Rauschenberg, and the sculptor John Chamberlain extended the color forms of Still and the painterly gestures of de Kooning. Louis was among a group known as Color-field painters, who—influenced by Frankenthaler's *Mountains and Sea* (1952; National Gallery of Art, Washington, D.C., on long-term loan from the artist)—began to experiment with pouring and staining paint directly onto unprimed canvas. Among Louis's most successful paintings are his *Veils*, such as *Saraband* (1959, fig.78), a series in which expansive areas of translu-cent color were poured in successive layers onto the canvas and overlapped to fill most of the paint-ing field. Other artists such as Ellsworth Kelly, Agnes Martin, and Tony Smith developed simplified idioms that took abstraction in a different, less gestural, direction.

fig. 78 Morris Louis, *Saraband*, 1959.
Acrylic resin on canvas, 257 x 378.5 cm.
Solomon R. Guggenheim Museum,
New York 64.1685

NOTES

1. Quoted in Herta Wescher, *Collage*, trans. by Robert E. Wolf (New York: Harry N. Abrams, 1968), pp. 299–300.

2. Peggy Guggenheim, *Out of This Century: Confessions of an Art Addict* (London: André Deutsch Limited, 1979), p. 209.

3. Translated in Anna Balakian, *Surrealism: The Road to the Absolute* (Chicago: The University of Chicago Press, 1986), p. 191.

4. Quoted in Jerry Tallmer, "Watch That Paint," *New York Post*, June 7, 1980, p. 13.

5. Harold Rosenberg, "The American Action Painters," *Art News* 51, no. 8 (December 1952), p. 23.

6. Quoted in *The School of New York*, exh. cat. (Beverly Hills: Frank Perls Gallery, 1951), p. 3.

7. Quoted in Shuzo Takiguchi, Saburo Hasegawa, and Isamu Noguchi, *Noguchi* (Tokyo, 1953), p. 28.

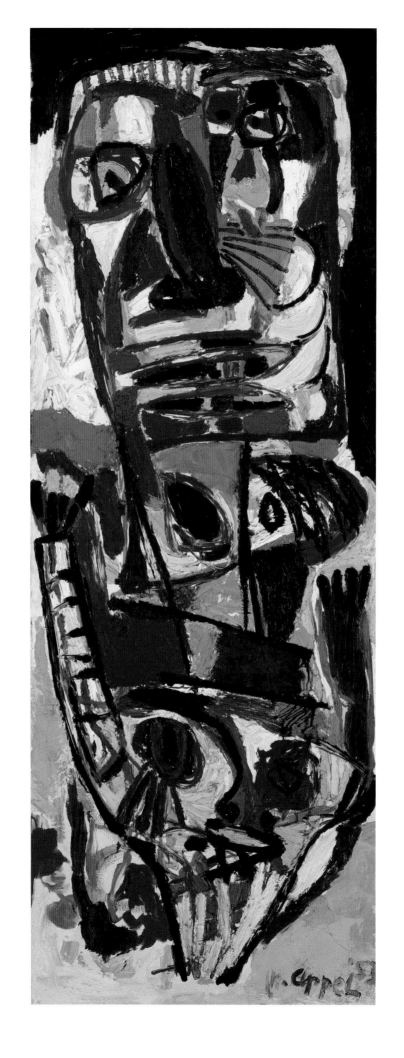

KAY HEYMER

Conflicting Figuration in the Postwar Period

Figurative art in the immediate postwar period in Europe presented a highly compromised image of mankind. Europe was in ruins, and any sort of idealism seemed impossible. Living meant surviving. People were wounded in body and soul. A number of artists registered the oppressiveness of this state of seeming disorientation. Hope could only be derived from unexpected sources; to reorient themselves, people turned to innocents: children, madmen, or even animals. In his poem "Winter of Starvation" from 1945, the Dutch painter Karel Appel wrote: "When men put on uniforms / and were no longer men / and no longer had faces / the birds kept flying free / . . . / I wish I were a bird."[1] ▬▬ At this absolute zero point, it no longer made sense to dream of any kind of utopia; mankind was thrown back on itself. This Heideggerian *Geworfenheit* (abandonment, dereliction) would become a consistent motif in the existentialist philosophy of the late 1940s and early 1950s. The German literary critic Hans Egon Holthusen spoke of man's "uprootedness."[2] In 1946 the poet Antonin Artaud, committed to the psychiatric hospital at Rodez some years before, described most vividly—in a letter about his precursor Isidore Ducasse, alias Comte de Lautréamont—the degree to which man was reduced to himself and his own body, without being able to rely on ideals, religion, or a social contract: "I insist that Isidore Ducasse was neither hallucinatory nor a visionary, but rather a genius who all his life never stopped seeing with perfect lucidity whenever he looked at the still unplowed wasteland of the unconscious and poked about in it. His own, no one else's, for there is no place in our bodies where we can communicate with everyone else's consciousness. And in our body we are alone. But the world has never admitted that, and it has always wanted to claim some way of gazing into the consciousness of all great poets from up close, and everyone has wanted to look into everyone else so as to know what everyone is up to."[3] Artaud experienced the totalitarianism of the twentieth century in his own body. His poetry and graphics, produced in personal revolt under psychiatry, served as models for numerous artists and writers. ▬▬ Any art wishing to precisely reflect this existentialist worldview was necessarily characterized by distortions and wounds. Jean Fautrier's paintings of hostages, inspired by a war crime committed by the Waffen SS in the French village of Oradour-sur-Glane, became typically broken patterns (see fig. 79). In 1945 the poet Francis Ponge wrote that with these works Fautrier transformed "man's horror into beauty" and then clarified the paradox by adding: "In Fautrier the human element is broken down, in a dilemma. It is far from being pure and authoritative. But to the same degree (in the same sense) it is all there: all together, all *included*. No one thing that satisfies at the expense of the rest: form, color,

facing page:
118. **Karel Appel**
Two Heads | Deux têtes, 1953

light, idea."[4] ▬▬ In addition to Fautrier's paintings it was those of the professional photographer Wols—with their obvious despair, their so seeming lack of control over forms and, especially, the picture surface—that most perfectly reflected the climate of the time. Wols's *Composition* (1947, fig. 80) shows how the painter, who was influenced by Surrealism, lost control of the work's format, for the composition virtually explodes—a feature exploited editorially in 1959 when the magazine *Magnum* juxtaposed one of Wols's compositions with the photograph of an A-bomb explosion. When World War II began, the German-born Wols was interned in France as an enemy alien; he had hoped to emigrate to the United States but was unable to do so. After the war ended, he lived in Paris in direst poverty. With his body already ravaged by personal excesses, the artist died from food poisoning in 1951. To the philosopher Jean-Paul Sartre, Wols represented the type of the *peintre maudit*, the poor devil destroyed by his art. But for a young artist like the Dane Asger Jorn, Wols was exemplary: "Sartre says 'Klee is an angel, Wols a poor devil.' That isn't true. Wols was by nature a *saint....* [Sartre] finds that there are no *words* behind the paintings Wols produced.... The paintings create the titles, and one title can be switched (with good reasons) for another. It is this pictorial ambiguity that Sartre perceives as being humiliating to a writer, which confuses him and makes him envious, which he confesses, by the way, with great candor."[5] Jorn went even further in his positive reinterpretation of Wols's work. He compared him to Jackson Pollock, and called their "unformed" art a manifestation of Kant's realm of the sublime, the antithesis of the realm of the beautiful.[6] Jorn's signature style in his paintings developed from just this tension between figuration and the "informal" that Wols and Pollock had explored. ▬▬ In 1946 and 1947, works by Fautrier and Wols could be seen at Galerie René Drouin in Paris, the city that was the focal point for what the critic Michel Tapié would speak of in 1952—on the occasion of an exhibition he curated at Studio Paul Facchetti in Paris—as *"un art autre"* ("other" art). Jean Dubuffet became one of the genre's most important representatives and theorists. He was interested in the art of outsiders, for which he coined the term Art Brut, and championed the work of Gaston Chaissac and Louis Soutter, two artists who lived in isolation and were avoided by a society that considered them to be madmen. Chaissac earned a living as a shoemaker in a small village in the Vaucluse, and Soutter, like the poet Artaud, lived in a mental institution. Chaissac and Soutter were mavericks, but in their sense of themselves as artists were extremely determined and clear-sighted. They created highly idiosyncratic and unmistakably imaginative figurative works. Both were most concerned with picturing the human figure, and both produced works on religious themes. Chaissac's *Untitled* (ca. 1948, fig. 81), a depiction of the Crucifixion, was paradigmatic of "other" art that followed. It shows the dilemma of twentieth-century mankind with exemplary clarity. André Malraux remarked in 1947 that "there is only one answer to the problem of man's condition: Catholicism. But I don't believe in this answer."[7] It is almost as if he was providing a caption for Chaissac's painting. In Soutter's extensive œuvre, it was especially the finger paintings from 1937 to 1941—painted as though without looking, in complete darkness—that would serve as a major influence on younger artists (see fig. 82).

fig. 79 Jean Fautrier, *Oradour-sur-Glane*, 1945. Oil, water-based paint, and dry pigment on paper, mounted on canvas, 145.1 x 112.7 cm. The Menil Collection, Houston

fig. 80 Wols, *Composition | Komposition*, 1947. Oil on canvas, 81 x 64.7 cm. Hamburger Kunsthalle

With their energetic gestures, though obviously expressive of major anxieties, his figures seem puzzlingly powerful. ▬▬ In *Portraits, Plus beaux qu'ils croient*, his exhibition at Galerie René Drouin in 1947, Dubuffet presented portraits—executed in his raw, deliberately uncivilized style—of associates from the world of "other" art: the painters Chaissac, Fautrier, and Henri Michaux, gallerist Drouin, poets Artaud, Francis Ponge, and Georges Limbour, and critics Jean Paulhan and Tapié. Among the key European figures of this period, one also has to include the Swiss sculptor Alberto Giacometti and the Irish-born painter Francis Bacon, whose very personal brand of figuration seemed to match precisely the era's paintings of distortion and suffering. This avant-garde was an avant-garde of outsiders, mavericks, and rebels, who could not be subsumed under a single style and who were revolting against society just as much as against traditional aesthetics. ▬▬ The figurative "other" art of Europe from the middle of the twentieth century is pointedly represented here with sculptures by Giacometti and paintings by Appel, Bacon, Dubuffet, and Jorn, and it is perhaps surprising that these holdings present a strength of the Guggenheim's collection that is too often overlooked. The late, cryptic work of the German Jan Müller, who emigrated to the United States, also fits well into this context. Hilla Rebay, the founding director of the Solomon R. Guggenheim Museum, had no use for figurative art. And, at the beginning of her essay in the present volume, Julia Brown emphasizes how well the non-objective art of the Panza Collection fits in with the Guggenheim's original mission. A residual institutional discomfort with figuration has perhaps had something to do with the fact that the Guggenheim's collection is strong precisely in this "conflicting" kind of figural art. Beginning in 1952, with the appointment of James Johnson Sweeney as director of the New York museum, it became more permissible to exhibit figurative painting and sculpture and add them to the collection. Among Sweeney's most important contributions in this field—in addition to several important acquisitions of works by Constantin Brancusi, as well as an exhibition devoted to the Romanian sculptor—was his sponsorship of one of the first museum exhibitions of Giacometti in June and July of 1955. Giacometti's *Nose* (1947, cast 1965; plate 120) is one of the sculptor's most puzzling works. At first glance the head of this sculpture hanging inside a cagelike rectangle looks like a skull, yet its exaggeratedly long nose contradicts that impression, for a skull only has a hole where a nose ought to be. Thus this sculpture is, in Giacometti's words, "something living and at the same time dead," and, for Jean Clair, "perhaps the most gruesome and shattering testimony to his art that he bequeathed to us."[8] Peggy Guggenheim purchased *Standing Woman ("Leoni")* (1947, cast November 1957; plate 94) from the artist in 1957. It is one of the most convincing of Giacometti's female figures from the 1940s. The viewer is forced to respond to the frontal view of a woman, and the notional distance between viewer and sculpture is unavoidably apparent.[9] One of Sweeney's early acquisitions was the large-format painting *Two Heads* (1953, plate 118) by Appel, who in 1954, the year it was purchased, had his first solo exhibition at Martha Jackson's gallery in New York. ▬▬ Thomas M. Messer, who became director of the New York museum in 1961, championed figurative painting by using the same selective subjectivity that has

fig. 81 Gaston Chaissac. *Untitled*. ca. 1948. Gouache on paper. 25.5 x 21 cm. Collection de l'Art Brut. Lausanne

fig. 82 Louis Soutter, *Souplesse*, 1939.
Finger painting. gouache on paper.
44 x 58 cm. Musée Cantonal des
Beaux-Arts de Lausanne

characterized the Guggenheim's collecting as a whole. In the introduction to a catalogue celebrating the fiftieth anniversary of the Solomon R. Guggenheim Foundation, Messer described his aims in a few lapidary phrases: "The Guggenheim, at least since the abandonment of its original dogma of non-objectivism in 1952, has never sought to ally itself with stylistic directions, and its institutional preferences have therefore covered a broad range . . . in the end collecting has been predicated upon a search for quality as this term has been understood by those charged with selections for exhibitions and for acquisition . . . particularly in the installations of the postwar painting of Europe and North America, collecting emphases are quite visible and may be seen as Guggenheim preferences."[10] In any case, one of Messer's definite preferences was the work of Dubuffet, to whom he devoted no fewer than six solo exhibitions in the New York museum during his tenure between 1961 and 1988—in 1966, 1973 (an extensive retrospective), 1974, 1981, and 1983 (two separate exhibitions), as well as one exhibition in 1986 at the Peggy Guggenheim Collection in Venice—and by whom the Guggenheim owns works from all the various stages in his career. The large-format painting *L'Instant propice* (plate 121) from 1962 is part of the series *Paris Circus*, with which Dubuffet returned to the life of the metropolis after an extended group of works related to nature. Yet his pictorial idiom is still characterized by the same crudeness that distinguished his paintings from the early postwar period.[11] ▬▬▬ Solo exhibitions at the Solomon R. Guggenheim Museum also preceded the acquisitions of paintings by Bacon, Jorn, and Müller. The works of Appel, Jorn, Dubuffet, and Müller, as well as those of Bacon and Giacometti, still have a definite immediacy today, and attest that figurative painting, in countless individual variations, exudes an enduring fascination. They can be easily described by distinguishing between imagination on the one hand and attempts at a likeness on the other. To the former CoBrA artists Appel and Jorn and to Dubuffet and Müller, imagination was paramount, though they drew inspiration from different sources. While the figuration of Appel and Jorn treads a line between "unformed" art and children's drawings, and Dubuffet's is additionally inspired by Art Brut, the late paintings of Müller represent a unique kind of imaginative painting. It was relatively late in his career when Müller—who had been a pupil of the abstract painter and highly influential teacher Hans Hofmann—decided to paint figuratively, inspired by reading Bible stories as well as the poems of Johann Wolfgang von Goethe (see plate 122). He only turned to figurative painting after the age of thirty-one, when he learned that because of a heart condition he could not count on living much longer. (In fact, Müller would only live for another five years, dying in 1958.) Müller's turn toward the personal and subjective was in a very literal and touching sense without illusions.[12] ▬▬▬ Together with the works by Bacon and Giacometti, based on observed reality, the selection of paintings by Appel, Dubuffet, Jorn, and Müller provide an overview of the various possibilities for imaginative or "other" figuration in art in the middle of the twentieth century. Bacon's *Three Studies for a Crucifixion* (March 1962, plate 123) is one of the painter's masterpieces. Its center panel was inspired by a Crucifixion by the Italian Renaissance master Cimabue, which Bacon always imagined "as a picture of a worm crawling down

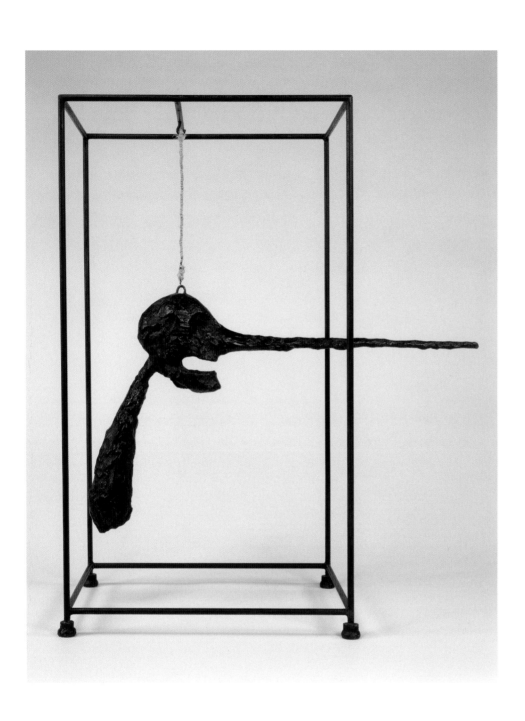

120. Alberto Giacometti
Nose | Le Nez, 1947, cast 1965

121. Jean Dubuffet
Propitious Moment | *L'Instant propice*, January 2–3, 1962

122. Jan Müller
Jacob's Ladder, January 1958

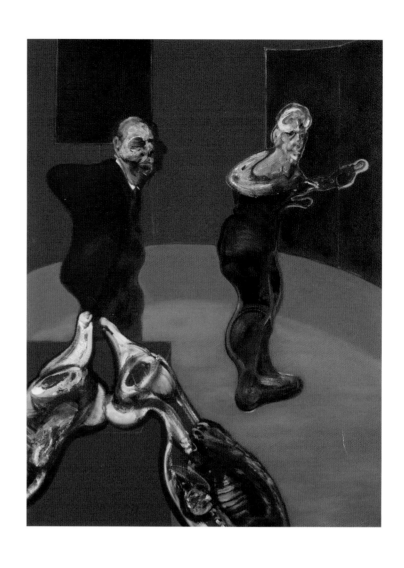

123. Francis Bacon
Three Studies for a Crucifixion, March 1962

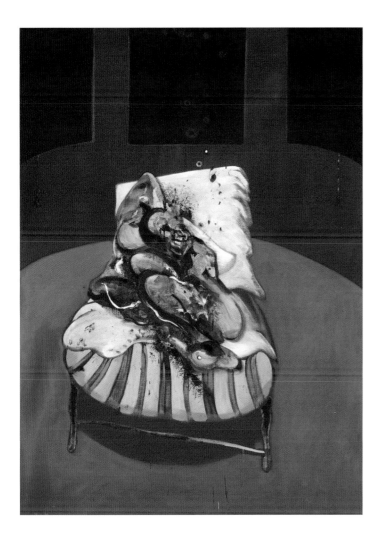

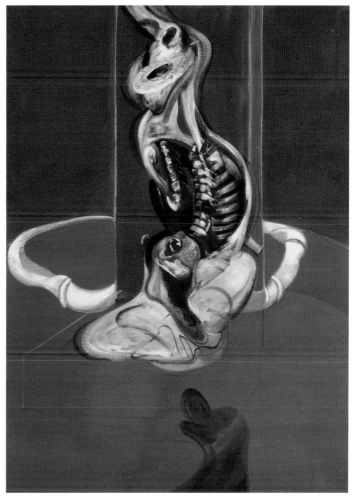

the cross."[13] Bacon's carnal painting can be read as a parallel to Artaud's existential sense of being reduced to his own body. It also illustrates a characteristic ambivalence between fascination with and disgust for religion, which Bacon talked about in conversation with David Sylvester: "I feel that most people who have religious faith, a fear of God, are much more interesting than people who live a hedonistic kind of life without plan. On the other hand, for all my admiration I can only despise them, since they live with utterly false assumptions that to my mind they get from their religious views. But ultimately, the only thing that makes a person interesting is his dedication, and as long as there was religion people could dedicate themselves to religion. That was at least something. But I am absolutely convinced that if one were to find a person completely without faith, who had totally dedicated himself to the senselessness of life, one would have found the more interesting person."[14] Bacon's painting is existential, obsessed with the reality of human existence. His distortions are distortions caused by violent physical movement. Bacon is the complete opposite of Giacometti. Both struggled with equal determination to reproduce with their art an aspect of life's reality. For Giacometti it was the statuelike, motionless appearance of an adored female figure, for Bacon the brutal, corporeal encounter with "the other."

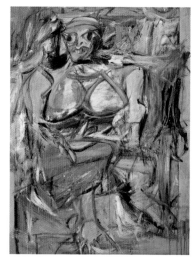

The selections in the exhibition *New Images of Man*, organized by Peter Selz for New York's Museum of Modern Art in 1959, were clearly characterized by the fragile figuration of "other" art. In the preface to the catalogue, the theologian Paul Tillich wrote: "The image of man became transformed, distorted, disrupted and it finally disappeared in recent art. But as in the reality of our lives, so in its mirror of the visual arts, the human protest arose against the fate to become a thing. The artists . . . are the representatives of such protest. They want to regain the image of man in their paintings and sculptures, but they are too honest to turn back to earlier naturalistic or idealistic forms, and they are too conscious of the limits implied in our present situation to jump ahead into a so-called neoclassicism. They tried to depict as honestly as they could, true representations of the human predicament, as they experienced it within and outside themselves."[15] Among the artists represented in the exhibition were Appel, Bacon, Dubuffet, Giacometti, and Müller, as well as Willem de Kooning (see fig. 83). In the catalogue's introduction, Selz made an important observation, one that served to define the work of most of the artists in the exhibition: "Kokoschka and Soutine still do likenesses, no matter how preoccupied with their own private agonies and visions; Dubuffet and de Kooning depart further from specificity, and present us with a more generalized concept of Man or Woman."[16] With its tortured, distorted, suffering image of mankind still apparently stamped by existentialism, *New Images of Man* was definitely a controversial exhibition in the late 1950s. For his review in *Artnews* the critic Manny Farber chose the title "New Images of (ugh) Man."[17] Particularly enraged reactions were voiced by realistic painters, who criticized the narrowing of perspective to personal visions as a limitation, and rejected a figuration that did not appear to be based on visual perception.[18] The breakthrough of Pop art had occurred only two years before, and the fragile

fig. 83 Willem de Kooning, *Woman I*, 1950–52. Oil on canvas, 192.7 x 147.3 cm. The Museum of Modern Art, New York, Purchase, 1953

figuration of the artists represented in *New Images of Man* gradually came to seem outdated. The work of Kenneth Armitage, Leonard Baskin, Reg Butler, Cosmo Campoli, Balcomb Greene, Rico Lebrun, James McGarrell, Nathan Oliveira, and Germaine Richier—all of whom were represented in the exhibition—has now been forgotten or is only rarely discussed. But perhaps even more than in an artistic style in the true, traditional sense, in this conflicting figuration it came down to the personal conviction of each individual artist, and some of their works—like those represented in the Guggenheim's collection—manage to step outside their time and to preserve an energy that is felt even today.

Translated from the German by Russell Stockman

NOTES

1. Quoted in R. H. Fuchs, ed., *Karel Appel. Ich wollte ich wäre ein Vogel. Berichte aus dem Atelier*, exh. cat. (Amsterdam: Meulenhoff, 1990), p. 7.

2. Hans Egon Holthusen, *Der unbehauste Mensch. Motive und Probleme der modernen Literatur* (Munich: R. Piper & Co., 1951). Holthusen's analysis of existentialism was written from a Christian perspective and was accordingly critical. In 1948 he wrote in his essay "Die Bewusstseinslage der modernen Literatur" that existentialism had "taken on the character of an intellectual mass psychosis." He described the contradiction in the existentialist position as a "rhetorical figure of aporia . . . a logical and existential cul de sac, it is the yes in no, the no in yes, it is the paradoxical, absurd, and impossible in a situation that is nevertheless endured." *Der unbehauste Mensch*, pp. 29, 31.

3. Antonin Artaud, *Van Gogh, der Selbstmörder durch die Gesellschaft und Texte zu Baudelaire, Coleridge, Lautréamont und Gérard de Nerval*, translated and selected by Franz Loechler, 2d ed. (Munich: Matthes & Seitz, 1979).

4. Francis Ponge, *Texte zur Kunst*, trans. Gerhard M. Neumann and Werner Spies (Frankfurt am Main: Suhrkamp Verlag, 1990), p. 15.

5. Quoted in Johannes Gachnang, ed., *Asger Jorn in Silkeborg*, exh. cat. (Bern: Kunsthalle Bern, 1981), pp. 67–68. Jorn's text on Wols was written in 1964.

6. Ibid.

7. Quoted in Holthusen, p. 31.

8. Giacometti quotation, Jean Clair, *Giacomettis Nase. Fastengesichter, Fastnachtsmasken* (Berlin: Verlag Klaus Wagenbach, 1998), p. 15; and Clair quotation, p. 81.

9. See entry on Giacometti's *Nose* in Angelica Zander Rudenstine, *Peggy Guggenheim Collection, Venice: The Solomon R. Guggenheim Foundation* (New York: Harry N. Abrams; Solomon R. Guggenheim Foundation, 1985), pp. 348–51. The entry includes discussion of notional space.

10. Thomas M. Messer, *Fifty Years of Collecting: An Anniversary Selection, Painting Since World War II: Europe, Latin America, North America*, exh. cat. (New York: Solomon R. Guggenheim Foundation, 1987), p. 11. According to Messer, the absence from the collection of works of major artists like Nicolas de Staël,

Balthus, Barnett Newman, and Jasper Johns was less the result of "lack of engagement" than of shortage of funds and missed opportunities.

11. Dubuffet described the *Paris Circus* works in a November 15, 1961, letter to Jean-Louis Ferrier: "I believe that my new paintings are neither more nor less figural than the previous ones. Only the themes have changed, since they deal with our gestures and expressions, with social life, with city life. Along with the theme, the methods I am using to picture things and make them expressive have also changed. To achieve this I had previously used heavy, substantial materials, unexpected earthy colors, imprecise and little accentuated forms, hardly suited to evoking associations, whereas I now try to elicit them first by means of distinct draftsmanly means (jagged, feverish lines) and then with screamingly bright colors tastelessly thrown together. Thus a change in method is taking place, but not in my essential aim; this continues to be to present our most common perceptions by means of arbitrary and unexpected transcriptions." Quoted in Jörn Merkert, *Jean Dubuffet. Retrospektive*, exh. cat. (Berlin: Akademie der Künste, 1980), p. 215.

12. This is the point of Meyer Schapiro's brief essay about Müller that was published in a catalogue for the 1962 Venice Biennale: *2 Pittori, 2 Scultori. Stati Uniti d'America. XXXI Biennale Venezia* (New York: Museum of Modern Art, 1962), p. 18.

13. Quoted in David Sylvester, *Gespräche mit Francis Bacon* (Munich: Prestel Verlag, 1982), p. 16.

14. Ibid., p. 136.

15. In Peter Selz, *New Images of Man*, exh. cat., (New York: Museum of Modern Art, , 1959), pp. 9–10.

16. In ibid., p. 13.

17. See David Sylvester, *About Modern Art: Critical Essays 1948–96*, (London: Chatto & Windus, 1996), p. 289.

18. In his recent book about Manhattan of the 1940s and 1950s, Jed Perl characterizes the artists exhibited in *New Images of Man* —with the exception of Giacometti—briefly and succinctly: "They weren't empiricists—they were sentimentalists." He also quotes from the painter Fairfield Porter's review in *The Nation*: "The common superficial look of the exhibition is that it collects monsters of mutilation, death and decay." Jed Perl, *New Art City* (New York: Alfred A. Knopf, 2005), p. 503.

SUSAN DAVIDSON

Shaping Pop: From Objects to Icons at the Guggenheim

The 1960s was one of the most provocative decades—culturally, politically, and philosophically—of the twentieth century. America had become an industrialized society poised on the brink of the information age. The remarkable economic growth that transpired from the end of World War II through the Cold War period of the 1950s resulted in a newly invigorated consumer culture in America. ■■■■ A number of the artists who emerged, or more appropriately, burst upon the art world, particularly in New York and Los Angeles in the first years of the decade, were responding to this new commercialism. Indeed those who came to be identified as Pop artists embraced consumerism as a fitting subject of their art. Expression and gesture—hallmarks of Abstract Expressionism that preceded Pop in the late 1940s and early 1950s—were replaced with cool, detached, mechanical illustrations of common objects, often based on appropriated advertising images. Pop art was in fact proposing a new kind of subjectivity, one that did not rely on an artist's singular expressive gesture, the *main d'artiste*. While many of the Abstract Expressionists had turned hermetically inward, the Pop artists turned outward for aesthetic stimuli. Radically redefining the subject matter deemed suitable for aesthetic use, Pop art was a significant sociological phenomenon and a mirror of society. In turn, the consumer industry itself adopted Pop art as an antidote to the rigidity of "high art." ■■■■ In Pop art, the narrative or epic impulse of Abstract Expressionism was replaced with straightforward depictions of the everyday, and the mass-produced was afforded the same significance as unique works of fine art; the gulf between "high art" and "low art" was gleefully eroded. Basing their techniques, style, and imagery on certain aspects of mass reproduction, media-derived imagery, and consumer society, artists such as Jim Dine, Roy Lichtenstein, Claes Oldenburg, James Rosenquist, Andy Warhol, and Tom Wesselmann took inspiration from advertising, pulp magazines, billboards, movies, television, comic strips, and shop windows. Their images, presented with—and sometimes transformed by—humor, wit, and irony, may be read as both an unabashed celebration and a scathing critique of popular culture. ■■■■ The Guggenheim played a leading role among museums in bringing Pop art to a wider audience when it presented—at the height of the movement—the seminal exhibition *Six Painters and the Object* (March 14–June 12, 1963), organized by British art historian, curator, and critic Lawrence Alloway, and its accompanying catalogue (fig. 84). Alloway's timely Pop art show—with its selection of work by Dine, Jasper Johns, Lichtenstein, Robert Rauschenberg, Rosenquist, and Warhol[1]—was organized at the very moment when the movement was so fresh that misconceptions and derision far

facing page:
124. Roy Lichtenstein
Grrrrrrrrrr!!, 1965

239

outweighed acceptance. The Guggenheim would demonstrate its ongoing commitment to this art with monographic exhibitions for Lichtenstein, Dine, Oldenburg, Rauschenberg, Rosenquist, and Warhol in subsequent years.[2] ▬▬ The term "Pop art" was first used in print by Alloway in 1958 to characterize the manifestations of popular culture (television, advertising, billboards, magazines) that were considered inferior to high culture.[3] Alloway, who was a member of the Independent Group[4]—an interdisciplinary group of British artists, architects, and critics—called for an art that would reflect contemporary experience and popular culture, would have a common interest in vernacular sources, and would share an aim to attack absolutist theories of art. The Independent Group organized four exhibitions, including the groundbreaking *This Is Tomorrow* (Whitechapel Art Gallery, London, 1956) where another one of its members, Richard Hamilton, presented his now-famous collage (originally made for the exhibition's poster and as a catalogue illustration) *Just what is it that makes today's homes so different, so appealing?* (1956, fig. 86), a seminal work that anticipated most aspects of Pop art. Signaling the dominance of American culture even in postwar-depressed London, Hamilton's sources were culled from American popular publications, such as *Life* magazine, brought to England by fellow artist John McHale. This seemingly nonsensical collage depicts a domestic interior engulfed in contemporary information transmission systems, including a movie marquee, tape recorder, and television. A standing muscleman holds a Tootsie Pop rather than a tennis racket, while a scantily clad woman lounges on the sofa, ignoring her domestic duties. The nearly nude muscleman and his voluptuous companion telegraph the erotic charge that modern advertising has attributed to acts of consumerism. ▬▬ While its terminology and initial critical thinking originated in England, Pop art simultaneously arose in America, where it would reach its fullest incarnation. Around the same time that the Independent Group was active, Rauschenberg proposed an alternative to the prevailing mode of art making in the United States. The diverse objects of Rauschenberg's celebrated Combine paintings fused two-dimensional painting with sculpture. Johns, playing on illusion and reality, repainted beer cans, targets, and the American flag, objects so iconic and commonplace that they required a new set of criteria to be viewed as artworks. The unique approach of Rauschenberg and Johns to the object paved the way for artists in the next decade. Oldenburg's configurations of functional objects like telephones—as in *Soft Pay-Telephone* (1963, fig. 87)—and his enlarged soft sculptures of food, Roy Lichtenstein's borrowings from comic strips, James Rosenquist's billboard montages of banal media-derived images, and Andy Warhol's repetitions of images of celebrities and contemporary brand-name products all pushed subject matter to such prominence that it temporarily masked out formal considerations. As the art historian Leo Steinberg said: "Our eyes will have to grow accustomed . . . to a new presence in art: the presence of subject matter absolutely at one with the form."[5] Many of these artists used commercial and mechanical processes such as photography or silkscreening, thus obtaining a flat rendering that denied any subjective emotion. Their work was snappy but detached—the epitome of cool. ▬▬ In 1962, Thomas M. Messer, the Guggenheim's director,

fig. 84 Cover of exhibition catalogue *Six Painters and the Object* (1963)

fig. 85 Sylvia Sleigh and Lawrence Alloway, ca. 1968

enticed Alloway to leave England permanently to become his principal curatorial appointment at the museum. It was Alloway's first curatorial job in America[6] and seemingly a bold move on Messer's part to charge an Englishman with the task of "acquainting the museum's public with aspects of current American art."[7] Like his predecessor at the Guggenheim, James Johnson Sweeney, whose interests encompassed a broad range of modern art, Alloway veered away from the founding director Hilla Rebay's lifelong passion for the spiritual in art and her reliance on "non-objective" painting and sculpture. Alloway's "liberal and broadly inclusive aesthetic orientation could not have been more dissimilar from Rebay's quest for the metaphysical essence of painting."[8] Yet the two were remarkably similar in their fundamental understanding of the art contemporary to their own time.[9] The Guggenheim's approach to the presentation of art has sought to commemorate elements of the recent art-historical past, while also focusing on the immediate present with an eye toward future developments. It was in this vein that Alloway, upon accepting his post, immediately began work on the exhibition *Six Painters and the Object*. That Alloway would want to organize a Pop exhibition for the Guggenheim was not so improbable. He had been charged with raising the profile of the institution and what better way to do so than to show radical new art that had everyone talking—a movement with which he was already intimately engaged. Being a recent immigrant to America was no disadvantage for him.[10] In fact, he readily accepted American Pop art as a more successful phenomenon than its counterpart in England. ▬▬ Intended to be the first museum exhibition devoted solely to this burgeoning trend in American art, *Six Painters and the Object*, was by the time it opened on March 14, 1963, in fact the second.[11] However, its importance cannot be underestimated. Of all the Pop art exhibitions that were organized in the 1960s, Alloway's was the only one that stressed the historical tradition of the movement. By underscoring the past, Alloway established a framework for Pop. He established as influences the eighteenth-century prints of William Hogarth, the nineteenth-century engravings of Gustave Courbet, Post-Impressionist paintings by Vincent van Gogh and Paul Gauguin, and the earlier twentieth-century machine paintings of Fernand Léger. Moreover, *Six Painters and the Object* was the only Pop art exhibition of significance presented by a New York museum in the 1960s, a fact that went a long way toward legitimizing the activities of these artists. The exhibition generated an unusual amount of national press coverage, not only in art magazines but also in monthly news journals and on television.[12] ▬▬ Prior to Alloway's Guggenheim exhibition, the art world was struggling to properly identify the new aesthetic it found itself confronted with. The speed with which Pop art excited the popular imagination was a corollary to the very brief period of time in which it initially flourished, from 1960 to 1964. Contrary to the adage that most great art is ignored for years, this new art quickly burst onto the scene, sparking so much interest and enthusiasm from critics, collectors, and gallery owners that even its moniker was much debated: New Realism, Popular Image Art, Common Object Art, Factualism, Neo Dadaism, American Dream Painting, Sign Painting, Anti-Sensibility Painting, and Cool-Art were just a few

names put forth in an attempt to label the new art.[13] Pop art won out, "Pop" being a shorthand for popular culture that then evolved to describe the artistic expressions of that culture.[14] ▬▬ It was actually a group of commercial art galleries that were the first to champion Pop art by presenting a profusion of single-artist shows,[15] and thus creating a buzz that in many cases generated immediate sales. Collectors—from taxi company owner Robert Scull to insurance executive Leon Kraushar to Burton and Emily Tremaine to Count Giuseppe Panza di Biumo—competed in a frenzied rush to acquire the best and latest of the new American art.[16] Kraushar, perhaps the gutsiest of the group and arguably the one who possessed the best eye, proselytized in *Life* magazine: "Pop is the art of today, and tomorrow, and all the future. These pictures are like IBM stock . . . and this is the time to buy."[17] ▬▬ Both 1960 and 1961 were still emergent years for the mainstream's awareness of Pop art,[18] but by 1962, the movement was well established in the art world. Museums across the country were picking up on the new art and including representative artists in thematic group exhibitions. The first to include nearly all the Pop artists was Douglas MacAgy's *1961* exhibition for the Dallas Museum of Contemporary Arts (April 3–May 13, 1962), which included works by Dine (*A Universal Color Chart*), Lichtenstein (*The Kiss*), Johns (*Portrait—Viola Farber*), Rauschenberg (*Stripper*), and Rosenquist (*Shadows*), as well as a selection of soft sculptures from Oldenburg's *The Store* installation. Taking the year of creation as the basis for inclusion of each work, *1961* was a mixed bag of thirty-six artists that ranged from Joseph Albers to Robert Motherwell to Jack Youngerman, with a host of regional Texas artists, such as Joseph Glasco and Roy Fridge, thrown in for good measure. Despite the mélange, the exhibition successfully tracked the diversity of artistic expression at the moment. Not limiting himself to the visual arts, MacAgy commissioned a performance piece from Oldenburg, whose *Injun* was the first Happening to take place in a museum.[19] Such avant-garde activity may seem at odds with the perception of Dallas as a cultural backwater, but MacAgy was a sophisticated transplant who had had an illustrious national career as both an art educator and museum director—he was someone with his finger on the pulse.[20] ▬▬ Later that year, another pioneer, Walter Hopps, curator of the Pasadena Museum of Art (now the Norton Simon Museum), assembled the first fully realized Pop art exhibition in the United States. (Alloway's Guggenheim exhibition would, nonetheless, have a greater impact on the national scene.) Hopps's exhibition was entitled *New Painting of Common Objects* (September 25–October 19, 1962) and included eight artists whose work he believed represented a common thread of the current avant-garde.[21] He featured the West Coast Pop painters Robert Dowd, Joe Goode, Phillip Hefferton, Ed Ruscha, and Wayne Thiebaud, whose work was less detached than the three Pop artists from New York—Dine, Lichtenstein, and Warhol—he included. Hopps's familiarity with the new art grew out of his years as cofounder, with assemblage artist Edward Kienholz, of the Ferus Gallery in Los Angeles. Like Alloway, Hopps had recently joined the staff of a museum and, also like Alloway, brought to the curatorial position a unique knowledge of contemporary art and an uncanny ability to refine this

126. Robert Rauschenberg
Barge, 1962–63

127. Robert Rauschenberg
Religious Fluke, 1962

facing page:
128. Robert Rauschenberg
Noname (Elephant), July 1973

129. Robert Rauschenberg
Yellow Body, 1968

130. Robert Rauschenberg
Glaze (Hoarfrost), 1975

131. Robert Rauschenberg
Talisman Freeze, 1979

132. Roy Lichtenstein
Preparedness, 1968

133. Roy Lichtenstein
Interior with Mirrored Wall, 1991

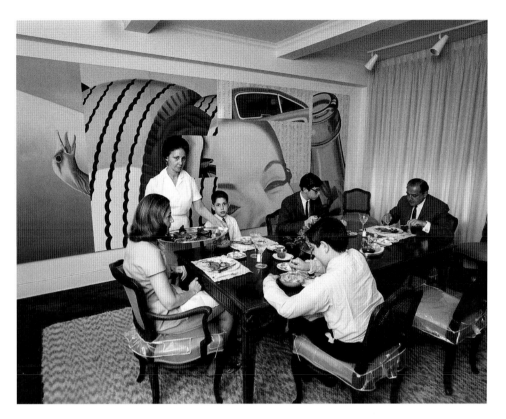

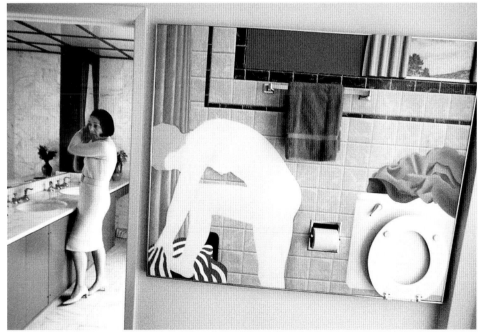

fig. 88 Robert Scull and family in their dining room, ca. 1964, with James Rosenquist's *Silver Skies* (1962) in background

fig. 89 Mrs. Leon Kraushar at home, ca. 1964, with Tom Wesselmann's *Bathtub Collage # 1* (1963) in foreground

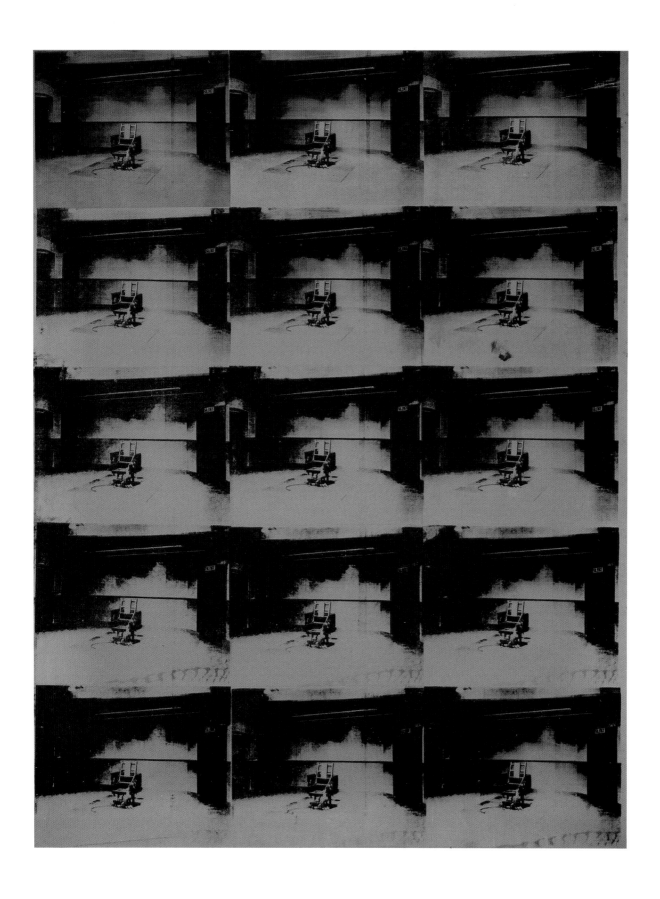

134. Andy Warhol
Orange Disaster #5, 1963

254

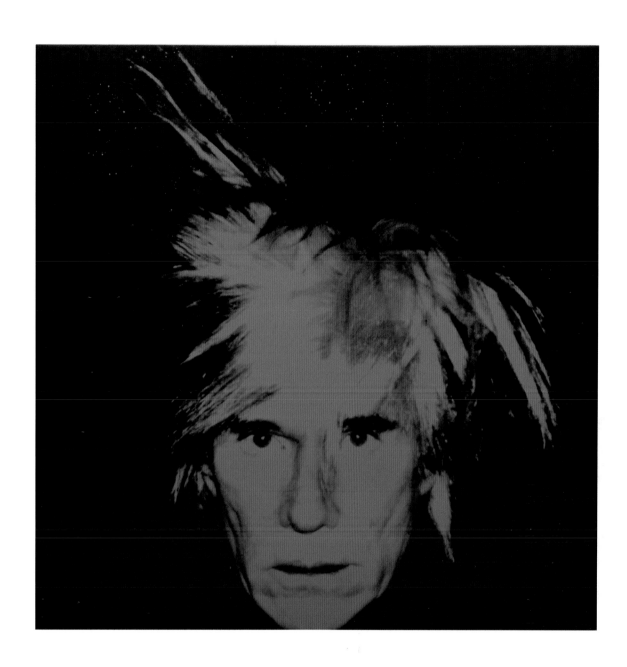

136. Andy Warhol
One Hundred and Fifty Multicolored Marilyns, 1979

knowledge.[22] While important in the critical acceptance of the history of Pop art and despite the fact that it was the first, the Pasadena exhibition garnered little national attention save two idiosyncratic reviews that struggled with the mundane and banal concepts of consumerism that the exhibition presented.[23] ▬▬▬ The latter months of 1962 brought many of the issues surrounding the legitimacy of Pop art to the fore. The Museum of Modern Art, New York, founded as the defender of modern art, held a symposium that debated the merits of the style.[24] Newspapers and periodicals devoted countless pages to the new American art, although most art critics were initially bemused, if not hostile.[25] With the exception of Alloway and Gene Swenson,[26] most believed that Pop art lacked metaphor and symbol, the very qualities that defined high art. In addition, commentators were appalled by Pop art's presentation of untransformed commercial subject matter, an issue much debated at the Museum of Modern Art's symposium. The fact that the subject of this new art depicted familiar things, things they all knew, unsettled the art critics because it did not follow modernism's prescriptions for aesthetic usage. Instead, Pop art glorified consumerism, a category traditionally considered lowbrow. ▬▬▬ *International Exhibition of the New Realists* (November 1–December 1, 1962), the largest and most critical gallery exhibition yet devoted to the emergent new art, was organized by the esteemed Sidney Janis Gallery in New York.[27] Well known for championing the work of Abstract Expressionist artists like Willem de Kooning, Jackson Pollock, and Mark Rothko—the very artists whose success the Pop group threatened—Janis's foray into the new art was something of a departure for the gallery. The exhibition presented Janis's interpretation of the worldwide activities of artists working under the Pop rubric, at that moment still unnamed.[28] One to three works each by fifty-four English, French, German, Italian, and American artists who were addressing the object as subject were assembled both in the gallery's two main rooms at 15 East Fifty-seventh Street, and in an empty storefront across Fifth Avenue from the gallery at 19 West Fifty-seventh Street, fully visible to midtown's busy city dwellers (see fig. 90). Mimicking Oldenburg's *The Store* on the Lower Eastside, where the initiated and the uninitiated could wander in off the street to purchase his then inexpensive sculptures of clothing (sneakers, pants, or shirts, ties, hats, etc.) or food (doughnuts, candy bars, sandwiches, cakes, etc.), Janis's show "hit the New York art world with the force of an earthquake."[29] ▬▬▬ Months before the Janis exhibition opened, Alloway formally proposed his Pop art exhibition to the Guggenheim's board of trustees. He envisioned an extravaganza that would fill "two ramps [of the museum's spiral] showing about forty-five artworks by a maximum of twenty artists from East and West coasts of U.S." and would "be sufficient to (a) demonstrate common features and (b) the diversity within the style."[30] Although Alloway had coined the term "Pop art" years earlier, he acknowledged that at this particular time (August 1962) the new art was still grappling with its identity, referring to his proposed exhibition as a "group show sampling a current trend: artists with no agreed-on name." Being the father of the term he considered exercising his proprietary claim to title the exhibition "Pop Artists"; another possibility was "Signs and Objects," which more clearly defined his curatorial aim.[31] Both titles

137. Richard Hamilton
The Solomon R. Guggenheim (Black and White), 1965–66

138. Richard Hamilton
The Solomon R. Guggenheim (Spectrum), 1965–66

referred "to the popular sources that all these artists have in common, i.e., the mass media and the man-made environment." Alloway passionately argued that the time was ripe for such an exhibition, noting that "interest in art of this kind is increasing and as it increases so do misunderstandings about it." He cited Max Kozloff's contemporaneous article "'Pop' Culture, Metaphysical Disgust, and the New Vulgarians" as an example. "A seriously documented and carefully chosen show at this time would, I think, interest the public by its topicality and also define this area historically." ▬▬ In his proposal, Alloway systematically established a classification of Pop imagery into four categories, placing specific artists in each: (1) Fully 3-D Objects (Rauschenberg and Oldenburg): found objects literally present and plastic simulacra; (2) Objects and Flat Painting (Dine, Gene Beery, Ernst Trova, and Alex Katz): anonymous artifacts and paintings cut into figurative shapes; (3) Paintings of Objects (Thiebaud, Peter Saul, Warhol, Rosenquist, Harold Stevenson, and Steven Durkee): still life and mass production, graffiti and abundance, Campbell Soup cans, Gigantism, and blow-ups of anatomical detail; and (4) Paintings of Signs (Johns, Lichtenstein, Ramos, Allan D'Arcangelo, Billy Al Bengston, Robert Indiana, and Ruscha): comic strips and ads, comic-strip heroes, Pop materials used allegorically, and emblematic presentation. ▬▬ Alloway wished to distinguish between object makers, i.e., sculptors, and painters whose subject matter was objects drawn from the "communications network and the physical environment of the city."[32] He perceived the exhibition, when "historically viewed, [to be] a compact section of a wider movement which includes phases of Junk Culture, such as the collage explosion and happenings. . . . My preference is to stress . . . the painted imagery rather than the objects." Alloway was clear in his desire that the Guggenheim exhibition not look like "Son of the Art of Assemblage," a reference to William Seitz's groundbreaking exhibition devoted to the history of collage and sculptural works held at the Museum of Modern Art the previous year.[33] ▬▬ Most important, Alloway seemed to have an insider's knowledge of which artists Janis planned to include in his forthcoming gallery exhibition, as well as how Janis intended to present them. Alloway suspected that it would be a jumble, referring to Janis's planned exhibition in his proposal as a "sloppy survey." For the Guggenheim exhibition, Alloway intended that "the catalogue could be small but should be packed with information" and "should combine the kick of topicality with art historical accuracy." Indeed, his essay for the *Six Painters and the Object* catalogue fulfilled this intention, becoming one of the most influential treatises on the movement, written from the perspective of a true insider. ▬▬ In fact, Janis's exhibition did confuse matters in its mixing of conceptual artists (Yves Klein and Daniel Buren) and assemblage artists (Jean Tinguely and Arman) with painters of common objects and signs (Lichtenstein, Rosenquist, and Warhol). In November, a few weeks after the New Realist exhibition opened, Alloway sent a memorandum to Messer, expressing concern that there were too many Pop shows on view at the moment, citing in New York, in addition to Janis's anthology, Warhol and Indiana at Stable Gallery and Oldenburg and Wesselmann at Green Gallery, as well as group shows being planned from Philadelphia to Pasadena.

fig. 90 *International Exhibition of the New Realists*, 1962, Sidney Janis Gallery's temporary annex, New York

He nonetheless was steadfast in his belief that a clear "definition in opposition to the general confusion" would not only be welcome but was needed.[34] Messer seconded his concern and urged him to press ahead with his plans. ▬▬ When *Six Painters and the Object* opened in mid-March, Alloway had narrowed his original concept to feature six New York–based artists with paintings by each that represented their interpretation of the object. The exhibition was installed in six of the eight bays on the top ramp of the Solomon R. Guggenheim Museum, with each bay displaying five or six works of a single artist. Alloway began with the work of Johns, followed by that of Dine, Rauschenberg, Warhol, Lichtenstein, and Rosenquist. It was a compelling presentation and attendance exceeded all expectations. Two thousand copies of the catalogue were printed—an unusually high number for the time. The book was designed by Herbert Matter, whose work for *Harper's Bazaar*, *Vogue*, and the furniture maker Knoll made him a prestigious graphic designer. ▬▬ The Guggenheim began plans to travel the exhibition even before the show opened in New York. Messer canvassed other museums, both large and small, throughout North America. In his letter, he advocated that "it would not be too much to say that [the exhibition] will attempt to set right the mixed presentations that have occurred in many places by stressing the pure painting forms in separation from the crowded assemblages of objects and other tendencies with which these have often been associated."[35] The responses were staggeringly quick and conspicuously enthusiastic. The Joslyn Art Museum in Omaha, Nebraska, perceived the exhibition as a "most timely ('hot') subject and wished to participate."[36] A number of the institutions who expressed interest had to be turned away;[37] there were only seven venues available for travel.[38] When the exhibition reached the Los Angeles County Museum of Art, Alloway expanded it to include six West Coast artists.[39] The lenders to the New York exhibition had been asked to part with their works for a year's tour. Most agreed, but a number did not, and Alloway was forced to make substitutions. Others were keen to come to the aid of the new art. John Weber of the Dwan Gallery, Los Angeles, recognized that many lenders, having acquired their works within the last two years, might be reticent to extend their loans and therefore offered a couple of paintings from the gallery's inventory, namely, Lichtenstein's *Tzing* from the *Live Ammo* series (1962) and Dine's large *Pink Bathroom* (1962).[40] As a result, the traveling exhibition was significantly different from the original Guggenheim presentation, although just as formidable. ▬▬ As a self-contained movement Pop art had dissipated by the end of the 1960s. Once considered a radical departure, Pop art has been thoroughly assimilated by the very consumer culture that it initially critiqued. In 1963, when the work was still considered risky, the Guggenheim staged the small but momentous *Six Painters and the Object*.[41] The endorsement that the Guggenheim bestowed upon Pop art at that critical juncture validated the movement and, in turn, demonstrated the museum's leadership in establishing artistic trends.

fig. 91 James Rosenquist paintings included in *Six Painters and the Object*, 1963, Solomon R Guggenheim Museum, New York

fig. 92 Lawrence Alloway, Robert Indiana, and Tom Wesselmann, ca. 1966

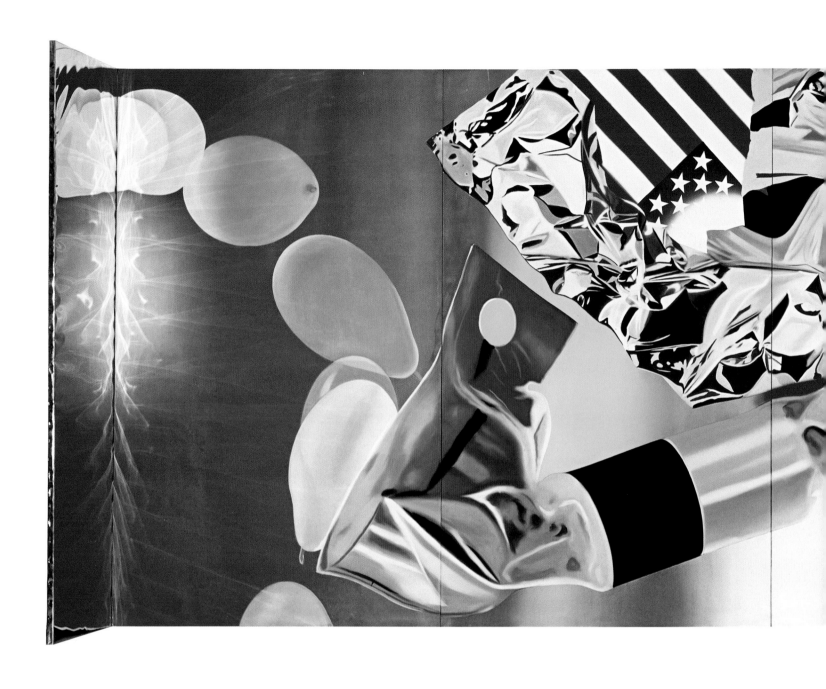

139. James Rosenquist
Flamingo Capsule, 1970

262

140. James Rosenquist
The Swimmer in the Econo-mist (painting 2), 1997

141. James Rosenquist
The Swimmer in the Econo-mist (painting 3), 1997–98

NOTES

1. Oldenburg and Wesselmann were included in Alloway's original exhibition prospectus but did not make the final cut. Whether this was due to space limitations—the sixth and top ramp of the Guggenheim spiral only has eight bays, and two were used for storage while the other six bays each showed the work of one artist—or was a curatorial decision is unknown.

2. In New York, Lichtenstein received monographic shows at the Guggenheim in 1969 and 1993–94, and a Dine exhibition featuring work from 1959 to 1969 was presented in 1999. At the behest of the Guggenheim, the Deutsche Guggenheim in Berlin commissioned and exhibited in 1998 Rosenquist's *The Swimmer in the Econo-mist* (1997–98), a three-part contemporary history painting. Oldenburg in 1995–96, Rauschenberg in 1997–98, and Rosenquist in 2003–04 had retrospectives organized for the Guggenheim in New York, which included national and international itineraries. Warhol was featured in several exhibitions, including one devoted to his Factory years (Guggenheim Museum Bilbao, 1999–2000) and another to his series of *Last Supper* paintings (Guggenheim Museum SoHo, 1998).

3. See Lawrence Alloway, "The Arts and the Mass Media," *Architectural Design* 28 (Feb. 1958), pp. 84–85.

4. For more on the Independent Group, see David Robbins, *The Independent Group: Postwar Britain and the Aesthetics of Plenty* (Cambridge: MIT Press, 1990); and Lynne Cooke, "The Independent Group: British and American Pop Art, A 'Palimpcestuous' Legacy," in Kirk Varnedoe and Adam Gopnik, eds., *Modern Art and Popular Culture: Readings in High and Low* (New York: Museum of Modern Art, 1999).

5. Leo Steinberg, comments at "A Symposium on Pop Art," the Museum of Modern Art, New York, Dec. 13, 1962, from proceedings published in *Arts Magazine* 37, no. 8 (Apr. 1963), p. 40.

6. Previously, Alloway had been deputy director of London's Institute of Contemporary Art from 1954 to 1957. While at the Guggenheim, he organized nearly twenty exhibitions, including *Word and Image* (Dec. 8, 1965–Jan. 2, 1966), *Barnett Newman: The Stations of the Cross: lema sabachthani* (Apr. 23–June 19, 1966), and *Systemic Painting* (Sept. 21–Nov. 27, 1966). He resigned from the museum in 1966 after clashing with Messer over what the Guggenheim was to exhibit at the Venice Biennale. Alloway has written extensively on Pop art and the art of his time. From 1968 to 1981 he was a professor of art history at the State University of New York at Stony Brook. His principal essays are collected under the title *Network: Art and the Complex Present* (Ann Arbor: UMI Research Press, 1984). He died on January 2, 1990, and is survived by his wife, the artist Sylvia Sleigh. See *An Unnerving Romanticism: The Art of Sylvia Sleigh and Lawrence Alloway*, exh. cat. (Philadelphia: Philadelphia Art Alliance, 2001).

7. Press release issued to announce Alloway's resignation from the Guggenheim, June 13, 1966, Rosalind Constable papers, Menil Archives, Houston.

8. Nancy Spector, "Against the Grain: A History of Contemporary Art at the Guggenheim," *Art of This Century: The Guggenheim Museum and Its Collection* (New York: Guggenheim Museum, 1997), p. 231.

9. Ibid.

10. Alloway received a four-month Foreign Leader's grant from the United States government to study American painting in 1958, which was his first visit. He met many influential people in the art world at that time, including the critic and art historian Eugene Goosen, who invited him for a one-year academic appointment in art history at Bennington College, Vermont (1961–62).

11. Walter Hopps's *New Painting of Common Objects*, held at the Pasadena Museum of Art (Sept. 25–Oct. 19, 1962), was the first such museum exhibition.

12. Some of the most important reviews include "Pop Art: Cult of the Commonplace," *Time*, May 3, 1963, pp. 60–70; "Art: Pop. Pop," *Time*, Aug. 30, 1963, p. 40; Don Factor, "Six Painters and the Object and Six More, L.A. County Museum of Art," *Artforum* 2, no. 3 (Sept. 1963), pp. 13–14; Leonard Horowitz, "Art: Six Characters in Search of an Art Movement," *Village Voice*, Apr. 4, 1963, p. 11; Donald Judd, "New York Exhibitions: In the Galleries–Six Painters and the Object," *Arts Magazine* 37, no. 9 (May–June 1963), pp. 108–09; Stuart Preston, "On Display: All-Out Series of Pop Art: Six Painters and the Object Exhibited at Guggenheim," *New York Times*, Mar. 21, 1963, p. 8; and Barbara Rose, "Pop Art at the Guggenheim," *Art International* 7, no. 5 (May 1963), pp. 20–22. Emily Genauer, the most respected art critic of the time, appeared on NBC television on March 14, 1963. As she walked through the Guggenheim, she compared the Pop artists to nineteenth-century American sign painters, American artist Stuart Davis, and contemporary advertisements. This sort of historical analysis would have pleased Alloway immensely.

13. March 1962 seems to be when the name "Pop" was settled upon. See Max Kozloff, "'Pop' Culture, Metaphysical Disgust, and the New Vulgarians," *Art International* 6, no. 2 (Mar. 1962), pp. 35–36. The list of other terms is taken from Sidra Stitch, *Made in USA: An Americanization in Modern Art, The '50s and 60s* (Berkeley: University of California Press, 1987), p. 2.

14. The term "Pop" was misapplied to Johns and Rauschenberg, and artists such as Dine and Rosenquist bristled at the label even as their inclusion in the movement significantly accelerated their careers. Barbara Rose was the first to identify the work of Johns and Rauschenberg as not necessarily Pop: "it is not as inappropriate to talk of them in the same breath as it is to associate them with 'pop art,' which has a lot to do with them, but with which they have nothing to do." See Rose, "Pop Art at the Guggenheim," pp. 20–22. Art history has since correctly assumed this position, treating Johns and Rauschenberg as precursors to the movement rather than central practitioners, e.g., see *Hand-Painted Pop: American Art in Transition 1955–1962*, exh. cat. (Los Angeles: Museum of Contemporary Art, 1993).

15. In New York, the 1962 exhibition year began with a Dine show at Martha Jackson (Jan. 9–Feb. 3); then, came the first one-person shows of Rosenquist at the Green Gallery, (Jan. 30–Feb. 17) and Lichtenstein at Leo Castelli (Feb. 10–Mar. 3). Warhol's *Thirty-two Campbell's Soup Cans* were exhibited at the Ferus Gallery, Los Angeles (July 9–Aug. 4). The fall season in New York opened with Oldenburg's soft sculptures at the Green Gallery (Sept. 24–Oct. 20), followed by Sidney Janis's *International Exhibition of the New Realists* (Nov. 1–Dec. 1). The year concluded with Warhol's first New York exhibition at the Stable Gallery (Nov. 6–24), Wesselmann's *Great American Nudes* at the Green Gallery (Nov. 13–Dec. 1), and a group show of thirteen artists, *My Country 'Tis of Thee* (Nov. 18–Dec. 15) at the Dwan Gallery, Los Angeles.

16. The Scull collection was sold at auction in 1973 when Robert and his wife Ethel divorced. Upon Krausher's death in 1967, his wife sold the collection to the German industrialist Karl Ströher, who died in 1988; Sotheby's sold the bulk of this collection in May 1989. The Tremaine collection was sold at auction in 1988 and 1991, while many Pop artworks from the Panza collection were sold to the Museum of Contemporary Art, Los Angeles, in 1984. Both the Sculls and the Tremaines were significant lenders to the *Six Painters and the Object* exhibition.

17. Quoted in "You Bought It—Now Live with It," *Life*, July 16, 1965, p. 59.

18. Four exhibitions in New York during these years greatly influenced the course of Pop art: *New Media–New Forms* (June 6–24, 1960) and *New Media–New Forms, Version 2* (Sept. 27–Oct. 22, 1960) at the Martha Jackson Gallery, *Environments–Situations–Spaces* (May 25–June 23, 1961) at the Martha Jackson and David Anderson galleries, and *The Art of Assemblage* (Oct. 2–Nov. 12, 1961) at the Museum of Modern Art.

19. *Injun*, a film of Oldenburg's work made by Roy Fridge in Dallas, was one of the first recordings of a Happening. For a history of performance art, see Barbara Haskell, *Blam! The Explosion of Pop, Minimalism, and Performance 1958–1964*, exh. cat. (New York: W. W. Norton; the Whitney Museum of American Art, 1984).

20. For an excellent study of MacAgy's career, see David Beasley, *Douglas MacAgy and the Foundations of Modern Art Curatorship* (Simcoe, Ontario: Davus Publishing, 1998).

21. See Jim Edwards's interview with Walter Hopps, in David Brauer et al., *Pop Art: U.S./U.K. Connections, 1956–1966*, exh. cat. (Houston: Menil Collection, 2001); see pp. 42–54 for Hopps's personal recollection of *New Painting of Common Objects*.

22. Walter Hopps became the Guggenheim's adjunct senior curator of twentieth-century art in 2001. In this capacity, in 2003, he organized, with Sarah Bancroft, a Rosenquist retrospective for the museum that was also seen in Houston and Bilbao. At the Guggenheim, he was also the cocurator (with this author) of the Rauschenberg retrospective in 1997. After leaving the Pasadena Museum of Art in 1967, Hopps became director of the Corcoran Gallery of Art, Washington, D.C., from 1967 to 1972, then a curator at the National Collection of Fine Arts (now Smithsonian American Art Museum), Washington, D.C., from 1972 to 1979, and director of the Menil Collection, Houston, from 1980 to 1988, where he was subsequently a consulting curator. He died in 2005.

23. See John Coplans, "The New Paintings of Common Objects," *Artforum* 1, no. 6 (Nov. 1962), pp. 26–29; and Jules Langsner, "Los Angeles Letter," *Art International* 6, no. 9 (Sept. 1962), p. 49.

24. "A Symposium on Pop Art" was held at the Museum of Modern Art, New York, Dec. 13, 1962. The proceedings were published in a special issue of *Arts Magazine* 37, no. 7 (Apr. 1963), pp. 36–45. Participants included Dore Ashton, Henry Geldzahler, Hilton Kramer, Stanley Kunitz, Leo Steinberg, and moderator Peter Selz.

25. These critics included Dore Ashton, John Canaday, Clement Greenberg, Thomas Hess, Max Kozloff, Hilton Kramer, Irving Sandler, and Peter Selz. It may be that at the time they were peeved for not being the first to signal the new art. Typically, it is the critics' enthusiasm, not the public's, that validates artistic styles.

26. See Gene Swenson, "The New American 'Sign Painters,'" *Art News* 61, no. 5 (Sept. 1962), pp. 44–47, 60–62, and his two-part article, "What is Pop Art?" *Art News* 62, no. 7 (Nov. 1963, Part I), pp. 24–27, 60–65; and 62, no. 10 (Feb. 1964, Part II), pp. 40–43, 62–67.

27. For an in-depth look at the importance of *International Exhibition of the New Realists*, see Bruce Altshuler, "Pop Triumphant: A New Realism," in Altshuler, *The Avant-Garde in Exhibition: New Art in the Twentieth Century* (New York: Harry N. Abrams, 1994), pp. 212–19.

28. For the title of the exhibition, Janis chose "New Realists," a translation of the French term favored by Pierre Restany. However, in his essay "On the Theme of the Exhibition" in the catalogue, Janis preferred "Factual Artists." *International Exhibition of the New Realists*, exh. cat. (New York: Sidney Janis Gallery, 1962).

29. Harold Rosenberg, "The Art Galleries: The Game of Illusion," *The New Yorker*, Nov. 24, 1962, p. 162.

30. This and subsequent quotations are taken from Alloway's memorandum to Messer of Aug. 28, 1962, *Six Painters and the Object* curatorial files, Solomon R. Guggenheim Museum Archives, New York.

31. Alloway would have the opportunity to use the title later for the second chapter in his *American Pop Art*, exh. cat. (New York: Collier, with the Whitney Museum of American Art, 1974).

32. Lawrence Alloway, *Six Painters and the Object*, exh. cat. (New York: Guggenheim Museum, 1963), p. 7. This quote was also used in the press release announcing the exhibition.

33. *The Art of Assemblage* (Oct. 2–Nov. 12, 1961) greatly influenced a number of younger artists, including Rosenquist. See Julia Blaut, "James Rosenquist: Collage and the Painting of Modern Life," in *James Rosenquist: A Retrospective*, exh. cat. (New York: Guggenheim Museum, 2003), pp. 16–43.

34. Alloway memorandum to Messer, Nov. 14, 1962, *Six Painters and the Object* curatorial files.

35. Messer's form letter of Feb. 7, 1963, *Six Painters and the Object* curatorial files.

36. Richard Ahlborn to Messer, Feb. 14, 1963, *Six Painters and the Object* curatorial files.

37. Among the interested institutions not included in the tour were the Joslyn Art Museum, Omaha, Nebraska; Art Gallery of Toronto; San Francisco Museum of Art; Wadsworth Atheneum, Hartford; Saint Louis Museum of Art; and Addison Gallery of American Art, Andover, Massachusetts.

38. In 1963, *Six Painters and the Object* traveled to the Los Angeles County Museum of Art (July 24–Aug. 25), where it was augmented with the exhibition *Six More*. The second stop on the tour was the Minneapolis Institute of Arts (Sept. 3–29), followed by the University of Michigan, Ann Arbor (Oct. 9–Nov. 3), the Poses Art Institute, Brandeis University, Waltham, Massachusetts (Nov. 18–Dec. 29), the Carnegie Institute, Pittsburgh (Jan. 17– Feb. 23, 1964), the Columbus Gallery of Fine Arts, Columbus, Ohio (Mar. 8–Apr. 5), and the Art Center, La Jolla, California (Apr. 20–May 17, 1964).

39. The companion exhibition *Six More* featured the work of the West Coast Pop painters Billy Al Bengston, Joe Goode, Phillip Hefferton, Mel Ramos, Ed Ruscha, and Wayne Thiebaud. Alloway contributed the catalogue essay.

40. See John Weber to Alloway, April 27, 1963, *Six Painters and the Object* curatorial files. In the end, the Dine painting was not included.

41. In addition to *Six Painters and the Object*, 1963 also witnessed the following Pop art shows: *Pop Goes the Easel*, organized by Douglas MacAgy for the Contemporary Arts Museum, Houston (Apr. 4–30), *The Popular Image Exhibition*, organized by Alice Denney for the Washington Gallery of Modern Art, Washington, D.C. (Apr. 18–June 2), *Pop Art USA*, organized by John Coplans for the Oakland Art Museum (Sept. 7–29), *Popular Art: Artistic Projections of Common American Symbols* at the Nelson Gallery-Atkins Museum in Kansas City (Apr. 28–May 26), which traveled to the Albright-Knox Art Gallery, Buffalo (Nov. 19–Dec. 15), and *Signs of the Times III: Painting by Twelve Contemporary Pop Artists* at the Des Moines Art Center (Dec.–Jan. 1964).

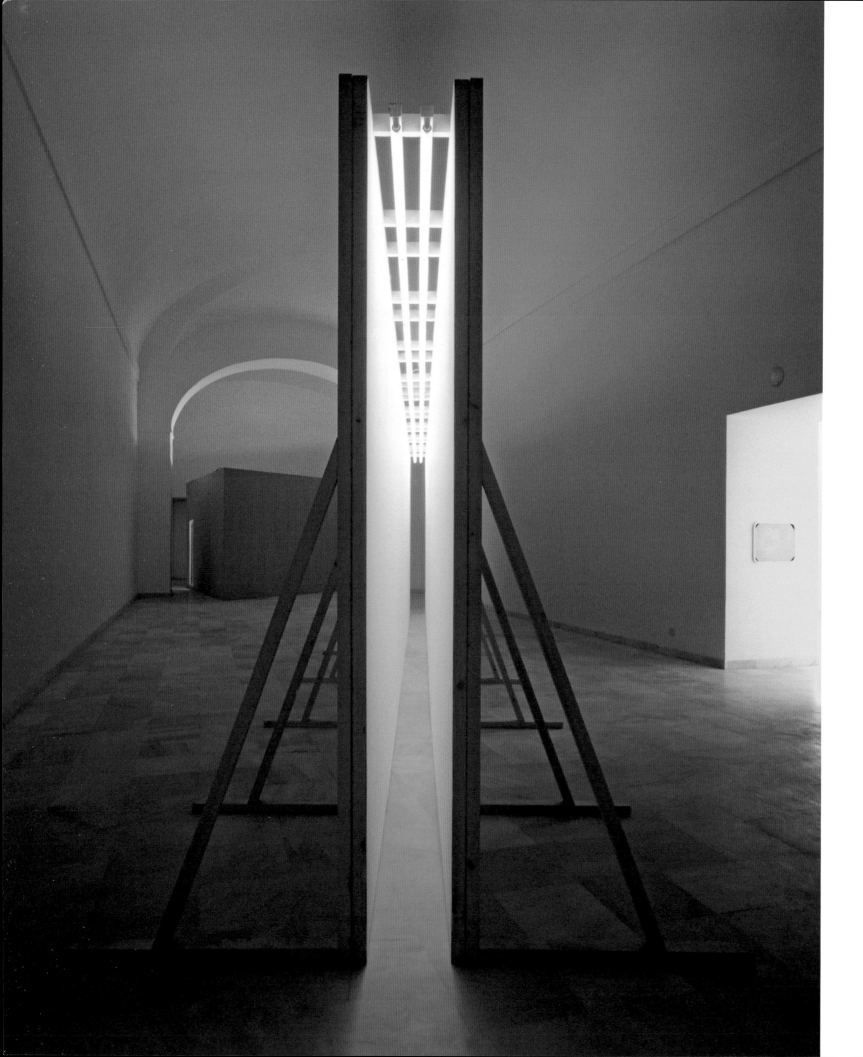

JULIA BROWN

A Search for the Essential

In 1991, the Guggenheim acquired a major portion of Count Giuseppe Panza di Biumo's collection of art from the 1960s and 1970s. The acquisition brought to the Guggenheim prime examples of the new directions taken by some of the leading artists of the period. Panza's commitment to particular artists echoes the Guggenheim's long-standing practice of collecting many works by important twentieth-century figures, such as Constantin Brancusi, Vasily Kandinsky, and Paul Klee. Furthermore, the Panza Collection's exploration of abstraction is in keeping with the Guggenheim's original mission as a museum of non-objective art. ▬▬▬ Although the Guggenheim acquired 357 works from Panza, this concentration of Minimalist, Conceptual, Process, and Environmental art of the 1960s and 1970s was but one part of the large collection he had assembled in close collaboration with his wife, Giovanna Panza, since 1956. Combining rigorous study with frequent studio visits and years of looking at art, the Panzas built the collection with seriousness and sensitivity. Rather than heeding prevailing fashions, they followed their own course. ▬▬▬ Between 1956 and 1963, the Panzas sought out European and American painting and sculpture of the mid-1940s through the early 1960s. Embarking on a collecting strategy that was to become a pattern, they focused on artists who were not well known at the time and concentrated on particular bodies of work or aspects of each artists' career. The first works they acquired are by two Europeans, Jean Fautrier and Antoni Tàpies. The six Fautrier paintings in their collection date from 1943 through 1947; characterized by rough, thickly painted surfaces and emotional subject matter, they anticipate Art Informel, the dominant art movement in postwar Europe. The fourteen paintings by Tàpies, made between 1955 and 1959, are among the most powerful pieces created by that artist. Although they purchased a work by Franz Kline in 1956, it was in 1959 that the Panzas began to focus more attention on American artists, traveling to the United States on a regular basis to visit galleries, museums, and artists' studios (a practice they continue to this day). Acquiring a total of seven paintings by Kline dating from 1953 through 1961 and seven paintings by Mark Rothko from 1953 through 1960, they brought some of the most profound works of Abstract Expressionism into their collection. The Panzas were also among the first patrons of Pop art, purchasing eleven of Robert Rauschenberg's Combines of the mid-1950s and sixteen of Claes Oldenburg's early sculptures (the latter acquired directly from the artist's legendary *The Store*, his 1961 installation in a storefront at 107 East Second Street in New York). They also purchased eight works by James Rosenquist from the early 1960s and four 1962 paintings by Roy Lichtenstein; these are iconic works of early Pop art, exploring formal issues of

facing page:
142. Bruce Nauman
Green Light Corridor, 1970

fig. 93 Giuseppe Panza standing in Bruce
Nauman's *Green Light Corridor* (1970,
plate 142), 1988.

abstraction along with subject matter derived from commercial imagery and popular culture. ▬▬▬ In the mid-1960s, the Panzas started buying works by East Coast artists such as Dan Flavin, Donald Judd, Sol LeWitt, Robert Mangold, Brice Marden, Robert Ryman, and Richard Serra, who were exploring a reduced and powerful abstraction. They also traveled to California and became deeply committed to the perceptual environments being made in Los Angeles by Robert Irwin, Maria Nordman, James Turrell, and Doug Wheeler and to the work of Bruce Nauman. Many of the pieces they purchased from these artists were acquired in the form of proposals and plans. Concurrently, the Panzas collected Conceptual art being made on both coasts and in Europe, bringing works by such artists as Hanne Darboven, Douglas Huebler, Joseph Kosuth, and Lawrence Weiner into the collection. ▬▬▬ The Panzas have worked to place large parts of their collection permanently in public institutions so that coherent grouping of works can be kept together. In addition to the works acquired by the Guggenheim—including a number of site-specific pieces that remain at the Panza di Biumo family estate, the Villa Litta in Varese, Italy—major portions of the collection were acquired by the Museum of Contemporary Art (MOCA) in Los Angeles. The Panza Collection at MOCA includes works by Fautrier, Kline, Lichtenstein, Oldenburg, Rauschenberg, Rosenquist, Rothko, George Segal, and Tàpies, as well as works created between 1982 and 1993 by Los Angeles painters and sculptors. Also, more than one hundred works from the Panzas' collection are on public view at the Villa Litta, which is now administered by the Fondo per l'Ambiente Italiano.

The Panza Collection at the Guggenheim includes Minimalist sculptures and paintings in which the focus is on the material object and the presentation of the object in space; Conceptual artworks in which an idea constitutes the work's content; and environments in which light and space, their condition over time, and perception itself are the subject of the art. Overall, the collection can be characterized by the idea of the absolute, and by the expression of actual—as opposed to implied or illusionistic—space. But although this art is grounded in the real, it is simultaneously transcendent and often deals with the intangible, such as a sense of time. ▬▬▬ The work in this collection shares the quality of being abstract and seemingly without content, in that it focuses on intrinsic form and presence without pictorial representation, illusion, metaphor, or narrative. It is also deeply experiential and in so being taps into both an awareness of the self and emotional associations that do not necessarily refer to anything outside the work but are not limited by it. Rich with meaning, the work appeals to the senses, creating both an inward perception of wordless thought and an outward experience of presence. ▬▬▬ The Panzas' collection has resulted from their pursuit of art that physically and visually manifests the intellectual, the spiritual, and the emotional. Their belief has always been that art must be exhibited in a sympathetic space of architectural distinction, a space with its own character and integrity, and that concentrations of work by a given artist should be shown together so that the viewer can be surrounded by the ideas and sensibility of that artist.

fig. 94 Dan Flavin, *the nominal three (to William of Ockham)*, 1963. Fluorescent light fixtures with daylight lamps, edition 2/3. h. 182.9 cm each fixture; overall dimensions vary with installation. Solomon R. Guggenheim Museum, New York, Panza Collection 91.3698

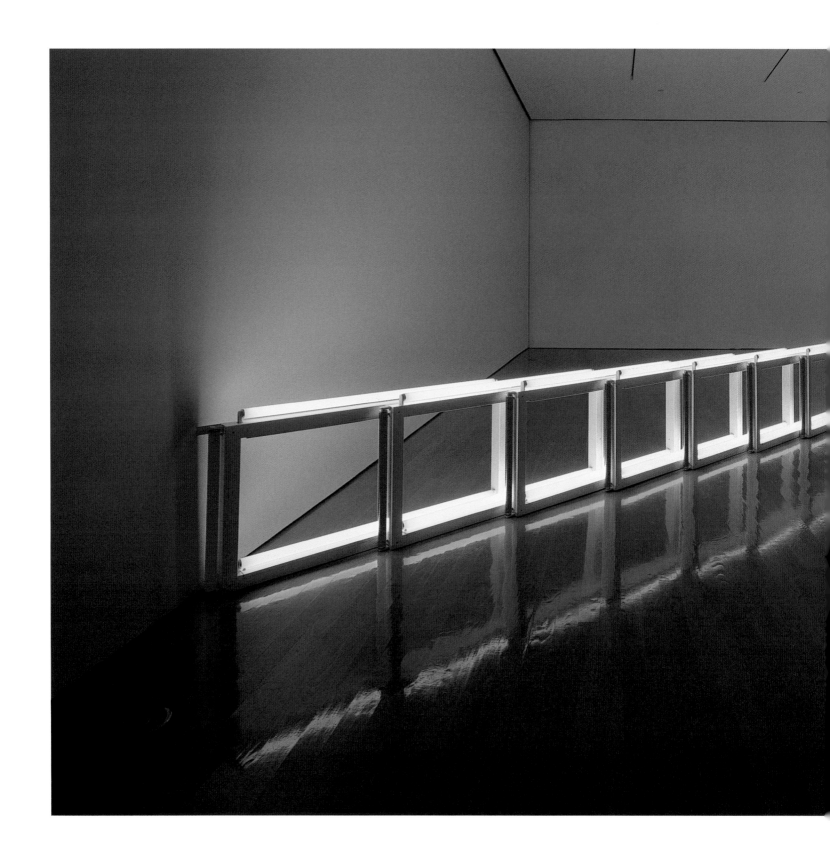

143. Dan Flavin
an artificial barrier of blue, red and blue fluorescent light (to Flavin Starbuck Judd), 1968

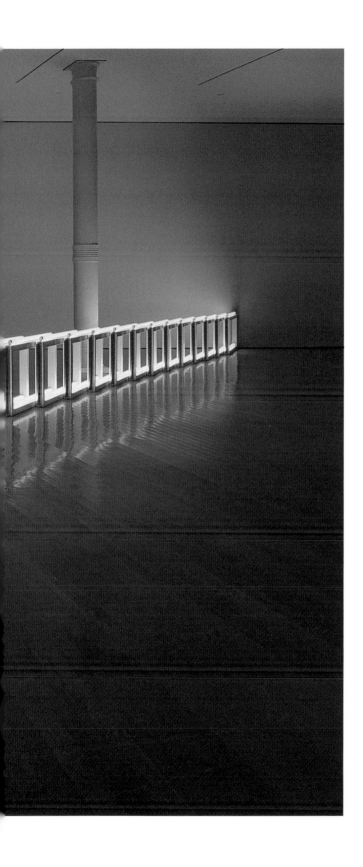

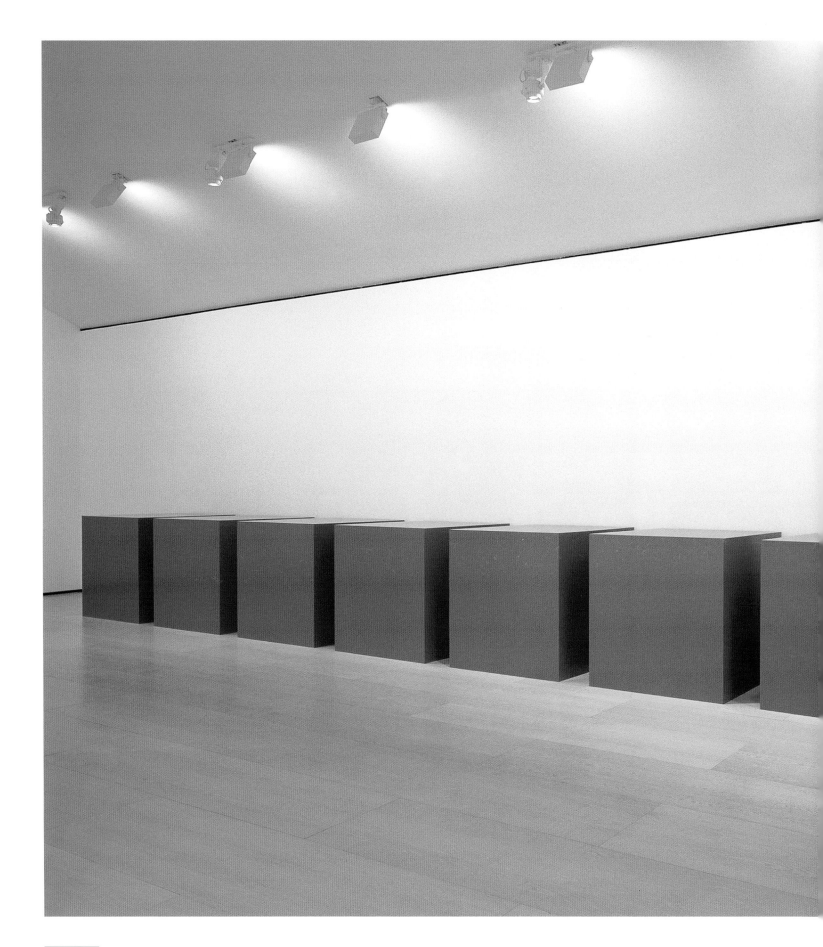

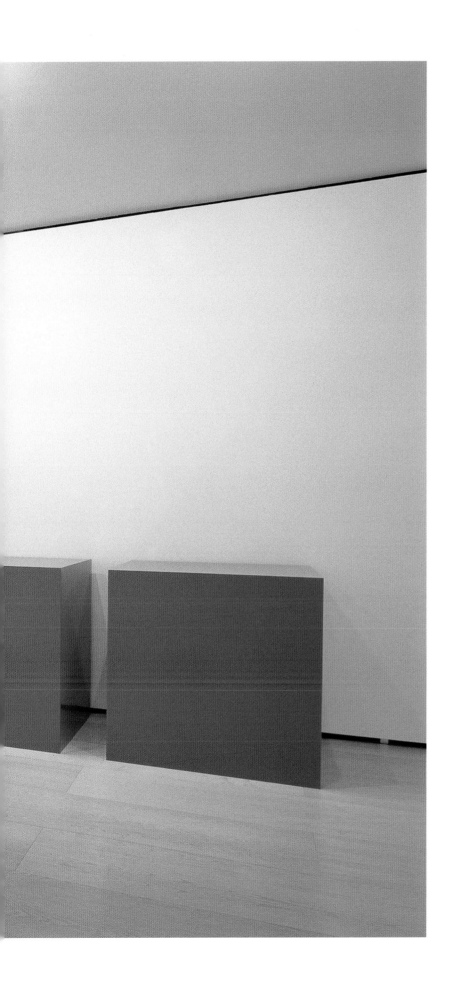

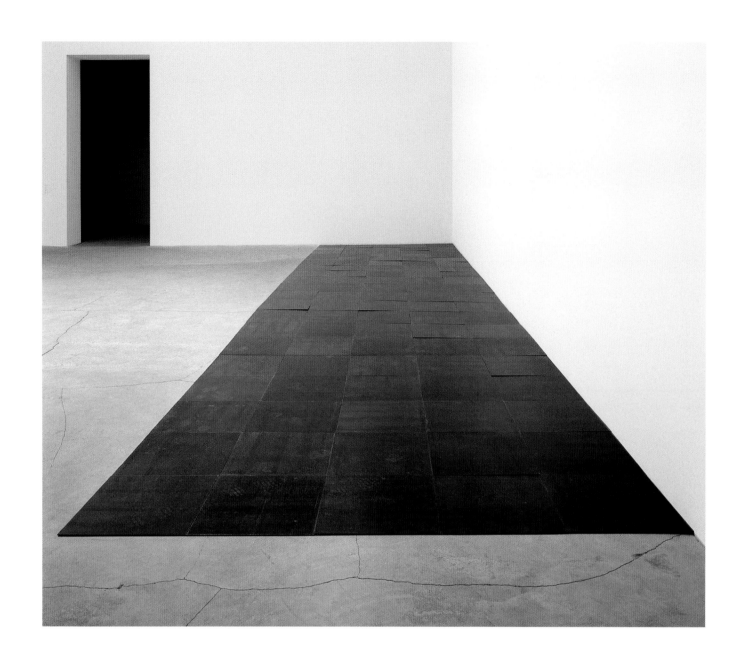

145. Carl Andre
5 x 20 Altstadt Rectangle, Düsseldorf, 1967

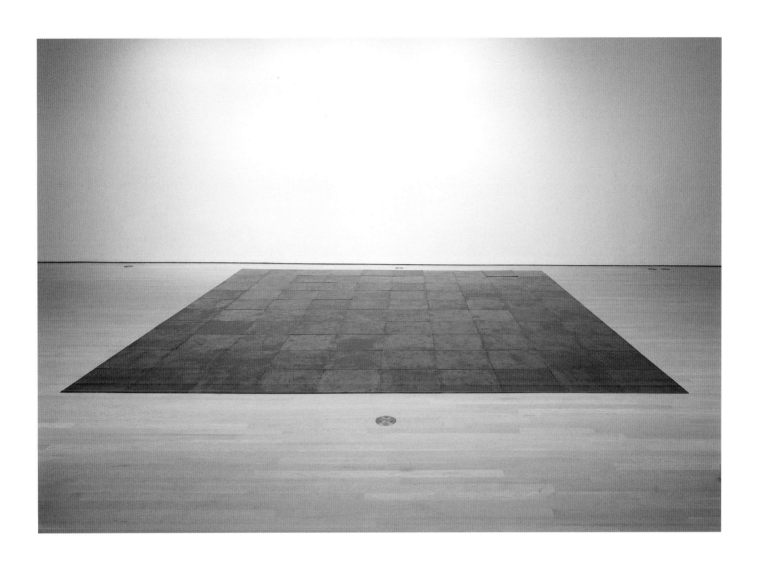

146. Carl Andre
10 x 10 Altstadt Copper Square, Düsseldorf, 1967

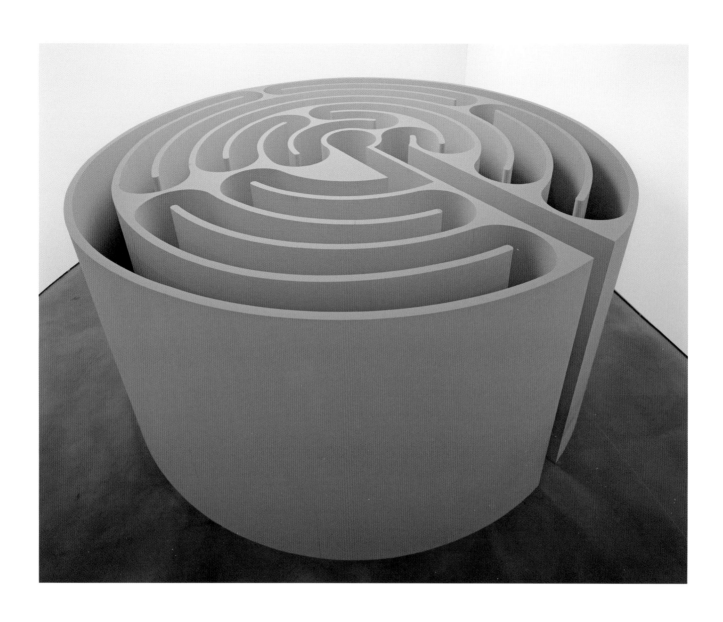

147. Robert Morris
Untitled (Labyrinth), 1974

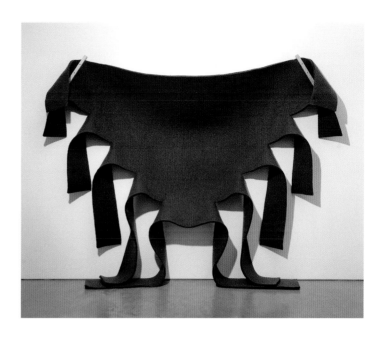

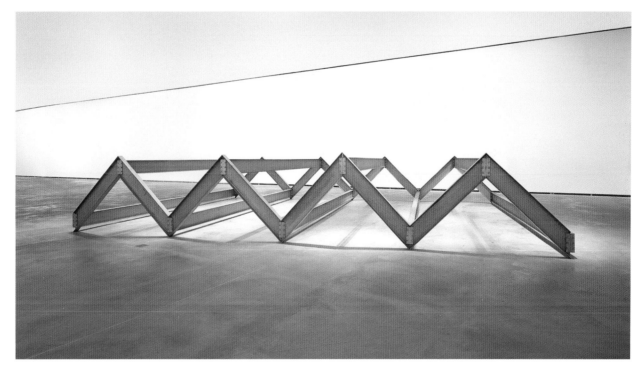

148. Robert Morris
Untitled (Brown Felt), 1973

149. Robert Morris
Untitled (Aluminum I-Beams), 1967

Central to the Panzas' collecting sensibility and inherent in much of the work in the collection is the idea that the nature of the installation and presentation of an artwork enhances its meaning and is critical to the viewer's understanding of it. Indeed, in many of the pieces in their collection, the work and the space are one and the same. In some cases, everything extraneous to the experience of art and architecture has been removed, giving rise to privileged, often dramatic, spaces. In keeping with the move away from the concept of the portable object, many of the works in the Guggenheim's Panza Collection were made for particular spaces, or were designed to be made according to specific plans and diagrams, and then disassembled or destroyed to be remade for future exhibitions, so they may be realized in accordance with the artist's instructions in the context of a given space and time. ▬▬▬ The collection possesses many definitive examples of Minimalist sculpture. Turning away from the emphasis on gesture and emotionality of Abstract Expressionism, this work embraces the tangibility and essences of materials and forms and foregrounds the object's relationship to space. Minimalist sculpture often frames presence in absence by underscoring the space between things, thus marking the volume of the void. In its distillation of abstract form, it represents a continuation of the non-objective tradition dating to the art of Brancusi, the Bauhaus, and Constructivism. Yet while often described as purely formal and material, Minimalist sculpture is also passionate in its consideration of questions about existence and sensuous in the straightforward beauty of its materials, surfaces, workmanship, and expression of spatial proportion. In Panza's words, "These shapes, which are apparently so intellectual, really hide something extremely emotional. I believe the greatest emotion is knowledge, the discovery of truth.... This art revealed the research of truth through simple forms."[1] ▬▬▬ Flavin's work, made from a common and readily available material—the fluorescent tube—creates both a concentration of light and color (the two being one) and its diffusion in a given space. His geometric and linear arrangements of fluorescent fixtures seem simultaneously tangible and intangible. Taking a functional object, he transformed it into a bearer of complex beauty, as sensuous as a Matisse and as strict as a Mondrian. Flavin's work ranges from simple and direct objects to whole environments. *an artificial barrier of blue, red, and blue fluorescent light (to Flavin Starbuck Judd)* (1968, plate 143) engages an entire room; placed directly on the floor, the sculpture, a low, segmented wall, divides the room, dominating and activating it through its physical form and through the light that fills the space. In *the nominal three (to William of Ockham)* (1963, fig. 94)—a sculpture consisting of six fluorescent fixtures, placed along the length of a wall in groupings of one, two, and three—Flavin made a work of the barest elemental structure, both in form and content. Yet this simple structure is transformed into something radiant, as the pure force of the white light transcends the ordinariness of its source. ▬▬▬ As in Flavin's work, Judd's sculpture is characterized by elemental, abstract forms. The materials Judd used speak for themselves, like a thought or a story expressed exclusively through nouns, without the embellishment of adjectives or verbs. Yet the simplicity of his forms and materials, as well as the purity and integrity of the works' craftsmanship, express a richness inherent in

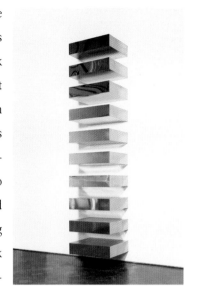

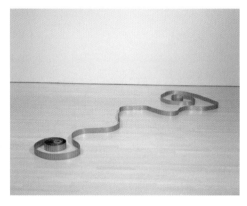

fig. 95 Donald Judd, *Untitled*, December 23, 1969. Copper, ten units with 9-inch intervals, 22.9 x 101.6 x 78.7 cm each; 457.2 x 101.6 x 78.7 cm overall. Solomon R. Guggenheim Museum, New York, Panza Collection 91.3713

fig. 96 Carl Andre, *Zinc Ribbon*, Antwerp, 1969. Zinc, one continuous strip, 9 x 2100 x 0.1 cm. Solomon R. Guggenheim Museum, New York, Panza Collection 91.3672

the bodies and surfaces of his sculptures. Judd's works are involved with an essential order, within themselves and in relation to surrounding space. For example, *Untitled* (1969, fig. 95) is a study of material and the combination of geometric units. A stack of ten copper boxes, it measures the space between floor and ceiling in evenly divided intervals of mass and void, so that the volumes of emptiness between each of the units is as tangible as the sculpture that defines them. The material the work is made of reflects light, mirroring the room and creating a shimmering beauty within the strict geometry of the surfaces. The experience of the work's proportions and divisions, its definition of space and volume, and the resonance of its materials are deeply satisfying both physically and intellectually. Judd's works can express the notion of the absolute, the answer to a specific problem, and the synthesis of an idea. They touch on some of the most basic questions about physical being and the power of the intellect to order one's existence. ▬▬ Carl Andre creates arrangements of simple units in his work, using various kinds of wood, metal, concrete, and other materials. Most of his sculptures have a horizontal orientation and lie directly on the floor, emphasizing the planar dimension of the ground and its lateral extension and making palpable the space between the viewer and the ground. Like Judd's work, Andre's sculptures give a sense of immediacy and directness to the object by removing the aspect of presentation inherent in pedestals. Andre's arrangements of thin steel or copper plates that hug the ground plane (see plates 145 and 146), emphasize the volume and scale of the spaces in which they are installed. Despite their seemingly static nature, Andre's sculptures, like Judd's, have a nonhierarchical sense of time, progression, and measure, whether they are comprised of equal or disparate elements. This progression is both self-contained and limitless, having no beginning, middle, or end. *Zinc Ribbon* (1969, fig. 96) appears to arrest the random motion of an unraveling coil of zinc, making a sculptural fact out of an ordinary event and action. It evokes the image of a road that has no origin or destination. ▬▬ Robert Morris's sculptures take material structure and form as their subject. In works such as *Untitled (Brown Felt)* (1973, plate 148), felt hanging from the wall or tumbled in a heap on the floor is simply what it is—matter, with its own weight determining its form. Morris's labyrinths in the Panza Collection, such as *Untitled (Labyrinth)* (1974, plate 147), seem to be visual constructions of the mind transformed into complete environments for the body that lead the viewer on a specific path.
▬▬ Minimalist paintings share Minimalist sculpture's concentration on the innate character and intrinsic beauty of materials and its emphasis on the primacy of the work of art as a self-referential object. They build on the tradition of pure abstraction exemplified by the work of artists such as Kazimir Malevich, Piet Mondrian, and Rothko. Marden's paintings have a sensuous quality derived from the combination of oil and wax on their canvas surfaces. These materials are built up in multiple layers, resulting in a rich surface that holds the memory of successive applications of color. The materials, as well as the works' muted colors, seem to absorb light, creating a sense of softness that contrasts with the discipline of the pared-down palette and the simple divisions of the canvas into balanced parts. The paintings are discrete abstractions, but they are also associative:

fig. 97 Brice Marden, *Untitled*, 1973. Oil and wax on canvas, two panels, 182.9 x 183.2 cm overall. Solomon R. Guggenheim Museum, New York, Panza Collection 91.3789

works such as *Untitled* (1973, fig. 97) suggest the meeting of sky, land, and water, or of adjacent fields, evoking reminiscences of experiences of nature, light, and landscape that bring to mind a sense of place. ▬▬▬ Ryman's paintings, like Marden's, are meditations on color and the material of paint, but his works also investigate the painting as a constructed object and the act of painting itself. Ryman plumbs the depths of ideas, conducting extended, disciplined explorations to produce works that express the wide range of possibilities attainable within strictly controlled means. Each detail of construction and finish in his work is an equal part of the whole. Among the subjects of his investigations are the variance of materials (both paint and ground), color, and gesture, and the description of the object itself—how it is made or built, its relationship to the wall, and its construction as a single element or multiple elements. His paintings have no reference, association, or narrative beyond their own internal processes and materials; the image and subject of the painting is the character of paint itself, and how the object is made and presented. In *Impex* (1968, fig. 98), Ryman established a square of oil on linen, then extended the square's border diagonally in blue chalk drawn directly on the wall. Throughout his work, Ryman breaks down the language of painting through nonreferential, self-reflective contemplation. These works, austere yet frequently tender, explore the fullness and complexity of white. ▬▬▬ In *Untitled* (1973), Mangold superimposed, on a square of pure color, a curved line made by extending his arm in a full circular reach; though the line at first appears to describe a perfect circle, its ends do not meet, creating a geometry that the viewer's eye tries to resolve and complete. Another work from 1973, *Circle Painting 1* (fig. 99), is a circular canvas with a flat surface on which a squarelike shape has been drawn; one form seems to be evenly placed within the other, but two of the seemingly perpendicular sides do not meet, upsetting the painting's illusion of geometric precision and symmetry. The geometric configurations and lucid colors of Marden's paintings introduce a sense of clarity without resolution, a sense of measure within an open field. Just as walls, by serving as boundaries, create spaces, Mangold's linear divisions within flat planes of color make the "empty" areas of his canvases visible and resonant. ▬▬▬ The work of LeWitt lies within the interstices of Minimalism, with its emphasis on basic forms and materials, and Conceptual art, which holds the idea as primary and its execution as simply the physical manifestation of the original work of art. His wall drawings, which cover the interior surfaces of rooms, are one with the walls on which they appear. In doing away with the drawing's conventional frame, LeWitt makes the architecture of a given space the work's support and frame; the architecture remains visible, yet it is transformed. The expansive and beautiful drawings are derived from a set of written instructions given to others to carry out, just as music results from the instructions of a musical score. Each manifestation varies from the next, depending on the conditions of the given space and the hand of the draftsperson who completes the drawing. In LeWitt's words, "Each person draws a line differently and each person understands works differently. Neither lines nor words are ideas, they are means by which ideas are conveyed."[2] Like sound in a concert hall, the repetition and combination of lines and forms in LeWitt's wall drawings fill the

fig. 98 Robert Ryman, *Impex*, 1968, Oil on unstretched linen canvas, and blue chalk line on wall, canvas 246.4 x 246.4 cm; overall dimensions variable. Solomon R. Guggenheim Museum, New York, Panza Collection 91.3842

fig. 99 Robert Mangold, *Circle Painting 1*, 1973. Acrylic and black pencil on canvas, diam. 182.2 cm. Solomon R. Guggenheim Museum, New York, Panza Collection 91.3763

150. Robert Mangold
Neutral Pink Area, 1966

151. Robert Ryman
Surface Veil I, 1970

152. Robert Ryman
Surface Veil II, 1971

153. Robert Ryman
Surface Veil III, 1971

following two pages:
154. Sol LeWitt
Wall Drawing #264. First installed: Varese, July 1975

155. Lawrence Weiner
Cat. #151 (1970) EARTH TO EARTH ASHES TO ASHES DUST TO DUST, 1970

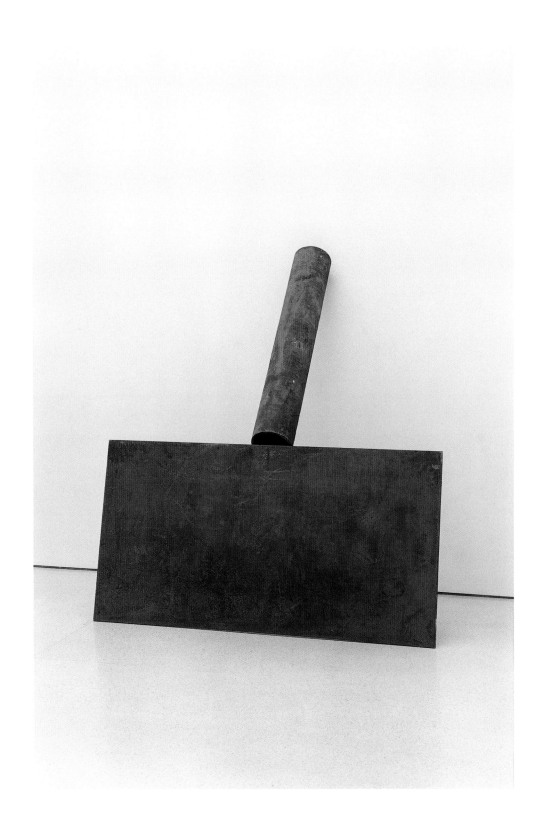

156. Richard Serra
Shovel Plate Prop, 1969

158. Richard Serra
Strike: To Roberta and Rudy, 1969–71

159. Bruce Nauman
Triangle Room, 1978/1980

160. Richard Long
Line of Lake Stones, 1983

rooms they occupy with color and light. ▬▬ In many of the works of Conceptual art in the Guggenheim's Panza Collection, language predominates. These works underscore the Panzas' belief in art as an expression of an idea, a judgment about life, or a visualization of an intellectual process. Many of these works are not unlike concrete poetry, using few words in combination to evoke larger meanings; the visual character of words themselves is part of the aesthetic content of the work. ▬▬ In the works in which language is the sole material, standing in for the art object, the immaterial character of the work alters the viewing experience. Weiner, for example, has created a body of work whose essential component is words. For each piece, he chooses a few words that serve as declarations of location and presence, condition and action; in some works, they remain words and their suggestions—placed carefully onto walls, in particular typefaces and colors—but in others they become actions performed by the artist. Because Weiner's work is a way of seeing through words, it evokes viewers' memories and experiences, bringing forth a myriad of associations. By incorporating location and condition into his simple statements—as in *Cat. #151 (1970) EARTH TO EARTH ASHES TO ASHES DUST TO DUST* (1970, plate 155)—Weiner brings to the exhibition space the sense of another place and the suggestion of conditions changing over time. ▬▬ Serra builds on the sculptural precedents of Minimalism, but incorporates a sense of movement and process in his work. The weight of matter, the balance of equal or unequal forces, and energy controlled and made visible are the subjects of his art. His work is also concerned with making and defining space through the manipulation of materials, as well as with investigating the experiences materials can evoke and what they can do physically. His sculptures in the Panza Collection have contained strength and energy, both within themselves and in their relationship to the surrounding space. *Shovel Plate Prop* (1969, plate 156), with its reliance on gravity, balance of weight and matter, and connection of the horizontal floor with the vertical wall, has a quality of impermanence, like an action arrested in motion. ▬▬ Nauman's *Green Light Corridor* (1970, plate 142) and *Triangle Room* (1978/1980, plate 159) explore claustrophobia, confinement, anxiety, self-possession, and self-remove. Unlike much Minimalist sculpture, Nauman's works seem to invite and depend on the interaction of the viewer for their completion. His constructed spaces, particularly in their unfinished character and rough materials, act as metaphors for the complicated and evolving emotional, intellectual, and physical places in which we live. The works foreground the viewers' physical and psychological relationship to these spaces. Nauman's subjects are the nature of subjectivity; the simultaneous separation and conjunction of the mind and body; and time expressed tangibly, experientially. ▬▬ The Panzas were among the first collectors to acquire in depth the work of artists who were making perceptual environments in Los Angeles in the 1960s. A radical new development in art at that time, this work engages presence and perception through the manipulation of space and light. The work is site-specific and experiential, usually engaging an entire room. No longer an object, the artwork is the space itself and is dependent on its location's given and changing conditions over time. Rather than simply looking, the viewer experiences and understands the work only

fig. 100 Robert Irwin, *Varese Scrim*, 1973. Nylon scrim, dimensions site-determined. Solomon R. Guggenheim Museum, New York, Panza Collection, Gift, on permanent loan to Fondo per l'Ambiente Italiano 92.4134

fig. 101 James Turrell, *Lunette*, Varese, 1974. A vertical portal cut to outside sky, interior filled with natural and warm white neon light, site-specific dimensions. Solomon R. Guggenheim Museum, New York, Panza Collection, Gift, on permanent loan to Fondo per l'Ambiente Italiano 92.4178

facing page:
fig. 102 James Turrell, *Sky Space I*, Varese, 1974. An overhead portal cut to outside sky, interior filled with natural light, site-specific dimensions. Solomon R. Guggenheim Museum, New York, Panza Collection, Gift, on permanent loan to Fondo per l'Ambiente Italiano 92.4177

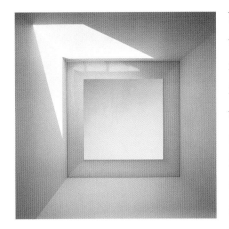

by being within it for a duration of time. While works by artists such as Judd and Serra emphasize the material and the actual, and Conceptual art, such as Weiner's, conveys experience and "what is real" through the expression of the idea of it, perceptual environments are engaged in making the intangible tangible, making light palpable, and allowing for the perception of space and oneself within it. ▬▬ In Irwin's *Varese Scrim* (1973, fig. 100), a panel of transparent nylon—a fabric that seems to hold light and to make it material—runs from floor to ceiling across the room. The scrim itself seems to disappear, leaving only a plane dividing the space in which it is placed, creating volumes of contained and mysterious light. In this foglike atmosphere, it is not clear what is there or not there, as in the state between waking and dreaming. Viewers must remain and observe for some time before the senses adjust; only then do the divisions of space articulated through light and the silence his work captures become evident. The space develops through light, like a photograph. ▬▬ Turrell uses light as a means to foreground the experience of seeing. His works give weight and emotion to light and color, each work creating different textures and volumes that change over time. Light becomes atmospheric, like the weather. Deeply experiential, his work engenders wordless thought. *Lunette* (1974, fig. 101) and *Sky Space I* (1974, fig. 102), both installed in the Villa Litta, mix interior and exterior illumination. Through openings to the sky, they form a seemingly tangible skin at the meeting of outside and inside, and chart the changing light from early morning through the day into twilight and night. The room itself becomes the work of art, a container for the space and light it holds and the experience of being in it. Yet in the soft white light, the room's architectural shape appears to dissolve, with all edges and boundaries erased. Viewers feel themselves to be in a boundless space, at once enveloped and released by the light. ▬▬ The hundreds of works that have entered the Guggenheim's holdings as part of the Panza Collection encompass an enormously rich period in American art history, during which art moved away from the object and into the room itself; the beauty of the idea gained equal footing with the beauty of the object; and the perception and experience of the viewer and the duration of time became key elements in the understanding of art. In keeping with one of the founding principles of the Guggenheim as a museum of non-objective art, this work continues a search into the nature of art without referential subject matter—art that appeals to the spirit—and introduces the process of thinking itself.

NOTES

1. Christopher Knight, "Interview with Giuseppe Panza," in *Art of the Sixties and Seventies: The Panza Collection* (New York: Rizzoli, 1987), p. 42.

2. Sol LeWitt, "Doing Wall Drawings," *Art Now: New York* 3, no. 3 (June 1971).

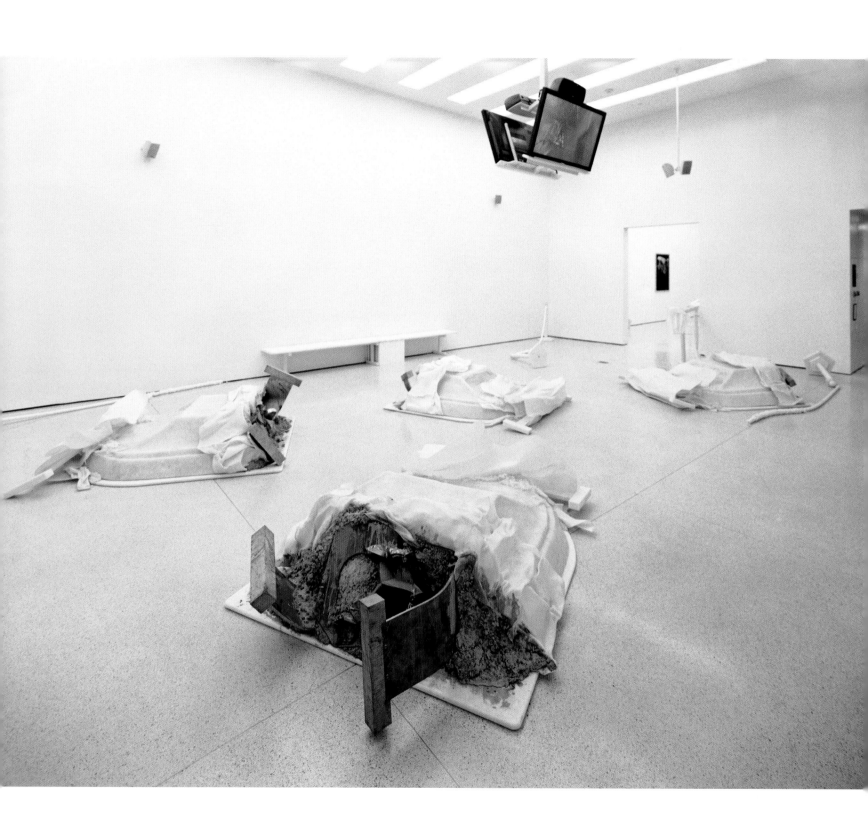

TED MANN

The Art of Tomorrow:
Collecting in the 1990s and Beyond

From its inception, the Solomon R. Guggenheim Foundation has been dedicated to collecting the art of the present. Hilla Rebay, Solomon's influential advisor and the first director of what would become the Solomon R. Guggenheim Museum, envisioned the institution as an active and dynamic champion of living artists.[1] For Rebay, however, the only contemporary art of interest was non-objective painting, as epitomized by the work of Vasily Kandinsky and Rudolf Bauer. Rebay viewed non-objective painting not as one among a variety of modern styles or movements, but as an unparalleled achievement in the history of art.[2] In the catalogue for *Art of Tomorrow* (1939), her landmark, inaugural exhibition at the Museum of Non-Objective Painting, she articulated the foundation's goal "to establish the power of Non-objectivity" and heralded the arrival of a new epoch, a "bright millennium of cooperation and spirituality with its love for order and rhythm."[3] ▬▬▬ Under Rebay's successors, this focus on non-objective painting was abandoned in favor of a more inclusive and comprehensive approach to collecting, which embraced multiple mediums, styles, and forms. The commitment to representing the new, however, has remained one of the core missions of the Guggenheim. Although Rebay's highly utopian approach to art and telescopic view of art history has not persisted, the museum remains firmly committed to "the art of tomorrow"—in all of its myriad forms. ▬▬▬ The past decade and a half has witnessed an unprecedented growth in the Guggenheim's holdings of contemporary art. Since 1990, the permanent collection has nearly doubled in size, with the majority of new acquisitions dating from 1970 or later. Many of these works were produced in the past fifteen years, including critical pieces by established as well as emerging artists.[4] As befits an international institution like the Guggenheim, these newly acquired works come from artists from all over the globe and encompass all mediums, from painting and sculpture to photography and media-based works, including film, video, and digital and internet art.[5] The Guggenheim does not attempt to form an encyclopedic collection, however. Instead, it seeks to represent certain artists in depth, while maintaining a breadth that reflects the state of the art of the present. ▬▬▬ Since 2002, two large-scale exhibitions in New York have highlighted certain areas of the museum's contemporary collection: *Moving Pictures* (2002–03) looked at contemporary photography, film, and video, showcasing many recent acquisitions from the Bohen Foundation, while *Singular Forms (Sometimes Repeated): Art from 1951 to the Present* (2004) paired works from the Panza Collection with more recent works to investigate the legacy of Minimalism and the impulse toward reductive form. The current exhibition in Bonn marks the first time in the Guggenheim's

facing page:
161. Matthew Barney
Chrysler Imperial, 2002

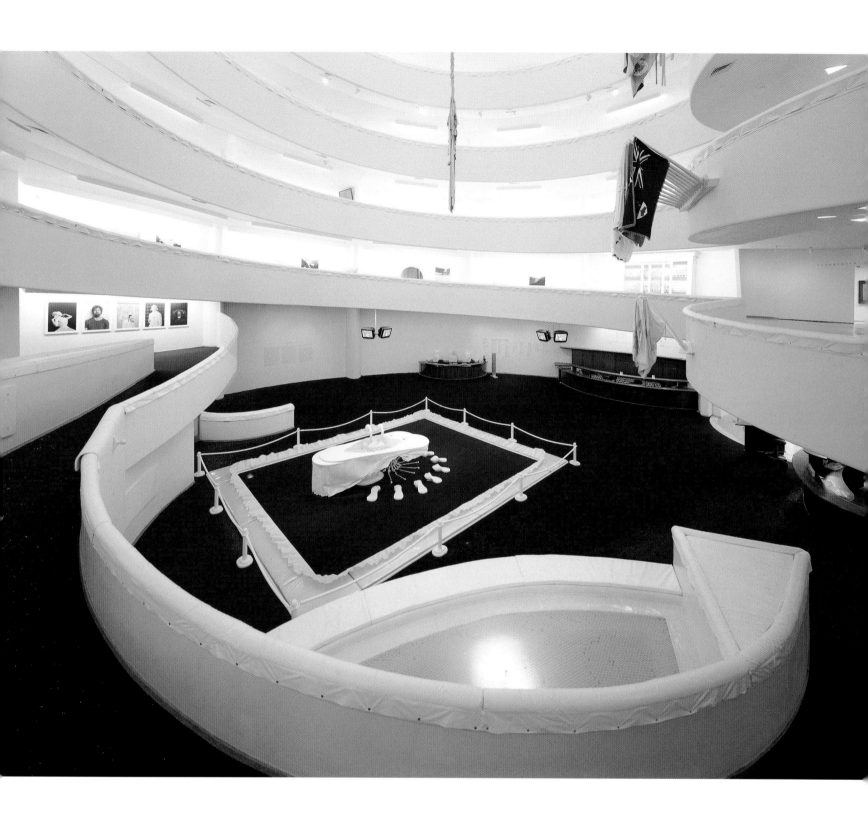

fig. 103 *Matthew Barney:*
The Cremaster Cycle, 2003, Solomon R.
Guggenheim Museum, New York

fig. 104 Roni Horn, *Untitled (Flannery)*, 1996–97. Optically clear blue glass, edition 1/3, two parts, 27.9 x 83.8 x 83.8 cm each. Solomon R. Guggenheim Museum, New York. Purchased with funds contributed by the International Director's Council and Executive Committee Members: Edythe Broad, Elaine Terner Cooper, Linda Fischbach, Ronnie Heyman, J. Tomilson Hill, Dakis Joannou, Barbara Lane, Peter Norton, Willem Peppler, Alain-Dominique Perrin, David Teiger, Ginny Williams, and Elliot K. Wolk 98.4624

fig. 105 Roni Horn, *Gold Field*, 1980–82. Pure gold (99.9%), edition 2/3 + 1 A.P., 124.5 x 152.4 x 0.002 cm. Solomon R. Guggenheim Museum, New York. Purchased with funds from the estate of Ruth Zierler, in memory of her dear departed son, William S. Zierler, and with funds contributed by the International Director's Council and Executive Committee Members: Tiqui Atencio, Ruth Baum, Edythe Broad, Elaine Terner Cooper, Dimitris Daskalopoulos, Harry David, Gail May Engelberg, Shirley Fiterman, Laurence Graff, Nicki Harris, Dakis Joannou, Rachel Lehmann, Linda Macklowe, Peter Norton, Tonino Perna, Simonetta Seragnoli, Cathie Shriro, David Teiger, Ginny Williams, and Elliot K. Wolk, and Sustaining Members: Linda Fischbach, Beatrice Habermann, and Cargill and Donna MacMillan 2005.64

163. Rachel Whiteread
Untitled (Apartment), 2001

recent history that a selection of its contemporary artworks has been shown in the same exhibition as its late-nineteenth-century and modern collections. It therefore offers a unique opportunity to consider how the contemporary holdings fit into the Guggenheim collection as a whole. ▬▬ The contemporary section of the current exhibition has been conceived as a nonlinear cluster of galleries, each room dedicated to the work of one of nine artists whom the Guggenheim has either collected in depth or represents through important singular installations: David Altmejd, Matthew Barney, Anna Gaskell, Douglas Gordon, Roni Horn, Iñigo Manglano-Ovalle, Matthew Ritchie, Kara Walker, and Rachel Whiteread. Rather than following the monographic structure of the installation, this essay contextualizes the artworks by briefly considering how they relate to one another as well as to pieces by other artists in the collection. A number of broad themes may be discerned that weave through the Guggenheim's contemporary collection, forming connections between seemingly heterogeneous artworks. Within the present exhibition, five such thematic groupings may be identified: responses to the forms of Minimalism; critiques of modernist architecture; the use of doubling and mirroring; the investigation of history and memory; and the construction of fantastic worlds and cosmologies. While these categories are by no means exhaustive, and the borders between them are not fixed, they nevertheless offer points of entry into the Guggenheim's collection and provide a way of looking at some of the concerns animating many of today's leading artists.

After Minimalism

With its pared-down aesthetic and economy of means, Minimalism has provided an appealing ready-made language for many artists of a younger generation. But such artists, while echoing the formal characteristics of the 1960s movement, have rejected one of its central premises: its claim to neutrality.[6] If Minimalism proposed literal, autonomous objects stripped of any symbolic content— the notion, summed up concisely by Frank Stella, that "what you see is what you see"—these artists have injected the personal, the political, and the poetic into their "minimal" works.[7] ▬▬ For Felix Gonzalez-Torres, appropriating the forms of canonic 1960s art held subversive potential.[8] The artist's paper stacks recall the iconic Minimalist cube as well as the metal "stacks" of Donald Judd, and his candy spills have been compared to such works as the metal carpets of Carl Andre. But in contrast to the solid, obdurate, industrially produced forms of Minimalism, Gonzalez-Torres's papers and candies are intended to be taken away by the viewer (and, in the case of the candies, consumed). They exist in a state of corporeal flux, suggesting vulnerability and loss, and are also generous and democratic in spirit, inviting the viewer to complete the work. Far from being simply literal objects-in-and-of-themselves, such works are charged with meaning. In *"Untitled" (Public Opinion)* (1991, fig. 106), which was created at the time of the first Gulf War and in a generally conservative climate, the black, missile-shaped licorice rods allude to American militarism, while the parenthetical subtitle suggests an uninformed and easily swayable citizenry. ▬▬ The multiform work of Roni Horn, a close friend of Gonzalez-Torres, similarly recalls the formal features of

fig. 106 Felix Gonzalez-Torres, *"Untitled" (Public Opinion)*, 1991. Black rod licorice candy, individually wrapped in cellophane (endless supply); ideal weight: 700 pounds, dimensions variable. Solomon R. Guggenheim Museum, New York, Purchased with funds contributed by the Louis and Bessie Adler Foundation, Inc., and the National Endowment for the Arts Museum Purchase Program 91.3969

166. Douglas Gordon
through a looking glass, 1999

167. Kara Walker
Insurrection! (Our Tools Were Rudimentary, Yet We Pressed On), 2000

Minimalism while resonating with subtle and varied allusions. Her *Gold Field* (1980–82, fig. 105) presents the viewer with a rectangle of thin, pure gold foil, set directly upon the floor. In its elemental shape, its lack of a pedestal, and its absence of any adornment or visible interference by the artist's hands, the work shares certain properties with the classic Minimalist object. But instead of a hard, industrially manufactured material, Horn has chosen an element that is rare, precious, and fragile—a material, moreover, that is packed with a multitude of associations, from the mythological to the cultural to the economic. Horn, however, is not interested in declaring any straightforward meaning to the viewer. By simply laying an elemental substance on the floor, she allows viewers to interpret it according to their own memories and associations.[9] Repetition was a central strategy of Minimalism. But whereas the goals of artists such as Andre, Judd, and Robert Morris were to break down traditional hierarchies and methods of composition, mimic industrial mass production, or emphasize a unitary gestalt to be perceived in relation to the viewer's body in space, Horn uses repetition to explore identity and difference. In her *Pair Objects*, begun in 1980, pairs of simple, identical volumes are positioned apart from each other in the exhibition space so that they are encountered sequentially. The viewer's memory is triggered, and he or she discerns subtle differences between the twinned object in terms of their lighting and shadow, the angle from which they are encountered, and their relation to the surrounding space. In *Untitled (Flannery)* (1996–97, fig. 104), two blocks of cast blue glass are positioned in relative proximity, so that one is illuminated by sunlight and the other stands in shadow, suggesting the temporal passage from day to night. These glowing blue wells are rife with metaphysical and psychological allusions.[10] Horn has extended her strategy of repetition to the medium of photography. Her ambitious photographic installation *PI* (1997–98, plate 162) consists of forty-five photographs hung around the walls of a gallery space, without a clear beginning or end. Shot in Iceland, a place to which Horn has repeatedly returned, the photographs depict a range of subjects, from taxidermic animals to landscapes with birds, to an elderly couple watching an American soap opera, to seascapes that have been sliced in two (the separate halves are hung in different locations within the room). Despite the apparent complexity of the work, *PI* repeatedly maps the basic geometric form of the circle, as implied by its title—which refers to the mathematical constant π, the ratio of a circle's circumference to its diameter. *PI* alludes to several imagined and metaphoric circles (and constants), including the Arctic Circle, the life cycles of the elderly couple and the birds, the harvest, the cycles of the tide, and the serial television show, as well as the cyclical structure of the physical installation itself, which, positioned above the viewer's head, takes the form of a surrounding horizon line. Rachel Whiteread's evocative castings have also been discussed in relation to Minimalism. Since the late 1980s, Whiteread has cast furniture and architectural spaces in plaster, rubber, and silicone, transforming the negative spaces inside and around objects and volumes into positive space (and vice versa), and producing elemental, evocative forms. For *Untitled (Apartment)*, (2001, plate 163), Whiteread cast the interior of her new studio in London, which is in a building with a long history

(it was once the site of a synagogue, which was destroyed by bombing during World War II, rebuilt in the 1950s, and later converted into a textile warehouse). Compared to some of her previous works, in which residues such as soot were transferred to the final casts, *Apartment*'s surfaces are blank and white. But despite the work's relatively generic appearance—it is a large mass of interlocked cubic forms with deep gaps where the dividing walls stood and indentations denoting doors and light fixtures—*Apartment* forms an index of the site, a subtle "archive" of its layered history.[11] In *Apartment*'s companion piece, *Untitled (Basement)* (2001, plate 164),[12] Whiteread has cast the staircases leading to the basement of the same building and turned them on their side, creating a vertiginous, zigzagging structure.

After Modernism: Contemporary Art and Architecture

Whiteread's architectural castings may be seen as representative of a larger trend among contemporary artists of investigating the built environment. Particular attention has been turned to the forms of high Modernism. Just as some artists have reconsidered the canonic shapes of Minimalist art, others have reflected on the pristine forms of International-style architecture and its utopian aspirations. ▬▬▬ In an ambitious series of video installations, Iñigo Manglano-Ovalle takes the iconic International-style architecture of Ludwig Mies van der Rohe as his setting. Staging social and political allegories that play on the architect's utopian goals, Manglano-Ovalle pays homage to Mies's spaces and simultaneously critiques them. In *Le Baiser / The Kiss* (1999), Manglano-Ovalle transforms the glass walls of Mies's Farnsworth House (1945–51) in Plano, Illinois, into a metaphoric barrier between social classes, as a window-washer outside and a wealthy homeowner inside exist in entirely separate realms. *Climate* (2000, plate 165), filmed in Mies's Lake Shore Drive Apartments (1949–51) in Chicago, presents an ominous future in which national borders have ceased to exist and global weather patterns are directly linked to changes in world financial markets. The piece comprises three seemingly disconnected narratives: a woman waiting nervously in the lobby of the building; weather and market forecasters in an apartment monitoring patterns and listening intently to incoming reports; and an anonymous man dismantling, cleaning, and reassembling a machine gun. These scenes are variously projected onto three double-sided screens surrounded by a hanging aluminum framework that echoes the architecture of the site. In this work, Mies's precise and transparent mid-century architecture is turned into the icy landscape of a future utopia, or dystopia—a "new state of world transparency"[13] as the artist calls it—where everything is interconnected and even weather patterns are manipulated by those in power. ▬▬▬ Rirkrit Tiravanija, whose installations have sought to humanize the institutional space of the art museum or gallery, has also occasionally taken iconic modernist buildings as his point of departure. But Tiravanija offers a more optimistic view of these structure's utopian promise.[14] In 1997, he arranged for the construction of a child-size model of Philip Johnson's Glass House (New Canaan, Connecticut, 1949) in the Museum of Modern Art's sculpture garden in New York; the famous modernist landmark was transformed

fig. 107 Rirkrit Tiravanija, *Untitled 2002 (he promised)*, 2002. Chrome and stainless steel, approximately 294.6 x 1198.9 x 599.4 cm. Solomon R. Guggenheim Museum, New York. Purchased with funds contributed by the International Director's Council and Executive Committee Members: Ruth Baum, Edythe Broad, Elaine Terner Cooper, Dimitris Daskalopoulos, Harry David, Gail May Engelberg, Shirley Fiterman, Nicki Harris, Dakis Joannou, Linda Macklowe, Peter Norton, Tonino Perna, Elizabeth Richebourg Rea, Mortimer D. A. Sackler, Simonetta Seragnoli, David Teiger, Ginny Williams, and Elliot K. Wolk, and Sustaining Members: Tiqui Atencio, Linda Fischbach, Beatrice Habermann, Miryam Knutson, and Cargill and Donna MacMillan; with additional funds contributed by American Express 2004.124

fig. 108 *Moving Pictures: Contemporary
Photography and Video from the
Guggenheim Museum Collections*,
2003–04, Guggenheim Museum Bilbao.
Work shown: John Pilson, *À la claire
fontaine* (2000, fig. 111)

168. Anna Gaskell
untitled #1 (wonder), 1996

169. Anna Gaskell
untitled #3 (wonder), 1996

170. Anna Gaskell
untitled #9 (wonder), 1996

171. Anna Gaskell
untitled #2 (wonder), 1996

172. Anna Gaskell
untitled #10 (wonder), 1996

173. Anna Gaskell
untitled #19 (wonder), 1996

174. Anna Gaskell
untitled #18 (wonder), 1996

175. Anna Gaskell
Erasers, 2005

into a miniature, open-air classroom for children's art workshops. Tiravanija's *Untitled 2002 (he promised)* (2002, fig. 107) was modeled on R. M. Schindler's open-structure studio and residence in West Hollywood (1921–22). Starting from Schindler's concepts about an alternative living space in which interior and exterior are merged, Tiravanija turned his replica into a platform for a whole range of social activities in and around the structure; for example, when the work was exhibited in New York in October 2005, the public was treated to a film and lecture series, a children's day, and an all-night concert. By replacing Schindler's wood, glass, concrete, and canvas with chrome and stainless steel, Tiravanija dematerialized the physical building by turning it into a series of reflections of the surrounding people and activities. ▬▬▬ Other artists have examined the legacy of modernist architecture more generally. Liam Gillick has focused on what he has termed the "semiotics of the built world." The Plexiglas and aluminum or steel screens, panels, and platforms of the works in the artist's *Discussion Island* series, such as *Trajectory Platform* (2000, fig. 109), resemble elements of modernist architecture or design, and are intended to create opportunities to reflect on the ways in which our lives are structured by the urban environment.[15] Painter and filmmaker Sarah Morris similarly decodes the urban space. In her household gloss paintings, Morris isolates and abstracts iconic architectural fragments, such as the facades of skyscrapers in midtown New York or glitzy casinos on the Las Vegas strip (see fig. 110). Far from being exercises in formalism, these colorful, gridded compositions allude to the network of social, political, and economic relationships that permeates urban architecture. John Pilson has also looked at the psychology of the city grid and the corporate office space, revealing the alienation and irrationality that lurk just beneath the surface. In one of his multichannel video installations, *À la claire fontaine* (2000, fig. 111), the artist presents a series of disjointed narratives set in an almost empty high-rise office building. In one scene, an office mailroom clerk is pelted with rubber balls; in another, a young girl presses against the window, exhaling onto the glass and drawing with her finger into the fog, while singing "À la claire fontaine," a French song about loss and longing.

Doubling and Mirroring

The strategy of doubling evident in Horn's paired works has been exploited by a number of other artists in the last two decades. In addition to making evident the subtle differences between related things, doubling can also foreground oppositions and multiplications within the self. Split personalities and double identities, as embodied by such literary twins as Dr. Jekyll and Mr. Hyde, have been a constant source of fascination for Douglas Gordon.[16] For *through a looking glass* (1999, plate 166), Gordon appropriated a famous scene from Martin Scorsese's film *Taxi Driver* (1976) in which the character Travis Bickle, played by Robert De Niro, asks, "You talkin' to me?" while looking in the mirror and pointing a gun at his reflection. In Gordon's work, this scene is projected onto screens on opposite walls of a gallery space. One screen shows the original episode, which was filmed as a reflection in the mirror; the screen on the opposite wall shows the same clip but with the image

fig. 109 Liam Gillick, *Trajectory Platform*, 2000. Anodized aluminum and red opaque Plexiglas, 121.9 x 243.8 x 3.8 cm. Solomon R. Guggenheim Museum, New York. Purchased with funds contributed by the Young Collectors Council 2001.28

fig. 110 Sarah Morris, *Mandalay Bay (Las Vegas)*, 1999. Household paint on canvas, 213.4 x 213.4 x 5.1 cm. Solomon R. Guggenheim Museum, New York Purchased with funds contributed by the Young Collectors Council 2000.121

reversed from left to right, so it becomes a mirror of a mirror. As the clips are replayed over and over, the two projections gradually fall out of sync, so that Travis soon appears to respond to himself, an effect that emphasizes the character's mental unraveling. Positioned in the precarious space between the two projections, the viewer is caught in the character's crossfire of threats, as if trapped inside Travis's torn psyche. ▬▬▬ Slater Bradley's *Doppelganger Trilogy* (2001–04, fig. 112) takes a similar chain of reflections one step further. Since 1999, Bradley has cast Benjamin Brock, his physical look-alike, in a series of works that explore the notion of double identity. In *The Doppelganger Trilogy*, a three-part installation, Bradley staged imaginary performances by three fallen music icons: Ian Curtis of Joy Division and Kurt Cobain of Nirvana, both of whom committed suicide, and Michael Jackson, who has slowly sunk into disrepute. Grainy and overexposed, the ersatz recordings have the look of lost originals. In each film, the musician is played not by Bradley, but rather by his doppelganger; thus Brock plays Bradley playing the performers, and Bradley transforms the ancient mythological figure of the doppelganger into a "tripleganger."[17] In addition to contemplating the dynamics of celebrity stardom and fan longing, the work becomes a "triangulation of reflections, an endless hall of mirrors that leads nowhere but to the recesses of the unconscious mind."[18] ▬▬▬ Another form of doubling and tripling takes place in Pierre Huyghe's video installation *The Third Memory* (1999, fig. 113). Like Gordon, Huyghe takes as his point of departure a well-known Hollywood film, in this case Sidney Lumet's *Dog Day Afternoon* (1975), which dramatized a bank robbery in Brooklyn that unfolded on live television in 1972. For his piece, Huyghe invited the real-life robber John Woytowicz to retell and restage the heist in a constructed set and with the assistance of actors, producing a new, third memory of the event. In the dual-channel installation, presented with a split-screen effect, Woytowicz's reenactment competes with scenes from the film, in which he is played by Al Pacino, as well as with the original television news footage. The result is a kaleidoscopic view of history that blurs the line between reality and simulation and foregrounds the instability and mutability of memory.

History and Memory

Other artists have explored the collective memory to exhume and record buried horrors of the past. Rather than using the conventional language of memorials, however, they have invented sophisticated new devices to bear witness to tragic histories. Luc Tuymans's investigation of Belgium's colonial history in the Congo is a prime example. Although Tuymans works in the traditional medium of oil painting, he does not create traditional history paintings.[19] Instead of painting central figures and events, Tuymans focuses on seemingly mundane objects or details that serve as traces and clues. *Leopard* (2000, fig. 114) belongs to a series entitled *Mwana Kitoko—Beautiful White Man* (2000–01), which is based on films and photographs of the King of Belgium's 1955 tour of the Congo. The painting depicts the moment just after the king has walked across the ceremonial leopard rug, a traditional symbol of power. The patterned skin occupies most of the composition; with

fig. 111 John Pilson, *À la claire fontaine*, 2000. Eight-channel video installation with sound, 00:02:35, edition 3/4, dimensions variable. Solomon R. Guggenheim Museum, New York, Purchased with funds contributed by the Young Collectors Council 2001.73

fig. 112 Slater Bradley, *Phantom Release*, 2003, from *The Doppelganger Trilogy*, 2001–04. Projection from a digital source, with sound, edition 1/3, dimensions variable. Solomon R. Guggenheim Museum, New York, Purchased with funds contributed by the International Director's Council and Executive Committee Members: Ruth Baum, Edythe Broad, Elaine Terner Cooper, Dimitris Daskalopoulos, Harry David, Gail May Engelberg, Shirley Fiterman, Nicki Harris, Dakis Joannou, Rachel Lehmann, Linda Macklowe, Peter Norton, Tonino Perna, Elizabeth Richebourg Rea, Mortimer D. A. Sackler, Simonetta Seragnoli, David Teiger, Ginny Williams, and Elliot K. Wolk, and Sustaining Members: Tiqui Atencio, Linda Fischbach, Beatrice Habermann, Miryam Knutson, and Cargill and Donna MacMillan 2004.73

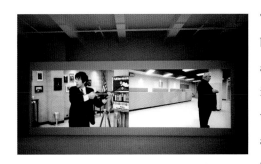

Tuymans's careful cropping and his bleached and flattened painting technique, the viewer can just barely discern the king's departing feet at the top right, which are given no greater weight than the anonymous hands that reach to collect the rug at the top left. Evoking the way in which memory itself works, Tuymans deliberately obfuscates his subject matter. His painting demands extended viewing, reviewing, and deciphering. ▬▬ William Kentridge explores the violent history and aftermath of apartheid South Africa through his drawn animations. Rejecting traditional cel animation, Kentridge works in a process he calls "additive animation," in which a single charcoal and pastel drawing is reworked extensively through erasing and redrawing between every shot. *Felix in Exile* (1994, fig. 115), made just before the African National Congress's landmark election to power, considers the landscape as a metaphor for memory. In the film, Felix Teitlebaum, a white South African who is one of the recurring characters in Kentridge's oeuvre, sits naked and alone in an empty hotel room. He is provided a view back into his native country through Nandi, a black South African woman, who surveys a barren landscape in which the corpses of massacred individuals disappear as they are absorbed into the ground. Kentridge says he was interested in the similarity between the "human act of disremembering the past" and "a natural process in the terrain . . . that also seeks to blot out events," and he describes his goal as "planting a beacon against the process of forgetting the routes of our recent past."[20] Kentridge's technique—in which the cumulative layers of charcoal preserve visible underdrawings and traces of earlier images—might itself be considered a metaphor for this striving for remembrance. ▬▬ Kara Walker confronts the brutal history of slavery and its long legacy in the United States through her appropriation of the antiquated form of the silhouette portrait. In a continuing series of large-scale, narrative wall installations that approach the form of a cyclorama or historical exhibit, Walker has conjured an imagined antebellum South in which plantation owners and slaves are cast in grisly scenes of murder, rape, castration, and cannibalism. Rather than depicting discrete individuals, Walker's black paper cutouts reduce the figures to flat, distorted racial types that recall minstrel show caricatures and call attention to the persistence of stereotypes. *Insurrection! (Our Tools Were Rudimentary, Yet We Pressed On)* (2000, plate 167), one of Walker's first works to make use of a color projection, depicts a slave revolt with a series of gruesome vignettes, including a woman carrying a baby on her head escaping a lynch mob and a group disemboweling a slave master with a ladle. The projection not only serves to heighten the cinematic effect of the installation, but also to implicate the viewer by casting his or her shadow into the field of depicted events. Like Tuymans, Walker has created a new kind of history painting; whereas his relies on understatement, blurring, and filtering, hers uses exaggeration, melodrama, and provocation to discomfort the viewer with the reality of a suppressed past.

Constructed Worlds

Rather than examining history or the here-and-now, a number of artists working since the 1990s have created their own cosmologies. Anna Gaskell crafts fantasies featuring adolescent girls that

fig. 113 Pierre Huyghe, *The Third Memory*, 2000. Two-channel video and sound installation, 00:09:32, edition 2/4, dimensions variable. Solomon R. Guggenheim Museum, New York, Gift, The Bohen Foundation 2001.131

fig. 114 Luc Tuymans, *Leopard*, 2000. Oil on canvas, 140 x 128.3 x 2.5 cm. Solomon R. Guggenheim Museum, New York, Purchased with funds contributed by the International Director's Council and Executive Committee Members: Ann Ames, Edythe Broad, Elaine Terner Cooper, Dimitris Daskalopoulos, Harry David, Ulla Dreyfus-Best, Gail May Engelberg, Nicky Harris, Ronnie Heyman, Dakis Joannou, Cindy Johnson, Barbara Lane, Linda Macklowe, Peter Norton, Willem Peppler, Denise Rich, Elizabeth Richebourg Rea, Simonetta Seragnoli, David Teiger, and Elliot K. Wolk 2001.2

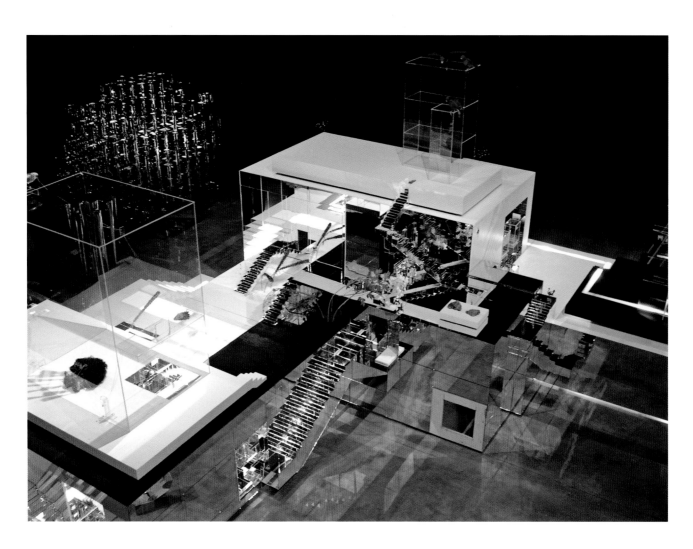

176. David Altmejd
The University 2, 2004 (overall view and detail)

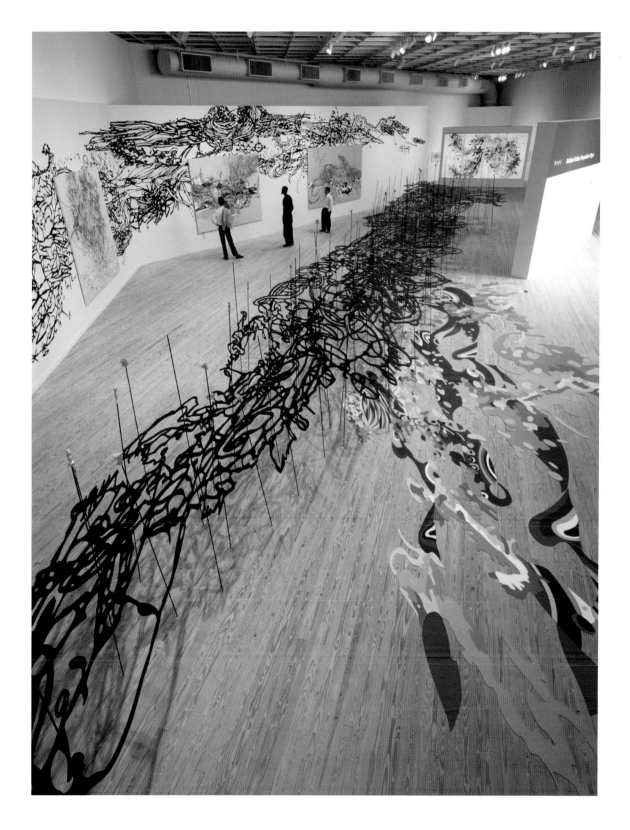

177. Matthew Ritchie
The Hierarchy Problem, 2003, and *The Fine Constant*, 2003

The Fine Constant and elements of *The Hierarchy Problem* are among the works
shown in this installation view of Ritchie's exhibition *The Proposition Player*, 2003,
Contemporary Arts Museum, Houston.

derive from the fictional worlds of such writers as the Brothers Grimm and Lewis Carroll, whose *Alice's Adventures in Wonderland* the artist recalls in her series *wonder* (1996–97) and *override* (1997). In *wonder* (plates 168–74), Gaskell retells the story of Alice through a series of photographs with elaborately constructed tableaux. The photographs present enigmatic scenes in a nonlinear narrative, with dramatic shifts in size from one photograph to the next that echo Alice's fabled growth and shrinking. Gaskell's work complicates Carroll's story by representing Alice not as a single individual but a set of twins, and making the relationship between them unclear.[21] Her work can be seen as part of an artistic tradition that uses photography, which by nature indexes real objects placed before the camera, to enact scenes that are unreal—a tradition that ranges from Cindy Sherman's portraits employing prosthetic body parts to Gregory Crewdson's uncanny transformations of suburbia. ▪▪▪▪ Gaskell's black-and-white film *Erasers* (2005, plate 175), by contrast, has the look of a documentary. In preparation for the film, Gaskell recounted the true story of a car accident she experienced in her childhood to a group of junior-high-school girls; a week later, she filmed each of the girls individually as they recounted the story as best they could recall it. Through editing and the girls' shifts in perspective, voice, and time, Gaskell's film fragments the memory of the original event to create a new version of the story. ▪▪▪▪ On a wholly different scale, Matthew Barney has created his own self-enclosed cosmology in his vast, ambitious *Cremaster Cycle* (1994–2002). Barney's five feature-length films form a dense and layered personal mythology centered on creation, potentiality, and physical transcendence. In addition to the films themselves, the cycle unfolds through photographs, drawings, sculptures, and installations. *Chrysler Imperial* (2002, plate 161),[22] one of his most ambitious sculptures, derives from *Cremaster 3* (2002), the last film to be completed and the "spine" of the series, in the artist's words. *Cremaster 3* is full of references to the series as a whole; the five films are represented by the five ramps of the Solomon R. Guggenheim Museum's rotunda that Barney ascends in a sequence entitled "The Order," and by the five 1967 Chrysler Crown Imperials that crash into a central vehicle in the lobby of the Chrysler building. The five-part *Chrysler Imperial* gives tangible form to this demolition derby scene, as translated into Barney's personal, and fantastical, sculptural vocabulary. ▪▪▪▪ David Altmejd, an artist whose work has been informed by Barney's, has also assembled his own elaborate mythology, one focusing on cyclical energy, transformation, and regeneration. At the center of Altmejd's cryptic iconography lies the werewolf, a potent symbol of transformation since as far back as ancient Greece. Altmejd represents not living werewolves, but their dead and decomposing carcasses, rendered in fake hair and plaster, which he places in labyrinthine, mirrored sets, as in the large-scale *University 2* (2004, plate 176). Rather than simply rot, his werewolves undergo postmortem metamorphosis: their carcasses sprout crystals, jewels, and signs of new life in the form of kitsch plastic flowers and birds. Altmejd conceives of his installations as living organisms pulsing with potential energy, and he has described the architectural structures that house his creatures as the systems that both trigger and circulate this energy. ▪▪▪▪ Like Barney, Matthew Ritchie regards artistic creation as

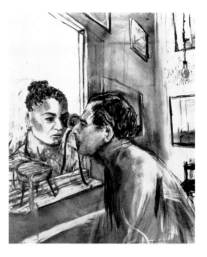

fig. 115 William Kentridge, *Felix in Exile*, 1994. Video with sound, 00:08:43, edition 7/10, dimensions variable. Solomon R. Guggenheim Museum, New York. Purchased with funds contributed by The Peter Norton Family Foundation and by the International Director's Council and Executive Committee Members: Ann Ames, Edythe Broad, Henry Buhl, Elaine Terner Cooper, Dimitris Daskalopoulos, Harry David, Gail May Engelberg, Linda Fischbach, Ronnie Heyman, Dakis Joannou, Cindy Johnson, Barbara Lane, Linda Macklowe, Peter Norton, Willem Peppler, Denise Rich, Simonetta Seragnoli, David Teiger, Ginny Williams, and Elliot K. Wolk 2000.117

analogous to the birth of the universe and has constructed an epic narrative that has unfolded over a series of works, each articulated with his own distinct, encoded vocabulary. Ritchie, however, is not interested in creating a wholly separate world of fantasy, but rather in mapping the world that we inhabit. Working from a personal code of forty-nine characters that he invented in the mid-1990s, Ritchie has constructed elaborate, sprawling installations that serve as visual metaphors for the creation and history of the universe. In *The Proposition Player* (2003, plate 177), he presented the universe in the guise of a game of chance, inviting visitors to roll the dice. *The Hierarchy Problem* (2003), assembled by the artist specially for the Guggenheim, consists of four, separately titled parts from *The Proposition Player*: a wall mural, a maplike carpet, a light box, and a painting resembling a whirling mass of energy. Here, as in all of his work, Ritchie seeks to articulate the complex order of our world and to make visible the invisible. The artist explains, "We can only see 5% of the universe. . . . We're working from a model with 95% of the information missing—so no wonder everybody's acting like they're in the dark. So the big question for me is: how do you visually represent that absence?"[23]

The works included in the Bonn exhibition and discussed in this essay represent only a selection of the Guggenheim Foundation's overall contemporary holdings, and many other combinations, connections, and possibilities for interpretation exist. This selection, however, showcases the quality and richness of the contemporary works added to the permanent collection during the past two decades and indicates the foundation's continued emphasis on keeping apace with the accelerated evolution of international art. In the decades to come, the Guggenheim looks forward to furthering its commitment to represent the art of the future.

NOTES

I am indebted to Nancy Spector, Curator of Contemporary Art and Director of Curatorial Affairs, for her help in developing this essay. Nancy has played a central role in shaping and interpreting the Guggenheim's contemporary collection, and I have relied upon her keen and insightful observations of the artworks while writing this piece.

1. In addition to purchasing from artists and exhibiting their works, Rebay and Guggenheim also provided financial support to artists, including critical assistance to European refugees during World War II. See Joan M. Lukach, *Hilla Rebay: In Search of the Spirit in Art* (New York: George Braziller, 1983).

2. For Rebay, the non-objective masterpiece represented "so far … the highest human document of creativeness in earth's history of culture." Quoted in ibid., p. 144. Although examples of "objective" painting were brought into the collection, they were regarded as historical precursors and largely relegated to Solomon Guggenheim's Plaza Hotel apartment. Surrealism, with its highly figurative and literary approach, was not collected whatsoever, a gap that would only be fully redressed by the Guggenheim Foundation's acquisition of the Peggy Guggenheim Collection in 1976. In contrast to Rebay, Peggy was an avid collector of Surrealism. For a thorough account of Peggy's collecting, see Susan Davidson, "Focusing an Instinct: The Collecting of Peggy Guggenheim," in Susan Davidson and Philip Rylands, eds., *Peggy Guggenheim and Frederick Kiesler: The Story of Art of this Century*, exh. cat. (Venice: Peggy Guggenheim Collection, 2004).

3. Hilla Rebay, *Art of Tomorrow* (New York: Solomon R. Guggenheim Foundation, 1939), pp. 9–10.

4. Since 1990, the museum has acquired work by approximately 600 artists. Of these, almost 450 had not previously been represented in the collection.

5. It is the Guggenheim's philosophy, however, not to collect according to medium, just as it does not organize itself departmentally in such a manner. The exception is the Film and Media Arts subdepartment, created within the curatorial department in 1996 with the help of a grant from the Bohen Foundation. However, film and media-based works are not exclusive to that subdepartment and are considered for acquisition by the department as a whole.

6. Many art historians have challenged the notion that Minimalism was neutral. See, for example, Anna Chave, "Minimalism and the Rhetoric of Power," *Arts Magazine*, no. 64 (January 1990), where she argues that Minimalist works were inscribed with signs of patriarchal power. In this light, the appropriation of Minimalist forms by a later generation of female artists, as well as gay artists such as Felix-Gonzalez Torres (see note 8), can be seen as particularly subversive.

7. The concept for this section derives from the Guggenheim's 2004 exhibition, *Singular Forms (Sometimes Repeated): Art from 1951 to the Present*. See Nancy Spector's introduction in the eponymous exhibition catalogue (New York: Guggenheim Museum, 2004).

8. Regarding the subversive potential of such formal appropriations, the artist told Nancy Spector, "In our case, we should not be afraid of using such formal references, since they represent authority and history. Why not take them? When we insert our own discourse into these forms, we soil them. We make them dark. We make them our own and that is our final revenge. We become part of the language of the authority, part of history." Quoted in Nancy Spector, ed., *Felix Gonzalez-Torres* (New York: Guggenheim Museum, 1995), p. 15.

9. Felix Gonzalez-Torres had a particularly strong response to Horn's *Gold Field* upon encountering it for the first time in 1990 at the Museum of Contemporary Art in Los Angeles: "Some people dismiss Roni's work as pure formalism, as if such purity were possible after years of knowing that the act of looking at an object, any object, is transfigured by gender, race, socioeconomic class, and sexual orientation. We cannot blame them for the emptiness in which they live, for they cannot see the almost perfect emotions and solutions her objects and writings give us. A place to dream, to regain energy, to dare. Ross [Gonzalez-Torres's partner, who died of AIDS later that year] and I always talked about this work, how much it affected us. After that, any sunset became "the Gold Field." Roni had named something that had always been there. Now we saw it through her eyes, her imagination." Felix Gonzalez-Torres, "1990: L.A., 'The Gold Field,'" in *Earths Grow Thick*, exh. cat. (Columbus, Ohio: Wexner Center for the Arts, 1996). Horn later created *Gold Mats, Paired (For Ross and Felix)* (1994–95) in homage to Gonzalez-Torres and his partner, in which one gold mat is placed on top of another, creating a glowing reflected light in between.

10. See Nancy Spector, "Untitled (Flannery): A Condensation of Acts," *Parkett*, no. 54 (1998/99), pp. 65-66.

11. According to the artist, the work also speaks to the "strange kind of architecture" that sprung up in London after the war: "with the massive rebuilding, we ended up in the 1960s with these residential building complexes that I suppose symbolized hope, and were full of optimism and good intentions, but had a very different outcome in reality." Quoted in Craig Hauser, "If Walls Could Talk: An Interview with Rachel Whiteread," in Lisa Dennison, ed., *Rachel Whiteread: Transient Spaces*, exh. cat. (New York: Guggenheim Museum, 2001), p. 48.

12. For more information on both works, see Dennison, ed., *Rachel Whiteread*.

13. Quoted in Irene Hofmann, "In the Presence of Mies: New Work by Iñigo Manglano-Ovalle," in *Iñigo Manglano-Ovalle*, exh. cat. (Bloomfield Hills, Michigan: Cranbrook Art Museum, 2001), p. 11.

14. Tiravanija's interest in the concept of a workable utopia may also be evidenced by the *Utopia Station* at the 50th Venice Biennale in 2003, which he conceived with Liam Gillick and curated with Molly Nesbit and Hans-Ulrich Obrist.

15. Gillick has professed a "simultaneous enthusiasm and skepticism for more utopianistic moments in Modernism." Alicia Miller, "Materialized Expression: The Sculpture of Liam Gillick," *Sculpture* 23, no. 1 (January/February 2004), p. 44. Both Gillick and John Pilson were included in a 2003 exhibition at the Castello di Rivoli, Museo d'Arte Contemporaneo, Turin, entitled *I Moderni / The Moderns*, which examined younger contemporary artists engaging Modernism in complex ways that go beyond postmodern critique. See Carolyn Christov-Bakarglev et al., *I Moderni / The Moderns*, exh. cat. (Turin: Castello di Rivoli; Milano: Skira Editore S.p.A., 2003).

16. Of even greater significance to Gordon than Robert Louis Stevenson's *The Strange Case of Dr. Jekyll and Mr. Hyde* (1886) has been Scottish novelist James Hogg's *The Private Memoirs and Confessions of a Justified Sinner* (1824). Gordon combined elements of the two novels in his video installation *Confessions of a Justified Sinner* (1995–96).

17. Paul Fleming, "Tripleganger: Slater Bradley's 'Doppelganger' Trilogy," exh. text (Los Angeles: Blum & Poe, 2004), http://www.blumandpoe.com/slaterbradley.

18. Nancy Spector, *Recent Acquisitions: Slater Bradley's Doppelganger Trilogy*, www.guggenheim.org/exhibitions/slater_bradley/.

19. For a discussion of Tuymans's relation to history painting and his leveling of the standard hierarchy of genres, see Emma Dexter, "The Interconnectedness of All Things: Between History, Still Life, and the Uncanny," in *Luc Tuymans*, exh cat. (London: Tate Publishing, 2004), pp. 16–27.

20. Quoted in "William Kentridge: Drawings for Projection," exh. brochure (New York: The Drawing Center's Drawing Room, 1998).

21. Nancy Spector describes the effects of this doubling: "Are these two girls actually a pair of twins or, rather, the physical manifestation of a split personality? If the character of Alice imagines her own alter ego into tangible form, if she conjures up her doppelganger, how can the rest of her story be 'believed?' In *wonder*, as well as in Gaskell's subsequent series, the artist manipulates her narrative by embedding a fiction within the main fiction, which throws into question the 'veracity' of the tale." Nancy Spector, *Anna Gaskell* (New York: powerhouse Books, 2001), unpaginated.

22. The Guggenheim's permanent collection includes *Cremasters 1, 2, 3*, and *5*, as well as *Chrysler Imperial* and *Chrysler Suite* (2002), a group of drawings donated by the artist and Barbara Gladstone.

23. Matthew Ritchie, "Reflections on an Omnivorous Visualization System: An Interview with Matthew Ritchie," in Lynn M. Herbert et al., *Matthew Ritchie: Proposition Player*, exh. cat. (Houston: Contemporary Arts Museum Houston in association with Hatje Cantz Publishers, 2003), p. 46.

Chronology

1929–30 At age sixty-six, the wealthy American industrialist Solomon R. Guggenheim begins to form a large collection of important modern paintings by artists such as Vasily Kandinsky, Paul Klee, and Marc Chagall. He is guided in this pursuit by a young German artist and theorist, Hilla Rebay (born Baroness Hilla Rebay von Ehrenwiesen). In July 1930, Rebay brings Guggenheim to Vasily Kandinsky's Dessau studio, and Guggenheim purchases several of the artist's paintings and works on paper; he will eventually acquire more than 150 works by Kandinsky. **1930s** Guggenheim's growing collection is installed in his private apartment at the Plaza Hotel in New York. Small exhibitions of newly acquired works are held there intermittently for the public. Rebay organizes a landmark loan exhibition entitled Solomon R. Guggenheim Collection of Non-Objective Paintings, which travels to Charleston, South Carolina; Philadelphia; and Baltimore. **1937** The Solomon R. Guggenheim Foundation is formed for the "promotion and encouragement and education in art and the enlightenment of the public." Chartered by the Board of Regents of New York State, the Foundation is endowed to operate one or more museums. Solomon Guggenheim is elected the first President of the Foundation, and Rebay is appointed its Curator. **1938** At age forty, Peggy Guggenheim, Solomon's niece, opens Guggenheim Jeune, a commercial art gallery in London representing such avant-garde artists as Jean Cocteau, Kandinsky, and Yves Tanguy. Initially advised by Herbert Read and Marcel Duchamp, she soon begins to amass her own important collection of Surrealist and abstract art. **1939** Under the auspices of the Solomon R. Guggenheim Foundation, the Museum of Non-Objective Painting opens in rented quarters at 24 East Fifty-fourth Street. Under Rebay's direction, the museum—decorated with pleated gray velour on the walls and thick gray carpeting, and featuring recorded classical music and incense—showcases Solomon's collection of American and European abstract artists. **1942** Peggy opens Art of This Century, a unique gallery-museum on Fifty-seventh Street in New York, designed by Frederick Kiesler. The inaugural installation features her own collection displayed in unconventional ways. Over the next five years, Peggy mounts dozens of important exhibitions devoted to European and American artists such as Giorgio de Chirico, Robert Motherwell, Jackson Pollock, and Mark Rothko. **1943** Solomon and Rebay commission Frank Lloyd Wright to design a permanent structure to house the Museum of Non-Objective Painting. Over the next fifteen years, Wright will make some 700 sketches, and six separate sets of working drawings, for the building. The Foundation acquires a tract of land between East Eighty-eighth and Eighty-ninth Streets on Fifth Avenue, but construction is delayed until 1956 for various reasons, foremost among them postwar inflation. **1949** One year after Peggy exhibits her now fabled collection of Cubist, Surrealist, and European abstract painting and sculpture at the Venice Biennale, she purchases the Palazzo Venier dei Leoni on Venice's Grand Canal, installs her collection there, and opens it to the public. She establishes the Peggy Guggenheim Foundation to operate and endow the museum. **1952** Rebay resigns and James Johnson Sweeney is named

Director of the museum. The name of the Museum of Non-Objective Painting is changed to the Solomon R. Guggenheim Museum to designate it as a memorial to its founder, who died in 1949, and to signify a shift toward a broader view of modern and contemporary art. Under Sweeney, the Foundation purchases several sculptures by Constantin Brancusi and other important artists whose work does not fall within the category of non-objective art. **1959** The museum opens to an enthusiastic public on October 21, just six months after Wright's death. From the beginning, the relationship between the breathtaking architecture of the building and the art it was built to display inspires controversy and debate. One critic writes that the museum "has turned out to be the most beautiful building in America . . . never for a minute dominating the pictures being shown," while another insists that the structure is "less a museum than it is a monument to Frank Lloyd Wright." **1961** One year after the resignation of Sweeney, Thomas M. Messer is appointed Director of the Solomon R. Guggenheim Museum. He will remain in that position for twenty-seven years, during which time he greatly expands the collection and establishes the Guggenheim as a world-class institution known for its art scholarship and special exhibitions. **1963** The Solomon R. Guggenheim Foundation receives a major portion of Justin K. Thannhauser's renowned personal collection of Impressionist, Post-Impressionist, and early modern art. Over the years, Thannhauser and his widow, Hilde, will give the Guggenheim more than seventy works, including thirty-four by Picasso alone. This donation greatly enlarges the scope of the collection to include painting of the nineteenth century, beginning with Camille Pissaro's *The Hermitage at Pontoise* (ca. 1867, fig. 32). Under the terms of the gift, the Thannhauser Collection is on permanent view at the Solomon R. Guggenheim Museum. **1976** Peggy Guggenheim transfers ownership of her collection to the Solomon R. Guggenheim Foundation with the understanding that the works of art will remain in Venice. Peggy dies in 1979 and the Foundation takes ownership of the palazzo. Thomas M. Messer is appointed Director of the Peggy Guggenheim Collection in addition to his role overseeing the New York museum, and he supervises a major effort to conserve and document the Venice holdings. In 1980, Messer is named Director of the Solomon R. Guggenheim Foundation. **1988** Thomas Krens succeeds Messer as Director of the Foundation. Krens takes charge of an expansion program already under way in New York, which will include an annex designed by Gwathmey Siegel and Associates Architects, and initiates planning for a comprehensive restoration of the Wright building. **1990** The Wright building is closed to the public so that the restoration and expansion can begin. Over the next two years, masterpieces from the collection are exhibited in a triumphant international tour to Venice, Madrid, Tokyo, Australia, and Montreal. **1991** Through purchase and gift, the Solomon R. Guggenheim Foundation acquires the Panza di Biumo Collection of Minimalist and Conceptual Art. This acquisition dramatically enlarges the Foundation's permanent collection, giving it great depth in works by American postwar masters Carl Andre, Dan Flavin, Robert Ryman, and Richard

Serra, among others. **1991–92** Agreements are signed between the Basque Administration and the Solomon R. Guggenheim Foundation to create a Guggenheim Museum in Bilbao, Spain. The Basque Administration will fully fund the $100 million construction and will make annual contributions to the operating budget. The Foundation will provide curatorial and administrative expertise as well as the core art collection and programming. Frank Gehry is chosen as the architect of the future museum. ▬ The Robert Mapplethorpe Foundation gives the Guggenheim 200 vintage photographs by Mapplethorpe, as well as a grant to launch a photography program. Contemporary photography quickly becomes a major area of collecting for the Solomon R. Guggenheim Foundation, and within a decade it is able to mount major exhibitions based on its holdings. **1992** After a three-year restoration of its interior, the Solomon R. Guggenheim Museum reopens to great acclaim. An eight-story annex, designed by Gwathmey Siegel and Associates Architects, opens simultaneously. ▬ The Guggenheim Museum SoHo opens. During its ten years in operation, the museum, designed by Arata Isozaki, will mount many small but important exhibitions focusing on artists such as Max Beckmann, Marc Chagall, and Antoni Tàpies as well as on art created in new media. **1997** The Guggenheim Museum Bilbao opens and is instantly hailed as an architectural masterpiece. Frank Gehry's titanium and steel structure becomes the first work of museum architecture to rival the Wright building in its achievement and influence. Guided by the Solomon R. Guggenheim Foundation, the Bilbao museum forms an important collection of postwar American and European painting and sculpture that complements the Foundation's holdings in New York and Venice. The exhibition program includes exhibitions that originate at the New York Guggenheim, as well as at other internationally prominent museums. In only a few years, the Guggenheim Museum Bilbao is widely credited with reviving the reputation and fortunes of the Basque region. ▬ The Deutsche Guggenheim, Berlin, opens. This small museum, designed by Richard Gluckman, is a unique partnership between the Solomon R. Guggenheim Foundation and Deutsche Bank. Funded entirely by the German corporation, the museum's primary purpose is to commission important new works by contemporary artists that will then enter the Guggenheim collection. Over the next eight years, several distinguished international artists are commissioned, including William Kentridge, Jeff Koons, Gerhard Richter, James Rosenquist, Hiroshi Sugimoto, Bill Viola, Lawrence Weiner, and Rachel Whiteread. **2000** The Solomon R. Guggenheim Foundation signs an alliance agreement with the State Hermitage Museum in St. Petersburg, which becomes a trilateral alliance in early 2001 when these institutions are joined by the Kunsthistorisches Museum in Vienna. The objectives of the alliance are to expand international cultural relations; to make each museum's collections accessible to broader audiences; to pursue collection sharing strategies that complement each institution's holdings; to implement joint exhibition, publishing, educational, and retail initiatives; and to facilitate each institution's long-term goals ▬ Philip Rylands is promoted from

Deputy Director to Director of the Peggy Guggenheim Collection. **2001** The Solomon R. Guggenheim Foundation and the State Hermitage Museum jointly open the Guggenheim Hermitage Museum at the Venetian Resort in Las Vegas. This small museum, designed by Rem Koolhaas, is devoted to masterworks from the permanent collections of the allied museums. ▬▬▬ Simultaneously, a large Kunsthalle called the Guggenheim Las Vegas opens at the Venetian in order to provide a venue for the Foundation's popular exhibition *The Art of the Motorcycle*. The exhibition runs for an unprecedented sixteen months, at which time the Guggenheim Las Vegas closes. **2005** Richard Serra's monumental site-specific installation *The Matter of Time* (2005) opens at the Guggenheim Museum Bilbao. The largest sculpture commission in history, it is hailed by critics as a singular achievement. ▬▬▬ Restoration of the exterior of the Frank Lloyd Wright building begins. Work will be finished in time for the fiftieth anniversary of the museum's opening. ▬▬▬ Lisa Dennison is promoted from Deputy Director and Chief Curator to Director of the Solomon R. Guggenheim Museum.

Plate List

1. Alexander Calder
Red Lily Pads, 1956
Painted sheet metal, metal rods, and wire, 106.7 x 510.6 x 276.9 cm
Solomon R. Guggenheim Museum, New York
65.1737

2. Vasily Kandinsky
In the Black Square | Im schwarzen Viereck, June 1923
Oil on canvas, 97.5 x 93 cm
Solomon R. Guggenheim Museum, New York
Gift, Solomon R. Guggenheim 37.254

3. Paul Cézanne
Man with Crossed Arms | Homme aux bras croisés, ca. 1899
Oil on canvas, 92 x 72.7 cm
Solomon R. Guggenheim Museum, New York
54.1387

4. Constantin Brancusi
Adam and Eve | Adam et Eve, 1921
Oak (Eve) and chestnut (Adam), 238.8 x 47.6 x 46.4 cm, including base
Solomon R. Guggenheim Museum, New York
53.1329

5. Alberto Giacometti
Spoon Woman | Femme-cuiller, 1926, cast 1954
Bronze, edition 3/6, 143.8 x 51.4 x 21.6 cm
Solomon R. Guggenheim Museum, New York
55.1414

6. Oskar Kokoschka
Knight Errant | Der irrende Ritter, 1915
Oil on canvas, 89.5 x 180 cm
Solomon R. Guggenheim Museum, New York
48.1172.380

7. Max Beckmann
Paris Society | Gesellschaft Paris, 1931
Oil on canvas, 109.2 x 175.6 cm
Solomon R. Guggenheim Museum, New York
70.1927

8. Max Beckmann
Alfi with Mask | Alfi mit Maske, 1934
Oil on canvas, 78.4 x 75.5 cm
Solomon R. Guggenheim Museum, New York
Partial Gift, Georgia van der Rohe 76.2202

9. Joan Miró
Personage | Personnage, summer 1925
Oil and egg tempera (?) on canvas, 130 x 96.2 cm
Solomon R. Guggenheim Museum, New York
48.1172.504

10. Joan Miró
The Flight of a Bird over the Plain III | Le Vol de l'oiseau sur la plaine III, July 1939
Oil on burlap, 89.5 x 115.6 cm
Solomon R. Guggenheim Museum, New York
Gift, Evelyn Sharp 77.2670

11. Pablo Picasso
Mandolin and Guitar | Mandoline et guitare, 1924
Oil with sand on canvas, 140.7 x 200.3 cm
Solomon R. Guggenheim Museum, New York
53.1358

12. Pablo Picasso
Pitcher and Bowl of Fruit | Pichet et coupe de fruits, February 1931
Oil on canvas, 130.8 x 162.6 cm
Solomon R. Guggenheim Museum, New York
By exchange 82.2947

13. Richard Serra
Right Angle Prop, 1969
Lead antimony, 182.9 x 182.9 x 86.4 cm
Solomon R. Guggenheim Museum, New York
Purchased with funds contributed by The Theodoron Foundation 69.1906

14. Ellsworth Kelly
White Angle, 1966
Painted aluminum, 183.5 x 91.4 x 183.5 cm
Solomon R. Guggenheim Museum, New York
Gift of the artist, by exchange 72.1997

15. Ellsworth Kelly
Dark Blue Curve, 1995
Oil on canvas, 116.8 x 482.6 cm
Solomon R. Guggenheim Museum, New York
96.4512

16. Richard Long
Red Slate Circle, 1980
Red slate stones, diam. 853.6 cm
Solomon R. Guggenheim Museum, New York
Purchased with funds contributed by Stephen and Nan Swid 82.2895
[not in exhibition]

17. Pablo Picasso
Woman with Yellow Hair | Femme aux cheveux jaunes, December 1931
Oil on canvas, 100 x 81 cm
Solomon R. Guggenheim Museum, New York
Thannhauser Collection, Gift, Justin K. Thannhauser
78.2514.59

18. Paul Cézanne
Still Life: Plate of Peaches | Assiette de pêches, 1879–80
Oil on canvas, 59.7 x 73.3 cm
Solomon R. Guggenheim Museum, New York
Thannhauser Collection, Gift, Justin K. Thannhauser
78.2514.4

19. Paul Cézanne
The Neighborhood of Jas de Bouffan | Environs du Jas de Bouffan, 1885–87
Oil on canvas, 65 x 81 cm
Solomon R. Guggenheim Museum, New York
Thannhauser Collection, Bequest, Hilde Thannhauser
91.3907

20. Pierre Auguste Renoir
Woman with Parrot | La Femme à la perruche, 1871
Oil on canvas, 92.1 x 65.1 cm
Solomon R. Guggenheim Museum, New York
Thannhauser Collection, Gift, Justin K. Thannhauser
78.2514.68

21. Edouard Manet
Before the Mirror | Devant la glace, 1876
Oil on canvas, 92.1 x 71.4 cm
Solomon R. Guggenheim Museum, New York
Thannhauser Collection, Gift, Justin K. Thannhauser
78.2514.27

22. Edgar Degas
Dancer Moving Forward, Arms Raised | Danseuse s'avançant, les bras levés, 1882–95, cast posthumously 1919–26
Bronze, 35.3 x 15.3 x 16.5 cm
Solomon R. Guggenheim Museum, New York
Thannhauser Collection, Gift, Justin K. Thannhauser
78.2514.8

23. Edgar Degas
Spanish Dance | Danse espagnole, 1896–1911, cast posthumously 1919–26
Bronze, 40.3 x 16.5x 17.8 cm
Solomon R. Guggenheim Museum, New York
Thannhauser Collection, Gift, Justin K. Thannhauser
78.2514.9

24. Edgar Degas
Seated Woman, Wiping Her Left Side | Femme assise, s'essuyant le côté gauche, 1896–1911, cast posthumously 1919–26
Bronze, 35.6 x 35.9 x 23.5 cm
Solomon R. Guggenheim Museum, New York
Thannhauser Collection, Gift, Justin K. Thannhauser
78.2514.10

25. Vincent van Gogh
Mountains at Saint-Rémy | Montagnes à Saint-Rémy, July 1889
Oil on canvas, 71.8 x 90.8 cm
Solomon R. Guggenheim Museum, New York
Thannhauser Collection, Gift, Justin K. Thannhauser
78.2514.24

26. Claude Monet
The Palazzo Ducale, Seen from San Giorgio Maggiore | Le Palais Ducal vu du Saint-Georges Majeur, 1908
Oil on canvas, 65 x 100.5 cm
Solomon R. Guggenheim Museum, New York
Thannhauser Collection, Bequest, Hilde Thannhauser
91.3910

27. Paul Gauguin
Haere Mai, 1891
Oil on burlap, 72.4 x 91.4 cm
Solomon R. Guggenheim Museum, New York
Thannhauser Collection, Gift, Justin K. Thannhauser
78.2514.16

28. Pablo Picasso
Fernande with a Black Mantilla | Fernande à la mantille noire, 1905–06
Oil on canvas, 100 x 81 cm
Solomon R. Guggenheim Museum, New York
Thannhauser Collection, Bequest, Hilde Thannhauser
91.3914

29. Pablo Picasso
Lobster and Cat | Le Homard et le chat, January 11, 1965
Oil on canvas, 73 x 92 cm
Solomon R. Guggenheim Museum, New York
Thannhauser Collection, Bequest, Hilde Thannhauser
91.3916

30. Robert Delaunay
Simultaneous Windows (2nd Motif, 1st Part) | Les Fenêtres simultanées (2ᵉ motif, 1ʳᵉ partie), 1912
Oil on canvas, 55.2 x 46.3 cm
Solomon R. Guggenheim Museum, New York
Gift, Solomon R. Guggenheim 41.464

31. František Kupka
Planes by Colors, Large Nude | Plans par couleurs, grand nu, 1909–10
Oil on canvas, 150.2 x 180.7 cm
Solomon R. Guggenheim Museum, New York
Gift, Mrs. Andrew P. Fuller 68.1860

32. Constantin Brancusi
Muse | La Muse, 1912
Marble, 45 x 23 x 17 cm
Solomon R. Guggenheim Museum, New York
85.3317
shown on:
Oak Base, 1920
Oak, 97.5 x 47.3 x 47 cm
Solomon R. Guggenheim Museum, New York
58.1516

33. Amedeo Modigliani
Portrait of a Student | L'Etudiant, ca. 1918–19
Oil on canvas, 60.9 x 46 cm
Solomon R. Guggenheim Museum, New York
94.4482

34. Giorgio de Chirico
The Red Tower | La Tour rouge, 1913
Oil on canvas, 73.5 x 100.5 cm
Peggy Guggenheim Collection, Venice
76.2553.64

35. Giorgio de Chirico
The Nostalgia of the Poet | La nostalgie du poète, 1914
Oil and charcoal on canvas, 89.7 x 40.7 cm
Peggy Guggenheim Collection, Venice
76.2553.65

36. Vasily Kandinsky
Blue Mountain | Der blaue Berg, 1908–09
Oil on canvas, 106 x 96.6 cm
Solomon R. Guggenheim Museum, New York
Gift, Solomon R. Guggenheim 41.505

37. Vasily Kandinsky
Landscape with Rain | Landschaft mit Regen, January 1913
Oil on canvas, 70.2 x 78.1 cm
Solomon R. Guggenheim Museum, New York
45.962

38. Vasily Kandinsky
Small Pleasures | Kleine Freuden, June 1913
Oil on canvas, 109.8 x 119.7 cm
Solomon R. Guggenheim Museum, New York
43.921

39. Franz Marc
White Bull | Stier, 1911
Oil on canvas, 100 x 135.2 cm
Solomon R. Guggenheim Museum, New York
51.1312

40. Franz Marc
Yellow Cow | Gelbe Kuh, 1911
Oil on canvas, 140.5 x 189.2 cm
Solomon R. Guggenheim Museum, New York
49.1210

41. Franz Marc
Stables | Stallungen, 1913
Oil on canvas, 73.6 x 157.5 cm
Solomon R. Guggenheim Museum, New York
46.1037

42. Franz Marc
Broken Forms | Zerbrochene Formen, 1914
Oil on canvas, 111.8 x 84.4 cm
Solomon R. Guggenheim Museum, New York
Bequest, Solomon R. Guggenheim 50.1240

43. Paul Klee
Flower Bed | Blumenbeet, 1913.193
Oil on board, 28.2 x 33.7 cm
Solomon R. Guggenheim Museum, New York
48.1172.109

44. Ernst Ludwig Kirchner
Gerda, Half-Length Portrait | Frauenkopf, Gerda, 1914
Oil on canvas, 99.1 x 75.3 cm
Solomon R. Guggenheim Museum, New York
Partial gift, Mr. and Mrs. Mortimer M. Denker 78.2421

45. Ernst Ludwig Kirchner
Artillerymen | Das Soldatenbad, 1915
Oil on canvas, 140 x 153 cm
Solomon R. Guggenheim Museum, New York
By exchange 88.3591

46. Georges Braque
Violin and Palette | Violon et palette, September 1, 1909
Oil on canvas, 91.7 x 42.8 cm
Solomon R. Guggenheim Museum, New York
54.1412

47. Georges Braque
Piano and Mandola | Piano et mandore, winter 1909–10
Oil on canvas, 91.7 x 42.8 cm
Solomon R. Guggenheim Museum, New York
54.1411

48. Pablo Picasso
Accordionist | L'Accordéoniste, Céret, summer 1911
Oil on canvas, 130.2 x 89.5 cm
Solomon R. Guggenheim Museum, New York
Gift, Solomon R. Guggenheim 37.537

49. Pablo Picasso
Landscape at Céret | Paysage de Céret, summer 1911
Oil on canvas, 65.1 x 50.3 cm
Solomon R. Guggenheim Museum, New York
Gift, Solomon R. Guggenheim 37.538

50. Marc Chagall
Paris Through the Window | Paris par la fenêtre, 1913
Oil on canvas, 135.8 x 141.4 cm
Solomon R. Guggenheim Museum, New York
Gift, Solomon R. Guggenheim 37.438

51. Marc Chagall
Green Violinist | Violiniste, 1923–24
Oil on canvas, 198 x 108.6 cm
Solomon R. Guggenheim Museum, New York
Gift, Solomon R. Guggenheim 37.446

52. Georges Seurat
Peasant with Hoe | Paysan à la houe, 1882
Oil on canvas, 46.3 x 56.1 cm
Solomon R. Guggenheim Museum, New York
Gift, Solomon R. Guggenheim 41.716

53. Georges Seurat
Peasant Woman Seated in the Grass | Paysanne assise dans l'herbe, 1883
Oil on canvas, 38.1 x 46.2 cm
Solomon R. Guggenheim Museum, New York
Gift, Solomon R. Guggenheim 37.714

54. Georges Seurat
Farm Women at Work | Paysannes au travail, 1882–83
Oil on canvas, 38.5 x 46.2 cm
Solomon R. Guggenheim Museum, New York
Gift, Solomon R. Guggenheim 41.713

55. Robert Delaunay
Saint-Séverin No. 3, 1909–10
Oil on canvas, 114.1 x 88.6 cm
Solomon R. Guggenheim Museum, New York
Gift, Solomon R. Guggenheim 41.462

56. Robert Delaunay
Eiffel Tower with Trees | Tour Eiffel aux arbres, summer 1910
Oil on canvas, 126.4 x 92.8 cm
Solomon R. Guggenheim Museum, New York
46.1035

57. Robert Delaunay
The City | La Ville, 1911
Oil on canvas, 145 x 112 cm
Solomon R. Guggenheim Museum, New York
Gift, Solomon R. Guggenheim 38.464

58. Fernand Léger
The Smokers | Les Fumeurs, December 1911–
January 1912
Oil on canvas, 129.2 x 96.5 cm
Solomon R. Guggenheim Museum, New York
Gift, Solomon R. Guggenheim 38.521

59. Fernand Léger
Contrast of Forms | Contraste de formes, 1913
Oil on burlap, 98.8 x 125 cm
Solomon R. Guggenheim Museum, New York
Gift, Solomon R. Guggenheim 38.345

60. Marcel Duchamp
*Nude (Study), Sad Young Man on a Train | Nu (esquisse),
jeune homme triste dans un train*, 1911–12
Oil on cardboard, mounted on Masonite, 100 x 73 cm
Peggy Guggenheim Collection, Venice
76.2553.9

61. Piet Mondrian
Summer, Dune in Zeeland | Zomer, Duin in Zeeland, 1910
Oil on canvas, 134 x 195 cm
Solomon R. Guggenheim Museum, New York
L149.75

62. Piet Mondrian
Still Life with Gingerpot II | Stilleven met gemberpot II,
1912
Oil on canvas, 91.5 x 120 cm
Solomon R. Guggenheim Museum, New York
L294.76

63. Piet Mondrian
Tableau No. 2/Composition No. VII, 1913
Oil on canvas, 104.4 x 113.6 cm
Solomon R. Guggenheim Museum, New York
49.1228

64. Piet Mondrian
Composition No. 1: Lozenge with Four Lines, 1930
Oil on canvas, 75.2 x 75.2 cm; vertical axis 105 cm
Solomon R. Guggenheim Museum, New York
Hilla Rebay Collection 71.1936.R96

65. Rudolf Bauer
Blue Triangle, 1934
Oil on canvas, 130.5 x 130.2 cm
Solomon R. Guggenheim Museum, New York
Gift, Solomon R. Guggenheim 40.153

66. Hilla Rebay
Andante Cantabile, 1943
Oil on canvas, 198.1 x 236.2 cm
Solomon R. Guggenheim Museum, New York
Hilla Rebay Collection 71.1936.RM270

67. Vasily Kandinsky
Painting with White Border | Bild mit weissem Rand,
May 1913
Oil on canvas, 140.3 x 200.3 cm
Solomon R. Guggenheim Museum, New York
Gift, Solomon R. Guggenheim 37.245

68. Paul Klee
*The Bavarian Don Giovanni | Der bayrische
Don Giovanni*, 1919.116
Watercolor and ink on paper, 22.5 x 21.3 cm
Solomon R. Guggenheim Museum, New York
48.1172.69

69. Paul Klee
Night Feast | Nächtliches Fest, 1921.176
Oil on paper, mounted on cardboard painted with oil,
mounted on board, paper 36.9 x 49.8 cm; cardboard
50 x 60 cm
Solomon R. Guggenheim Museum, New York
73.2054

70. Paul Klee
Singer of Comic Opera | Sängerin der komischen Oper,
1923.118
Watercolor and ink on paper, mounted on cardboard,
paper 29.2 x 23.5 cm; cardboard 37.7 x 30.4 cm
Solomon R. Guggenheim Museum, New York
48.1172.61

71. Paul Klee
Barbarian Sacrifice | Barbaren-Opfer, 1932.12
Watercolor on paper, mounted on cardboard, paper
62.9 x 48 cm; cardboard 64.8 x 49.8 cm
Solomon R. Guggenheim Museum, New York
69.1893

72. Paul Klee
Rocks at Night | Felsen in der Nacht, 1939.83
Watercolor, gouache, and ink on primed paper, mounted
on cardboard, paper 20.9 x 29.5 cm; cardboard 27.6 x
36.2 cm
Solomon R. Guggenheim Museum, New York
48.1172.538

73. Jean Arp
*Constellation with Five White Forms and Two Black,
Variation III | Constellation aux cinq formes blanches et
deux noires, variation III*, 1932
Oil on wood, 60 x 75.5 cm
Solomon R. Guggenheim Museum, New York
55.1437

74. Constantin Brancusi
King of Kings | Le Roi des rois, ca. 1938
Oak, 300 x 48.3 x 46 cm
Solomon R. Guggenheim Museum, New York
56.1449

75. Theo van Doesburg
Composition XI | Compositie XI, 1918
Oil on canvas, 64.6 x 109 cm, including artist's
painted frame
Solomon R. Guggenheim Museum, New York
54.1360

76. Theo van Doesburg
Counter-Composition XIII | Contra-Compositie XIII,
1925–26
Oil on canvas, 49.9 x 50 cm
Peggy Guggenheim Collection, Venice
76.2553.41

77. Vasily Kandinsky
Blue Circle | Blauer Kreis, 1922
Oil on canvas, 109.2 x 99.2 cm
Solomon R. Guggenheim Museum, New York
46.1051

78. Vasily Kandinsky
Composition 8 | Komposition 8, July 1923
Oil on canvas, 140 x 201 cm
Solomon R. Guggenheim Museum, New York
Gift, Solomon R. Guggenheim 37.262

79. Vasily Kandinsky
Three Sounds | Drei Klänge, August 1926
Oil on canvas, 59.9 x 59.6 cm
Solomon R. Guggenheim Museum, New York
Gift, Solomon R. Guggenheim 41.282

80. Vasily Kandinsky
Decisive Rose | Entscheidendes Rosa, March 1932
Oil on canvas, 81 x 100 cm
Solomon R. Guggenheim Museum, New York
49.1178

81. Vasily Kandinsky
Dominant Curve | Courbe dominante, April 1936
Oil on canvas, 129.4 x 194.2 cm
Solomon R. Guggenheim Museum, New York
45.989

82. Vasily Kandinsky
Various Actions | Actions variées, August–
September 1941
Oil and enamel on canvas, 89.2 x 116.1 cm
Solomon R. Guggenheim Museum, New York
47.1159

83. László Moholy-Nagy
A II, 1924
Oil on canvas, 115.8 x 136.5 cm
Solomon R. Guggenheim Museum, New York
43.900

84. László Moholy-Nagy
T1, 1926
Oil on Trolitan, 139.8 x 61.8 cm
Solomon R. Guggenheim Museum, New York
Gift, Solomon R. Guggenheim 37.354

85. László Moholy-Nagy
Dual Form with Chromium Rods, 1946
Plexiglas and chrome-plated steel rods, 92.7 x 121.6 x
55.9 cm
Solomon R. Guggenheim Museum, New York
48.1149

86. Naum Gabo
Translucent Variation on Spheric Theme, 1951
(base 1937)
Perspex, 56.8 x 44.8 x 44.8 cm
Solomon R. Guggenheim Museum, New York
48.1174

87. Yves Tanguy
The Sun in Its Jewel Case | Le Soleil dans son écrin, 1937
Oil on canvas, 115.4 x 88.1 cm
Peggy Guggenheim Collection, Venice
76.2553.95

88. Paul Delvaux
The Break of Day | L'Aurore, July 1937
Oil on canvas, 120 x 150.5 cm
Peggy Guggenheim Collection, Venice
76.2553.103

89. Pablo Picasso
The Studio | L'Atelier, 1928
Oil and black crayon on canvas, 161 x 129.9 cm
Peggy Guggenheim Collection, Venice
76.2553.3

90. Pablo Picasso
Half-length Portrait of a Man in a Striped Jersey |
Buste d'homme en tricot rayé, September 14, 1939
Gouache on paper, 63.1 x 45.6 cm
Peggy Guggenheim Collection, Venice
76.2553.6

91. Constantin Brancusi
Maiastra, 1912 (?)
Polished brass, 73.1 x 18.5 x 19 cm, including base
Peggy Guggenheim Collection, Venice
76.2553.50

92. Constantin Brancusi
Bird in Space | L'Oiseau dans l'espace, 1930s
Polished brass, h. 151.7 cm, including base
Peggy Guggenheim Collection, Venice
76.2553.51

93. Alberto Giacometti
Woman with Her Throat Cut | Femme égorgée, 1932,
cast 1940
Bronze, 23.2 x 89 cm
Peggy Guggenheim Collection, Venice
76.2553.131

94. Alberto Giacometti
Standing Woman ("Leoni") | Femme debout ("Leoni"),
1947, cast November 1957
Bronze, h. 153 cm, including base
Peggy Guggenheim Collection, Venice
76.2553.134

95. René Magritte
Voice of Space | La Voix des airs, 1931
Oil on canvas, 72.7 x 54.2 cm
Peggy Guggenheim Collection, Venice
76.2553.101

96. Salvador Dalí
Birth of Liquid Desires | La Naissance des désirs liquides,
1931–32
Oil and collage on canvas, 96.1 x 112.3 cm
Peggy Guggenheim Collection, Venice
76.2553.100

97. Amédée Ozenfant
Guitar and Bottles | Guitare et bouteilles, 1920
Oil on canvas, 80.5 x 99.8 cm
Peggy Guggenheim Collection, Venice
76.2553.24

98. Max Ernst
The Forest | La Forêt, 1927–28
Oil on canvas, 96.3 x 129.5 cm
Peggy Guggenheim Collection, Venice
76.2553.72

99. Max Ernst
The Antipope, December 1941–March 1942
Oil on canvas, 160.8 x 127.1 cm
Peggy Guggenheim Collection, Venice
76.2553.80

100. Jackson Pollock
The Moon Woman, 1942
Oil on canvas, 175.2 x 109.3 cm
Peggy Guggenheim Collection, Venice
76.2553.141

101. Jackson Pollock
Circumcision, January 1946
Oil on canvas, 142.3 x 168 cm
Peggy Guggenheim Collection, Venice
76.2553.145

102. Jackson Pollock
Enchanted Forest, 1947
Oil on canvas, 221.3 x 114.6 cm
Peggy Guggenheim Collection, Venice
76.2553.151

103. Jackson Pollock
Number 18, 1950
Oil and enamel on Masonite, 56.0 x 56.7 cm
Solomon R. Guggenheim Museum, New York
Gift, Janet C. Hauck, in loving memory of Alicia
Guggenheim and Fred Hauck 91.4046

104. Jackson Pollock
Ocean Greyness, 1953
Oil on canvas, 146.7 x 229 cm
Solomon R. Guggenheim Museum, New York
54.1408

105. Adolph Gottlieb
The Red Bird, 1944
Oil on canvas, 101.6 x 76.2 cm
Solomon R. Guggenheim Museum, New York
48.1172.515

106. Adolph Gottlieb
Augury, 1945
Oil on canvas, 101.6 x 76.1 cm
Solomon R. Guggenheim Museum, New York
48.1172.516

107. Clyfford Still
Untitled, 1964
Oil on canvas, 259 x 222 cm
Guggenheim Museum Bilbao
GBM1996.3

108. Robert Motherwell
Elegy to the Spanish Republic No. 110, Easter Day, 1971
Acrylic with pencil and charcoal on canvas,
208.3 x 289.6 cm
Solomon R. Guggenheim Museum, New York
Gift, Agnes Gund 84.3223

109. Mark Rothko
Untitled (Violet, Black, Orange, Yellow on White
and Red), 1949
Oil on canvas, 207 x 167.6 cm
Solomon R. Guggenheim Museum, New York
Gift, Elaine and Werner Dannheisser and The
Dannheisser Foundation 78.2461

110. Mark Rothko
Untitled (Black on Gray), 1969/1970
Acrylic on canvas, 203.3 x 175.5 cm
Solomon R. Guggenheim Museum, New York
Gift, The Mark Rothko Foundation, Inc. 86.3422

111. Willem de Kooning
Composition, 1955
Oil, enamel, and charcoal on canvas, 201 x 175.6 cm
Solomon R. Guggenheim Museum, New York
55.1419

112. Franz Kline
Painting No. 7, 1952
Oil on canvas, 146 x 207.6 cm
Solomon R. Guggenheim Museum, New York
54.1403

113. Hans Hofmann
The Gate, 1959–60
Oil on canvas, 190.7 x 123.2 cm
Solomon R. Guggenheim Museum, New York
62.1620

114. Ellsworth Kelly
Blue, Green, Yellow, Orange, Red, 1966
Oil on canvas, five panels, 152.4 x 609.6 cm overall
Solomon R. Guggenheim Museum, New York
67.1833

115. Tony Smith
For W.A., 1969
Welded bronze with black patina, edition 1/6 + 1 A.P.,
two units, 152 x 83.3 x 83.3 cm each
Solomon R. Guggenheim Museum, New York
Purchased with the aid of funds from the National
Endowment for the Arts in Washington, D.C., a Federal
Agency; matching funds contributed by the Junior
Associates Committee 80.2753

116. Agnes Martin
White Flower, 1960
Oil on canvas, 182.6 x 182.9 cm
Solomon R. Guggenheim Museum, New York
Anonymous gift 63.1653

117. Agnes Martin
White Stone, 1965
Oil and graphite on linen, 182.6 x 182.6 cm
Solomon R. Guggenheim Museum, New York
Gift, Mr. Robert Elkon 69.1911

118. Karel Appel
Two Heads | Deux têtes, 1953
Oil on canvas, 200 x 75 cm
Solomon R. Guggenheim Museum, New York
54.1363

119. Asger Jorn
A Soul for Sale | Ausverkauf einer Seele, 1958–59
Oil on canvas, 200 x 250 cm
Solomon R. Guggenheim Museum, New York
Purchased with funds contributed by the Evelyn Sharp
Foundation 83.3040

120. Alberto Giacometti
Nose | Le Nez, 1947, cast 1965
Bronze, wire, rope, and steel, edition 5/6, 81 x 97.5 x
39.4 cm overall
Solomon R. Guggenheim Museum, New York
66.1807

121. Jean Dubuffet
Propitious Moment | L'Instant propice, January 2–3, 1962
Oil on canvas, 200 x 165 cm
Solomon R. Guggenheim Museum, New York
74.2080

122. Jan Müller
Jacob's Ladder, January 1958
Oil on canvas, 212.1 x 292.1 cm
Solomon R. Guggenheim Museum, New York
62.1609

123. Francis Bacon
Three Studies for a Crucifixion, March 1962
Oil with sand on canvas, three panels,
198.2 x 144.8 cm each
Solomon R. Guggenheim Museum, New York
64.1700

124. Roy Lichtenstein
Grrrrrrrrrr!!, 1965
Oil and Magna on canvas, 172.7 x 142.5 cm
Solomon R. Guggenheim Museum, New York
Gift of the artist 97.4565

125. Robert Rauschenberg
Untitled, 1963
Oil, silkscreened ink, metal, and plastic on canvas,
208.3 x 121.9 x 15.9 cm
Solomon R. Guggenheim Museum, New York
Purchased with funds contributed by Elaine and
Werner Dannheisser and The Dannheisser Foundation
82.2912

126. Robert Rauschenberg
Barge, 1962–63
Oil and silkscreened ink on canvas, 203.88 x 980.44 cm
Solomon R. Guggenheim Museum, New York, and
Guggenheim Museum Bilbao, with additional funds con-
tributed by Thomas H. Lee and Ann Tenenbaum; the
International Director's Council and Executive
Committee Members: Eli Broad, Elaine Terner Cooper,
Ronnie Heyman, J. Tomilson Hill, Dakis Joannou,
Barbara Lane, Robert Mnuchin, Peter Norton, Thomas
Walther, and Ginny Williams; Ulla Dreyfus-Best; Norma
and Joseph Saul Philanthropic Fund; Elizabeth Rea; Eli
Broad; Dakis Joannou; Peter Norton; Peter Lawson-
Johnston; Michael Wettach; Peter Littmann; Tiqui
Atencio; Bruce and Janet Karatz; and Giulia Ghirardi
Pagliai 97.4566; GBM1997.10

127. Robert Rauschenberg
Religious Fluke, 1962
Transfer drawing, pencil, washed colored-pencil, water-
color, and acrylic on strathmore paper, 58.5 x 73.6 cm
Solomon R. Guggenheim Museum, New York
Gift, Estate of Geraldine Spreckels Fuller 2000.46

128. Robert Rauschenberg
Noname (Elephant), from the portfolio *For Meyer
Schapiro*, July 1973
Solvent transfer, broken stone embossment,
hand-painted gesso, and tape on paper, edition 91/100,
71.1 x 50.8 cm
Solomon R. Guggenheim Museum, New York
Gift, Janet and George M. Jaffin 78.2400.9

129. Robert Rauschenberg
Yellow Body, 1968
Solvent transfer on paper with pencil, watercolor,
gouache, and wash, 57.2 x 76.2 cm
Solomon R. Guggenheim Museum, New York
Gift, Robert Rauschenberg Foundation 98.5219

130. Robert Rauschenberg
Glaze (Hoarfrost), 1975
Solvent transfer on silk and cotton, 187.9 x 102.2 cm
Solomon R. Guggenheim Museum, New York
Purchased with funds contributed by the Louis and
Bessie Adler Foundation, Inc., Seymour M. Klein,
President 84.3165

131. Robert Rauschenberg
Talisman Freeze, 1979
Solvent transfer, fabric collage, and paper with
lithography, 106.7 x 80.6 cm
Solomon R. Guggenheim Museum, New York
Gift, Robert Rauschenberg Foundation 98.5223

132. Roy Lichtenstein
Preparedness, 1968
Oil and Magna on canvas, three panels,
304.8 x 183 cm each; 304.8 x 548.7 cm overall
Solomon R. Guggenheim Museum, New York
69.1885

133. Roy Lichtenstein
Interior with Mirrored Wall, 1991
Oil and Magna on canvas, 320.3 x 406.2 cm
Solomon R. Guggenheim Museum, New York
92.4023

134. Andy Warhol
Orange Disaster #5, 1963
Acrylic and silkscreened enamel on canvas,
269.2 x 207 cm
Solomon R. Guggenheim Museum, New York
Gift, Harry N. Abrams Family Collection 74.2118

135. Andy Warhol
Self-Portrait, 1986
Silkscreened ink on synthetic polymer paint on canvas,
269.2 x 269.2 cm
Solomon R. Guggenheim Museum, New York
Gift, Anne and Anthony d'Offay 92.4033

136. Andy Warhol
One Hundred and Fifty Multicolored Marilyns, 1979
Acrylic and silkscreened enamel on canvas, 201 x
1055 cm
Guggenheim Museum Bilbao
GBM1997.19

137. Richard Hamilton
The Solomon R. Guggenheim (Black and White),
1965–66
Fiberglass and cellulose, 122 x 122 x 19 cm
Solomon R. Guggenheim Museum, New York
67.1859.2

138. Richard Hamilton
The Solomon R. Guggenheim (Spectrum), 1965–66
Fiberglass and cellulose, 122 x 122 x 19 cm
Solomon R. Guggenheim Museum, New York
67.1859.3

139. James Rosenquist
Flamingo Capsule, 1970
Oil on canvas and aluminized Mylar, 290 x 701 cm
Guggenheim Museum Bilbao
GBM1997.9

140. James Rosenquist
The Swimmer in the Econo-mist (painting 2), 1997
Oil on canvas, 350 x 1460 cm
Solomon R. Guggenheim Museum, New York
Commissioned by Deutsche Bank AG in consultation
with the Solomon R. Guggenheim Foundation for the
Deutsche Guggenheim, Berlin 2005.76

141. James Rosenquist
The Swimmer in the Econo-mist (painting 3), 1997–98
Oil on canvas, 350 x 610 cm
Solomon R. Guggenheim Museum, New York
Commissioned by Deutsche Bank AG in consultation
with the Solomon R. Guggenheim Foundation for the
Deutsche Guggenheim, Berlin 2005.77

142. Bruce Nauman
Green Light Corridor, 1970
Painted wallboard and fluorescent light fixtures with
green lamps, dimensions variable, approximately 304.8 x
1219.2 x 30.5 cm
Solomon R. Guggenheim Museum, New York
Panza Collection, Gift 92.4171

143. Dan Flavin
*an artificial barrier of blue, red and blue fluorescent light
(to Flavin Starbuck Judd)*, 1968
Fluorescent light fixtures with blue and red lamps,
edition of 3, 2- and 4-ft. fixtures, 61 x 1413.5 x 30.5 cm
overall
Solomon R. Guggenheim Museum, New York
Panza Collection 91.3707

144. Donald Judd
Untitled, February 22, 1971
Orange enamel on cold-rolled steel, eight units with
12-inch intervals, 121.9 x 121.9 x 121.9 cm each; 121.9 x
1188.7 x 121.9 cm overall
Solomon R. Guggenheim Museum, New York
Panza Collection 91.3718

145. Carl Andre
5 x 20 Altstadt Rectangle, Düsseldorf, 1967
Hot-rolled steel, 100 units, 0.5 x 50 x 50 cm each; 0.5 x
250 x 1000 cm overall
Solomon R. Guggenheim Museum, New York
Panza Collection 91.3667

146. Carl Andre
10 x 10 Altstadt Copper Square, Düsseldorf, 1967
Copper, 100 units, 0.5 x 50 x 50 cm each; 0.5 x 500 x
500 cm overall
Solomon R. Guggenheim Museum, New York
Panza Collection 91.3673

147. Robert Morris
Untitled (Labyrinth), 1974
Painted plywood and Masonite, h. 488 cm;
diam. 1097 cm
Solomon R. Guggenheim Museum, New York
Panza Collection 91.3814

148. Robert Morris
Untitled (Brown Felt), 1973
Felt, dimensions variable
Solomon R. Guggenheim Museum, New York
Panza Collection 91.3802
[not in exhibition]

149. Robert Morris
Untitled (Aluminum I-Beams), 1967
Aluminium, 167.6 x 777.2 x 1021.1 cm
Solomon R. Guggenheim Museum, New York
Panza Collection 91.3813

150. Robert Mangold
Neutral Pink Area, 1966
Oil on Masonite, two panels, 121.9 x 243.8 cm overall
Solomon R. Guggenheim Museum, New York
Panza Collection 91.3759

151. Robert Ryman
Surface Veil I, 1970
Oil and blue chalk on stretched linen canvas, 365.6 x
365.8 cm
Solomon R. Guggenheim Museum, New York
Panza Collection 91.3851

152. Robert Ryman
Surface Veil II, 1971
Oil and blue chalk on stretched linen canvas, 365.8 x
365.8 cm
Solomon R. Guggenheim Museum, New York
Panza Collection 91.3854

153. Robert Ryman
Surface Veil III, 1971
Oil and blue chalk on stretched cotton canvas, 366.4 x
366.4 cm
Solomon R. Guggenheim Museum, New York
Panza Collection 91.3855

154. Sol LeWitt
*Wall Drawing #264. A wall divided into 16 equal parts
with all one-, two-, three-, and four-part combinations of
lines in four directions and four colors. First installed:
Varese, July 1975*
Red, yellow, blue, and black pencil, site-specific
dimensions
Solomon R. Guggenheim Museum, New York
Panza Collection, Gift 92.4156

155. Lawrence Weiner
*Cat. #151 (1970) EARTH TO EARTH ASHES TO
ASHES DUST TO DUST*, 1970
Language + the materials referred to, dimensions
variable
Solomon R. Guggenheim Museum, New York
Panza Collection, Gift 92.4184

156. Richard Serra
Shovel Plate Prop, 1969
Steel, 203 x 213.4 x 81.3 cm overall; plate 199.5 x 101.2 x
2.4 cm; tube l. 144.9 cm, diam. 24.2 cm
Solomon R. Guggenheim Museum, New York
Panza Collection 91.3867

157. Richard Serra
Shafrazi, 1974
Oil stick on linen, 290 x 541.7 cm
Solomon R. Guggenheim Museum, New York
Panza Collection 91.3873

158. Richard Serra
Strike: To Roberta and Rudy, 1969–71
Hot-rolled steel, 246.38 x 731.52 x 3.8 cm
Solomon R. Guggenheim Museum, New York
Panza Collection 91.3871

159. Bruce Nauman
Triangle Room, 1978/1980
Painted plywood and three sodium vapor lamps,
one wall 340.8 x 914.4 cm; two walls 340.8 x 609.6 cm
Solomon R. Guggenheim Museum, New York
Panza Collection 91.3826

160. Richard Long
Line of Lake Stones, 1983
Stones, approximate l. 2179.3 cm
Solomon R. Guggenheim Museum, New York
Panza Collection 91.3758

161. Matthew Barney
Chrysler Imperial, 2002
Cast concrete, cast petroleum jelly, cast thermoplastic,
stainless steel, marble, and internally lubricated plastic,
five units, four units at approximately 61.0 x 152.4 x
228.6 cm each; one unit at approximately 167.6 x 396.2 x
426.7 cm
Solomon R. Guggenheim Museum, New York
Partial gift, Dimitris Daskalopoulos; purchased with
funds contributed by the International Director's Council
and Executive Committee Members: Ruth Baum,
Edythe Broad, Elaine Terner Cooper, Dimitris
Daskalopoulos, Harry David, Gail May Engelberg,
Shirley Fiterman, Nicki Harris, Dakis Joannou, Rachel
Lehmann, Linda Macklowe, Peter Norton, Tonino Perna,
Elizabeth Richebourg Rea, Mortimer D.A. Sackler,
Simonetta Seragnoli, David Teiger, and Elliot K. Wolk
2003.88
[not in exhibition]

162. Roni Horn
Pl, 1997–98
45 Iris prints on Somerset Satin paper, edition 5/5,
22 components, 51.4 x 69.2 cm each; 13 components,
51.4 x 51.4 cm each; 10 components, 51.4 x 41.3 cm each
Solomon R. Guggenheim Museum, New York
Purchased with funds contributed by the International
Director's Coucil and Executive Committee members:
Ann Ames, Edythe Broad, Elaine Terner Cooper,
Dimitris Daskalopoulos, Harry David, Ulla Dreyfus-Best,
Gail Willem Peppler, Tonino Perna, Elizabeth Rea
Richebourg, Denise Rich, Simonetta Seragnoli,
David Teiger, and Elliot K. Wolk; with additional funds
contributed by the Photography Committee 2001.71

163. Rachel Whiteread
Untitled (Apartment), 2001
White robust plasticized plaster, 284.5 x 1110 x 614.7 cm
Solomon R. Guggenheim Museum, New York
Commissioned by Deutsche Bank AG in consultation
with the Solomon R. Guggenheim Foundation for the
Deutsche Guggenheim, Berlin 2005.118

164. Rachel Whiteread
Untitled (Basement), 2001
White robust plasticized plaster
325.1 x 657.9 x 368.3 cm
Solomon R. Guggenheim Museum, New York
Commissioned by Deutsche Bank AG in consultation
with the Solomon R. Guggenheim Foundation for the
Deutsche Guggenheim, Berlin 2005.119

165. Iñigo Manglano-Ovalle
Climate, 2000
Three-channel video installation with sound, 00:23:35,
edition 1/3, dimensions variable
Solomon R. Guggenheim Museum, New York
Gift, The Bohen Foundation 2001.190

166. Douglas Gordon
through a looking glass, 1999
Two-channel video installation, with sound, 00:60:00,
edition 3/3, dimensions variable
Solomon R. Guggenheim Museum, New York
Purchased with funds contributed by the International
Director's Council and Executive Committee Members:
Edythe Broad, Henry Buhl, Elaine Terner Cooper, Gail
May Engelberg, Linda Fischbach, Ronnie Heyman,
Dakis Joannou, Cindy Johnson, Barbara Lane, Linda
Macklowe, Peter Norton, Willem Peppler, Denise Rich,
Simonetta Seragnoli, David Teiger, Ginny Williams, and
Elliot K. Wolk 99.5304

167. Kara Walker
*Insurrection! (Our Tools Were Rudimentary, Yet We
Pressed On)*, 2000
Cut paper silhouettes and light projections, dimensions
vary with installation
Solomon R. Guggenheim Museum, New York
Purchased with funds contributed by the International
Director's Council and Executive Committee Members:
Ann Ames, Edythe Broad, Henry Buhl, Elaine Terner
Cooper, Dimitris Daskalopoulos, Harry David, Gail May
Engelberg, Ronnie Heyman, Dakis Joannou, Cindy
Johnson, Barbara Lane, Linda Macklowe, Peter Norton,
Willem Peppler, Tonino Perna, Denise Rich, Simonetta
Seragnoli, David Teiger, Ginny Williams, and Elliot K.
Wolk 2000.68

168. Anna Gaskell
untitled #1 (wonder), 1996
C-print, laminated and mounted on Sintra, A.P. 2/2,
edition of 5, 40 x 50 cm
Solomon R. Guggenheim Museum, New York
Gift, Nina and Frank Moore, 2004.104

169. Anna Gaskell
untitled #3 (wonder), 1996
C-print, laminated and mounted on Sintra, A.P. 2/2,
edition of 5, 149.1 x 121.8 cm
Solomon R. Guggenheim Museum, New York
Purchased with funds contributed by the Young
Collectors Council 97.4578

170. Anna Gaskell
untitled #9 (wonder), 1996
C-print, laminated and mounted on Sintra, edition 1/5,
16.1 x 19.8 cm
Solomon R. Guggenheim Museum, New York
Purchased with funds contributed by the Young
Collectors Council 97.4584

171. Anna Gaskell
untitled #2 (wonder), 1996
C-print, laminated and mounted on Sintra, A.P. 2/2,
edition of 5, 120.8 x 100.6 cm
Solomon R. Guggenheim Museum, New York
Purchased with funds contributed by the Young
Collectors Council 97.4577

172. Anna Gaskell
untitled #10 (wonder), 1996
C-print, laminated and mounted on Sintra, A.P. 2/2,
edition of 5, 39.1 x 47.6 cm
Solomon R. Guggenheim Museum, New York
Purchased with funds contributed by the Young
Collectors Council 97.4585

173. Anna Gaskell
untitled #19 (wonder), 1996
C-print, laminated and mounted on Sintra, A.P. 2/2,
edition of 5, 101 x 123 cm
Solomon R. Guggenheim Museum, New York
Purchased with funds contributed by the Young
Collectors Council 97.4594

174. Anna Gaskell
untitled #18 (wonder), 1996
C-print, laminated and mounted on Sintra, A.P. 2/2,
edition of 5, 90.2 x 74.6 cm
Solomon R. Guggenheim Museum, New York
Purchased with funds contributed by the Young
Collectors Council 97.4593

175. Anna Gaskell
Erasers, 2005
Video, 00:10:00, continuous loop, edition 2/4
Solomon R. Guggenheim Museum, New York
Purchased with funds contributed by the Photography
Committee 2005.66

176. David Altmejd
The University 2, 2004
Wood, paint, plaster, resin, mirrored glass, Plexiglas, wire,
glue, plastic, cloth, synthetic hair, jewelry, glitter,
minerals, paper, beads, synthetic flowers, electricity, and
light bulbs, 271.8 x 546.1 x 640.1 cm
Solomon R. Guggenheim Museum, New York
Purchased with funds contributed by the International
Director's Council and Executive Committee Members:
Ruth Baum, Edythe Broad, Elaine Terner Cooper,
Dimitris Daskalopoulos, Harry David, Gail May
Engelberg, Shirley Fiterman, Nicki Harris, Dakis
Joannou, Rachel Lehmann, Linda Macklowe, Peter
Norton, Tonino Perna, Elizabeth Richebourg Rea,
Mortimer D. A. Sackler, Simonetta Seragnoli, David
Teiger, Ginny Williams, and Elliot K. Wolk, and
Sustaining Members: Tiqui Atencio, Linda Fischbach,
Beatrice Habermann, Miryam Knutson, and Cargill and
Donna MacMillan; with additional funds contributed by
the Young Collectors Council 2004.126

177. Matthew Ritchie
The Hierarchy Problem, 2003
Multipart installation consisting of *Snake Eyes*, oil and
marker on canvas, 251.5 x 335.3 cm [not illustrated];
The Hierarchy Problem, acrylic on wall, 426.7 x
3657.6 cm; *The Two Way Joint*, photographic print
on Duratrans mounted on lenticular acrylic panels,
aluminum frame, and fluorescent lights, 243.8 x 487.7 x
61 cm; and *The God Impersonator*, rubber, adhesive,
and Tyvek, 731.5 x 1463 x 0.6 cm
Solomon R. Guggenheim Museum, New York
Purchased with funds contributed by the International
Director's Council and Executive Committee Members:
Ruth Baum, Edythe Broad, Elaine Terner Cooper,
Dimitris Daskalopoulos, Harry David, Gail May
Engelberg, Shirley Fiterman, Nicki Harris, Dakis
Joannou, Rachel Lehmann, Linda Macklowe, Peter
Norton, Tonino Perna, Elizabeth Richebourg Rea,
Mortimer D.A. Sackler, Simonetta Seragnoli, David
Teiger, Ginny Williams, and Elliot K. Wolk, and
Sustaining Members: Tiqui Atencio, Linda Fischbach,
Beatrice Habermann, Miryam Knutson, and Cargill
and Donna MacMillan 2004.75
exhibited with:
The Fine Constant, 2003
Powder-coated aluminum, stainless steel, gypsum,
wax, and enamel, edition of 1 + 1 A.P., 241.3 x 358.1 x
1101.1 cm
Courtesy the artist and Andrea Rosen Gallery, New York

The following works are included in the exhibition but are not illustrated in the catalogue:

Matthew Barney
The Cremaster Cycle
CREMASTER 1, 1995, 00:40:30
CREMASTER 2, 1999, 1:19:00
CREMASTER 3, 2002, 3:01:59
CREMASTER 4, 1994, 00:42:16
CREMASTER 5, 1997, 00:54:30
Five color digital videos with Dolby SR sound, and Astroturf
Courtesy the artist
The permanent collection of the Solomon R. Guggenheim Museum, New York, includes editions of the films and vitrines for *Cremasters 1, 2, 3,* and *5,* purchased between 1996 and 2002 with funds contributed by the International Director's Council and Executive Committee Members.

Anna Gaskell
untitled #4 (wonder), 1996
C-print, laminated and mounted on Sintra, A.P. 2/2, edition of 5, 58.9 x 73.6 cm
Solomon R. Guggenheim Museum, New York
Purchased with funds contributed by the Young Collectors Council 97.4579

Anna Gaskell
untitled #5 (wonder), 1996
C-print, laminated and mounted on Sintra, A.P. 2/2, edition of 5, 122.1 x 102.2 cm
Solomon R. Guggenheim Museum, New York
Purchased with funds contributed by the Young Collectors Council 97.4580

Anna Gaskell
untitled #6 (wonder), 1996
C-print, laminated and mounted on Sintra, A.P. 2/2, edition of 5, 48.3 x 59 cm
Solomon R. Guggenheim Museum, New York
Purchased with funds contributed by the Young Collectors Council 97.4581

Anna Gaskell
untitled #7 (wonder), 1996
C-print, laminated and mounted on Sintra, A.P. 2/2, edition of 5, 21 x 17.4 cm
Solomon R. Guggenheim Museum, New York
Purchased with funds contributed by the Young Collectors Council 97.4582

Anna Gaskell
untitled #8 (wonder), 1996
C-print, laminated and mounted on Sintra, A.P. 2/2, edition of 5, 73.6 x 89.5 cm
Solomon R. Guggenheim Museum, New York
Purchased with funds contributed by the Young Collectors Council 97.4583

Anna Gaskell
untitled #11 (wonder), 1996
C-print, laminated and mounted on Sintra, A.P. 2/2, edition of 5, 89.4 x 73.6 cm
Solomon R. Guggenheim Museum, New York
Purchased with funds contributed by the Young Collectors Council 97.4586

Anna Gaskell
untitled #12 (wonder), 1996
C-print, laminated and mounted on Sintra, A.P. 2/2, edition of 5, 148.5 x 122.1 cm
Solomon R. Guggenheim Museum, New York
Purchased with funds contributed by the Young Collectors Council 97.4587

Anna Gaskell
untitled #13 (wonder), 1996
C-print, laminated and mounted on Sintra, A.P. 2/2, edition of 5, 27.2 x 33.3 cm
Solomon R. Guggenheim Museum, New York
Purchased with funds contributed by the Young Collectors Council 97.4588

Anna Gaskell
untitled #14 (wonder), 1996
C-print, laminated and mounted on Sintra, A.P. 2/2, edition of 5, 17.2 x 13.7 cm
Solomon R. Guggenheim Museum, New York
Purchased with funds contributed by the Young Collectors Council 97.4589

Anna Gaskell
untitled #15 (wonder), 1996
C-print, laminated and mounted on Sintra, A.P. 2/2, edition of 5, 27.4 x 34.7 cm
Solomon R. Guggenheim Museum, New York
Purchased with funds contributed by the Young Collectors Council 97.4590

Anna Gaskell
untitled #16 (wonder), 1996
C-print, laminated and mounted on Sintra, A.P. 2/2, edition of 5, 57.9 x 46.5 cm
Solomon R. Guggenheim Museum, New York
Purchased with funds contributed by the Young Collectors Council 97.4591

Anna Gaskell
untitled #17 (wonder), 1996
C-print, laminated and mounted on Sintra, A.P. 2/2, edition of 5, 59 x 48.8 cm
Solomon R. Guggenheim Museum, New York
Purchased with funds contributed by the Young Collectors Council 97.4592

Anna Gaskell
untitled #20 (wonder), 1996
C-print, laminated and mounted on Sintra, A.P. 2/2, edition of 5, 122 x 152.3 cm
Solomon R. Guggenheim Museum, New York
Purchased with funds contributed by the Young Collectors Council 97.4595

Lawrence Weiner
Cat. #157 (1970) TO THE SEA, 1970
Language + the materials referred to, dimensions variable
Solomon R. Guggenheim Museum, New York
Panza Collection, Gift 92.4185

Lawrence Weiner
Cat. #158 (1970) ON THE SEA, 1970
Language + the materials referred to, dimensions variable
Solomon R. Guggenheim Museum, New York
Panza Collection, Gift 92.4186

Lawrence Weiner
Cat. #159 (1970) FROM THE SEA, 1970
Language + the materials referred to, dimensions variable
Solomon R. Guggenheim Museum, New York
Panza Collection, Gift 92.4187

Lawrence Weiner
Cat. #160 (1970) AT THE SEA, 1970
Language + the materials referred to, dimensions variable
Solomon R. Guggenheim Museum, New York
Panza Collection, Gift 92.4188

Lawrence Weiner
Cat. #161 (1970) BORDERING THE SEA, 1970
Language + the materials referred to, dimensions variable
Solomon R. Guggenheim Museum, New York
Panza Collection, Gift 92.4189

Copyright Notices and Photo Credits